Anatomy Lessons
FROM THE
Great Masters

Anatomy Lessons
FROM THE
Great Masters

**BY ROBERT BEVERLY HALE
AND TERENCE COYLE**

WATSON-GUPTILL PUBLICATIONS/NEW YORK

Paperback edition © 2000

Copyright © 1977 by Watson-Guptill Publications

First published in 1971 in the United States and Canada
by Watson-Guptill Publications,
an imprint of the Crown Publishing Group,
a division of Random House, Inc., New York
www.crownpublishing.com
www.watsonguptill.com

Library of Congress Cataloging in Publication Data
Hale, Robert Beverly
 Anatomy lessons from the great masters.
 Bibliography: p.
 Includes index.
 1. Anatomy, Artistic. I. Coyle, Terence,
joint author. II. Title.
NC760.H27 1977 743'.4 77-12810

ISBN-13: 978-0-8230-0281-8
ISBN: 0-8230-0281-0

Manufactured in the U.S.A

14 / 16

Acknowledgments

We wish to thank all the people and institutions who aided us in the survey and gathering of the master prints for this book. Special thanks are due to Jacob Bean, Curator of Drawings, and to the staff of the Department of Drawings of the Metropolitan Museum of Art.

We are most thankful to our editor, Bonnie Silverstein, for her patience and skill and, above all, we gratefully acknowledge the sound advice and guidance from the beginning of this book to its completion of Don Holden, Editorial Director of Watson-Guptill.

CONTENTS

Introduction 9
Preface 11

1 THE RIB CAGE 15
Vertebral Column, Landmarks 16
Rib Cage, Anterior Aspect 18
Rib Cage, Posterior Aspect 20
Rib Cage, Lateral Aspect 22
External Oblique 24
Rectus Abdominis 26
Muscles of Back and Shoulder Girdle 28
Pectoralis Major, Male 30
Pectoralis Major, Female 32

2 THE PELVIS AND THIGH 35
Structural Points, Anterior Aspect 36
Structural Points, Posterior Aspect 38
Structural Points, Lateral Aspect 40
Muscles, Anterior Aspect 42
Muscles, Posterior Aspect 44
Muscles, Medial Aspect 46
Gluteus Maximus 48
Gluteus Medius 50
Tensor Fasciae Latae 52
Sartorius 54
Quadriceps 56
Adductor Group 58
Hamstring Group 60

3 THE KNEE AND LOWER LEG 63
Knee, Anterior Aspect 64
Knee, Posterior Aspect 66
Knee, Lateral Aspect 68
Knee, Medial Aspect 70
Lower Leg, Anterior Aspect 72
Lower Leg, Posterior Aspect 74
Lower Leg, Lateral Aspect 76
Lower Leg, Medial Aspect 78
Lower Leg, Flexion, Lateral Aspect 80
Lower Leg, Flexion, Medial Aspect 82

4 THE FOOT 85
Structural Points, Lateral Aspect 86
Structural Points, Medial Aspect 88
Structural Points, Superior Aspect 90
Structural Points, Inferior Aspect 92
Muscles, Lateral Aspect 94
Muscles, Medial Aspect 96
Muscles, Superior Aspect 98
Extension and Adduction 100
Flexion and Abduction 102

5 THE SHOULDER GIRDLE 105
Clavicle 106
Scapula 108
Trapezius 110
Rhomboids 112
Infraspinatus 114
Teres Major 116
Latissimus Dorsi 118
Pectoralis Major 120
Deltoid 122
Landmarks, Anterior Aspect 124
Landmarks, Posterior Aspect 126
Sternoclavicular Articulation, Elevation and Lowering 128
Sternoclavicular Articulation, Forward and Back 130
Acromioclavicular Articulation, Forward and Back 132
Acromioclavicular Articulation, Up and Down 134

6 THE ARM 137
Axilla, Arm in Flexion 138
Axilla, Arm in Vertical Elevation 140
Biceps Brachii, Anterior Aspect 142
Biceps Brachii, Lateral Aspect 144
Flexion 146
Triceps, Posterior Aspect 148
Triceps, Lateral and Medial Aspect 150
Extension 152
Lower Arm, Anterior Aspect 154
Lower Arm, Posterior Aspect 156
Lower Arm, Lateral Aspect 158

Lower Arm, Medial Aspect 160
Pronation 162
Supination 164
Demipronation 166
Forced Pronation 168

7 THE HAND 171
Muscles and Bony Landmarks, Anterior Aspect 172
Muscles and Bony Landmarks, Posterior Aspect 174
Muscles and Bony Landmarks, Lateral Aspect 176
Muscles and Bony Landmarks, Medial Aspect 178
Extension 180
Flexion 182
Adduction 184
Abduction 186

8 THE NECK AND HEAD 189
Neck, Anterior Aspect 190
Neck, Posterior Aspect 192
Neck, Lateral Aspect 194
Neck, Extension 196
Neck, Flexion 198
Neck, Rotation 200
Neck, Lateral Inclination 202
Constructed Head 204
Head, Anterior Aspect 206
Head, Lateral Aspect 208
The Eye 210
The Nose 212
The Mouth 214
The Ear 216
Emotions: High Spirits to Laughter 218
Emotions: Contempt to Disgust 220
Emotions: Attention to Horror 222
Emotions: Reflection to Grief 224
Emotions: Defiance to Rage 226
Proportions 228

9 ANATOMICAL REFERENCE PLATES 231
Plate 1: The Skull 232
Plate 2: The Skull 233
Plate 3: Skeleton of the Trunk 234
Plate 4: Skeleton of the Trunk 235
Plate 5: Skeleton of the Trunk 236
Plate 6: Vertebral Column 237
Plate 7: The Pelvis 238
Plate 8: Bones of the Upper Limb 239
Plate 9: Bones of the Upper Limb 240
Plate 10: Bones of the Lower Limb 241
Plate 11: Bones of the Lower Limb 242
Plate 12: Bones of the Lower Limb 243
Plate 13: Bones of the Foot 244
Plate 14: Muscles of the Head 245
Plate 15: Muscles of the Head 246
Plate 16: Muscles of the Neck 247
Plate 17: Muscles of the Trunk and Neck,
 Posterior Region 248
Plate 18: Muscles of the Trunk and Neck,
 Posterior Region 249
Plate 19: Muscles of the Trunk and Head 250
Plate 20: Muscles of the Trunk and Head 251
Plate 21: Muscles of the Trunk and Head 252
Plate 22: Muscles of the Upper Limb 253
Plate 23: Muscles of the Upper Limb 254
Plate 24: Muscles of the Upper Limb 255
Plate 25: Muscles of the Upper Limb 256
Plate 26: Muscles of the Lower Limb 257
Plate 27: Muscles of the Lower Limb 258
Plate 28: Muscles of the Lower Limb 259
Plate 29: Muscles of the Lower Limb 260
Plate 30: Muscles of the Foot 261

Suggested Reading 263
Index 265

INTRODUCTION

When I wrote *Drawing Lessons from the Great Masters*, I tried to explain to laymen or beginners (after all, they are the same thing) that the creation of a first-class drawing requires a wealth of information, as well as much prior practice and application. I pointed out that the techniques necessary were no mystery, since they had all been worked out through the years—at times by some of the greatest minds in history. I tried to show that a good drawing consists of an understanding of techniques and conventions, and that these techniques and conventions were all interdependent, one upon the other. Furthermore, I stated that these elements were invariably present in the works of all first-rate artists, though not too apparent to the layman's eye, for it evidently takes much practice in drawing before these qualities can be readily recognized. Finally, I suggested that after the student had had a certain amount of experience, the drawings of the masters made by far the best teachers, and would graciously provide answers to all problems—assuming, of course, that the student had the creative curiosity to formulate the questions.

However, there was not enough space in *Drawing Lessons from the Great Masters* to set down all the necessary anatomical material. So I was delighted when Terence Coyle, a former student of mine and a fellow instructor at the Art Students League, suggested that he would like to write a companion volume, *Anatomy Lessons from the Great Masters*, which would explore in full detail the subject of artistic anatomy as conceived and used by the masters. I was convinced that such a book would be of great help to students.

A cursory glance at the drawings herein should at once reveal that each artist had absorbed the technical details of anatomy so well that these details could be set down instinctively. This has to be so, for if an artist has to occupy his mind with the task of clumsily grouping the elemental facts of anatomy as he draws, there can be little room left for really important matters—such as the spirit of the drawing and the artist's expressive intent.

The beginner must fully understand that there is much, much more to drawing than just a full knowledge of anatomy. Otherwise, any medical man could create a first-rate figure drawing, which he cannot. The reason he cannot is that he is not aware that his splendid knowledge of anatomy must be related to all the other conventions and elements of drawing. In fact, the anatomy must frequently be subordinated to these other factors. If you wish to be a fully trained artist, all these conventions and elements must be so fully learned that, like anatomy, they may be instinctively expressed.

And what *are* all these mysterious conventions and elements? That is what my previous book, *Drawing Lessons from the Great Masters*, is all about. The great master drawings and anatomical facts so skillfully compiled by Terence Coyle—in *Anatomy Lessons from the Great Masters*—are meant to complement the analysis of drawing principles in the earlier volume. I hope you will find time to read them both.

ROBERT BEVERLY HALE
New York, May 1977

PREFACE

For many years, I was privileged to attend and assist at Robert Beverly Hale's famous lectures at the Art Students League of New York. Everyone who has been present at these lectures has felt the spell of this unforgettable man, who is surely America's greatest teacher of figure drawing and artistic anatomy. Attending a Hale lecture, one shares the speaker's rich intellectual experience. Hale's colorful analogies relate the act of drawing to biology, anthropology, physics, architecture, history, and always to everyday life. He awakens the student's awareness and scientific curiosity—teaches him to look beyond mere anatomical facts. Under Hale's guidance, the study of the human figure becomes a path to the understanding and appreciation of nature's fundamental order.

Hale has long felt the need for an anatomical counterpart to his earlier book, *Drawing Lessons from the Great Masters*, but his busy life has always been filled with other projects. Over the years, I have kept detailed notes on his anatomical lectures and I finally suggested that I assemble these notes—appended to 100 master drawings—in a new book to be called *Anatomy Lessons from the Great Masters*. Hale gave his blessing to the project and the present book is the result.

However, when I insisted that Hale's name receive "top billing" on the jacket and title page of *Anatomy Lessons from the Great Masters*, he objected, "But I didn't really write the book—you did!" Surely it is obvious that there would be no book at all without Hale—without his years of inspired teaching and his vast knowledge, to which my lecture notes can scarcely do justice. And so Robert Beverly Hale's name stands first, where it truly belongs.

The purpose of this book is to introduce art students to the practical applications of artistic anatomy in the figure drawings of the great masters. Like *Drawing Lessons from the Great Masters*, this new volume reproduces 100 great figure drawings. Each drawing is then analyzed to show how that particular master dealt with a specific area of the body. Thus, the student may see at once how the masters used anatomy to solve their figure drawing problems. An analytical caption is placed on the page opposite each master drawing. On that same caption page is a diagram of the drawing (or a significant part of it) so there is no time-consuming search for page references and diagrams in remote areas of the book. The master drawings are carefully selected to show how the anatomical area under discussion is treated in a variety of styles and techniques. As such, the book is essentially a self-teacher.

The book is divided into eight chapters generally based on the order of Hale's lectures. At the end of the book, for further reference, we have used an appropriate selection of fine plates drawn by Dr. Paul Richer in *Artistic Anatomy* (translated and edited by Robert Beverly Hale). The anatomical terms used in the text are those found in *Gray's Anatomy* and in Richer's book and are in common use today. When an unfamiliar anatomical name is introduced, the familiar name is given first and then followed by the technical name. Thereafter, the technical name is used throughout the text.

Through the study of anatomical forms in these magnificent drawings of the living figure, we discover patterns and relationships that are not apparent at first glance. We discover that every action is a combination of the actions of many muscles—a series or pattern of moving forms. We observe how the great masters *designed* anatomical shapes. They used anatomy selectively, emphasizing some shapes more than others. It is this selectivity and emphasis, based on sound anatomical knowledge, that is the ultimate "lesson" of the great masters.

TERENCE COYLE
New York, May 1977

Anatomy Lessons
FROM THE
Great Masters

1

THE RIB
CAGE

Giovanni Battista Tiepolo (1696-1770)
TWO BACCHANTES
pen and brown ink
12 1/4" x 9 1/2" (311 x 241 mm)
Robert Lehman Collection
Metropolitan Museum of Art, New York

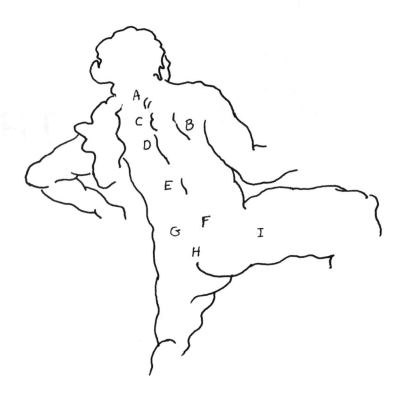

Vertebral Column, Landmarks

Tiepolo was a master at the economical selection of clues to suggest the hidden structure and functions of the body. In this wash drawing, the artist has indicated at the base of the neck the vertebra prominens (A) or seventh cervical vertebra, a very important landmark of the back. He has designed this point with two short contour lines to describe the form and has harmonized the lines, varying their thickness and length for variety and movement. This area is defined by his halftone wash, and is separated at the side from the scapular region by the accentuated vertebral or inner border of the scapula (B).

The two short curves (C) below the seventh cervical vertebra indicate the spineous processes of the first and second thoracic vertebra. Below this, the masses of muscle project beyond the spines, and the vertebrae will not usually show unless the back is bent forward.

To indicate the direction of the median or central furrow, Tiepolo has added a downward accent (D) in the upper thoracic region of the spine, and followed it by another near the bottom of the rib cage (E).

The base of the vertebral column and top of the sacral triangle is indicated by the dimples (F) and (G). The inferior angle of the sacral triangle is located at the top end of the split of the buttocks (H).

Just as Tiepolo uses a spiral of clues to hint at the position of the vertebral column and to suggest the direction of the rib cage, he uses the direction and shape of the sacral triangle (FGH), by showing its position in perspective, to hint at the direction of the pelvis. The artist also used the inferior angle of the sacral triangle (H) as a landmark to indicate the halfway point of the body in terms of height and the level of the top of the great trochanter (I).

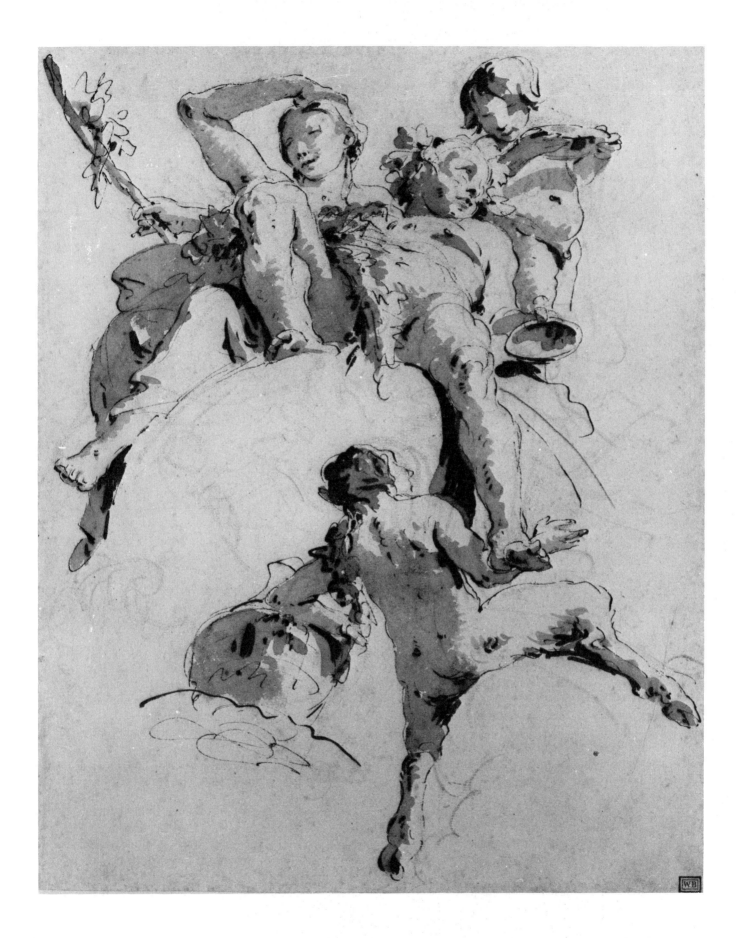

Peter Paul Rubens (1577-1640)
STUDY FOR *THE FIGURE OF CHRIST ON THE CROSS*
black and white chalk, some bistre wash
20 3/4" x 14 9/16" (528 x 370 mm)
British Museum, London

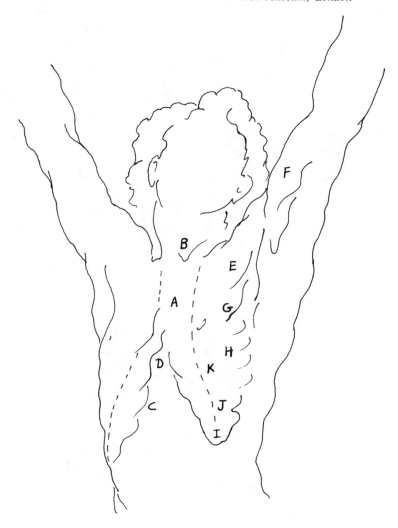

Rib Cage, Anterior Aspect

In this dynamic study, Rubens has first conceived of the great mass of the rib cage as a blocklike cylinder in a perspective box. The sternum and median line (A), indicated by the shaded inner edges of the pectoralis, help to define the direction of the rib cage in space, and one can almost see the perspective lines as they converge to vanishing points outside the frame of the picture. Follow the line of the sternum up to the pit of the neck or suprasternal notch (B). This is the top of the bony mass of the rib cage beneath, and the beginning of the neck.

The formula for the thoracic arch (C) has been reinforced with linear accents of white chalk and follows the general formula for false ribs: two large curves above on each side, followed by two small curves below. At the top of this arch is the infrasternal notch or pit of the stomach (D), an important landmark. It indicates the position of the ensiform cartilage, the bottom of the sternum, the level of the fifth rib, the line of the bottom of

the pectoralis muscle, and the halfway point of the rib cage. The tiny ensiform cartilage or xiphoid appendage, the lowest and smallest portion of the sternum lies, within this notch, but it seldom shows. The base of this appendage is on a level with the widest part of the rib on the front view.

The fibers of the elongated pectoralis muscle (E) stretch across the rib cage to insert in the anterior or front portion of the humerus bone. Beneath the ridge of the bottom of pectoralis (G), Rubens has accentuated four digitations (bulges resembling fingers) of the serratus anterior (H). Below this is the clear bulge of the tip of the tenth rib (I). The vertical line of shading (J) suggests the plane break at the inner edge of the furrow between the ninth and tenth ribs. This begins the upward spiral of the line where the rib meets the cartilage (K), one of the most useful construction lines of the body. This is the line where rib meets cartilage and where front plane meets side plane.

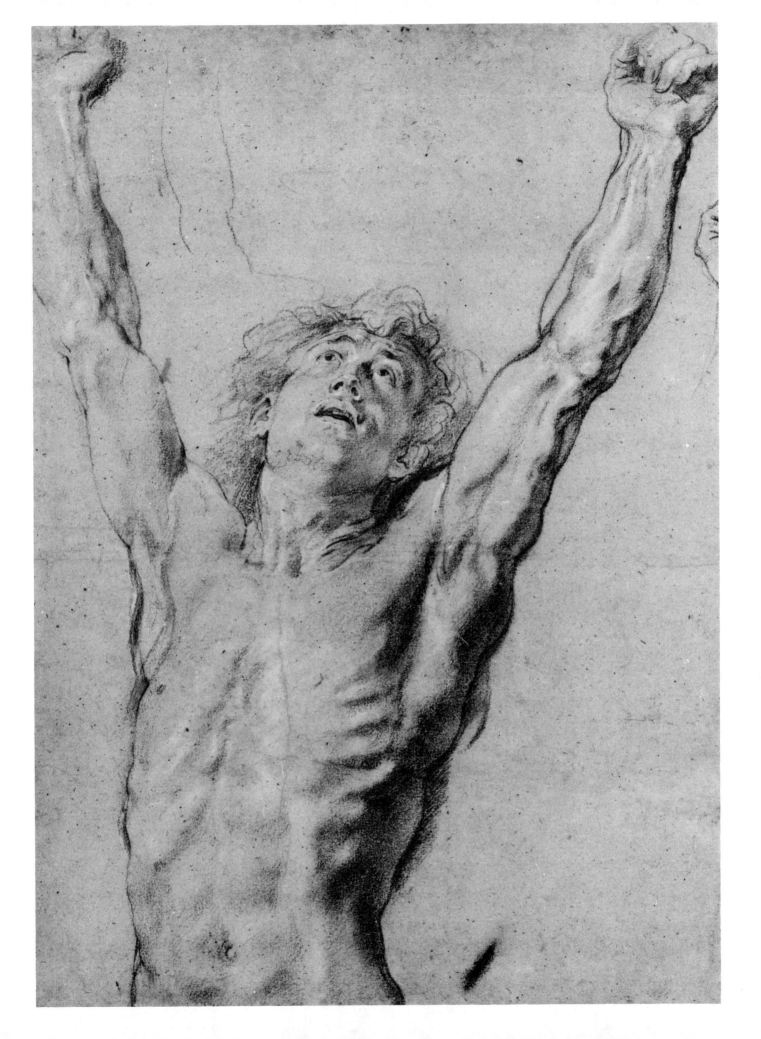

Raphael Sanzio (1483-1520)
TWO MALE FIGURE STUDIES
pen and ink
16 1/8" x 11" (410 x 281 mm)
Albertina, Vienna

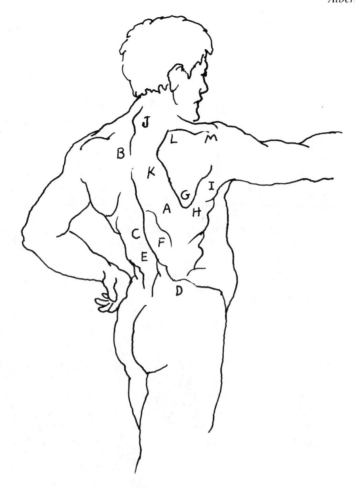

Rib Cage, Posterior Aspect

Observe how Raphael was aware of the influence of the shape of the rib cage and of the deep-lying muscles below upon the form of the superficial muscles of the latissimus dorsi (A) and the trapezius (B).

You can follow the route of the latissimus dorsi as it moves across the rib cage from its origins in the spineous process of the lower six thoracic vertebrae in the area of the median furrow (C), the posterior third of the iliac crest (D), and the external surface of the lower three ribs. It moves out and over the erector spinae (E), often called the "strong chords," which form a strong relief on either side, with the lumbar furrow in-between. The latissimus goes over the middle and largest of the erector spinae, the longissimus dorsi (F), around the mass of the rib cage (A), and creates a relief (G), where it crosses the inferior angle of the scapula to hold it against the rib cage. As the latissimus curves around the side of the bony framework beneath, it reveals the serratus anterior (H), and cradles

the teres major (I), which it holds sling-like at the armpit.

The elongated diamond-shaped muscle of the trapezius is also molded by the deeper muscles beneath, as well as by the rib cage. In this drawing you can easily trace the movements of the trapezius from its central origins in the twelve thoracic vertebrae. The vertebral column is defined by the median furrow (C) and the prominence of the seventh cervical vertebra (J). From here, the trapezius passes over the stretched out rhomboids (K) with a hint of the spinalis beneath. It then moves over the superior angle of the scapula (L), which defines the inner limits of the bulge of the supraspinatus, and inserts in the spine and acromion process (M) of the scapula.

The numerous bodily curves are not easily memorized and you will soon learn to move your lines from anatomical point to point, along a curve, to locate them. These checkpoints will make it easier to locate and define the various lines, values, and shapes.

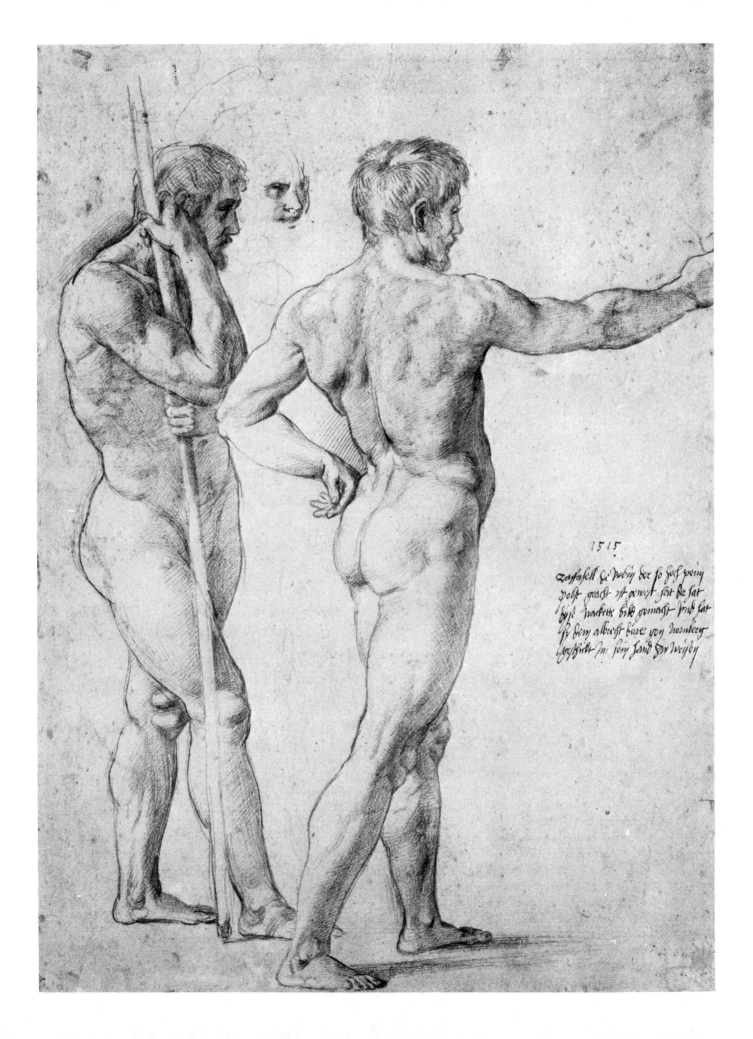

1515

Raffahell de vrbin der so hoch peim
pobst geacht ist gewest hat die hat
hye nackete bild gemacht vnd hat
sye dem albrecht durer gen noremberg
geschickt Jm sein hand zu weysen

Raphael Sanzio (1483-1520)
TWO NAKED FIGURES CROUCHING UNDER A SHIELD
black chalk
10 1/2" x 18 15/16" (266 x 223 mm)
Reproduced by gracious permission of Her Majesty the Queen
Royal Library, Windsor

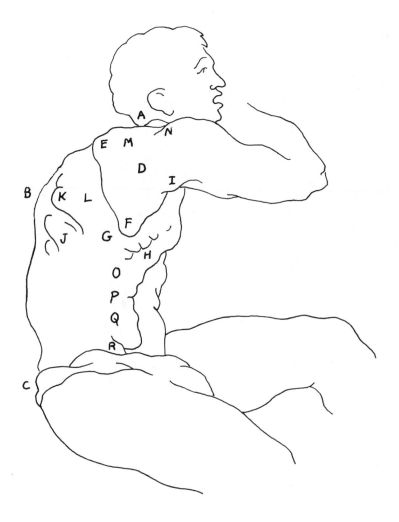

Rib Cage, Lateral Aspect

In this figure, Raphael makes you aware of the shape of the rib cage in his flow of line and shading. You can feel the spiral motion of the vertebral column from its beginning at the base of the skull (A) moving around the rib cage to the widest point (B) and then down to the sacrum (C) below.

The scapula (D) follows the upraised arm and glides across the surface of the rib cage. Raphael has indicated this by placing the superior or upper angle of the scapula (E) in a lower position than it would be at rest, and by moving the inferior or lower angle (F) forward as it bulges under the overlapping latissimus dorsi (G). Just below, Raphael has indicated four lower digitations of the serratus anterior (H) protruding from under the anterior border of the latissimus dorsi. The teres major (I) bulges out over the edge of the latissimus dorsi.

The back of the rib cage is enveloped by the trapezius. From its origin low in the vertebral column,

you can trace its upward passage over the rib cage. Raphael has revealed strong signs of the rib cage beneath by his shading of the intercostal furrows (J) and by indicating the curves of the posterior ribs (K), which protrude through the flattened-out mass of rhomboids (L). The trapezius moves over the superior angle of the scapula (E), which it holds against the rib cage, and then inserts into the spine (M) and the acromion process (N) of the scapula.

The external oblique muscle (O) flows down over the surface of the rib cage, following the general direction of the lower eight ribs to which it is attached. Just below the tenth rib, Raphael shows a break (P) in the anterior or front border of the oblique muscle, where it breaks into its thick abdominal portion (Q). Raphael knew that from there, the external oblique inserts into the anterior half of the iliac crest. So he continued this border down to the anterior superior iliac spine or front point (R) of the iliac crest of the pelvis.

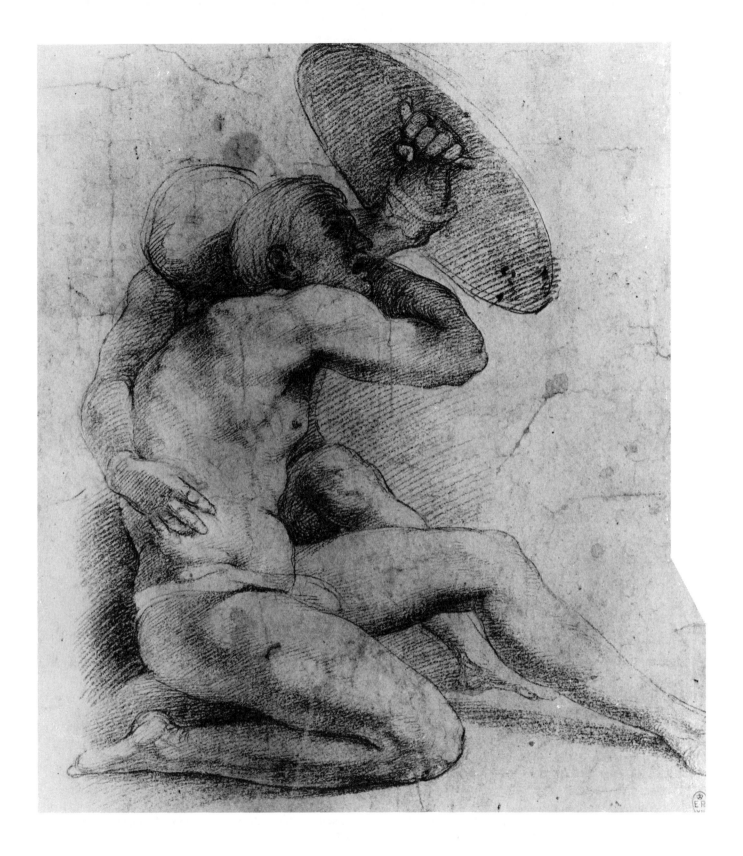

Jacopo Pontormo (1494-1556)
STUDIES
red chalk
16 1/8" x 10 5/8" (410 x 270 mm)
Musée des Beaux Arts, Lille

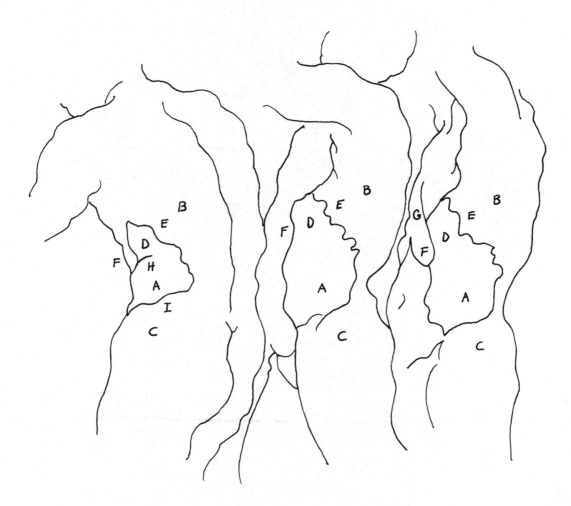

External Oblique

Sometimes we use analogies to clarify our understanding of anatomical functions. The lower and fleshy abdominal portion of the external oblique (A) is often compared to the folds of an accordion as it stretches out or bunches up between the two moving bony systems of the rib cage (B) and the pelvis (C). Like the sternocleidomastoid that links head and rib cage, the changing shape of the external oblique (A) is also formed by the movement of the larger masses which it connects.

In the two figures on the right, this spiral mass of the external oblique (A) resembles a teardrop elongated between the two larger bony masses. In the thin superior or thoracic portion of the oblique (D), the artist has defined its upper limits by toothlike bulges that interlock with the four slips of the serratus anterior (E).

The tip of the tenth rib (F) marks the base of the rib cage and the upper limit of the abdominal portion

of the external oblique. It also marks the base of the construction line (G) where rib meets cartilage, the major plane break on the mass of the rib cage.

On the figure on the left, which continues the sequence of movement across the page, the rib cage is flexed upon the pelvis and inclined to the side. We see the change in size, shape, and direction of the external oblique as it is compressed like an accordion between thorax (D) and pelvis (C). While the thoracic portion follows the direction of the rib cage to which it is attached, the abdominal portion (A) becomes much smaller. Its upper border is defined by a curved line (H), and its lower limit is inserted into the iliac crest (I).

The flowing movement of the spiral-like mass of the external oblique allows the artist to maintain a continuity and rhythm in line and shading in the transition from rib cage to pelvis. You will discover many such harmonic transitions throughout the body.

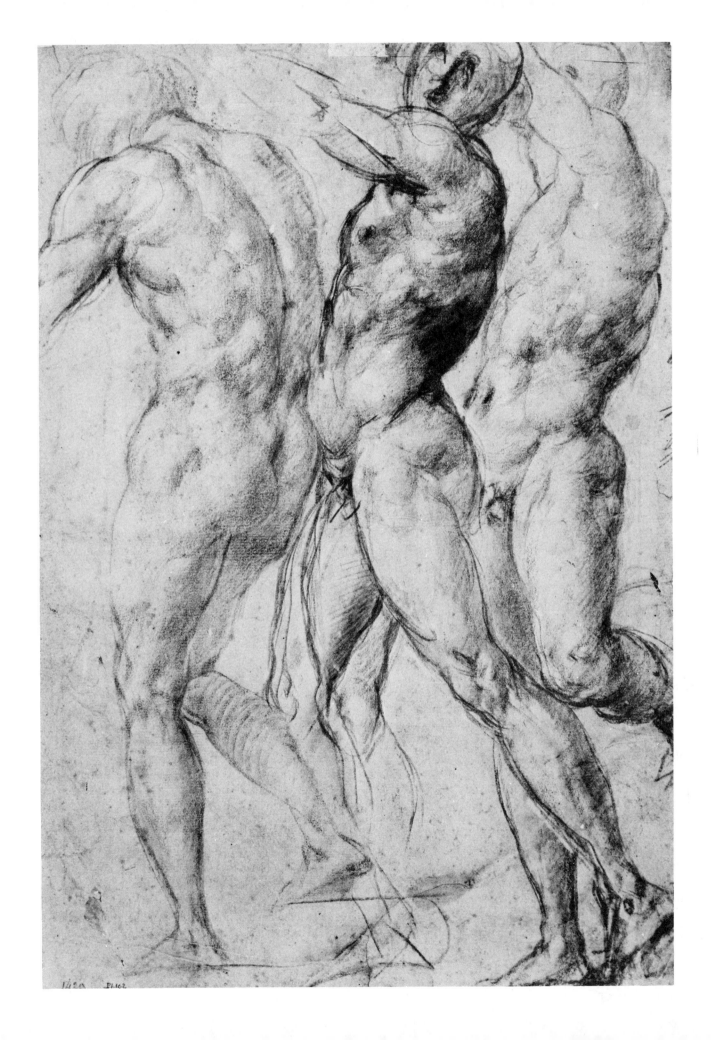

Michelangelo Buonarotti (1475-1564)
YOUTH BECKONING; A RIGHT LEG
pen and ink over black chalk
14 3/4" x 7 7/16" (375 x 189 mm)
British Museum, London

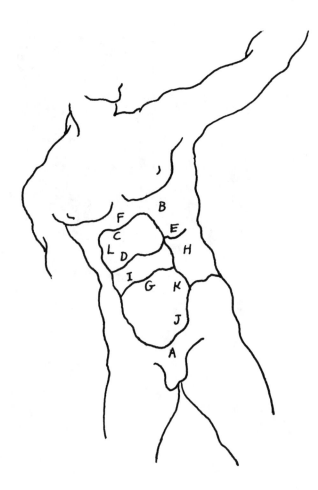

Rectus Abdominis

The rectus abdominis might first be thought of as a link in the front of the body between the rib cage and the pelvis. From its origin in the pubis (A) this long, almost flat, and vertical muscle reaches as far up as the fifth, sixth, and seventh ribs (B).

The uppermost transverse or lateral line (C) follows the shape of the false ribs that make up the thoracic arch. Directly below this lies the division of the middle transverse line (D). Put your pencil on the tip of the tenth rib (E) and follow the contour of this line (D) across the upper abdomen. Notice that this lateral line lies about halfway between the infrasternal notch (F) above and the umbilicus or navel (G) below and marks the upper level of the abdominal portion of the external oblique (H). Note also that Michelangelo purposely

placed the lowest (I) of the usual three lines dividing the rectus abdominis a little above the navel.

The hatching marks of great artists often suggest the direction of the muscle fibers. Michelangelo's hatchings reveal his easy familiarity with these directions when they suit his design needs. His hatchings (J) over the lower portion of the rectus abdominis follow the general direction of the fibers of the deep internal oblique which, with the superficial external oblique (H), covers the rectus abdominis. His upward hatchings (K) suggest the vertical movement of the fibers of the rectus abdominis. After having established the dominant upward flow in the larger and lower portion of the rectus, Michelangelo now masses in the upper rectus (L) with horizontal lines, emphasizing its flow into the rib cage.

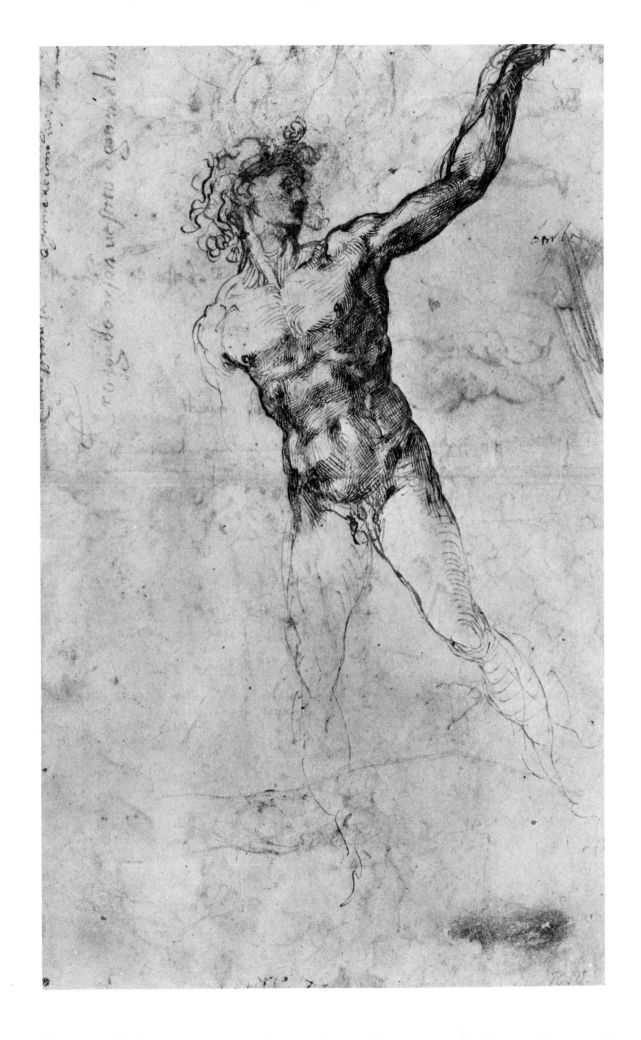

Giovanni Battista Tiepolo (1696-1770)
NUDE BACK
chalk on tinted blue paper
13 9/16" x 11" (344 x 280 mm)
Staatsgalerie, Stuttgart

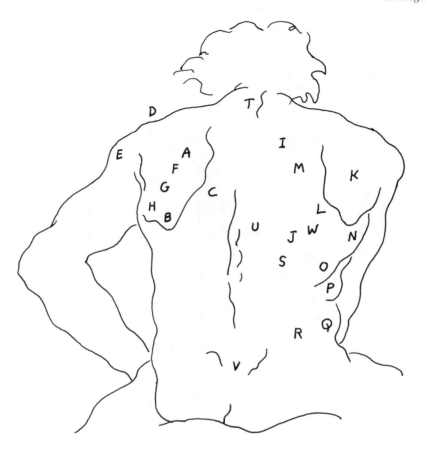

Muscles of Back and Shoulder Girdle

An important aspect of drawing the back lies in deciding where the scapula (A) is positioned. You should also be aware of the direction of the arm, since the scapula always follows the direction of the humerus bone of the upper arm. In this drawing, Tiepolo shows us two opposite positions of the arm, demonstrating how each acts upon the muscles of the upper back.

With the backward movement of the left arm, notice that the inferior angle of the scapula (B) protrudes slightly as it rotates around the rib cage toward mid-back. The direction of this motion, while urged on by the rhomboids (C), is countered above by the forward and downward movement to the front of the body of the upper portion of the scapula. This is indicated by the position of the acromion process (D), where the deltoid (E) is attached.

The bulges of the contracting infraspinatus (F) and teres minor (G) muscles inform us that they are assisting the deltoid (E) in the outward and backward rotation of the arm. At the side, notice the mass of the teres major (H).

Observe how the forward position of the right arm has stretched the two large muscles of the back—the trapezius (I) and the latissimus dorsi (J)—tightly over the curving form of the rib cage. The bulge of the infraspinatus (K) clues us to the position of the under-lying scapula, the inner border of which Tiepolo has accentuated with his contoured hatchings (L).

The rhomboid (M) is barely visible under the outer edge of the trapezius. From beneath, the extended latissimus dorsi muscle, you can follow the contours of the serratus anterior (N), serratus posterior inferior (O), the side of the ninth and tenth ribs (P) just above the external oblique (Q), and two major prominences of the erector spinae muscles: the iliocostalis (R) and the longissimus dorsi (S).

The direction of the curve of the center line of the back, from the seventh cervical vertebra (T) through the protrusions of the three or four thoracic vertebrae (U) to the sacrum (V), shows the exact position of the rib cage in perspective. Tiepolo has further used his knowledge of structure to place the dominant plane break of the back (W) along the upper portion of the line of the angle of the ribs, further defining the position and mass of the underlying rib cage.

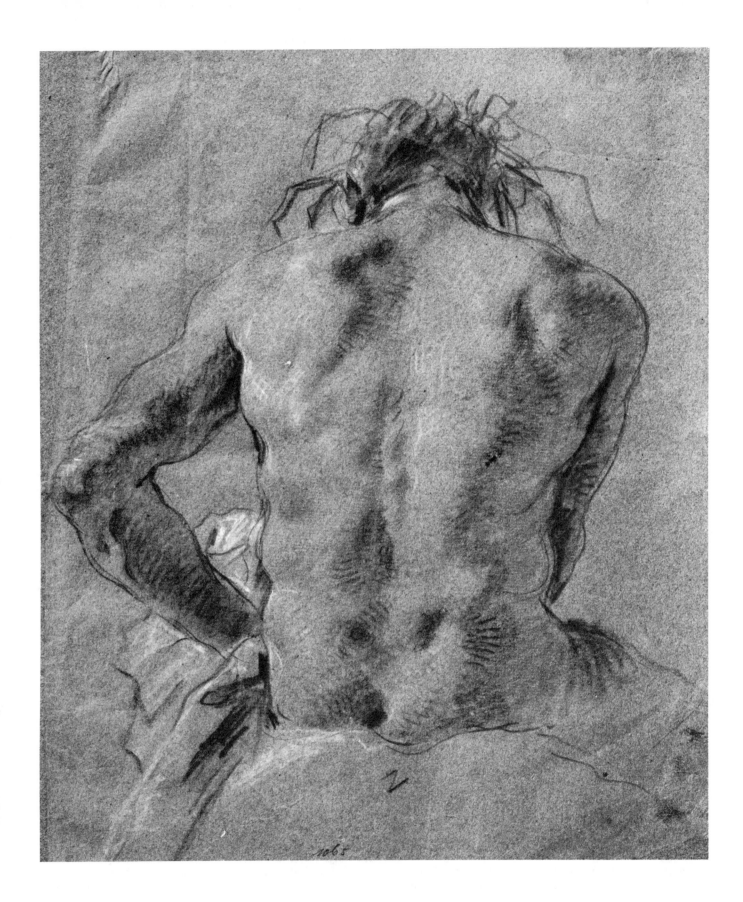

Michelangelo Buonarotti (1475-1564)
MALE NUDE WITH PROPORTIONS INDICATED
red chalk
11 1/2" x 7 1/8" (289 x 180 mm)
Reproduced by gracious permission of Her Majesty the Queen
Royal Library, Windsor

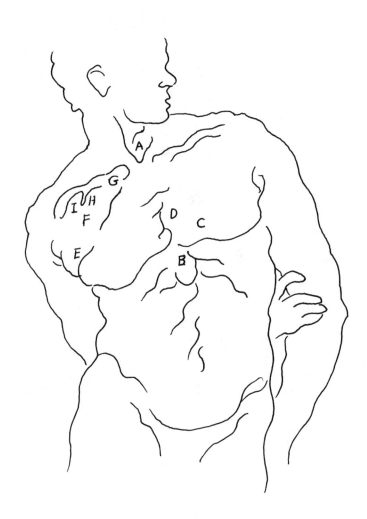

Pectoralis Major, Male

The massive, blocklike pectoralis muscle in this well-developed male figure widens the chest beyond the area of the rib cage, but it still reveals the arched form of the rib cage beneath by the contours of its muscular bundles and grooves.

The pectoralis major, which covers the upper half of the rib cage, extends vertically from the pit of the neck (A) to the ensiform cartilage (B). Its lower and larger portion (C) attaches to the anterior surface of the sternum (D), where you can count the protrusions of five ribs.

In the fold at the side of the pectoralis (E), Michelangelo indicates the beginning of an intermuscu-lar line that curves along the base of the upper and clavicular portion (F) of the pectoralis to its insertion in the clavicle (G). Following along the clavicle, note the little slip of a connection (H) and, to the left, the recession (I) below the bend in the clavicle, beneath which the pectoralis minor attaches to the scapula.

Notice the angular pose of Michelangelo's figure. The shifting of weight on the torso due to the slightly lifted leg thrusts the pelvis on the left into the rib cage. The line of gravity runs from the pit of the neck to the inner ankle of the foot that carries the weight. By the simple lifting of a leg, Michelangelo was suggesting the beginnings of a gesture, since the body in symmetrical balance implies stillness.

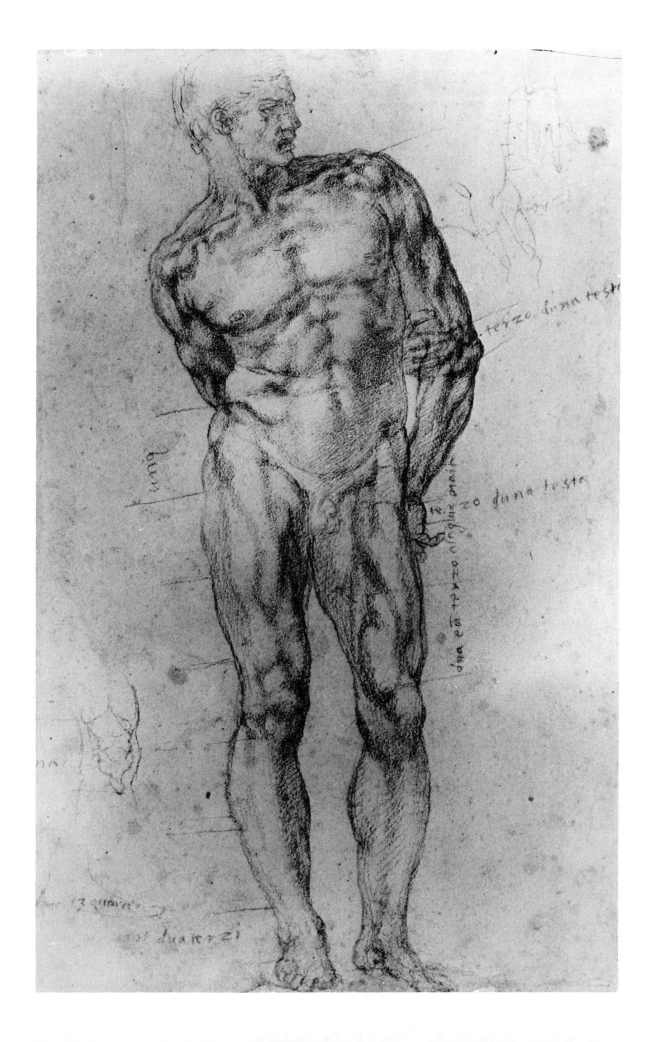

Albrecht Dürer (1471-1528)
LUCRETIA
black ink
13" x 9" (334 x 230 mm)
Albertina, Vienna

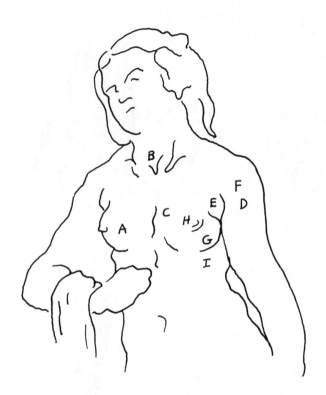

Pectoralis Major, Female

In this drawing Dürer correctly positioned the breasts (A) in the middle third of the rib cage. The large female breast (A) covers the lower half of the pectoralis major. The pectoralis major, upon which the breasts lie, originates in the sternum or breast bone (C), is located below the pit of the neck (B), and inserts at the side in the humerus bone (D).

Dürer was well aware of the pull of gravity on the fatty mass of the breast. He was also aware that the upper rib cage is smaller in the female than in the male, and so allowed ample space at the armpit between trunk and arm. At this "axillary tail" of the breast (E), where the mass of the pectoralis major crosses over the pectoralis minor to go under the deltoid (F) and into the humerus (D), he put his shading well up where the plane breaks on this mass. By adding a little gray highlight below, he keeps the armpit "full of air," avoiding flatness and the dark "hole" that students often make when their shading is a solid dark. He similarly avoids flatness on the sphere of the breast itself by adding a reflected light to the dark side of this mass (G).

The nipple (H) and the slightly raised areola surrounding it take on the shading of the sphere on which they lie. The detail of the nipple dies out in the highlight; its dark outline fuses with the darks below that define the dominant plane break of the rib cage (I).

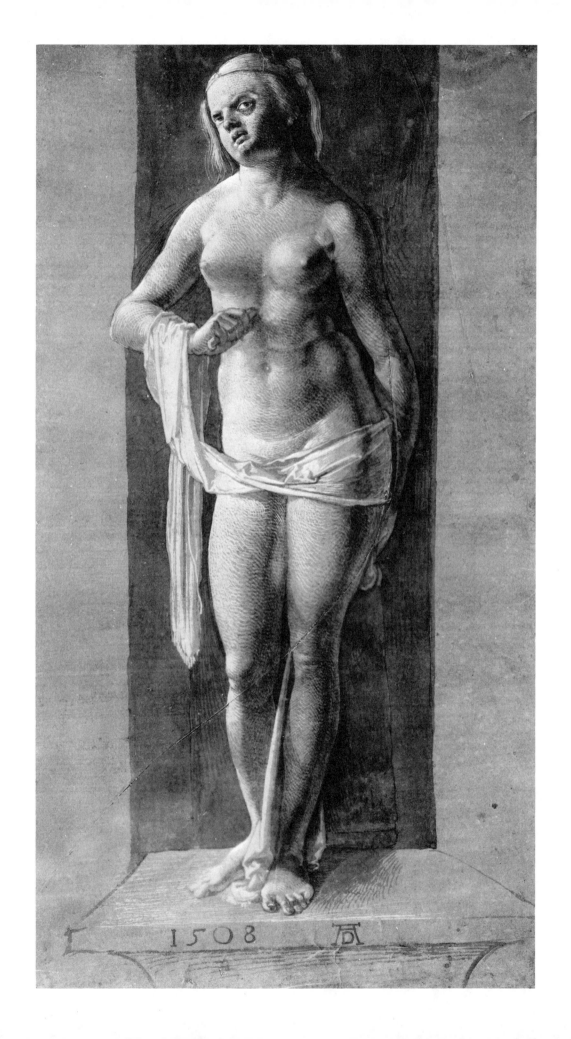

1508

2

THE PELVIS
AND
THIGH

Sebastiano del Piombo (c.1485-1547)
STANDING FEMALE NUDE
chalk
13 7/8" x 7 7/16" (352 x 189 mm)
Louvre, Paris

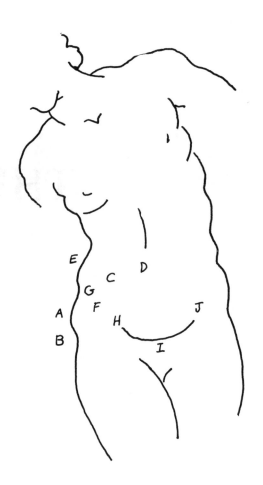

Structural Points, Anterior Aspect

Architecturally, the pelvis is placed in a strategic location. As a link between trunk and legs, the pelvis serves to coordinate their movement and, at the same time, helps to stabilize the entire body.

The pelvis is often thought of by the artist as a constellation of fixed points. It is fairly easy to draw the lines of muscular masses between the landmarks of their points of origin and insertion. A knowledge of these structural points and of construction lines will help you to see the body in perspective and allow you to vary the design of the body in your drawings.

Follow the edge of the mass of the gluteus medius (A) from its insertion in the external surface of the great trochanter (B) of the femur bone to its origin in the iliac crest, the high point (C) of which is approx-

imately on the level of the navel (D). The line of the external oblique (E) points to the front of the iliac crest (F), also known by artists as the pelvic or front point. The curve of this crest extends slightly outward to include the wide point of the ilium (G). Poupart's ligament (H), the unofficial dividing line between the torso and legs, extends from the pelvic point (F) to the pubis (I), following along the upper line of the groin (J).

When the pelvis is level, the pelvic points (F) of both sides lie in the same horizontal plane. By drawing lines through these points and by using these points to help see the pelvis as a box shape, it becomes easier, not only to draw the pelvis, but to place it in perspective as well.

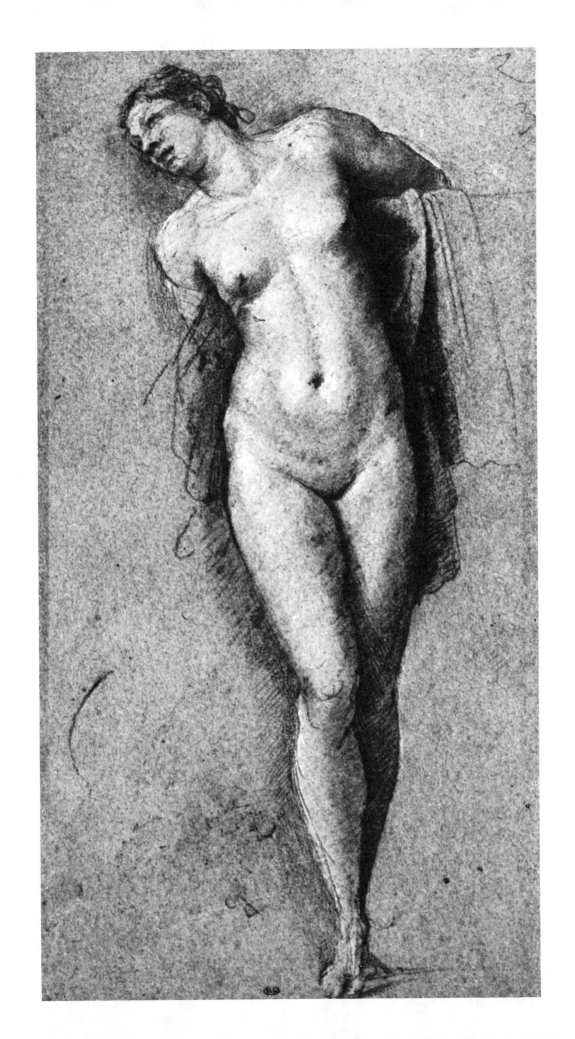

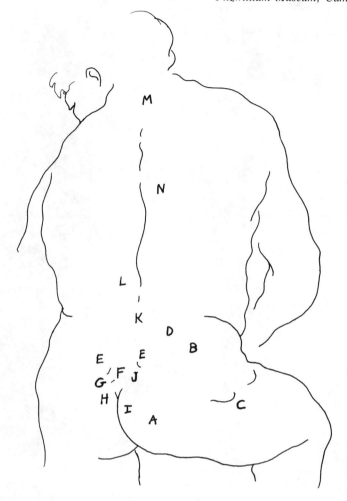

Peter Paul Rubens (1577-1640)
STUDY OF MALE FIGURE, SEEN FROM BEHIND
charcoal heightened with white
14 3/4" x 11 1/4" (375 x 285 mm)
Bequest of C. H. Shannon
Fitzwilliam Museum, Cambridge, Massachusetts

Structural Points, Posterior Aspect

It is very important to know what is happening to the backbone, whether you actually see it, or have to "see through" the body to discover its position. This is because all the major movements and rhythms of the upper masses of the body evolve from this structural core.

When the right leg is raised, you can see the masses of the gluteus maximus (A) and gluteus medius (B) stretched out between their insertions in the great trochanter (C) of the femur and their origins along the iliac crest (D). The stretched position causes the posterior superior iliac spines (E)—that is, the back points that form the upper corners of the sacral triangle (F)—to show more as bony eminences than as dimples. The shape of the sacral triangle is further suggested by the accents of the sacral foramina (G). The inferior angle of the triangle (H) indicates the top of the coccyx and ends the split of the buttocks (I).

The sacral triangle (F) is about one-third the width of the pelvis in man, and is vertical. In a woman, the pelvis tilts forward and the sacrum (F) forms a forward-curving equilateral triangle, which, though shorter than a man's, is wider, in keeping with the shape of her pelvis.

Directly below the back point (E), which is the posterior limit of the iliac crest, is located the sacro-iliac joint (J). For all practical purposes, this joint does not permit movement of the pelvis on the vertebral column. What appears to be movement of the pelvis actually occurs above in the relatively mobile lumbar vertebrae (K) of the spine. The strong chords (L) of the back also "extend" the pelvis by their contractions, just as the abdominal muscles in the front "flex" the pelvis.

Variations in the direction and degree of curvature of the spine from the seventh cervical vertebra (M) down through the thoracic (N) and lumbar regions (K), describe the position of the thorax and its relation to the pelvis.

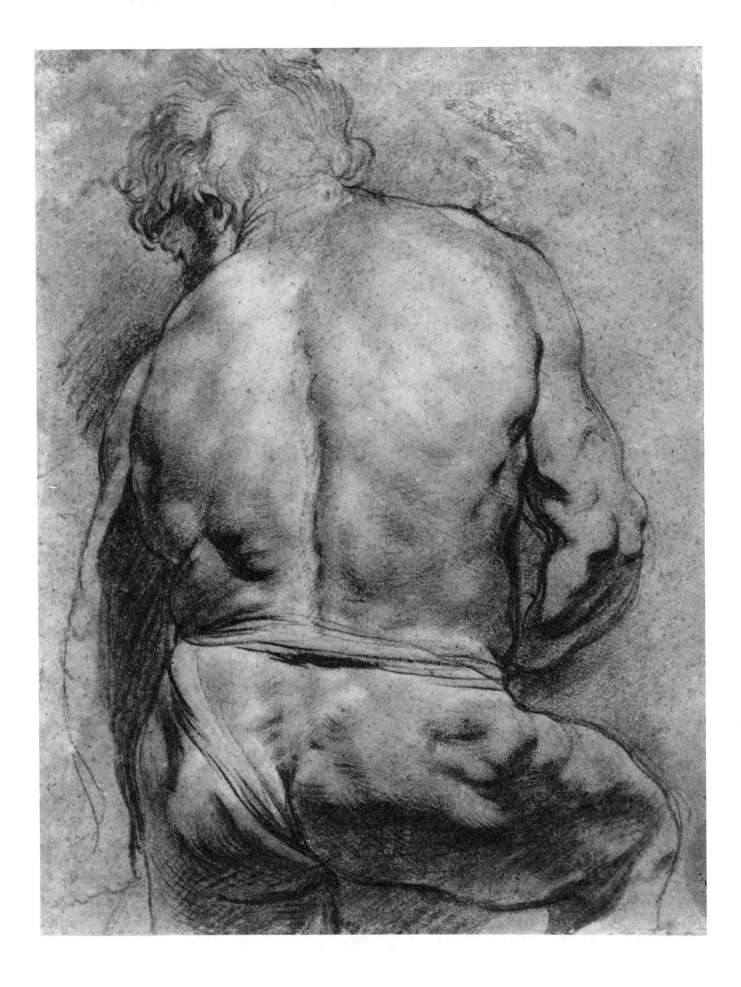

Benvenuto Cellini (1500-1571)
DRAWING OF A SATYR FOR
THE PORTAL OF FONTAINEBLEAU
pen and wash on paper
16 1/4" x 7 15/16" (415 x 202 mm)
Woodner Family Collection I, New York

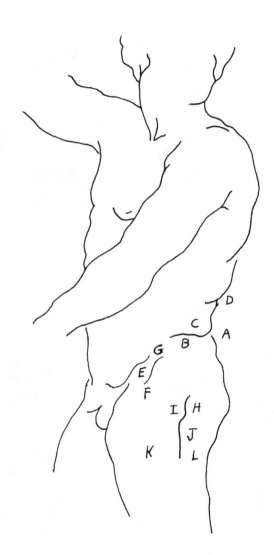

Structural Points, Lateral Aspect

In analyzing old master drawings, no matter where you begin, you must decide what the artist had in mind when he drew the shapes, sizes, and positions of the masses, lines, and values.

In this drawing, Cellini has emphasized the fold of the iliac line (A). You can see the high point (B) of the crest of the pelvis and, above, the external oblique muscle (C) lightly overlapping the posterior crest.

The rib cage is in slight rotation and flexion upon the pelvis. The external oblique is contracted—a strong flexion fold (D) marks the upper limit of its abdominal portion. This fold also is at the level of the tip of the tenth rib and the base of the rib cage.

Just below the pelvic point (E) is the secondary point (F), and just above the pelvic point, on the line of the crest of the ilium, is the wide point (G).

The large dimple (H) in the side of the gluteus maximus marks the back of the great trochanter (I) of the femur. The vertical groove (J), below, is a line between the functions that separates the quadriceps (K) from the hamstring groups (L) of muscles. The term "line between the functions" refers to the break that forms between two sets of muscles when they meet. It should be distinguished from a plane break, which merely describes a change in the direction between two planes.

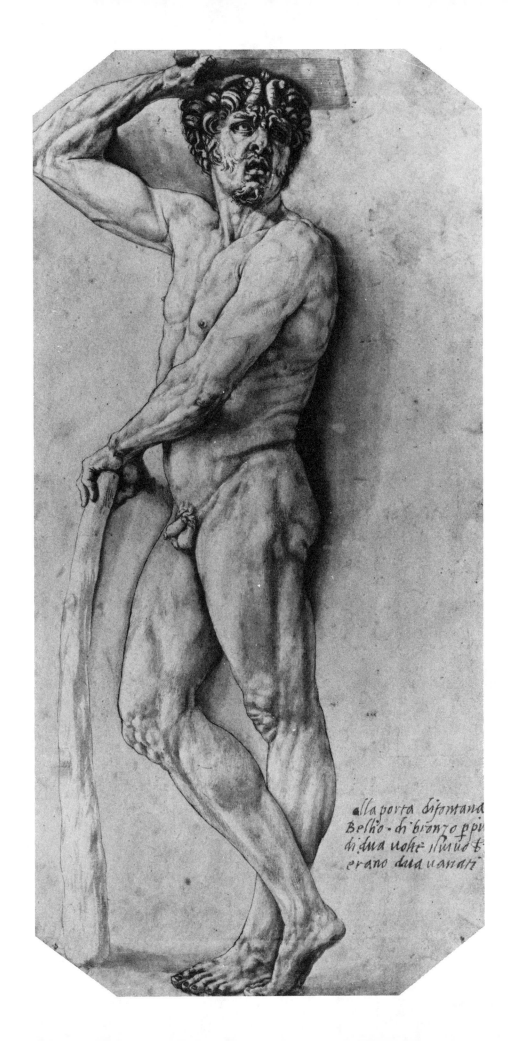

alla porta di fontana
Belho di bronzo ppu
di dua uohe siano b
erano dua uanati

Michelangelo Buonarotti (1475-1564)
THE RISEN CHRIST
black chalk
14 11/16" x 8 11/16" (373 x 221 mm)
Reproduced by gracious permission of
Her Majesty the Queen
Royal Library, Windsor

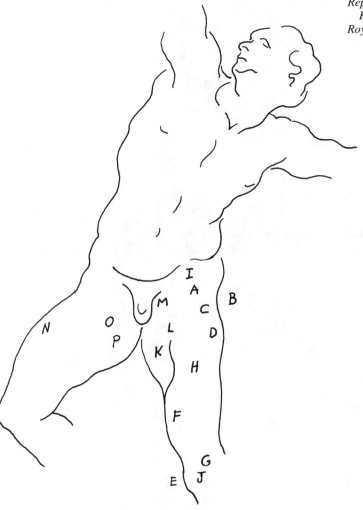

Muscles, Anterior Aspect

Any artist who has sketched ballet dancers or athletes in action knows that the ball and socket hip joint (A) in the pelvis provides a great degree of freedom for the movement of the femur bone of the thigh.

All the muscles that flow over the hip are capable of moving the femur bone at the hip joint. Above the joint, the muscular masses are attached to the pelvis or sacrum and, below the joint, to the femur of the upper leg or the tibia or fibula of the lower leg.

The shaft of the femur descends obliquely through the thigh from the depression below the gluteus medius (B), where the tensor of the fasciae latae (C) and the vastus externus (D) converge, to the level of the bulge of the medial condyle (E) below at the inner knee. The muscles of the outer thigh reflect the forward convexity of the femur.

For convenience, artists have combined the muscular masses that make up the front of the thigh. The vastus externus (D), vastus internus (F), vastus inter-

medius or crureus (G), and rectus femoris (H) combine to form the quadriceps group. This mass moves down along the front of the leg, from the secondary point (I) to the patella or kneecap (J). The adductor group (K) fills out the internal section of the thigh between the spiral-like sartorius muscle (L) and the lower fold of the groin (M).

The left leg is raised and bends at the hip and knee. The weight of the body is balanced upon the other leg, and the pelvis is tilted laterally to accommodate this sideward leg lift. The rectus femoris (N) is contracted as it assists the sartorius (O), the adductors (P), the gluteal muscles in the buttocks, and the deep muscles of the spine and pelvis in these actions at the hip joint.

Michelangelo has used his great knowledge of anatomy to create the rhythmic insertion of one group of masses into another, which contributes so much to the harmony and unity of his drawings.

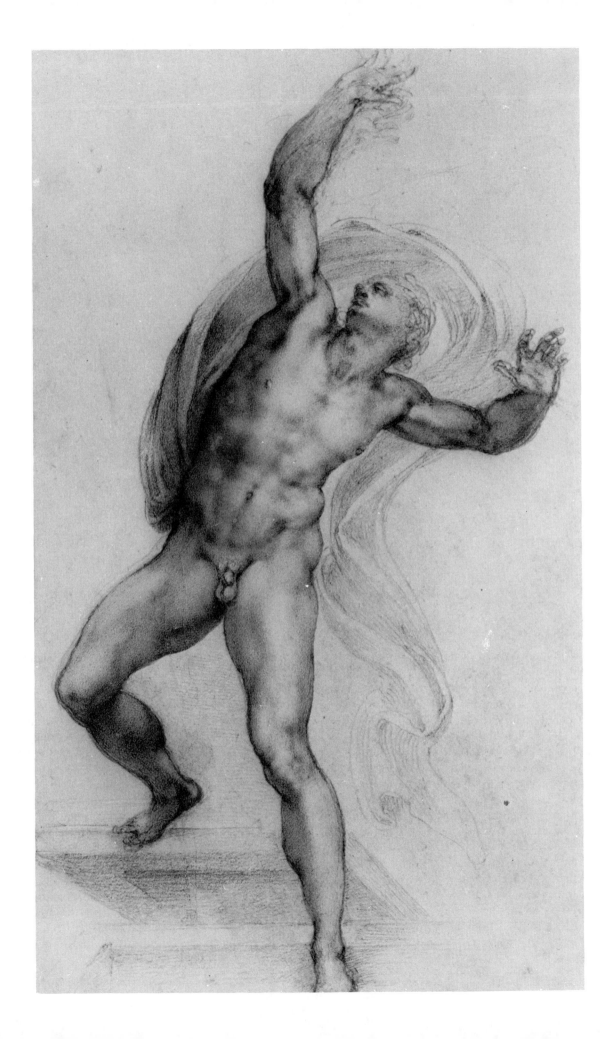

Agnolo Bronzino (1503-1572)
COPY AFTER BANDINELLI'S *CLEOPATRA*
black chalk on white paper
15 1/8" x 8 7/8" (384 x 225 mm)
Bequest of Charles A. Loeser
Fogg Art Museum, Harvard University, Cambridge

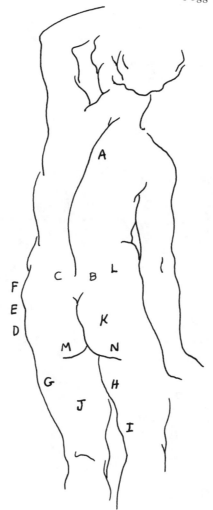

Muscles, Posterior Aspect

As a student of drawing and anatomy, you will soon discover that curiosity can be one of your greatest assets. Observation, continually reinforced by questioning the shapes, sizes, directions, and relationships of forms, will rapidly advance your knowledge and skills. For example, let us consider how Bronzino depicts the posterior aspect of the female.

The curve of the vertebral column (A) suggests the slight rotation and lateral inclination of the thorax. The sacral dimples, graded in value from dark on the right (B) to almost imperceptible on the left (C), mark the bottom of the vertebral column, the back point of the iliac crest of the pelvis, and the top of the equilateral triangle of the sacrum. The greater width of the female pelvis, together with her tendency to fatty deposits, contributes to the greater width in the average woman at a point (D) below the level of the great trochanter (E). In a man, this point tends to be higher and at about the level of the tensor (F). Could it be that

Bronzino's wavering line in this area was intended to make this adjustment?

The outline of the thighs depends on the shape of the vastus externus (G) on the outside and on the inside on the shape of the gracilis (H) above and the sartorius (I) below. The mass of the hamstring group (J) fills out the back of the thigh down to the knee joint.

To avoid a static, equilateral, light shape on the gluteus maximus (K), Bronzino extended the light area to include the gluteus medius (L), placing the shading of the plane break along the edge of both masses.

The observant artist knows that the gluteal fold (M) at the base of the gluteus maximus is more pronounced in the standing leg than the bent one. He can then utilize this crease to suggest the contour and direction of the lower buttocks and thigh. He also knows, as Bronzino has shown here, that with the flexion of the leg, the depth of the fold decreases and its direction becomes more oblique (N).

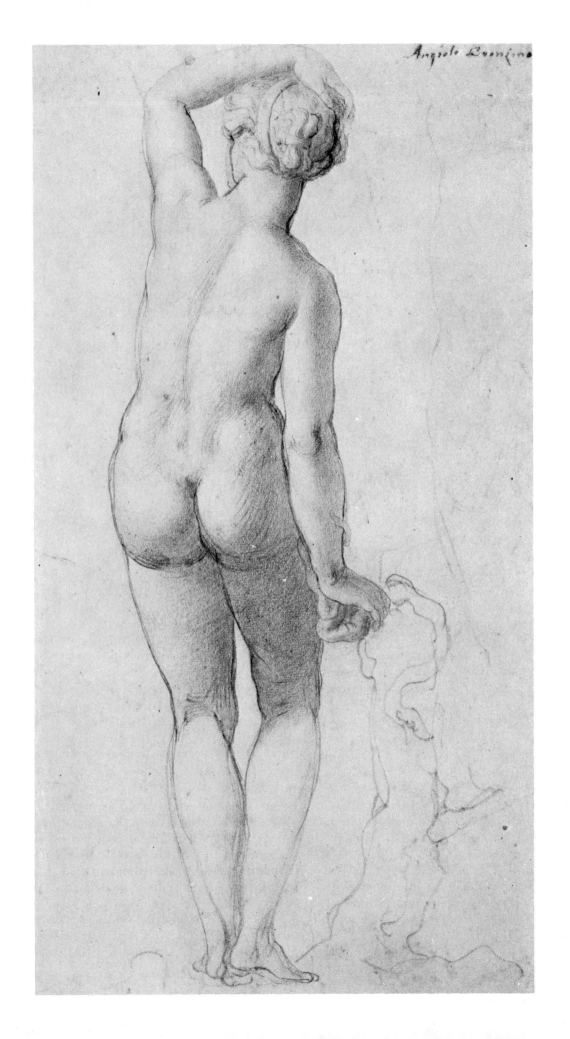

Titian (1477/90-1576)
SKETCH FOR THE SAINT SEBASTIAN
pen and ink
7 1/4" x 4 3/4" (183 x 118 mm)
Stadelsches Kunstinstitut, Frankfurt-am-Main

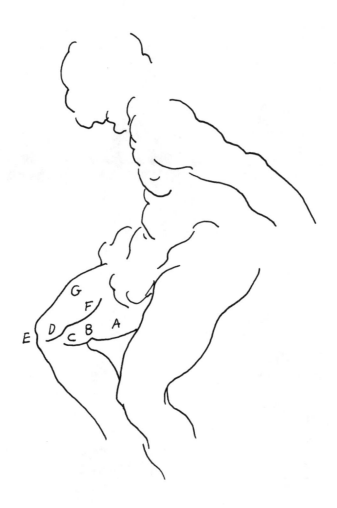

Muscles, Medial Aspect

Even in the rough scratchings of his pen and ink drawing, Titian instinctively simplified anatomical details by grouping them into constructional masses.

The curve of his outline and the long inner hatching lines describe in a simple way the shape of the adductor mass (A), which fills the upper portion of the inner thigh. Shorter hatchings curve over the lower sartorius (B) as it follows the thin, straplike tendon of the gracilis muscle (C).

The long fleshy ovoid of the vastus internus (D) extends to the middle of the patella or kneecap (E). Its backward movement along the edge of the sartorius is indicated by a long line of hatchings (F) that suggest its contour. Above the vastus internus (D) outlining the front of the thigh and reflecting the long curve of the thigh bone beneath, the rectus femoris (G) is lightly outlined.

Titian's pen practically dances over the page. Practice varying the pressure and angle of your pen or pencil for greater interest, more variety, and better design.

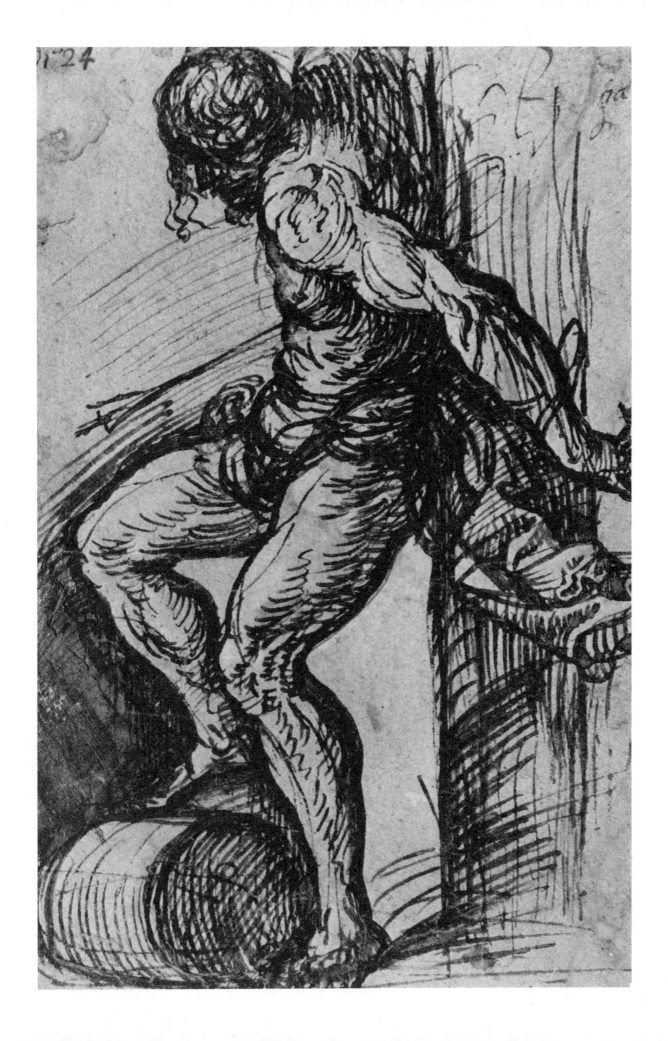

Jacopo Bertora
STUDIES OF TWO FEMALE NUDES,
SEEN FROM THE BACK
red chalk
10 9/16" x 7 3/4" (268 x 197 mm)
National Gallery of Scotland, Edinburgh

Gluteus Maximus

In order to place the muscles of the body, it is helpful to first locate the bones. The larger figure in Bertora's drawing is standing on her right leg. Her pelvis tilts downward in the direction of its unsupported side and is pushed upward by the supporting leg, carrying the muscular masses with it. You can check the degree of the tilt by the position of the sacral triangle (A). From the posterior superior iliac spine or back point (B) of the iliac crest at the dimple of the sacral triangle, you can approximate the other pelvic points: the high point (C), wide point (D), pelvic point (E), secondary point (F), and point of the ischium (G).

From these points, you can further construct the figure. You know that the iliac crest of the pelvis makes an angle at about halfway between the back

point (B) and the high point (C), known to artists as the re-entering angle (H). A continuation of the vertical line at this angle points to the line of the angle of the ribs (I), which is the outside limit of the strong chords of the back (J) and the major plane break of the back. Bertora has knowingly massed both of his figures along this line.

You can now easily place the origin of the gluteus maximus (K) in the posterior iliac crest (B) and in the sacrum (A). This large muscular mass covers the posterior portion of the gluteus medius (L). The gluteus maximus is a powerful muscle. It straightens and rotates your thigh, lifts you up from a seated posture, keeps you erect by supporting your pelvis from behind, and pulls your flexed thigh back when you walk.

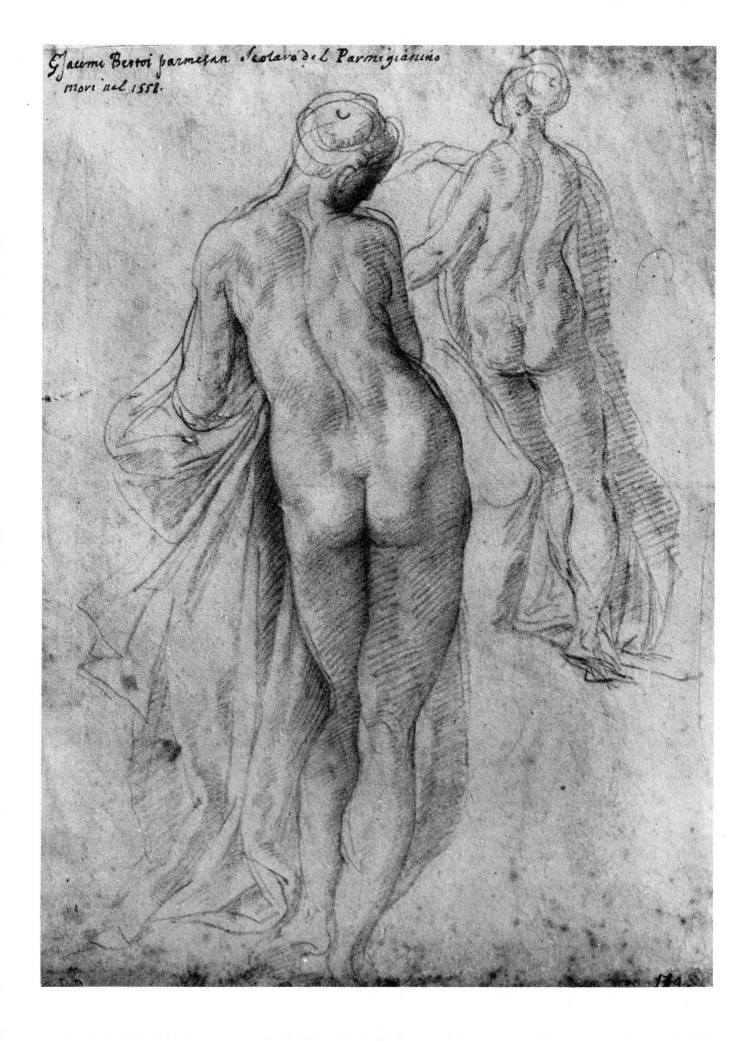

Giacomo Bertoi parmesan Scolaro del Parmigianino
mori nel 1558.

1448

Raphael Sanzio (1483-1520)
THREE GRACES (STUDY FOR THE FARNESINA DECORATIONS)
red chalk
8" x 10 1/4" (203 x 260 mm)
Reproduced by gracious permission of Her Majesty the Queen
Royal Library, Windsor

Gluteus Medius

The crest of the ilium (A) is only lightly indicated on the central figure. However, at the pelvic point (B), you can distinguish its short bulge from the curve of the tensor fasciae latae (C).

The gluteus medius (D) originates in the anterior iliac crest above, and is inserted in the great trochanter of the humerus bone (E) below.

In its shape and actions, the fan-shaped gluteus medius is similar to the deltoid muscle of the shoulder. The lateral fibers (F) of the gluteus medius, acting together with the gluteus minimus beneath it, abduct the femur; the anterior fibers (G) rotate the femur internally and assist in flexing it; while the posterior fibers (H) extend the femur and rotate it externally.

You can test the counterbalancing action of the gluteus medius on your own body. Stand erect with your hands placed over the upper side of your hips.

Now, if you lift one leg, you will feel the gluteus medius of the other side contract. When you walk, the gluteus medius on the side of the supporting leg holds the pelvic bone to the great trochanter so you do not fall over. As you take the step, the rotary action of the gluteus medius swings the pelvis forward. By alternation of this action in walking, the muscle keeps the pelvis level.

Raphael has only lightly indicated the line between the functions of the gluteus medius (I), which moves out from the great trochanter (E). He has placed the strong value contrast of his dominant plane break on the gluteus maximus (J). Below, he has lightly indicated another line between the functions on the thigh (K), where the gluteus maximus moves between the quadriceps (L) and the hamstring (M) groups. He has kept the strong plane break well to the back of the thigh.

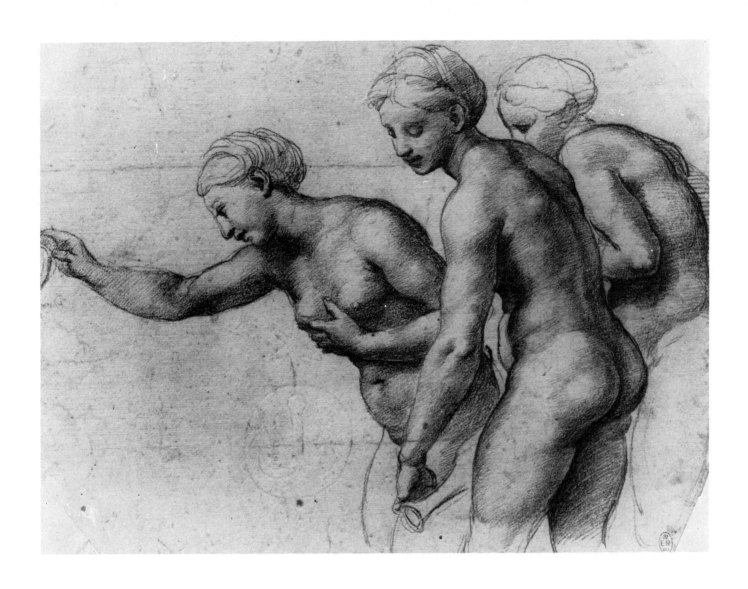

Théodore Géricault (1791-1824)
STUDY FOR ONE OF THE FIGURES
ON *THE RAFT OF THE MEDUSA*
charcoal on white paper
11 1/2" x 8 1/8" (289 x 205 mm)
Musée des Beaux Arts, Besançon

Tensor Fasciae Latae

The figure in Géricault's study for "The Raft of Medusa" is depicted lying exhausted over a portion of the raft. Try to familiarize yourself with the important points on the pelvis that are invaluable clues in working from the model: the right (A) and left (B) pelvic points, the middle line of the linea alba (C), and symphysis pubis (D), and the curve of the iliac crest (E). After locating these points, you can now begin to see the tilt and shape of the pelvis.

At a position about two fingers below and slightly back from the pelvic point is the secondary point (F), the origin of the rectus femoris (G). Géricault drives the inner edge of the adductor group (I) and the line of the sartorius (H) to the pelvic point (B).

Géricault uses lines again in the half ovoid of the navel (J). Consider how its position and shape, together with the adjacent hatchings, suggest the shape and direction of the abdomen.

We know that the rectus femoris (G) is situated in the middle of the anterior thigh. Here, it contracts to flex or bend the thigh, assisted by the tensor fasciae latae (K) next to it. The great trochanter is indicated by a dimple (L) where the adjacent gluteus medius (M) inserts from above. The tensor fasciae latae (K) lies close to the trochanter and separates the buttocks from the anterior or front of the thigh. From its origin at the front of the iliac crest (E) and at the pelvic point (B), the tensor (K) moves into the iliotibial band (N) at the outer side of the leg, creating the traction that keeps your knee from buckling when you walk. Because of its position in front of the hip joint, the tensor can assist in the inward rotation and the abduction or outward movement of the thigh.

When the upper leg is extended, as it is here, artists think of the tensor as a spindle shape or a bump on the relaxed side. But when the leg is bent and the tensor is compressed upon itself, the tensor looks like a double-egg symbol.

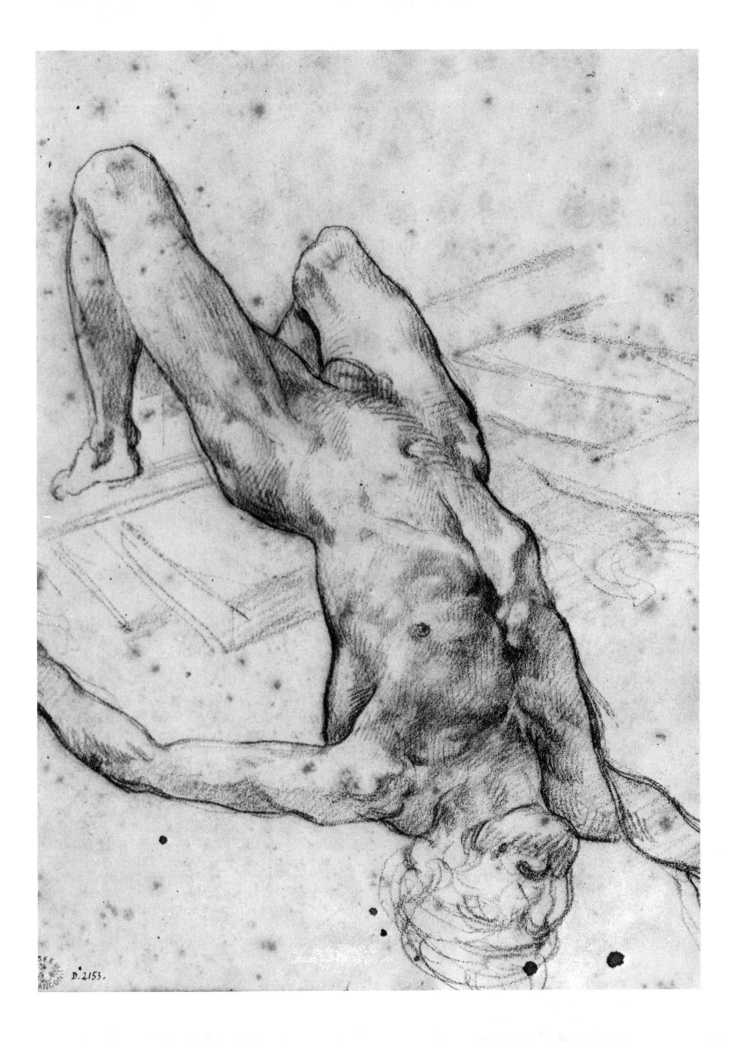

Leonardo da Vinci (1452-1519)
STUDY OF THE LOWER HALF
OF A NUDE MAN FACING FRONT
black chalk
7 1/2" x 5 1/2" (190 x 139 mm)
Reproduced by gracious permission of Her Majesty the Queen
Royal Library, Windsor

Sartorius

In this drawing Leonardo is preoccupied with the muscles of the anterior thigh. Its masses are as clearly defined as a good version of the plaster cast of Houdon's flayed figure that we see in art schools.

The sartorius (A) or "tailor's muscle" is named after the crosslegged position of tailors, a pose that accentuated this most superficial muscle of the thigh and the longest muscle in the body. From its origin in the pelvic point (B), its ribbonlike form spirals obliquely downward and inward across the thigh. It forms the boundary between the adductor group (C) at the upper and inner thigh, and the quadriceps (D) on the outer thigh.

Like the rectus femoris (E), the sartorius passes over and acts upon two joints. From its origin at the side of the pelvis, the contracting sartorius can pull upon its insertion at the inner tibia of the leg and rotate the thigh outward. It can flex the lower leg and, when it is flexed, rotate it inward. Together with the iliotibial band (F) on the outside of the thigh, it stabilizes the knee in walking.

The downward wedge (G) formed between the lower border of the sartorius and the adductor group (C) is counterbalanced vertically by the dimpled upward triangle (H) that the sartorius forms with the tensor fasciae latae (I). Out of this depression arises the mass of the rectus femoris (E) of the quadriceps group.

The terminology of anatomy seems complex, but is meaningful. The vague terms like "hip" and "knee" used by the average person tell us little of what bone and muscle do, how they are shaped, or how dynamically nature has interrelated their forms. The language of the artist must be far more specific.

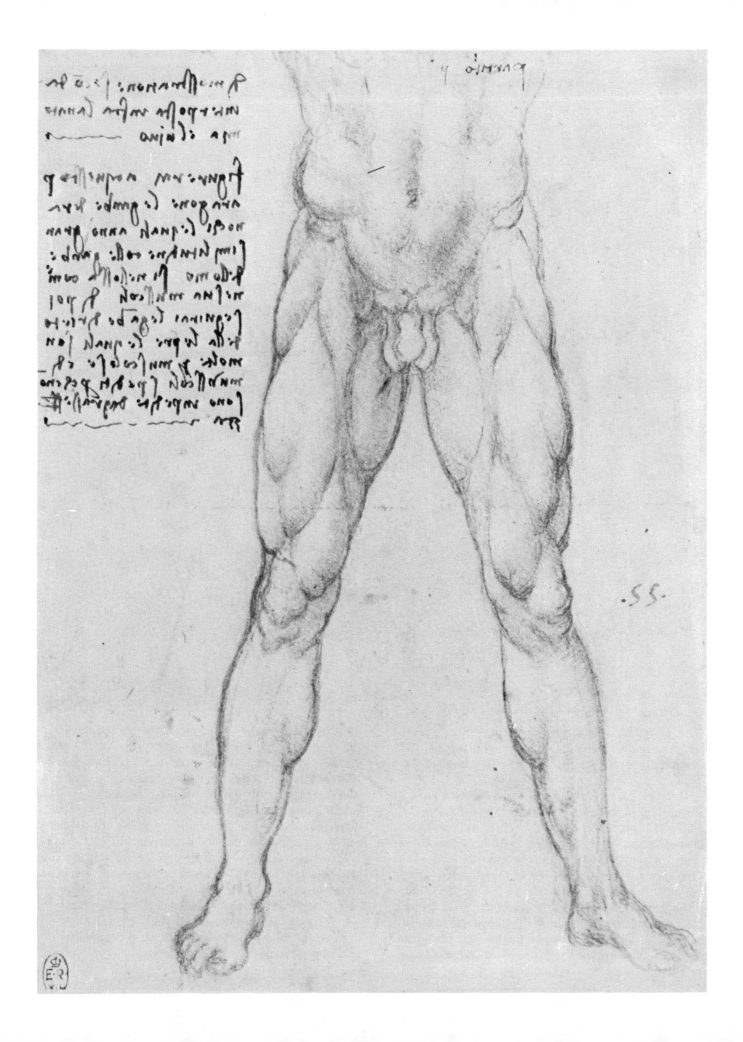

Titian (1477/90-1576)
STUDIES OF LEGS
charcoal on blue paper
16 1/4" x 10" (411 x 252 mm)
Uffizi, Florence

Quadriceps

Here Titian might have been observing how the movements of the lower limbs affect the forms of the quadriceps (or the extensor group) at the front of the thigh.

Three of the four muscles in the quadriceps are emphasized in the nearly extended leg of Titian's model. The rectus femoris (A) is the only member that crosses the hip joint, extending from the pelvis above to the patella (B), where it connects to the tibia. Thus the rectus femoris can flex the thigh, as well as assist the other quadriceps in extending the lower leg. The rectus femoris (A) follows the direction of the femur (or thigh bone), and Titian has indicated the longitudinal furrow (C) at the center of the muscle, from which its fibers move outward and downward. At about its

lower quarter, the rectus muscle turns into the flat (D) tendon that can be traced downward to the patella. At the sides of the rectus, the vastus internus (E) bulges low on the inside, and the vastus externus (F) creates a smaller bulge higher on the outside. The deeper vastus intermedius (G), which originates with the two other vasti muscles in the femur, projects very slightly below the tendon of the vastus externus (F).

From its connection in the iliotibial band (H) at the side, Richer's band (I) of fascia contours over the front of the thigh, paralleling the angle made by the base of the bulges of the vastus internus (E) and externus (F). Richer's band makes only a slight change in the front of the thigh, compared to the deep depression made by the sartorius (J) at the inside.

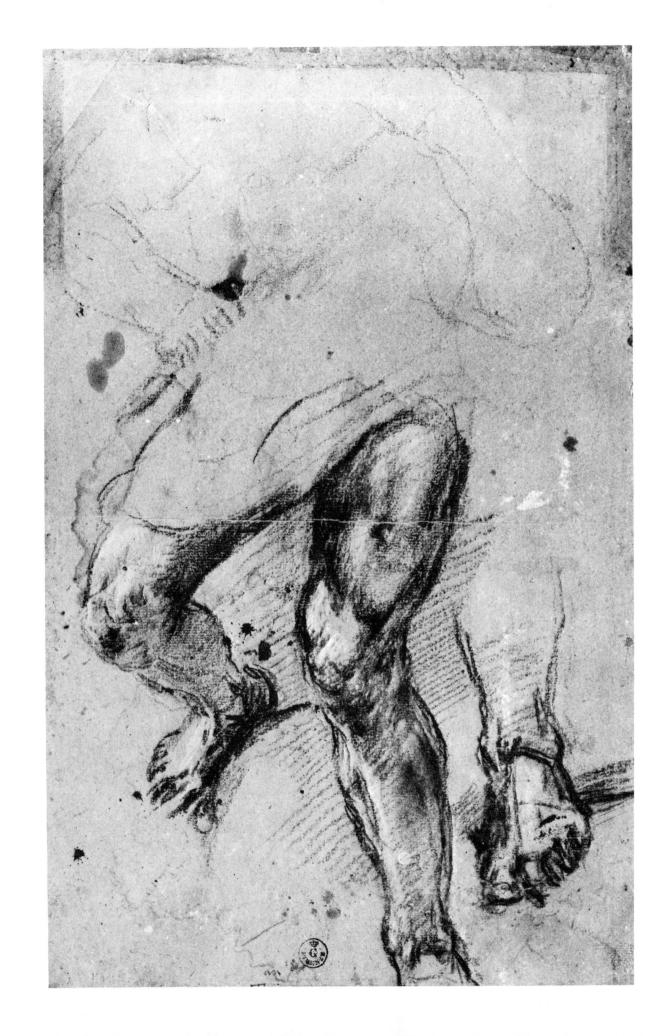

Michelangelo Buonarotti (1475-1564)
STUDY OF THE LEGS OF A NUDE MAN
black chalk
Library of Christchurch, Oxford

Adductor Group

Michelangelo's study of a leg gives us a clear view of the relative position of the wedge of the adductor group (A), between the quadriceps group (B) of the thigh in front and the hamstring group in the back of the thigh. The adductor group fills the area known as the femoral triangle (or hollow of the thigh) formed by the sartorius (C), the fold of the groin that underlies Poupart's ligament (D), and the inner side of the thigh (E). The thin, straplike gracilis (F) traverses the edge of this area and runs down the inner thigh, going behind the medial epicondyle (G) of the femur to insert in the lower leg.

It is interesting to note that Michelangelo's line (H) points to the joint of the knee. Just below this, the tendon of the gracilis (F), the farthest reaching member of the adductor group, joins the tendons of the semi-tendinosus and the sartorius in the mass called the "goose foot" (I). This mass covers the surface of the tibia at the inner knee, as the muscles move together to their insertion near the crest of the tibia.

Michelangelo has treated the adductor group as a mass, from the outer gracilis (F) to the slight plane change at the side of the adductor longus (J) and the adjacent pectineus (K). The adductor brevis and the adductor magnus muscle beneath form the floor of the adductor group. Together with the iliopsoas (L), made up of two flexors of the thigh, they fill out the inner corner of the femoral triangle.

The members of the football-like mass of the adductor group help flex your leg when you step into the stirrup to ride horseback, hold your thighs inward against the horse (in adduction) as you ride, and contribute to the inward rotation of your thighs and legs.

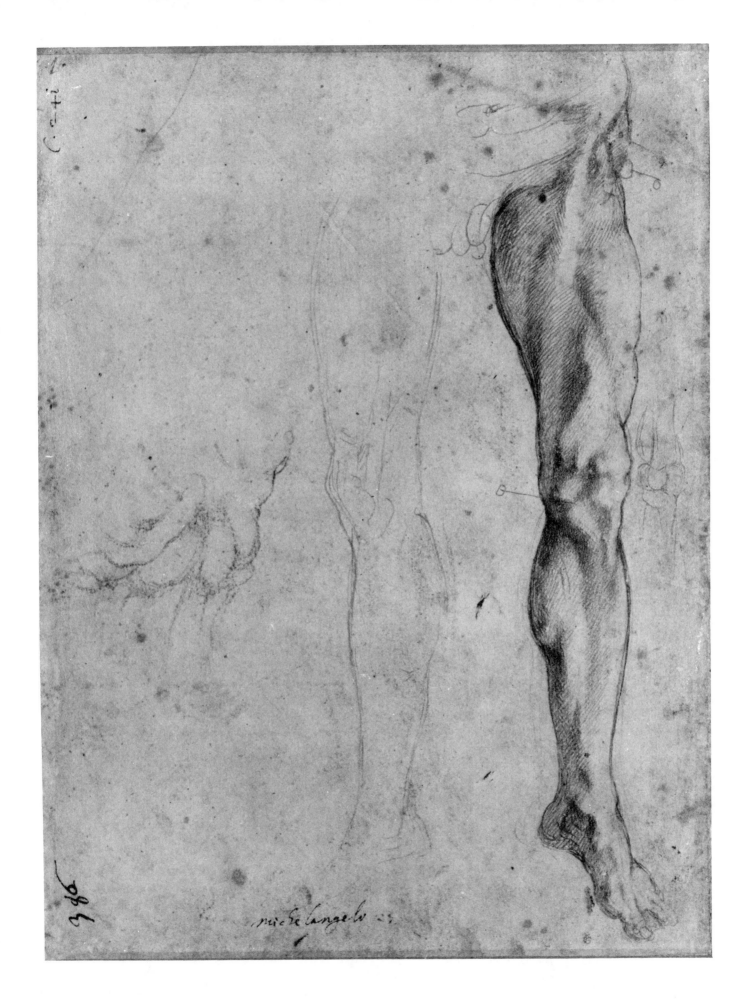

michelangelo

Leonardo da Vinci (1452-1519)
STUDIES OF HUMAN LEGS AND THE BONES
OF THE LEG IN MAN AND DOG
pen and ink
11 1/4" x 8 1/8" (285 x 205 mm)
Reproduced by gracious permission of Her Majesty the Queen
Royal Library, Windsor

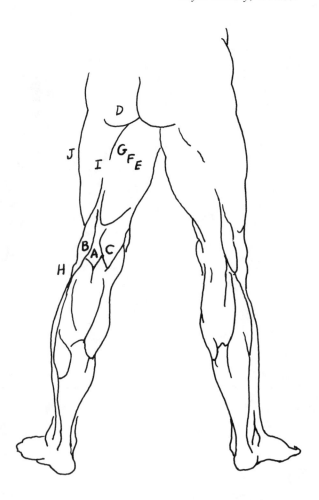

Hamstring Group

Like all of the great masters, Leonardo sought to understand the universal laws of design in the structure and functions of the human body. He constantly observed and compared, and his drawings are a key to his speculations and discoveries.

In Leonardo's time, warriors often disabled an opponent by the cut of a sword across the back of the knee in the area of the ham, or popliteal fossa (A), cutting the tendons. This practice was often extended to the punishment of criminals, hence the term, to "hamstring" one's opponent.

If you are sitting in a chair, you can reach down and feel the tendons of your hamstrings, the stout cord of the biceps (B) on the outside, and the combined tendons of the semitendinosus and semimembranosus (C) on the inside of your knee. When you bend over and try to touch your toes, you can feel the taut hamstrings at the back of your thigh. The powerful gluteus maximus muscle (D), together with these hamstrings, brings you erect again by drawing your pelvis backward.

The dog's leg in Leonardo's sheet of studies is drawn upright for comparison with a man's leg. But we know that because of the underdevelopment of its gluteus maximus, a dog could not maintain such a position for long.

Leonardo has massed the semimembranosus (E) and the semitendinosus (F) of the inner hamstrings with the biceps (G), or the outer hamstring. The groove between the first two and the last would show on a flayed figure, but not on the model. Leonardo has emphasized the tendinous slip of the combined long and short heads of the biceps (B) that inserts into the head of the fibula (H). The mass of the vastus externus (I), together with the long, thin border of the iliotibial band (J) creates the outline of the outer thigh in the back view.

By their attachments above in the ischium of the pelvis, and below in the tibia and fibula, the hamstring muscles link the bones of the lower leg to the pelvis. At the back of the knee, they also help to form the upper sides of the popliteal space.

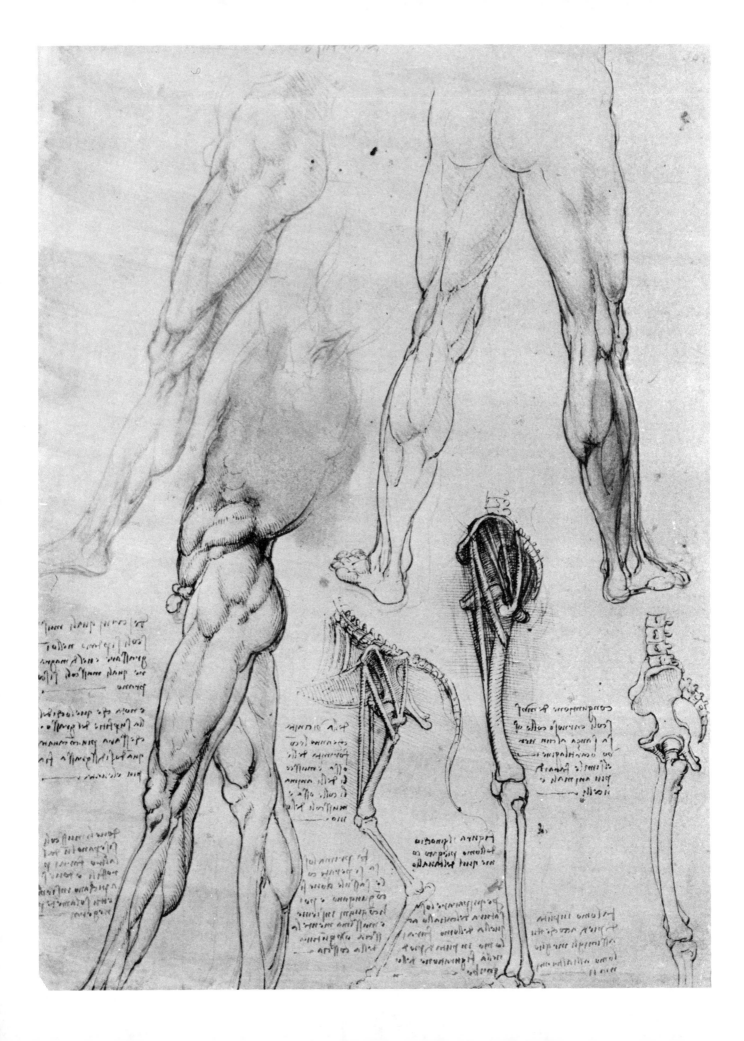

3

THE KNEE
AND
LOWER LEG

Pietro Faccini (1562-1602)
STANDING NUDE, FRONT VIEW, BENDING FORWARD
black chalk on gray paper
Teyler Museum, Haarlem

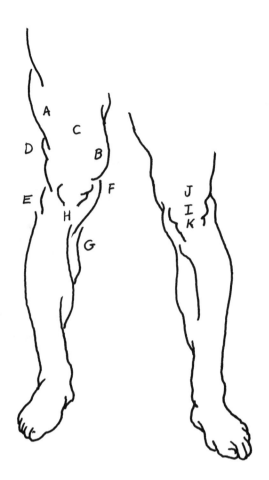

Knee, Anterior Aspect

While the general shape and outline of the thigh is created largely by the muscles that surround it, the shape of the knee is largely formed by the underlying bones. This weight-bearing hinge joint, the knee, is strengthened by the massive inner and outer condyles of the femur bone of the thigh. The femur's rockerlike condyles roll and glide on the head of the tibia bone, below. The joint is supported on all sides by powerful tendons and ligaments. When drawing the knee, remember that it is low on the inside, high on the outside, narrow in front, and wide behind.

Above the knee, there are the quadriceps muscles. Made up of the higher mass of the vastus externus (A) and the lower bulge of the vastus internus (B), with the rectus femoris (C) in between and the vastus intermedius beneath, they all point the eye down to the knee.

Below, the hamstrings grip the knee, tonglike, from the sides. The tendon of the biceps (D) creates an almost vertical line as it moves down to the head of the fibula (E). At the inside (F), there is the straplike sartorius, the gracilis, and the semitendinosus, known collectively as the tripod muscles, that all originate in the pelvis. Together they create a long, low convex curve over the bulge of the internal condyle of the femur bone, at the knee. This line overlaps the gastrocnemius (G) or the calf muscle, behind, and goes on to the common insertion on the inner side of the tibia at the level of the kneeling point (H).

With the leg on this muscular subject extended, the patella or kneecap (I) is at its most obvious position. This flat, irregular, bony triangle is held in place by the quadriceps tendon (J) above and the patella ligament (K) below. The base of the patella in the relaxed leg is level with the knee joint.

If you think of the leg as a series of spirals alternating around a bony central axis, you can then see that the knee, where bone meets flesh, provides an interval of rest or transition. It is a visual breathing space, carrying the flow of line harmoniously from thigh to lower leg.

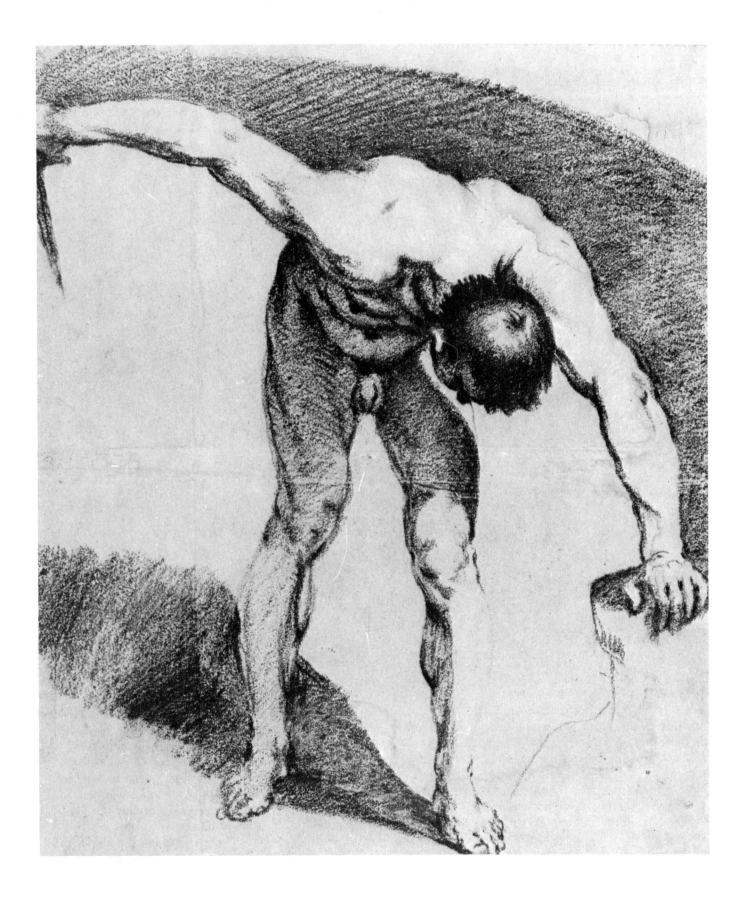

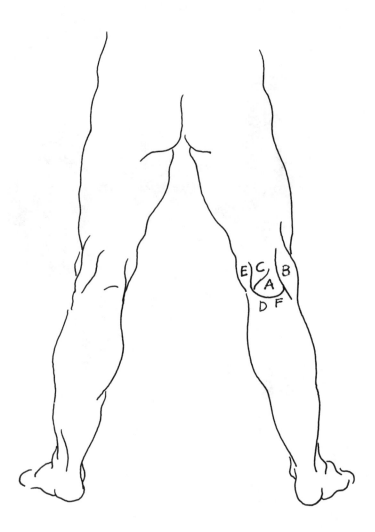

Leonardo da Vinci (1452-1519)
NUDE MAN STANDING, BACK TO SPECTATOR
red chalk
10 5/8" x 6 5/16" (270 x 160 mm)
Reproduced by gracious permission of
Her Majesty the Queen
Royal Library, Windsor

Knee, Posterior Aspect

The legs of Leonardo's model are extended, and the popliteal space (A) or ham at the back of the knee appears as a full, slightly rounded form. Beneath this mound, the large ends of the femur bone of the thigh and the tibia of the lower leg face each other like clenched fists, their large condyles pressing backward against the contents of the popliteal space.

When the knee is flexed, the condyle of the femur slides forward on the head of the tibia, and the mound of the popliteal space (A) becomes a hollow that, upon closer examination, proves to be somewhat of a lozenge or diamond shape. This area is enclosed on the outside by the cord-like tendons of the biceps (B), on the inside by the semimembranosus (C), and below, by the two heads of the gastrocnemius or calf muscle (D).

Throughout the body, you must look for furrows that clue you to the edges of bone, muscle, and tendon. In this extended leg, the popliteal space forms a "U" shape, with the tendons of the biceps (B) and the semitendinosus (E) of the hamstring group on either side, and the curved line (F) of the horizontal flexion fold at the upper limit of the gastrocnemius (D).

The muscles that act at the knee joint are principally the extensors (or quadriceps) in the front of the thigh, the flexors (the hamstrings in the back of the leg), and the sartorius and gracilis at the inside of the thigh.

The knee is wider in the female than in the male, and the mound of the popliteal space behind the kneecap is fuller. The muscular fibers surrounding the female knee also tend to be longer and lower, making the contours less irregular and more curved.

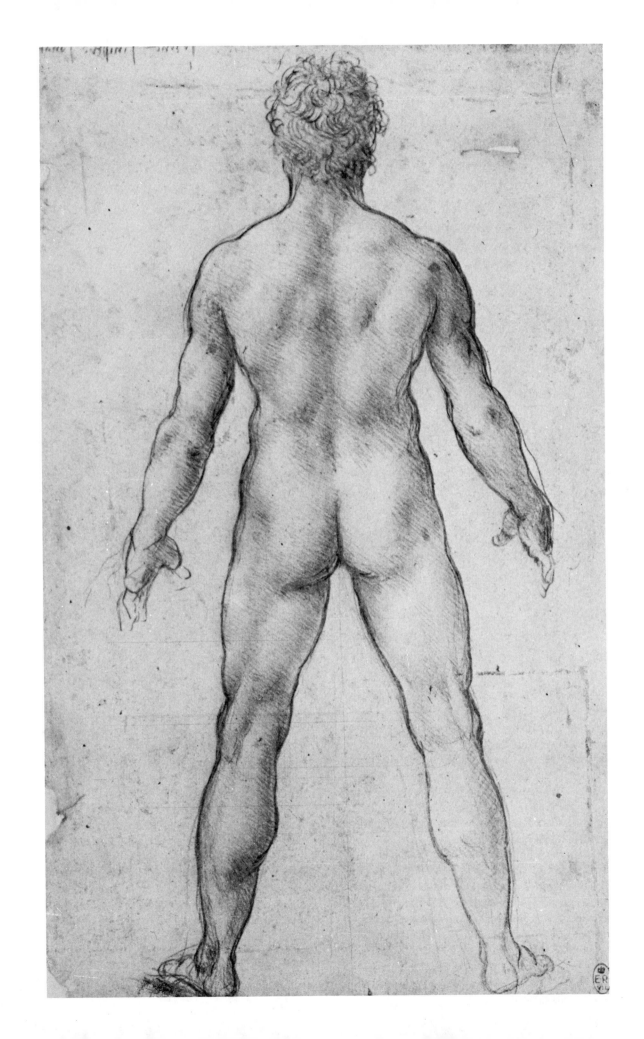

Rembrandt van Rijn (1606-1669)
ADAM AND EVE
etching
6 1/2" x 4 1/2" (165 x 114 mm)
British Museum, London

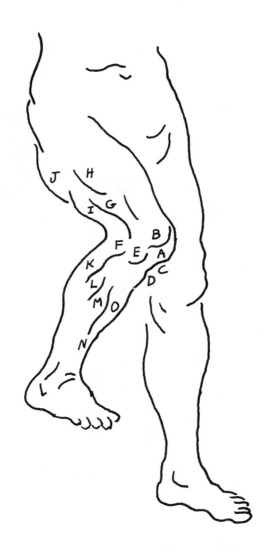

Knee, Lateral Aspect

In his depiction of Adam and Eve, Rembrandt contrasts the bony male knee with the long soft curves about the female knee. He was aware that in flexion of the lower leg, the patella (A) sinks deeply into the bony hollow at the base of the femur. The front of the knee is formed by the condyle of the femur (B). The straight edge of the patella ligament (C) goes to the kneeling point (D) of the tibia bone below.

Throughout this etching, Rembrandt rhythmically changes the direction, size, and degree of curvature of his contoured hatchings in order to hint at the anatomical divisions and planes of the knee and the surrounding area. His anatomical knowledge made him intimately familiar with the landmarks surrounding the knee: the lateral condyle of the tibia (E); the head of the fibula (F); the long line of the iliotibial band (G) passing above the head of the fibula enroute to the tibia at the front; the vastus externus above (H) and below (I); the biceps (J); the gastocnemius (K) and soleus (L); the very vertical peroneus longus (M) and the massing of lines across the extensor digitorum longus (N) to the tibialis anterior (O).

The extended legs stand parallel to each other in the front view but the thighs incline inward. Because the pelvis is wider in the female, the slant of the femur bone is more pronounced, though only slightly so here. However, individuals vary greatly. You may occasionally observe a model on which this slant is exaggerated. This is called "knock-kneed," the opposite of "bow-legged."

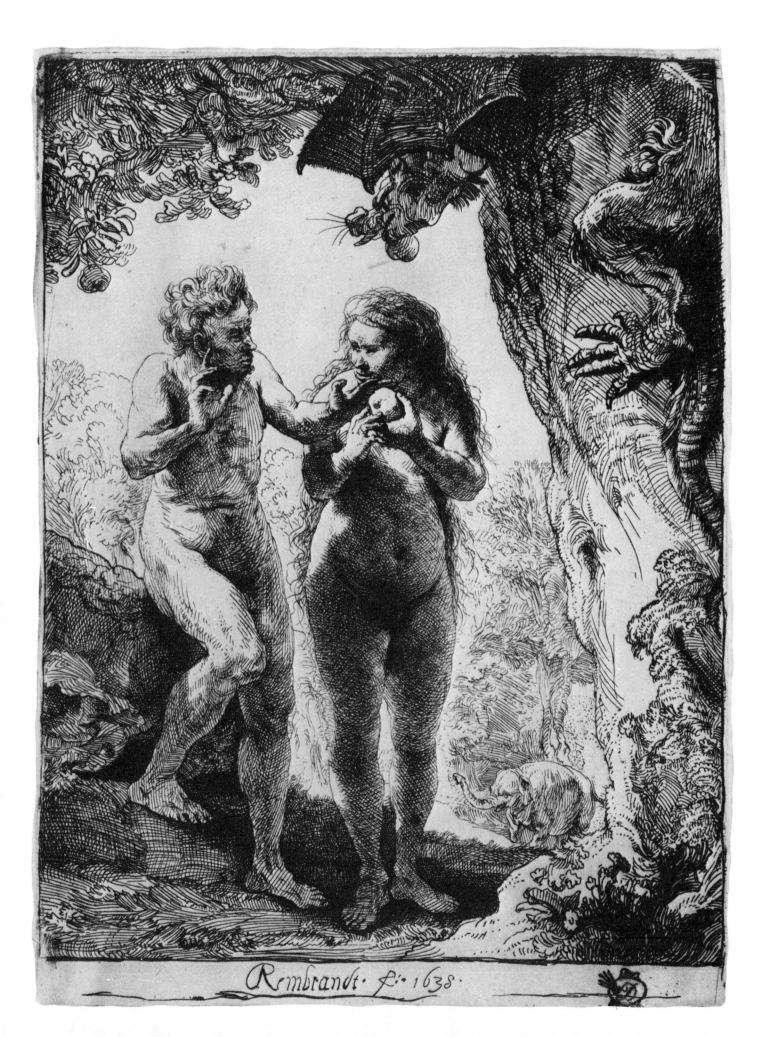

Rembrandt. f. 1638.

Pierre-Paul Prud'hon (1758-1823)
SEATED FEMALE NUDE
black and white chalk
22" x 15" (559 x 381 mm)
Bequest of Walter C. Baker
Metropolitan Museum of Art, New York

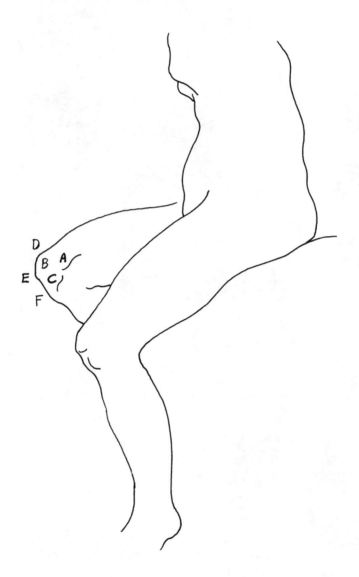

Knee, Medial Aspect

Prud'hon has placed his dominant plane break on the inner edge of the vastus internus (A) as it moves low on the leg over the spool-like medial condyle of the femur, to the border of the patella (B). He carries the massing of form down and over the bulge of the sartorius and gracilis at the medial condyle of the tibia (C). The patella (D) is indicated above by a slight recession and change of direction, and below (E) by the shaded area where the knee narrows at the patella strap above the kneeling point (F).

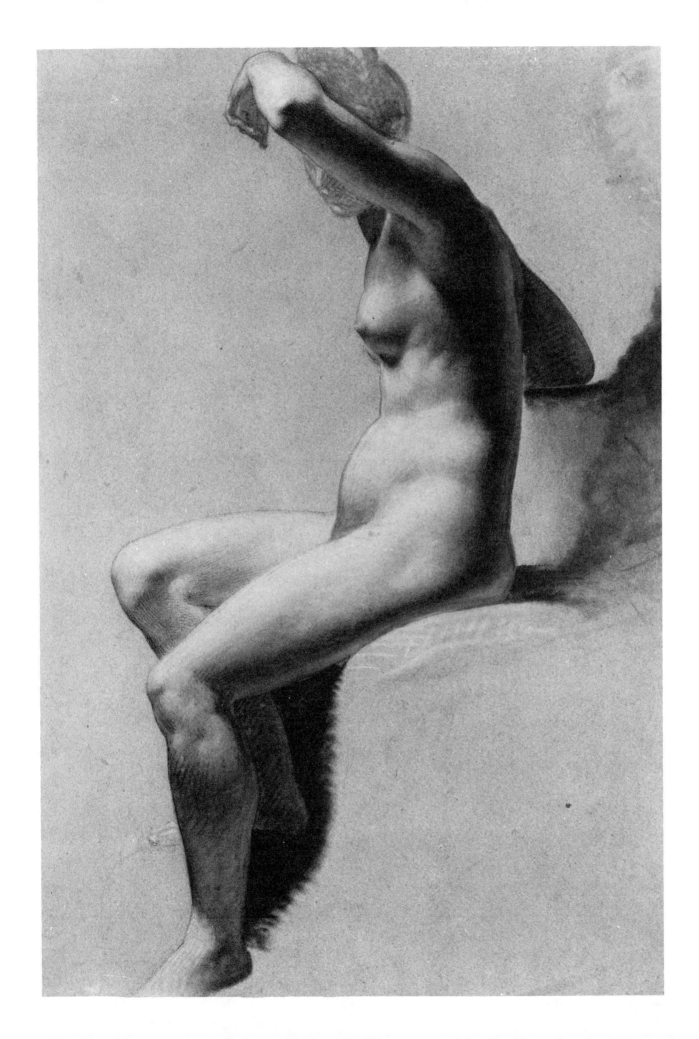

Luca Signorelli (c.1441/50-1523)
HERCULES AND ANTAEUS
11 3/16" x 6 1/2" (283 x 163 mm)
chalk
Reproduced by gracious permission of
* Her Majesty the Queen*
Royal Library, Windsor

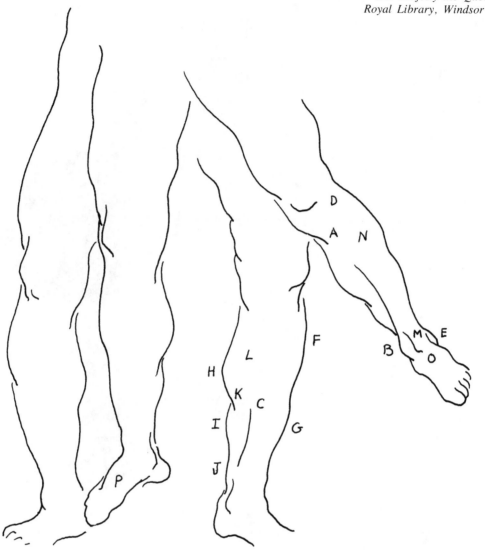

Lower Leg, Anterior Aspect

In Signorelli's drawing, we can trace the tibia or shin bone by the long line curving from the kneeling point (A) to the internal malleolus (B) at the ankle. In the lower leg, the tibia is defined by the long highlight (C) that follows the axis of the conelike cylinder of the leg.

The smaller of the two leg bones—the long, thin fibula—is hidden by muscles and visible to the eye only at the side of the knee (D) and at the outer ankle (E).

Signorelli's long oblique hatchings mass the larger form of the leg. The detail of muscle is subtly suggested in several ways: by the variation in the outlines of the soleus (F) and peroneus longus (G) on the outside; by the changing sizes of the gastrocnemius (H), soleus (I), and flexor digitorum longus (J) on the inside; by linear overlapping (K); and by minor value changes (L) at the lines between the functions. The extensor digitorum longus (M) of the lower leg moves across the front of the ankle, extending the four outer toes and drawing back the foot.

The muscular portion of the tibialis anterior is massed along the upper and outer edge of the tibia (N). Where its lower tendinous portion crosses the ankle, the deep accent (O) tells us that the model's foot is in flexion, or turned upward, as contrasted to the slightly extended or downward position of his other foot (P).

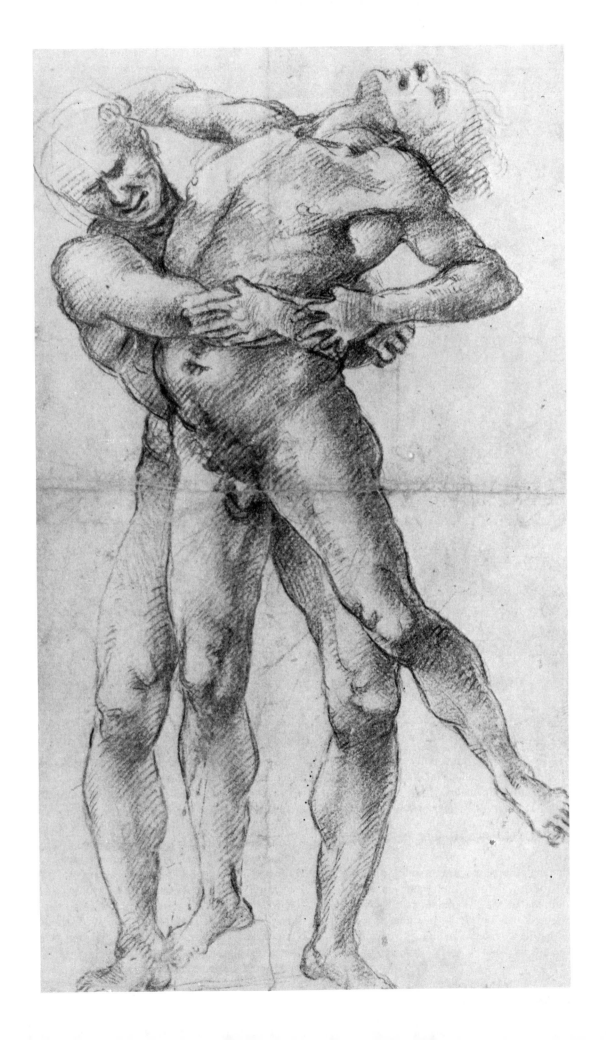

Luca Signorelli (c.1441/50-1523)
NUDE SEEN FROM BEHIND WITH LEGS APART
black chalk and colored wash
Musée Bonnat, Bayonne

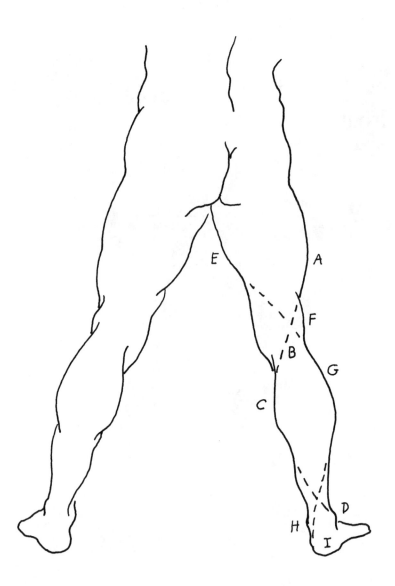

Lower Leg, Posterior Aspect

One of the ways of getting more unity and balance into a drawing is by taking advantage of the natural curves in anatomical structure. In nature, form follows function. The airfoil-like curves of fish and bird give impetus (lift) to their flight. The alternating curves of our bodies still reflect our common ancestry with them. In this drawing, Signorelli observes the rhythmical alternation and balance of large and small curves along his outline of the lower limbs and from side to side.

The contour line of the external line of the thigh (A) projects across the top of the popliteal space (B) and is linked to the counterbalancing movement of the outline of the medial head of the gastrocnemius (C) on the inside, and then back again to the lateral malleolus (D) or outer ankle.

At the inside of the thigh, the outline of the gracilis (E) projects down across the knee, along the tendon of the biceps (F) into the outside contour line of the calf, created by the soleus (G), and back again to the inner ankle (H) and around the calcaneus or heel bone (I).

Look for these outer and inner lines of continuity throughout the body, where they are found on both large and small scale. Once observed, they can be emphasized for greater balance and unity throughout your drawing.

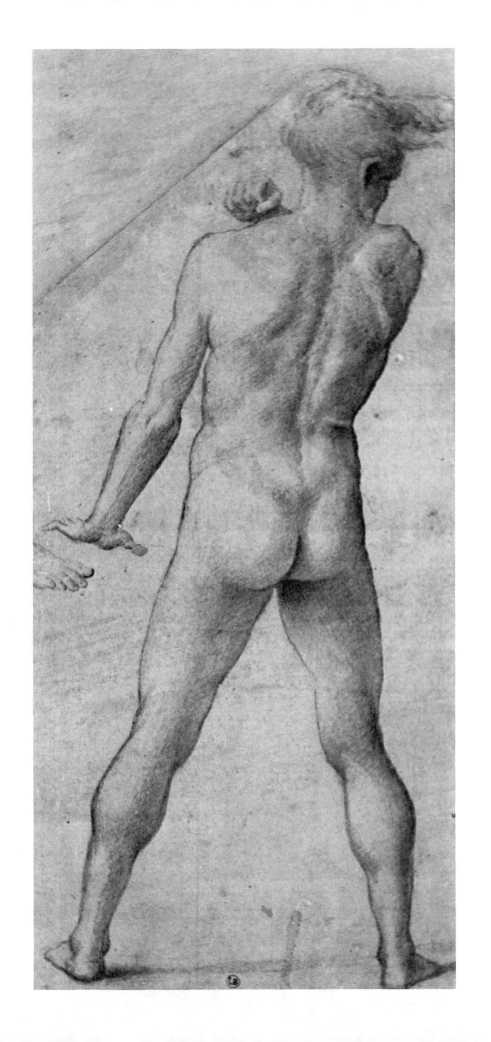

Taddeo Zuccaro (1529-1566)
NUDE MALE FIGURE WITH UPRAISED ARMS
red chalk
16 3/8" x 11 5/16" (416 x 287 mm)
Rogers Fund, 1968
Metropolitan Museum of Art, New York

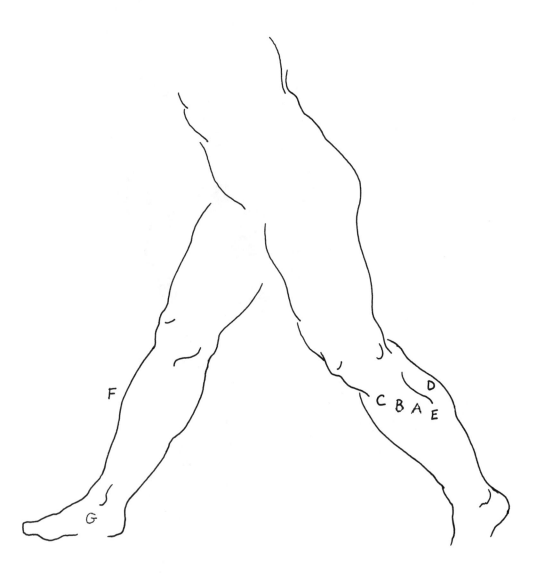

Lower Leg, Lateral Aspect

The leg on the right is massed along the edge of the peroneus longus (A). The tibialis anterior (B) is bathed in light, and the overlap of the patella strap at the kneeling point (C) suggests the front edge of the tibia bone.

Zuccaro's figure is walking energetically. The leg on the right is still stretched out, its heel raised in the plantar-flexed position, a push-off position initiated by the still-bulging gastrocnemius (D) and soleus (E) of the calf group. The knee is slightly flexed and the leg is about to swing forward. The pelvis has tilted downward on the far side to accommodate the forward step of the leg on the left. This momentum has carried the center of gravity of the body beyond the support of the leg on the right, but imbalance of the body has been checked by the heel strike of the forward foot on the left.

The contractions of the dorsiflexors of the foot in the forward leg, most visible in the outline of the tibialis anterior (F), provide a controlled approach of the plantar surface of the foot to the ground, establishing a new base of support.

The tendon of the tibialis posterior (G), by its pull on the navicular bone of the inner foot (see drawing of the foot on page 244), inverts or tilts the foot slightly inward to provide cushioning action when the foot lands. It is responsible for wearing out the side of the heel of your shoe.

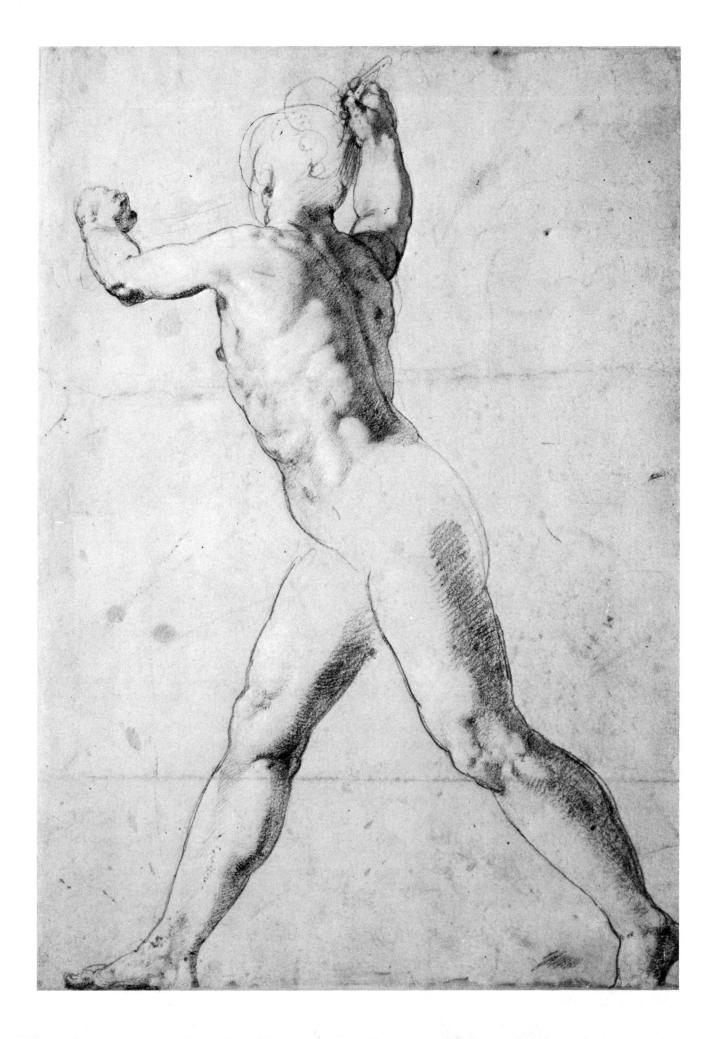

Raphael Sanzio (1483-1520)
ANEAS AND ANCHISES (STUDY FOR *THE BURNING OF BURGO*)
red chalk
12" x 6 3/4" (304 x 170 mm)
Albertina, Vienna

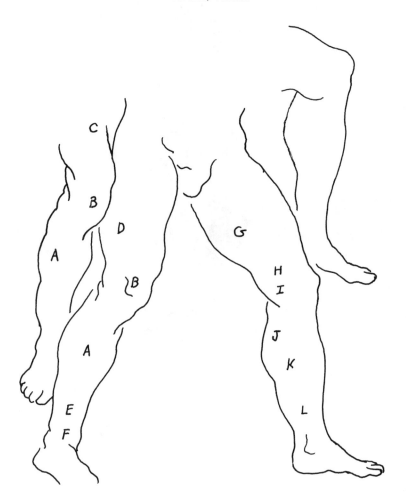

Lower Leg, Medial Aspect

The great masters seldom displayed anatomical knowledge for its own sake in their drawings. Quite the contrary. Drawing from their vast knowledge of anatomy as from a bank or vocabulary, they would carefully select the most appropriate piece of anatomy to support the design they intended.

Raphael contrasts the lean, limp leg of the disabled figure to the firm, solidly modeled leg of the supporting figure. His knowledge of the location, size, shape, direction, and function of the tibialis anterior (A) helped him to express these contrasts.

The disabled warrior's weak tibialis anterior muscle (A) blends with the mass of the peroneal group, leaving the anterior edge of the tibia as a stark line. The furrows of the patella (B) and the surrounding knee are exaggerated and help intensify the long straight lines and the emaciated look of the quadriceps (C) and of the upper part of the figure itself.

In contrast, strong curved lines dominate the supporting figure. His muscles are firm and round. Raphael masses the form along the edge of the vastus externus (D) and at the side of this patella (B) on this lower figure. Because Raphael was aware that as the foot bends backward, the swelling tibialis anterior muscle on the supporting figure (A) slightly overlaps the upper edge of the tibia, he softened the modeling there. Below the mid-leg, where the muscle turns to a tendon, he rhythmically picks up its edge (E), but he softens it again at the ankle, where it forms a flat plane (F) with the tendon of the extensor longus digitorum.

On the inner leg, the edge of the plane break is lost and found. His edge moves from the adductors (G) through the vastus internus (H) and the mass (I) of the sartorius, gracilis, semitendinosus, and semi-membranosus muscles that flex and steady the knee, to the edge of the gastrocnemius (J) and soleus (K), and finally over the long flexor of the toes (L). Thus the alternating rhythms of long and short, hard and soft, curved and straight, are all based upon Raphael's selection and interpretation of anatomy.

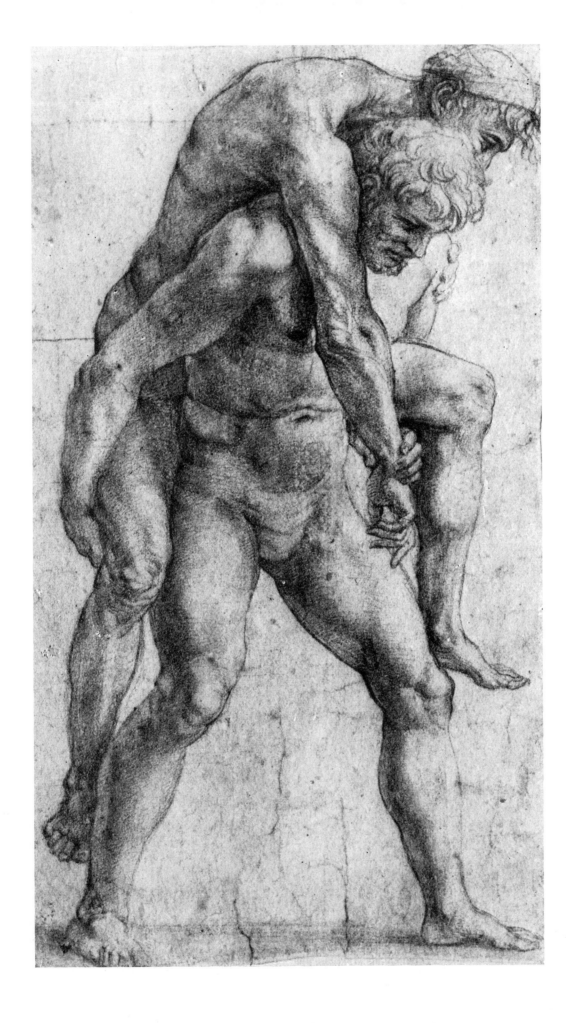

Michelangelo Buonarotti (1475-1564)
TORSO OF SEATED MAN
black chalk
7 3/4" x 9 5/8" (188 x 245 mm)
British Museum, London

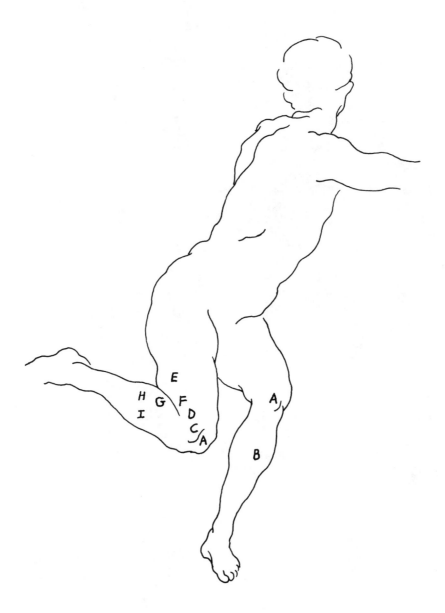

Lower Leg, Flexion, Lateral Aspect

This is a good example of the lower leg, shown in two stages of flexion. The leg on the right-hand side is in flexion at a right angle. At the knee, the patella (A) which stands out clearly in extension, here is drawn into the intercondyloid notch of the femur or thigh bone. Because the femoral condyles are not quite parallel and differ in size, a slight degree of inward rotation occurs in the leg up to this mid-flexion position. The position of the patella (A) in relation to the knife edge of the tibia (B) helps express the direction of the leg and the foot.

The other leg of the model is in acute flexion. Michelangelo has massed the forms in front where the patella (A) meets the external condyle of the femur (C). The vastus intermedius (D) surfaces from under the iliotibial band (E) and the tendons of the hamstrings (F) bulge over the calf. Michelangelo places his strong plane break (G) well back on the calf. He has only lightly indicated the division between the calf group (H)—sometimes called triceps surae—and the peroneal group (I). This is really a line between functions and, as such, its values are kept lighter than the light of the large dark areas.

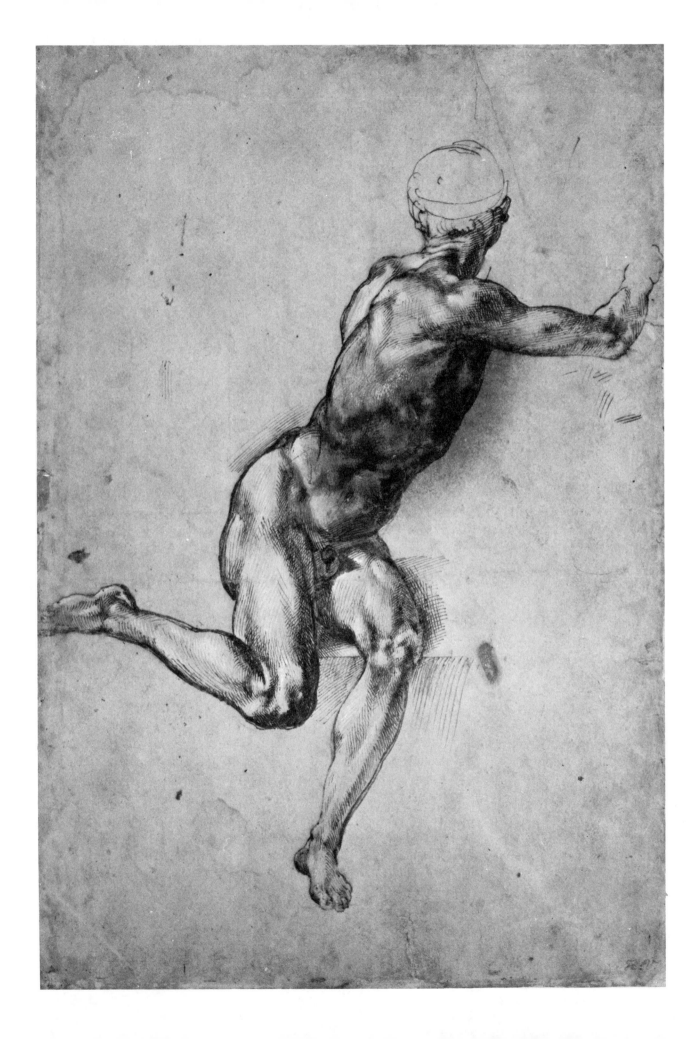

Michelangelo Buonarotti (1475-1564)
STUDY FOR LEFT LEG OF *DAY*
black chalk
16 1/8" x 8 1/8" (410 x 206 mm)
Teyler Museum, Haarlem

Lower Leg, Flexion, Medial Aspect

The joints of the body are prevented from collapsing by the reciprocal tension of the muscles arranged in front and behind them. In this drawing, the hinge joint of the knee is flexed by the dominant contractions of the hamstring muscles (A). The gracilis (B) and the sartorius (C), which move obliquely across the inner thigh to their insertions in the upper tibia bone, aid in this flexion. On the other hand, the rectus femoris (D) and the vastus internus (E), which are inserted into the anterior or front of the tibia through the patella (F) and its ligament (G), maintain a synergetic and stabilizing countermovement. Since they are minimally active and away from the light source, Michelangelo has subdued them through an overall middle tone.

The foot is a lever that has its fulcrum at the ankle (H). Although here pictured at rest, the powerful Achilles tendon (I) which is attached to the base of the calcaneus or heel bone (J), together with the soleus (K) and gastrocnemius or calf muscles (L), can pull up the heel to place you on your toes. The long, sub-cutaneous posterior portion of the shaft of the tibia bone (M) separates this group of calf muscles from the tibialis anterior (N). The tibialis anterior muscle, with its inner tendon of insertion (O) in the foot helps put you back on your heels.

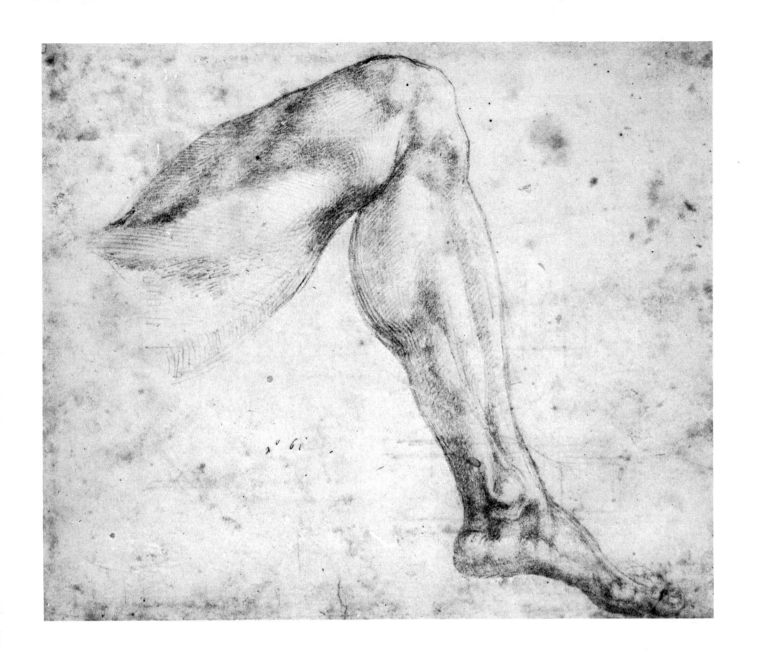

4

THE FOOT

Albrecht Dürer (1471-1528)
RIGHT FOOT AND ITS BONE STRUCTURE
charcoal
7 5/8" x 11 5/16" (194 x 287 mm)
British Museum, London

Structural Points, Lateral Aspect

It is thought that the most recent major evolution of the human foot took place between ten to twenty million years ago in Asia and Africa with the development of the arches as efficient levers for walking on two legs.

It is evident that Dürer had the underlying bony structure in mind when he drew the foot. The tibia (A) and fibula (B) of the leg sit upon the astragalus or talus (C), the keystone and summit of the longitudinal arch of the foot. The arched vault of the foot is supported at its ends by the calcaneus, also called the os calcis or heel bone (D) at the back and by the heads of all five metatarsals (E) at the toes.

The transverse arch (F) results from the shape of the tarsal bones of the distal row: the first (G), second (H), and third (I) cuneiforms; the cuboid (J); and the base of the metatarsal bones (K). The astragalus (C) is primarily related to the navicular bone (L), the three cuneiform bones (G-I), and the three inner metatarsal bones and their phalanges, all known as the ankle system.

The flatter, more rigid heel system—made up of the calcaneus (D), the cuboid (J), and the outer two metatarsal bones and their phalanges—hugs the ground and supports the moving foot. The arched and more flexible ankle system adds flexibility.

Dürer might have been thinking of the lower instep line of a shoe when he drew the spiral line (M) just behind the root of the toes. Constant flexion of the foot and extension of the toes in walking will cause a crease in your shoe at this point.

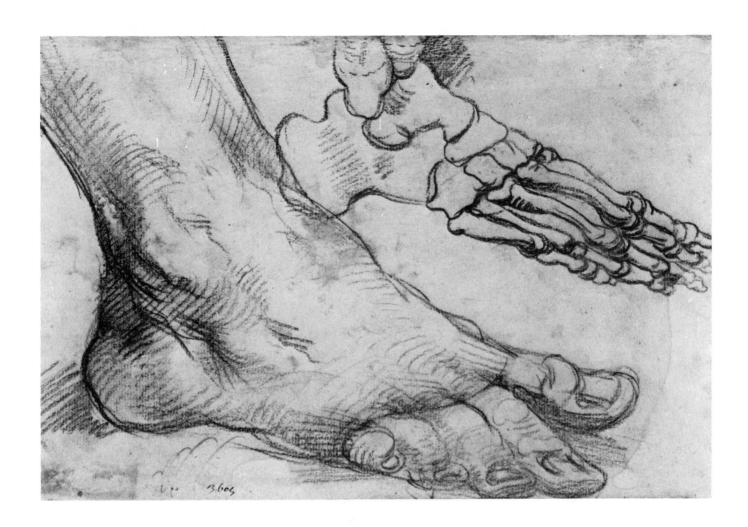

Domenichino (1581-1641)
TWO STUDIES OF A LEFT LEG
chalk
15" x 9 3/4" (381 x 247 mm)
Reproduced by gracious permission of
Her Majesty the Queen
Royal Library, Windsor

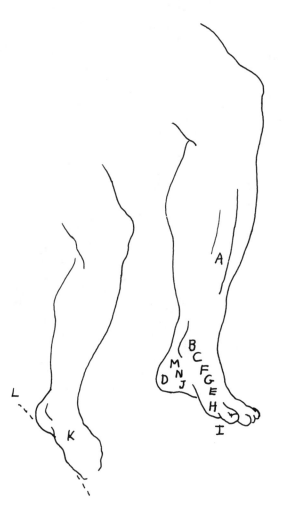

Structural Points, Medial Aspect

Looking at a sketch of the foot by Domenichino, the long, graded vertical highlight (A) clearly places the tibia bone of the lower leg on top of the arch of the foot. The medial malleolus or inner ankle (B) of the tibia, sits astride the astragalus (C). The calcaneum or os calcis (D) forms the base of support at the heel and the bones of the metatarsals (E) and tarsus (F) make up the larger anterior base of support of the arch. This forward portion projects the top or dorsum of the foot (G) downward, forming the more cylindrical and convex instep of the foot.

At the toes, the foot is broader and flatter. It is widest at the level of the head of the metatarsal of the big toe (H). Domenichino has placed his shading behind this mass. It forms a narrow neck (I) where it meets the first phalanx of the big toe.

In the inner concavity, at the waist of the sole of the foot, Domenichino has indicated the principal muscle of this area, the abductor hallucis (J). This muscle moves from heel to the first phalange of the big toe and rounds out the inner arch.

The instep of the lower foot (K) is low, and the so-called "water line" (L), which extends from the base of the heel to the end of the toes, almost touches the ground. In the upper foot, the arch is high and provides a more flexible base of support for walking.

Domenichino has placed an oblique accent (M) below the inner ankle, thus indicating the groove between the bone of the inner ankle (B), the sustentaculum tali eminence of the calcaneus or heel bone (N) just above the abductor hallucis (J). His knowledge of anatomy also helps him to show direction and linear movement in the foot, creating a greater interest in that area.

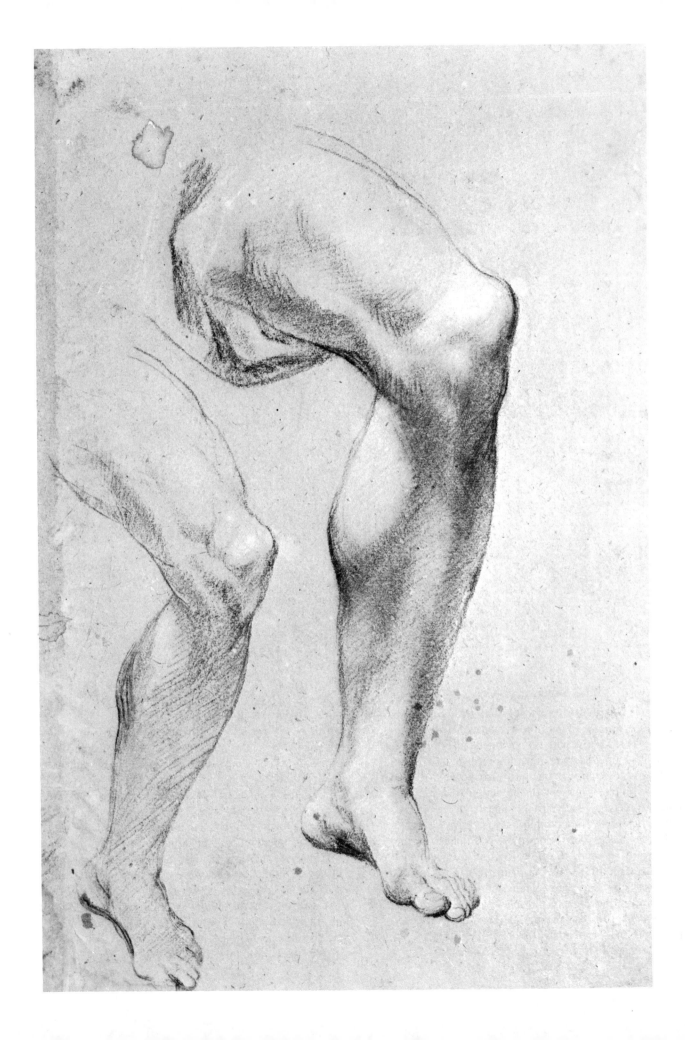

Jacopo Pontormo (1494-1556)
STUDY OF LOWER PART OF FEMALE NUDE
red chalk
15 9/16" x 10 1/4" (395 x 260 mm)
Uffizi, Florence

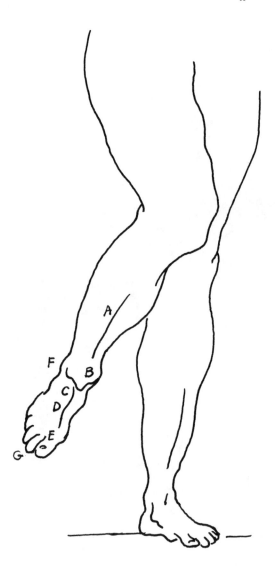

Structural Points, Superior Aspect

You must be able to create illusions in figure drawing, such as a feeling of motion or, through foreshortening, a sense that a part is moving back into space. To be able to do this, you must know and understand anatomy thoroughly. You must also be able to move from a simple statement of the action to the more complex details, and must be able to juggle many things at once in your mind as you draw.

In the raised foot, Pontormo has emphasized the downward curve of the tibia (A) and exaggerated the upper surface of its internal malleolus (B). Outward of this mass, he starts the highline of the foot. This line moves over the tops of the inner tarsal bones (C), and down the top of the metatarsal (D), and along the proximal and distal phalanges (E) of the big toe. Since his dominant light is from the left, he places his

strong plane break along the edge of this line. On the up plane of the instep, he grades the light up to the highline and to the ankle, where this trapezoid-like dorsal mass interlocks with the internal (B) and external malleolus (F).

The distal phalanges of the toes come to a point at the longer second toe (G). All the toes tend to converge upon this toe as, in the hand, all the fingers converge upon the middle finger.

Pontormo also adds a base upon which to place the figure so that we might become aware of how far the model is above or below our eye level. The platform of the model stand is usually below eye level, as it is here. Pontormo has aided the illusion by placing the heel of the forward pointing foot above, as well as behind, the front ball of the foot.

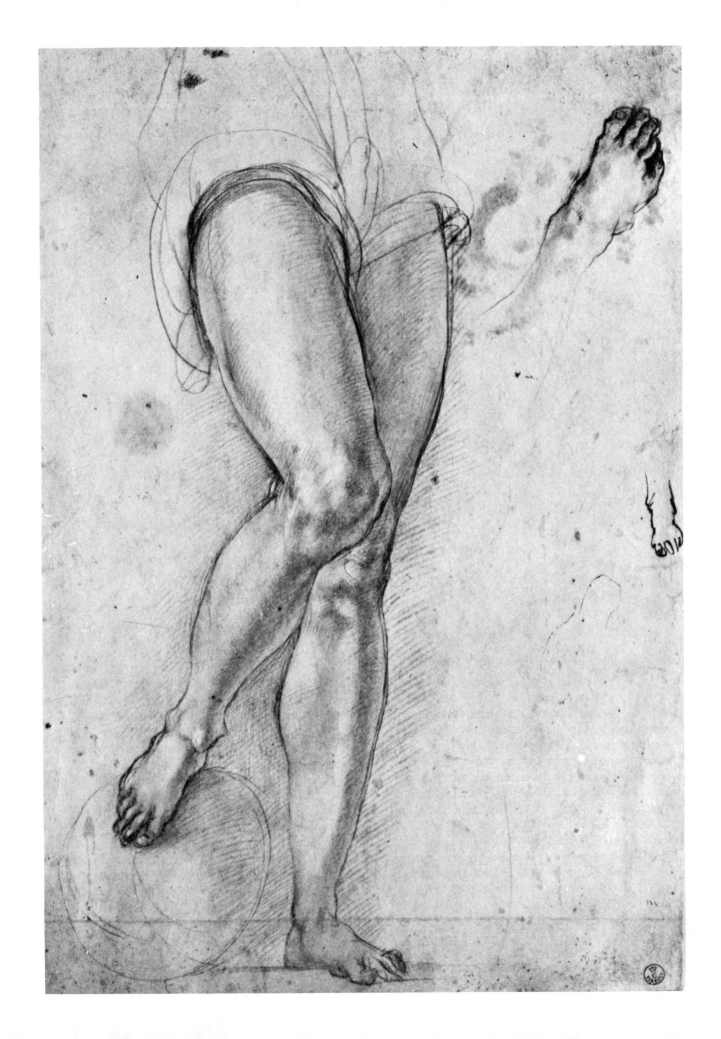

Peter Paul Rubens (1577-1640)
NUDE MAN RAISING HIS BODY,
STUDY OF LOWER LEG AND FOOT
black chalk
8 3/16" x 11 11/16" (207 x 295 mm)
Victoria and Albert Museum, London

Structural Points, Inferior Aspect

In footprints on the beach, the observant artist will have noticed the variations in the sole of the foot, known as the plantar surface. The shape is broadest at the front at the line of the metatarsal heads (A), narrower at the heel (B), and most narrow along the long outer rim (C). The middle portion of the inner side of the arch (L) does not touch the ground. Longitudinally, the foot may be divided into thirds made up of the heel (D), the inner arch (E), and the toes and their pads (F).

When you walk, your weight is transferred over the surface of the foot in a series of points starting with the heel. As the heel strikes the ground at the outer edge (G), the weight of the body is moved along the outer rim of the foot via the base (H) and head (I) of the metatarsal of the little toe, to the undersurface of the little toe (J) to the big toe (K).

The sole is covered by pads of fat that protect the four layers of muscle that flex, abduct, adduct, and stabilize the foot much as in the hand. Just below the surface, long ligaments act as tie rods and springs for the longitudinal arch. On the surface, Rubens uses the alternating size, direction, and value intensity of the contour lines over the transverse flexion folds (L) to express shape and depth. He breaks the direction of these lines at the longitudinal furrow (M) that runs through the center of the sole or from heel to toe.

The proximal phalanges of the fingers (N) are about as long as the entire length of the toes (O). The movable portion of the hand makes up half its length. In the process of evolution, the movable portion of foot has been reduced to about one third of the total length of the foot. The big toe, which corresponds to the thumb, has lost most of its mobility, and the little toe seems to be on the way out, evolutionally speaking.

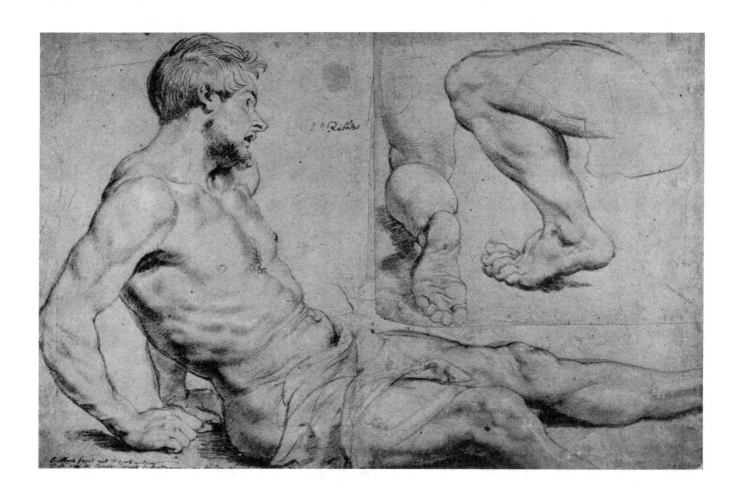

Domenichino (1581-1641)
LEFT FOOT
chalk
8 5/8" x 13 1/2" (218 x 343 mm)
Reproduced by gracious permission of
Her Majesty the Queen
Royal Library, Windsor

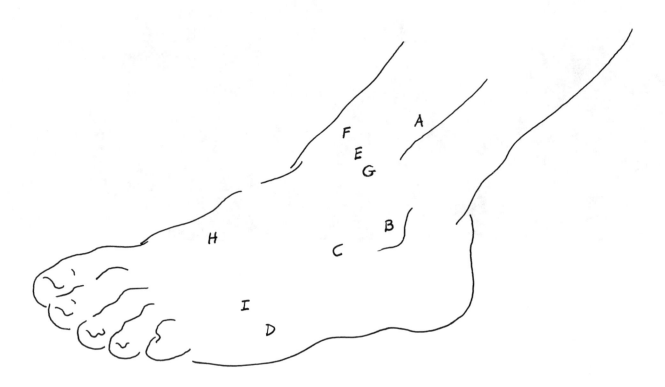

Muscles, Lateral Aspect

In this finely modeled foot, Domenichino has carried his dominant plane break down along the edge of the peroneus longus (A), to the external malleolus (B) of the fibula, over the egg-shaped and often bluish extensor digitorum brevis (C), and on to the long ridge of the abductor digiti minimi (D), the abductor of the little toe.

Domenichino's secondary value movements include the hollow (E) between the tibialis anterior (F), and the extensor digitorum longus (G). As a line between the functions, the values are only lightly suggested.

The large area at the top of the foot is broken up by the oblique movement of the internal or long saphenous vein (H) above, and by the external or short saphenous vein (I) and its tributaries, coming from behind the external malleolus (B). But these details have been subordinated to the larger massing and the simple two-value concept of the foot.

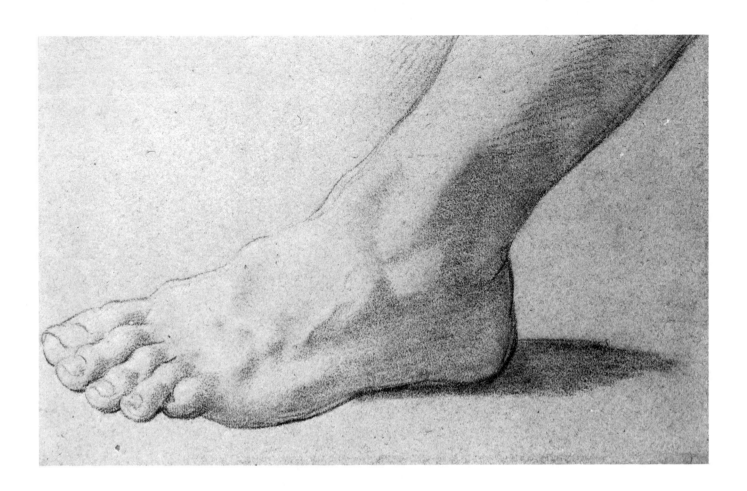

Rembrandt van Rijn (1606-1669)
FEMALE NUDE SITTING ON STOOL
pen and brown ink, washed in sepia
8 11/16" x 6 7/8" (211 x 174 mm)
Art Institute of Chicago

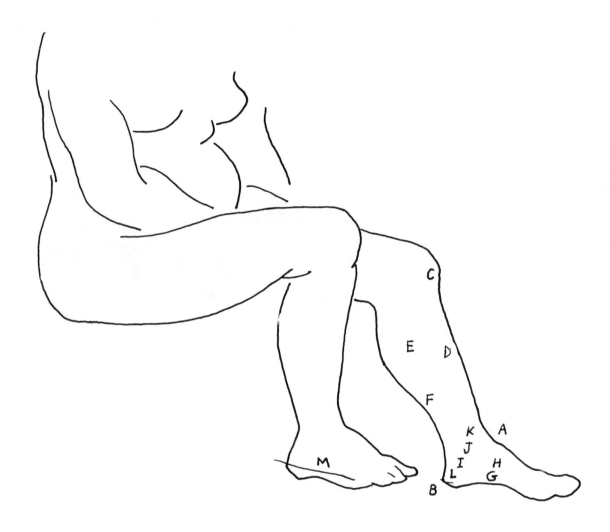

Muscles, Medial Aspect

Rembrandt used his vast anatomical knowledge in designing his powerful and simplified line and wash drawings. The tendon of the tibialis anterior (A) carries a linear flow from leg to foot in a curve made up of a series of straight lines. Rembrandt turns the outside corner at the heel (B)—not abruptly, but with a similar series of transitional linear movements.

Brief halftone washes define the down plane of the knee (C), the flat inner mass of the tibia (D), which sets off the muscles of the calf (E) above the Achilles tendon (F) at the down plane of the side of the leg.

At the inner side of the foot, a curved wash covers the narrow area of the abductor hallucis (G), and peaks above at the level of the tubercle of the scaphoid or navicular bone (H).

Anatomical or design meaning can be found even in Rembrandt's seemingly most idle scratchings. Two little lines (I) behind and below the medial malleolus (J) of the inner leg suggest the size and direction of the internal annular ligament. This ligament, similar in function to the anterior annular ligament (K) above, extends from the medial malleolus (J) to the calcaneus or heel (L), and holds in the three long flexor tendons passing at the side of the ankle.

The varied levels of the phalanges of the toes are used to create rhythm, movement, and interest. The long slash (M) along the base of the right foot, that might seem like an afterthought or mistake to the casual eye, defines the upper level of the abductor digiti minimi and turns a flat and dull area into a movement of two planes.

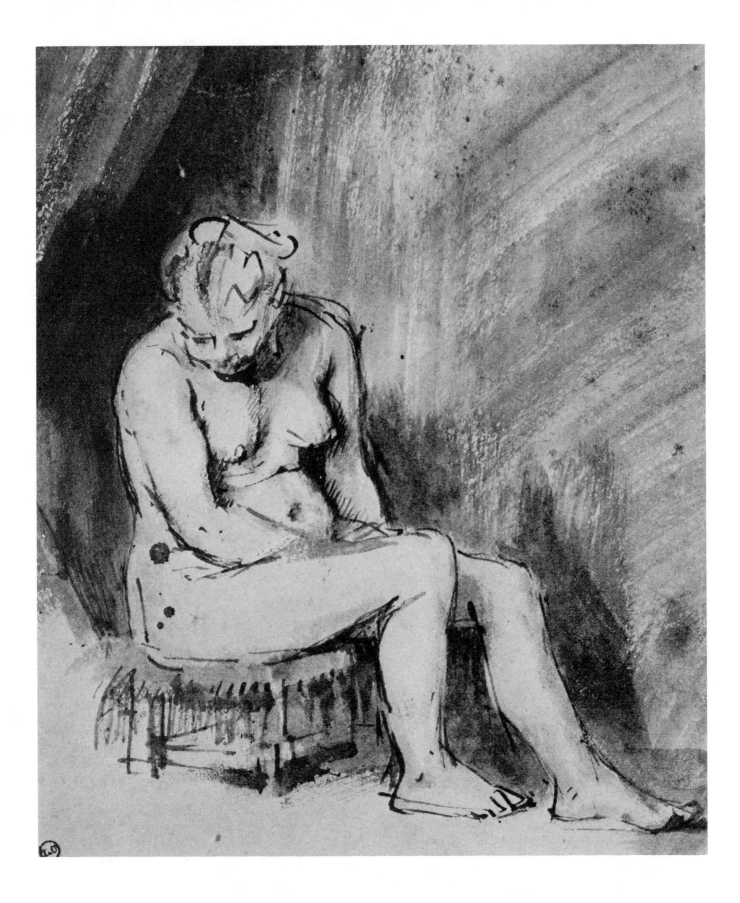

Charles Lebrun (1619-1690)
PROMETHEUS BOUND
sanguine, heightened with white
19 3/16" x 12 1/8" (487 x 308 mm)
Woodner Family Collection II, New York

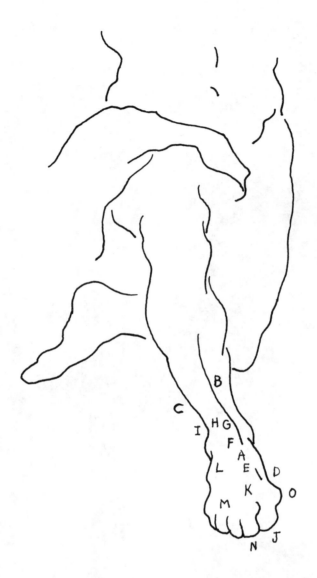

Muscles, Superior Aspect

Artists look for continuity, a rhythmic flow of lines from one segment of the body to the other, as an aid in placing and unifying separate parts of the body. One such line is the longitudinal eminence (A) on the inner border of the top of the foot. This highline is often a continuation of the front edge of the tibia (B). The outer outline of the lower leg around the mass (C) of the peroneus brevis and tertius muscles spirals from side to side across the ankle in an imaginary line of continuity and is picked up by the accent (D) at the inside of the metatarsal of the big toe. A highlight marks the base of the metatarsal of the big toe (E) and the summit of the instep.

From the hollow (F) between the line of the tendon of the tibialis anterior (G) and the extensor longus digitorum (H), the hallucis longus passes under the anterior annular ligament (I) and inward over the foot to the base of the big toe (J), creating a ridge (K) in the lower top section of the foot. At the ankle, the downward extension of line (G) suggests the tendon of the tibialis anterior moving to the first cuneiform and base of the first metatarsal.

The mass of the extensor digitorum brevis (L) sends its four tendons obliquely across the foot into the four internal toes. Lebrun has indicated the tendons of the extensor digitorum longus going to the phalanges of the toes by little accents (M) near their bases.

Jamming toes together in boots and shoes compresses them inward, abnormally flattening their sides and accentuating their convergence around the second toe (N). This makes the head of the metatarsal of the big toe protrude to the side (O).

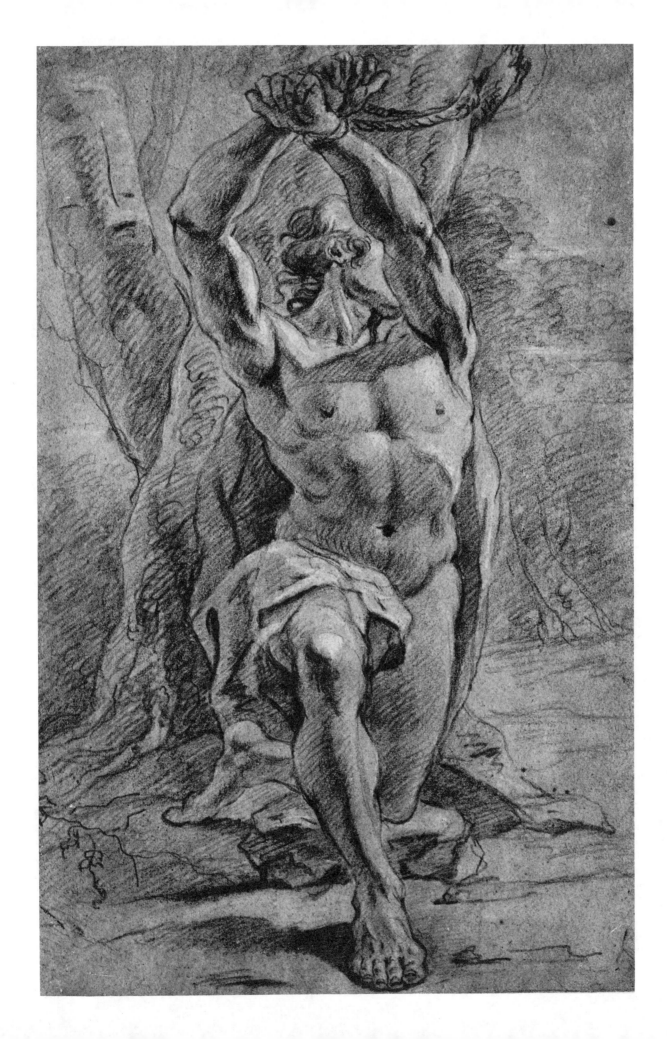

Rembrandt van Rijn (1606-1669)
NAKED MAN, SITTING ON THE GROUND
etching
3 3/4" x 6 9/16" (97 x 166 mm)
Rijksuniversiteit, Leiden

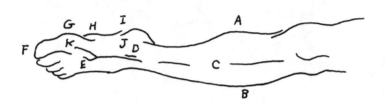

Extension and Adduction

Extension, or plantar flexion of the foot, takes place at the ankle. It is produced by the muscles of the calf (A), with the help of muscles of the peroneal group (B). As they contract, the heel is pulled upward, and the front of the foot is lowered and extended upon the leg.

Rembrandt breaks (C) his dark hatching along the edge of the tibia, suggesting the presence of the tibialis anterior muscle. Below, at the ankle, a small accent (D) further suggests the action of this muscle on the foot. The foot is massed along the highline with an accentuation at the base of the metatarsal of the big toe (E).

The great toe (F) and its metatarsal (G) dominate the inside section of the foot. Rembrandt's line overlaps the abductor hallucis (H) and suggests the waist of the arch of the instep. The line breaks again (I) just before the heel. The medial malleolus (J) is suggested by a graded series of lines: one for the base, and three moving upward for the inner edge. A series of short lines accentuates the side of the tendon of the extensor hallucis longus (K) as it extends the big toe and aids in the adduction of the foot. The tendon of this special extensor of the toe is analagous to the extensor pollicis of the thumb.

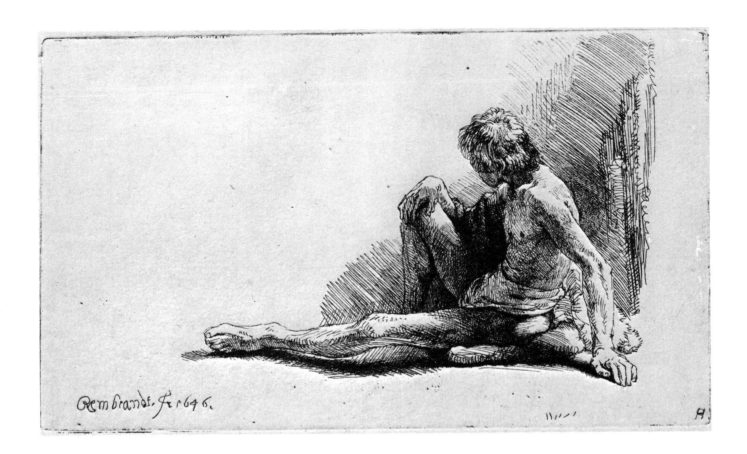

Rembrandt van Rijn (1606-1669)
RETURN OF THE PRODIGAL SON
etching
6 1/8" x 5 3/8" (156 x 136 mm)
British Museum, London

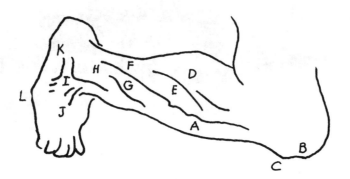

Flexion and Abduction

The prodigal son in Rembrandt's etching is kneeling. The downward movement in kneeling is caused by the force of gravity and controlled by both the flexors and extensors of the leg. The young man's hip and knee joints are flexed and the ankle is bent upward or dorsiflexed. The foot is balanced on the ends of the toe pads and the big toe is in dorsiflexion. The foot is slightly abducted, moving away from the body for support against the ground.

Thee tibialis anterior (A) keeps the foot flexed. The patella (B) protects the knee joint. The tuberosity of the tibia, or kneeling point (C), supports the weight of the body.

Rembrandt drives a line obliquely across the leg, setting off the calf group of muscles (D) from the peroneus longus (E). Below this, a parallel line (F) cuts under the base of the muscular portion of the peroneus longus and then moves in a broken line along the front edge of the muscle. A third and shorter oblique line below this parallels the second. This line skims the base of the muscular fibers of the peroneus brevis (G), moving inward over the long tendon (H) of the peroneus longus.

The mound of the extensor digitorum brevis (I) is bordered above by two lines indicating the outer tendons of the extensor digitorum longus (J) and below, by a series of lines representing the ridge of the abductor digiti minimi (K). Directly to the left, Rembrandt has used the base of metatarsal of the little toe (L) to break up the long outline of the sole of the foot.

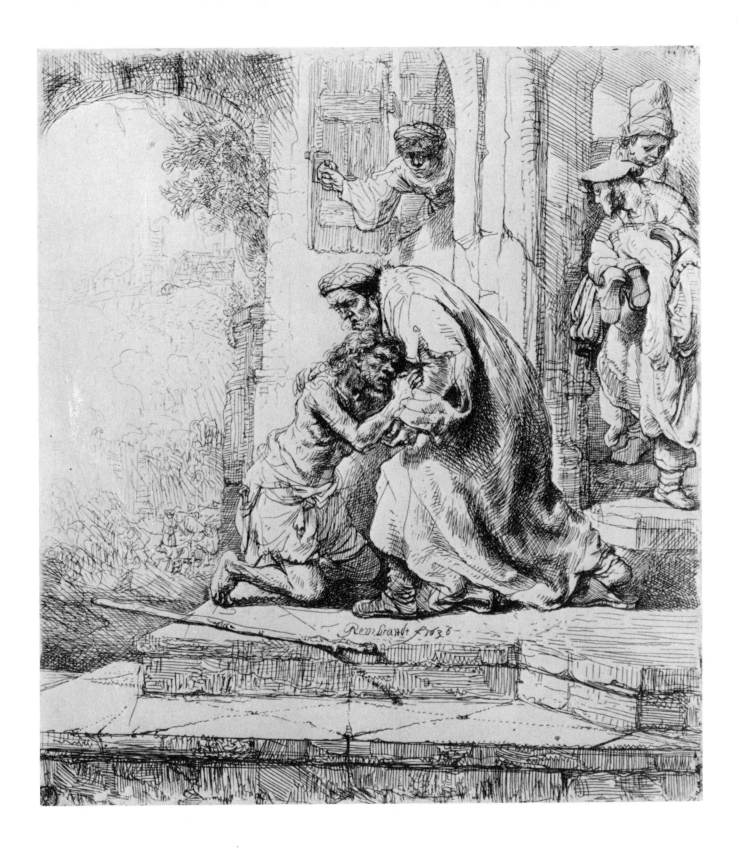

THE
SHOULDER
GIRDLE

Michelangelo Buonarotti (1475-1564)
STUDY FOR A BATHER
pen touched with white
16 3/8" x 11" (415 x 280 mm)
British Museum, London

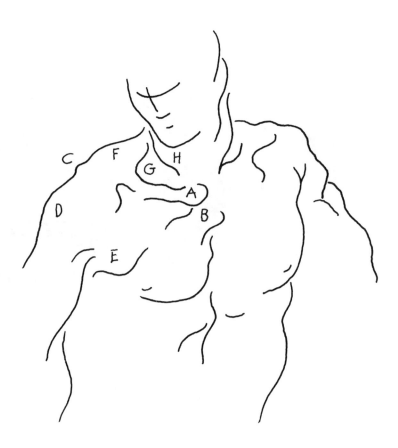

Clavicle

The clavicle or collar bone (A) is the most prominent bony landmark of the anterior portion of the shoulder girdle. It is the only skeletal connection between the shoulder girdle and the rib cage and sustains the upper extremity of the scapula in various positions that allow great latitude of arm motion.

This drawing is made well above eye level and the longer inner curve of the clavicle follows the convex contour of the rib cage. Michelangelo has accentuated the enlarged inner end of the clavicle (A) where it attaches to the side of the upper portion of the sternum, which is called the manubrium. The first rib is partly covered by the clavicle, but Michelangelo has indicated the prominence of the second rib (B) as a clue to the angle of the sternum and the direction of the rib cage.

The double curve of the clavicle spirals out to its meeting with the acromion process (C) of the scapula. Here, at the summit of the shoulder, the deltoid muscle (D) has its origin along the outer third of the clavicle. Below, the oblique shading shows part of the clavicular portion (E) of the pectoralis major. Above, the trapezius (F) spirals from its origin at the base of the skull and inserts in the outer third of the clavicle.

The posterior triangle of the neck (G) is formed by the edge of the trapezius (F), the clavicle (A), and the side of the large neck muscle, the sternocleidomas-toideus (H). Notice how this triangle deepens and widens when the arm is in a slightly forward position, as on the left. On the right, however, where the arm is pulled back, the triangle is reduced to a mere slit. If you stand in front of a mirror and observe these movements in your own body, you will remember them.

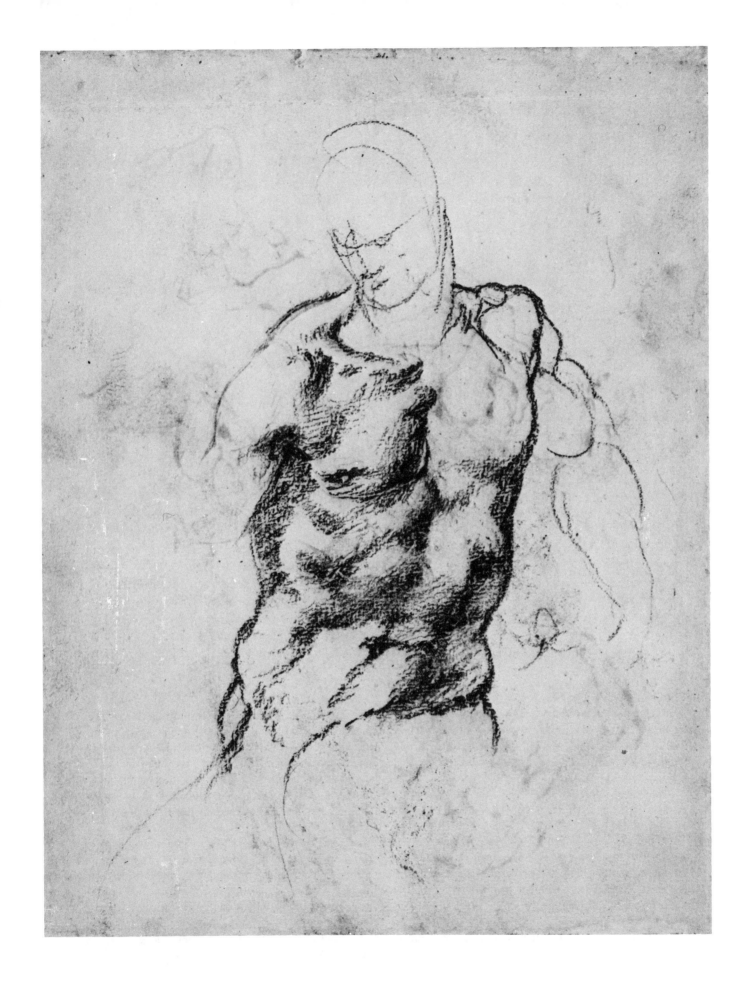

Peter Paul Rubens (1577-1640)
STUDY OF A RIVER GOD FOR *THE FOUR RIVERS*
black chalk heightened with white
17 7/8" x 17 1/2" (454 x 445 mm)
Victoria and Albert Museum, London

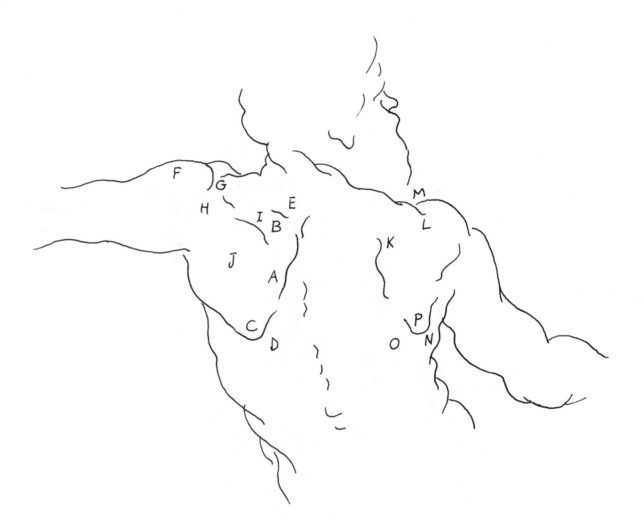

Scapula

The scapula or shoulder blade acts as a floating and participating base or platform for the movements of the shoulder girdle. This flat, triangular-shaped bone could be thought of as a triangle moving upon an egg, as it shifts across the upper half of the rib cage.

The vertebral or inner border (A) of the scapula is easily traced from the superior (upper) angle (B) to the dark accent of the inferior (lower) angle (C). The inferior angle presses out against the edge of the overlapping latissimus dorsi (D). The superior angle is held into the chest wall by the trapezius (E).

Observe the rhythmic movement that Rubens has given the middle portion of the deltoid (F) as it bulges from its origin in the acromion process (G) of the scapula in lifting to a horizontal position. If you follow the upper edge of the scapular portion (H) of the deltoid, you will find the edge of the spine of the scapula to which it is attached. The supraspinatus (I) and the infraspinatus (J) steady the head of the humerus in the glenoid cavity of the scapula and assist in the outward rotation and abduction of the arm.

The right arm is lowered to the front and the scapula moves with it. Rubens has accented (K) the inner end of the spine of the scapula, which also serves to indicate the direction of the entire shoulder blade. If you follow this point to the insertion of the middle portion of the deltoid (L) at the acromion process (M), you will discover the curve of the spine of the scapula (K-M). The bulge of the teres major (N), held in place by the latissimus dorsi (O), gives us the inferior angle of the scapula (P).

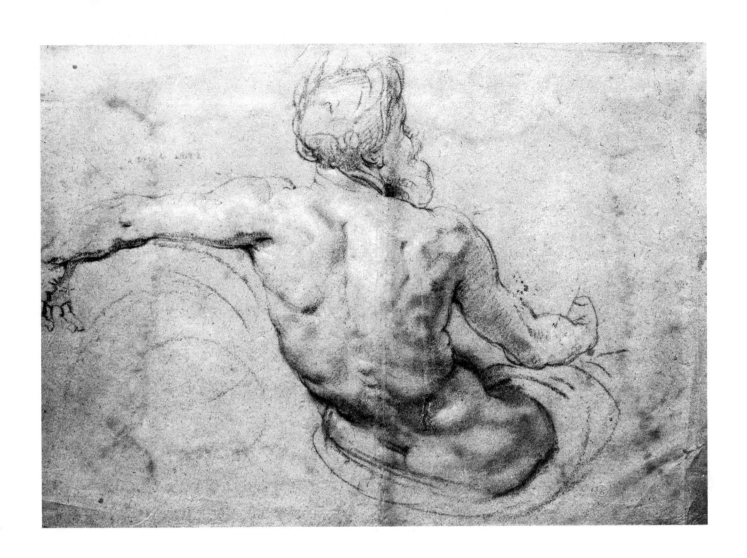

Michelangelo Buonarotti (1475-1564)
STANDING NUDE, SEEN FROM THE BACK
pen and bistre
15" x 7 1/2" (381 x 189 mm)
Albertina, Vienna

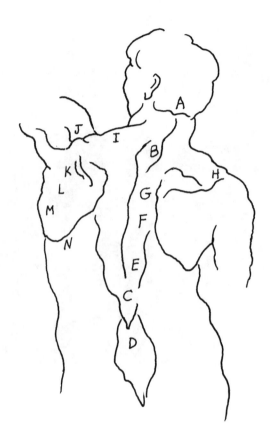

Trapezius

Michelangelo was fascinated by the many variations of bones and muscles in the upper back. In this figure we can clearly see the broad, flat, four-sided triangle of the trapezius. Follow its center line from its origin at the base of the skull (A), down along the spine, through the seventh cervical vertebra (B), to the base of the triangle at the twelfth thoracic vertebra of the spine (C) where it overlaps the triangular aponeurosis of the latissimus (D).

Now move your pencil up along the right-hand side of the trapezius as it curves over the spinal muscles (E), over the bulge of the rhomboids (F), and over the upper and inner edge of the scapula (G), where a dimple clues you to the root of its spine. Michelangelo indicates the trapezius' insertion in the scapula by

deep shaded lines that lead to its outer limits in the acromion process (H).

On the left, you can also see a series of convex lines carrying the trapezius (I) to the acromion process (J) of the scapula. The spine of the scapula (K) is clearly outlined by the protruding muscles. Below, we can see the infraspinatus (L), the edge of the teres major (M), and the latissimus dorsi (N) moving over the teres major and the base or inferior angle of the scapula.

As you learn to analyze these drawings of the masters, you begin to see how each great artist has made subtle personal selections from his extensive knowledge of anatomy, applying timeless principles of design to the drawings.

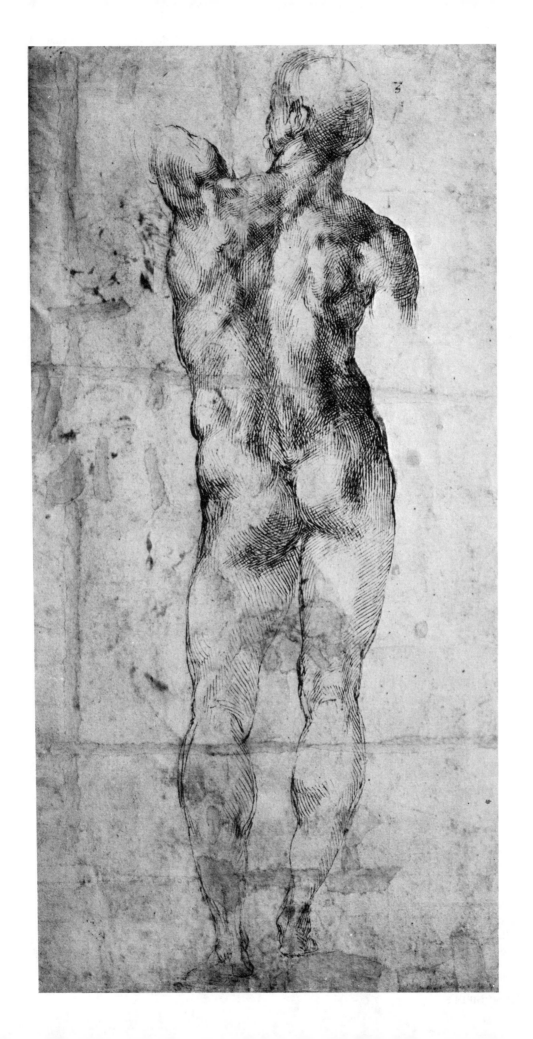

Michelangelo Buonarotti (1475-1564)
STUDY FOR ONE OF THE RESURRECTED
OF *THE LAST JUDGMENT*
black chalk heightened with white
11 1/2" x 9 1/4" (290 x 235 mm)
British Museum, London

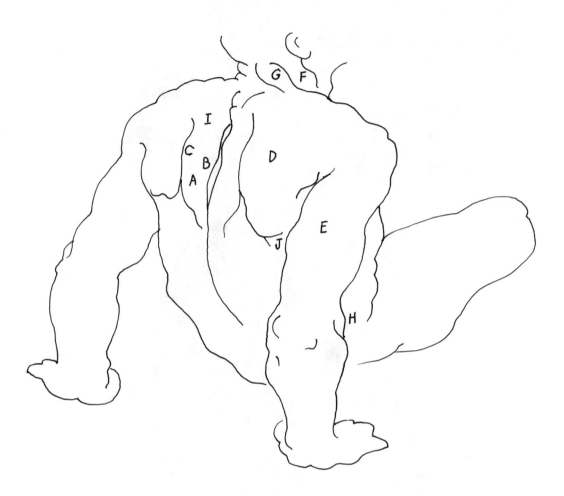

Rhomboids

The names given to muscles can help in recalling important things about their shape and their functions. Muscles are named for a variety of reasons. The rhomboids (A) are named for their shape: a parallelogram in which the angles are oblique and the adjacent sides unequal. The smaller side of the rhomboid is the vertical line (B), where it originates in the lower four cervical and upper five thoracic vertebrae of the spine. The larger side of the muscle is at its insertion into the inner border of the scapula (C).

The infraspinatus (D) is named for its location below the spine of the scapula; the triceps (E) for its three internal divisions; the sternocleidomastoideus (F) for its origin in the sternum and clavicle and insertion in the mastoid process of the temporal bone; the levator anguli scapulae (G) beneath the trapezius for its function in raising the scapula; and the supinator longus (H) for its rotating function and its long size.

When the arms are placed behind the back in an extended position, as in this drawing of Michelangelo, the rhomboids (A) stand out and can be distinguished from the overlying mass of the middle portion of the trapezius (I).

Functionally, the smaller rhomboid minor above and the larger rhomboid major below may be regarded as a single muscle. Together with the middle portion of the trapezius, they retract the scapula and bring the shoulders backward to a position of "attention." As the rhomboids retract the scapula inward, a slight counterbalancing forward and steadying motion outward is begun by its antagonist, the serratus anterior (J).

If you think of the muscles and their groups as individual in size, shape, direction, location, and function, they will become more than just lumps, ridges, or depressions. You will see them as important participants in the varied design of the body.

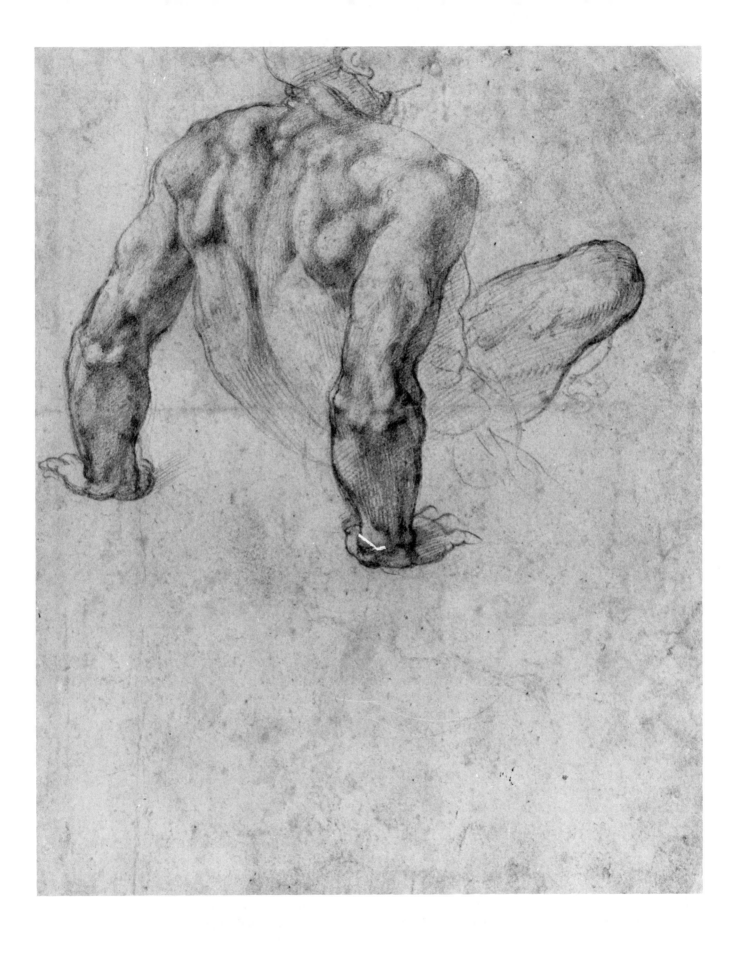

Anthony Van Dyck (1599-1641)
STUDIES OF A WOMAN SLEEPING
black chalk heightened with white, retouched with red chalk
12 1/4" x 14 7/8" (310 x 378 mm)
Biblioteca Nacional, Madrid

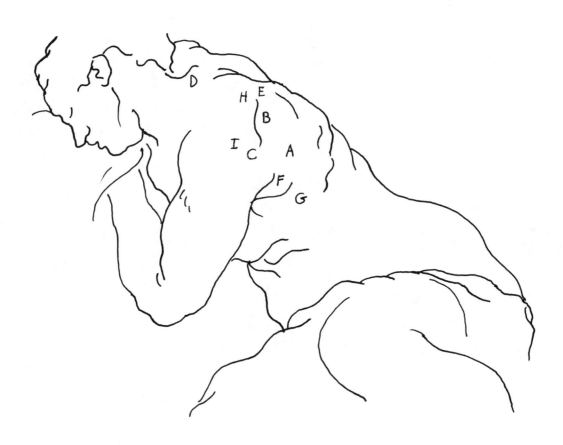

Infraspinatus

In this drawing, the upper arm is moved forward in flexion alongside the rib cage. The mass (A) of the infraspinatus and the teres minor beneath it (its smaller companion muscle), which are outward rotators, are inactive.

The barely discernible triangular mass of the infraspinatus has been indicated by a line of shading (B) that also marks the rear or posterior edge of the deltoid (C), inserting into the scapula. Behind, the trapezius (D) crosses over the base of the spine (E) and inner border of the scapula. Below the infraspinatus (A), the smaller mass of the teres major (F) is cradled by the mass of the latissimus dorsi (G).

If a fly were to suddenly land on the knee of Van Dyck's model and she were to fling her arm out to the side, the infraspinatus (A), together with the teres minor and the supraspinatus (H), would help hold the head of her humerus (I) in its scapular joint as well as assist in outward rotation of her arm. Notice how the shape of the ball of the humerus is reflected in the highlight on the middle portion of the deltoid.

Forms are structured to protect important functions of the body. The muscles do double duty in this respect by both moving the bones and protecting the joints.

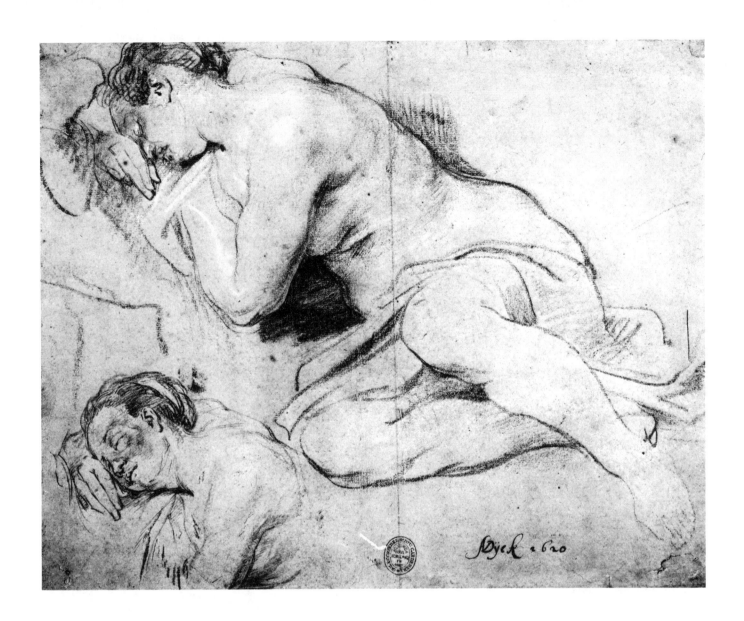

Annibale Carracci (1560-1609)
STUDY OF A NUDE
12 11/16" x 9 1/4" (321 x 231 mm)
Reproduced by gracious permission of
Her Majesty the Queen
Royal Library, Windsor

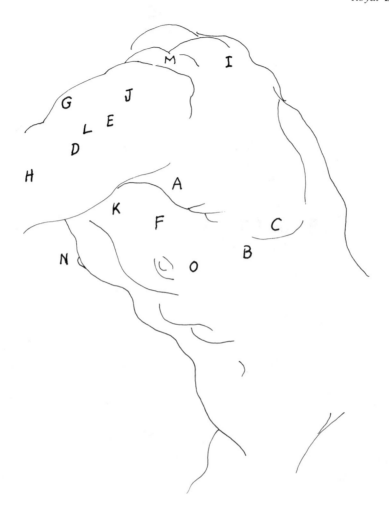

Teres Major

The figure Carracci has drawn might be in the act of flinging an object. The teres major (A) helps initiate this action by assisting the latissimus dorsi (B) in inwardly rotating the arm in order to fling it forward.

Note how Carracci's sweeping lines harmonize with the contour of the rib cage, the direction of the muscle fibers, and the forward motion of the arm. Imagine the contraction and tension set up by the posterior origin of the teres major in the inferior angle of the scapula (C) on the one hand, and by its insertion in the anterior side of the humerus (D) on the other.

The latissimus dorsi (B) holds the bottom of the scapula to the rib cage in the back and curves under the teres major (A), moving with it to its nearby insertion (E) in the humerus. Together with the pectoralis major (F), the teres major (A) and the forward portion of the latissimus dorsi form the rear of the armpit.

The arm is sustained in this upward position by the deltoid (G), which inserts halfway down the humerus (H), and by the supraspinatus (I), moving from beneath the trapezius to the greater tuberosity (J) of the humerus bone. From below, the pectoralis major (K) converges upward to its position (L) in the line of anterior insertions in the humerus bone of the arm. This slightly irregular line of insertions leads us to the summit of the shoulder and to the acromion process (M) of the scapula.

If you run a curved line through the nipples (N-O) and around the inferior angle of the scapula (C), you can feel the contour of the cylinder of the rib cage beneath the muscles. To draw this mass in perspective, visualize the rib cage as a block. Use these same landmarks as a series of points or edges for the blocks, and let them converge to vanishing points in space.

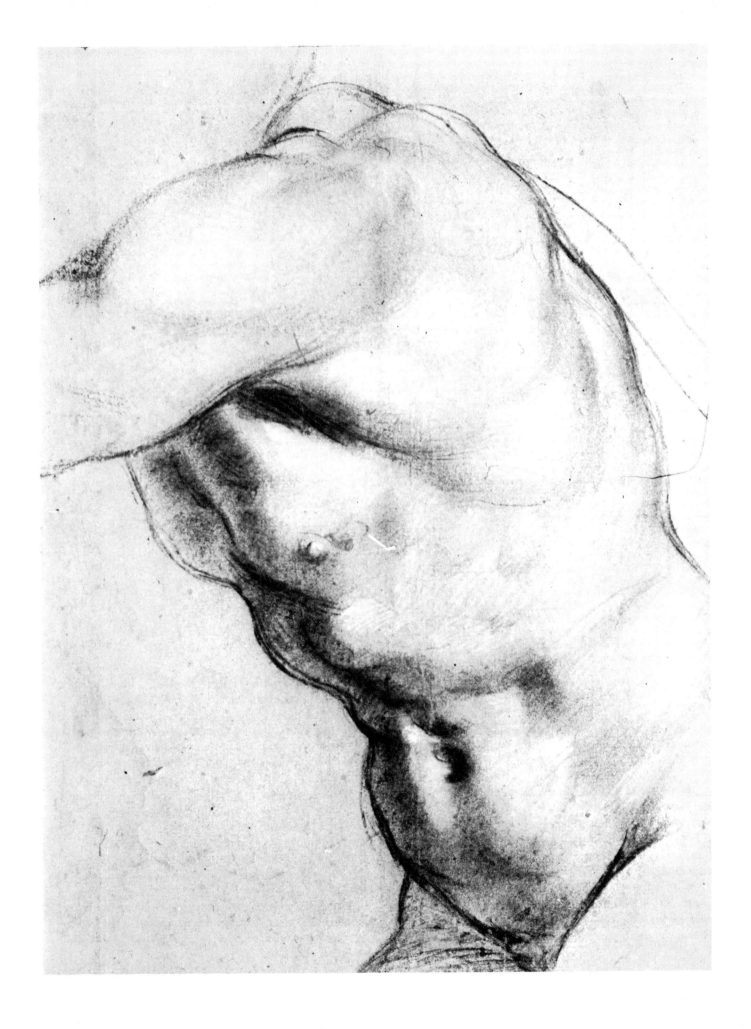

Henry Fuseli (1741-1825)
POLYPHEMUS HURLING THE ROCK AT ODYSSEUS
lead pencil and wash
18 1/8" x 11 7/8" (460 x 300 mm)
Auckland City Art Gallery, New Zealand

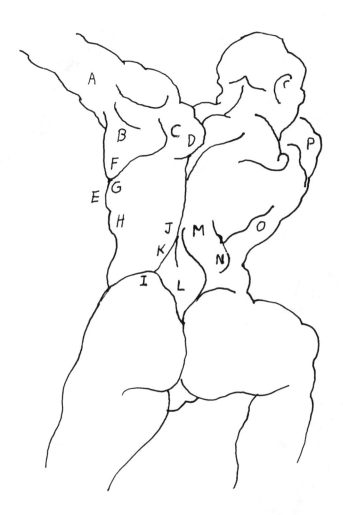

Latissimus Dorsi

Here we see Fuseli's figure at the beginning or wind-up phase of the act of throwing. His right leg is firmly supported and the left leg has just given an upward and forward impetus to the rotating motion that is about to occur in the rib cage and shoulder girdle.

In the arm on the left, the great weight of the rock presses down along the humerus (A) to its insertion in the scapula (B). The superior angle of the scapula (C), and its overlying supraspinatus muscle, are thrust out against the supporting trapezius (D).

Follow the edge of the latissimus dorsi (E) with your pencil. Its strong fibers envelop the inferior angle of the scapula (F) and the finger-like serratus anterior (G). Then it outlines the side of the rib cage (H), and moves into its origin at the high point (I) and posterior third of the iliac crest, and the lower six thoracic vertebrae (J).

The line of insertion (K) of the fleshy fibers of the latissimus dorsi marks the border of its aponeurotic triangle and bulging spinal muscles (L). On the right, Fuseli has united the longissimus dorsi (M) and the exaggerated mass of the serratus posterior inferior (N) from under the latissimus dorsi. The strong plane break at the side of the latissimus dorsi (O) draws our attention to the action of its inferior fibers in helping to pull down the shoulder and the humerus. Together with the rotation of the rib cage and the force of gravity, the latissimus dorsi will join the pectoralis major and the posterior deltoid (P) in flinging the humerus, the upper arm, and the rock down to the right.

Carry on your study of anatomy at places like the athletic field, the gym, and the basketball court, where you can freely observe, sketch, and analyze similar actions of the body.

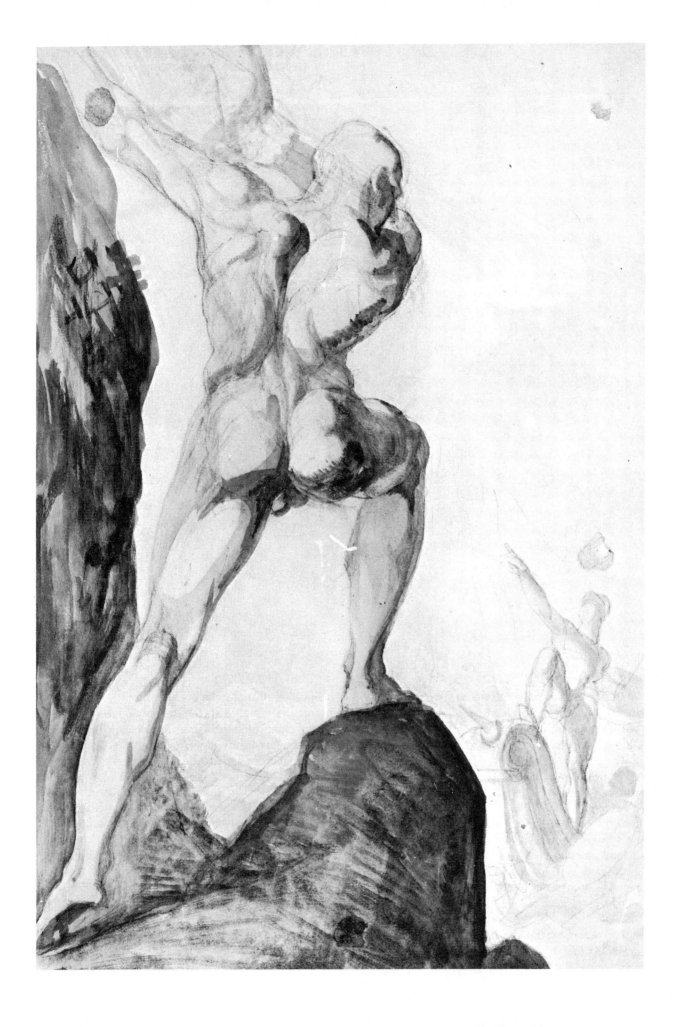

Michelangelo Buonarotti (1475-1564)
STUDY OF THE NUDE YOUTH OVER THE PROPHET DANIEL
FOR THE SISTINE CHAPEL CEILING
red chalk
13 3/16" x 9 3/16" (335 x 233 mm)
Gift in memory of Henry G. Dalton by his nephews
George S. Kendrick and Harry D. Kendrick
Cleveland Museum of Art

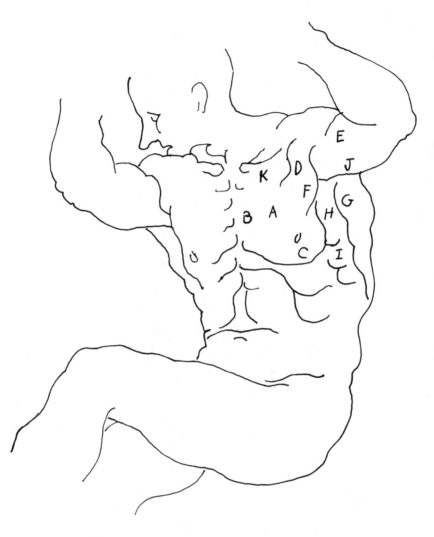

Pectoralis Major

When the arm is raised above the head, as in Michelangelo's drawing, we clearly see the changes that take place in the form of the pectoralis (A) as it follows the movement of the arm and shoulder girdle.

The lower portion of the pectoralis (A) converges from its origin in the sternum (B) and lateral surface of the fourth and fifth ribs (C) to a tendon that moves over the pectoralis minor (D), to its insertion in the upper humerus bone (E). The pectoralis acts in downward and forward movements of the arm. The edge of this vertically elongated pectoralis (F), together with the front edge of the latissimus dorsi (G), the side of the thorax (H), the serratus anterior (I), and the inner arm (J), give us a clear outline of the walls of the armpit or axilla.

The upper pectoralis (K), by its origin in the clavicle, connects to the shoulder girdle. The action of

this portion of the pectoralis varies with the position of the arm. When the arm is down, it gives you the hunching motion of the shoulders. When the arm is horizontal, as in this drawing, it acts as an adductor, carrying the arm in and to the front. As the arm is raised above the horizontal, which the right arm here is approaching, the line of pull of the upper clavicular fibers of the pectoralis shifts above the center of the shoulder joint, and these fibers cease to adduct and instead become abductors of the humerus.

The basis of muscular function is the ability of fibers to contract, shorten, and to pull the bones. Direction of bone movement is influenced by the relation of the line of pull of the muscle to the joint structure. The great masters understood bodily function, and when we study them closely, we can see how they applied this knowledge to their drawings.

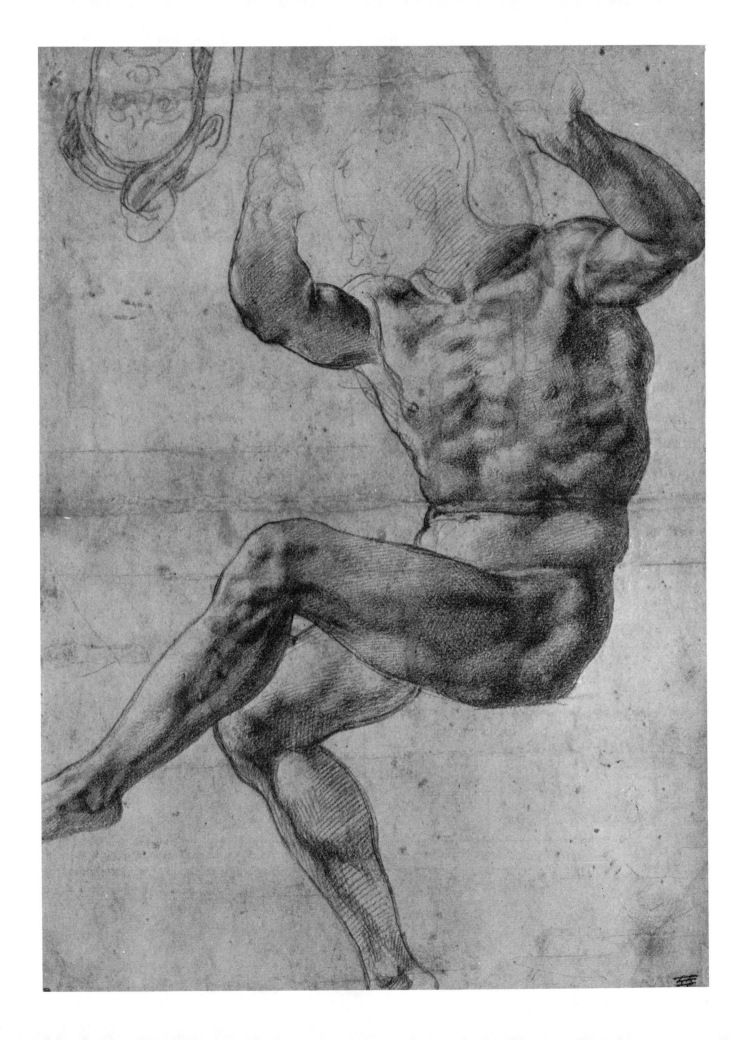

Jacopo Pontormo (1494-1556)
NUDE STUDIES
red chalk heightened with white
16" x 8 7/8" (406 x 225 mm)
Pierpont Morgan Library, New York

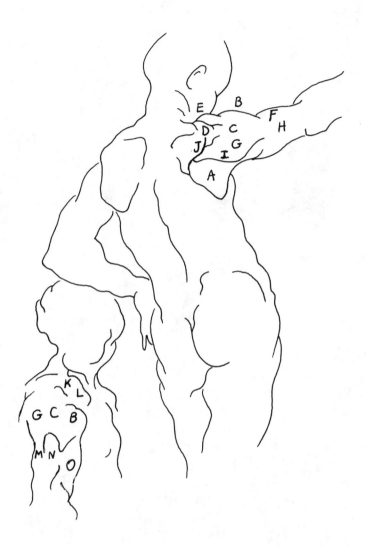

Deltoid

The complex structure of the triangular-shaped deltoid, together with the arrangement of its fibers and attachments, gives it a potential for great strength without undue bulk.

In Pontormo's drawing, the arm of the figure on the right is raised just above the horizontal. The action of raising the arm (or the abduction of the humerus) is carried out by the entire deltoid muscle, up to shoulder level. Above this, any upward motion is due to rotation of the scapula (A). Forward movement or medial rotation is aided by the anterior portion (B) of the deltoid. With two little lines, Pontormo shows the middle portion (C) going to its origin in the acromion process (D) of the scapula. The line of the anterior portion (E) of the deltoid goes inward behind the mass of the acromion process (D) to its origin in the outer third of the clavicle. The outward movement of this line of the deltoid curves in front of the biceps (F) to meet the fibers of the middle (C) and the posterior (G) portions of the deltoid, to insert about halfway along the humerus (H).

The posterior portion of the deltoid (G) helps the backward extension and rotation of the arm. A shaded line (I) points to the origin of this posterior portion in the spine of the scapula (J).

In the figure at the lower left, follow Pontormo's structural clues that describe the deltoid. Note the acromion process (K) and origin of the mid-portion (C); the clavicle (L) and origin of the anterior portion (B); and the curve of the posterior deltoid (G) moving in over both the long (M) and lateral (N) heads of the triceps, joining the middle (C) and anterior (B) fibers of the deltoid to go between the triceps and the lateral head of the biceps (O), and going on to its insertion in the humerus. You will find such anatomical shorthand throughout the works of the great masters.

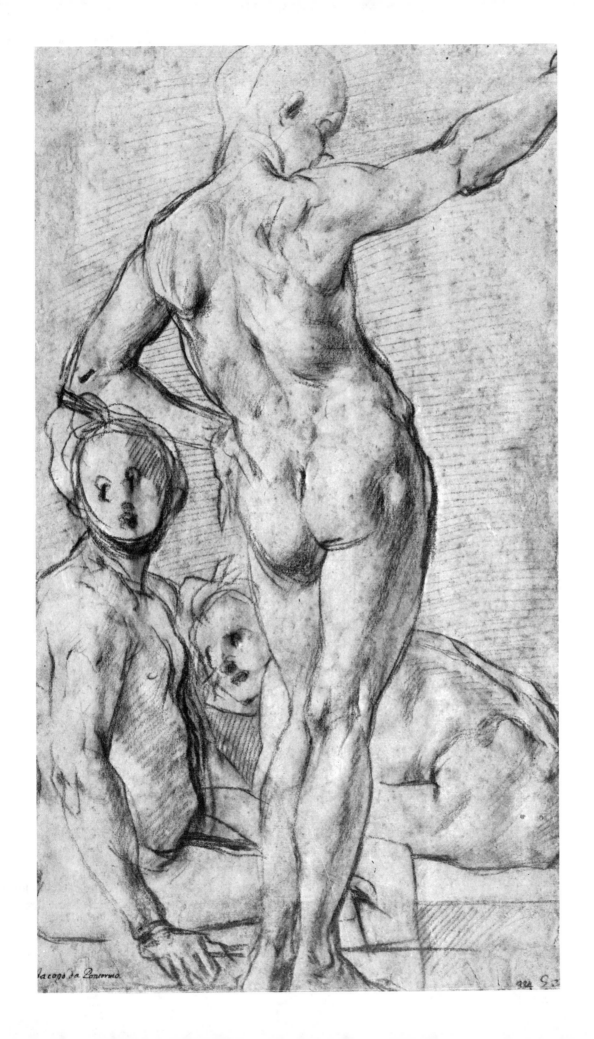

Iacopo da Pontormo.

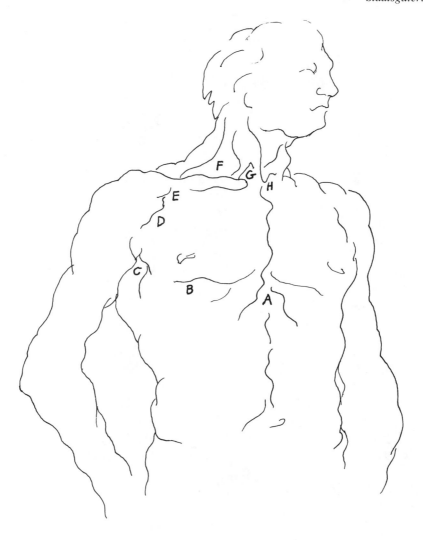

Giovanni Battista Tiepolo (1696-1770)
NUDE STUDY
red and white chalk on tinted paper
10 5/8" x 7 1/4" (270 x 185 mm)
Staatsgalerie, Stuttgart

Landmarks, Anterior Aspect

When studying anatomy, you may be confused by the many different names used for the same bony or muscular landmark. You are presented with layman's terms, teacher's pet names, descriptive terms of origin, insertion, function, terms in English, Latin names, and complicated medical terminology. Until you can sort out and utilize the terms that are most useful and meaningful to you, you may find it easier to see these landmarks in terms of their relationships to each other.

In this fine example by Tiepolo, notice the overall direction formed by the position of the landmarks. They form a rough fanlike circle of protrusions, hollows, and folds in the upper body. Beginning with the handle of the fan at the base of the sternum, this mass of synonymous names may be organized into an easily remembered circle as follows:

A. Base of sternum, pit of stomach, infrasternal notch, epigastric depression

B. Inframammary furrow

C. Armpit, axillary fold, axilla

D. Deltoid furrow, delpectoral line

E. Infraclavicular fosset

F. Salt box, supraclavicular fosset, posterior triangle of neck

G. Sternoclavicular fosset

H. Pit of neck, suprasternal notch, jugular notch

Upon observing such an arrangement, you might then notice the variations of values, shapes, sizes, and directions of each landmark in relation to the direction of the light and the model's individual structure. You may also consider the relationships of scale, balance, harmony, and unity that Tiepolo gave to these landmarks and begin to apply them to your own drawings.

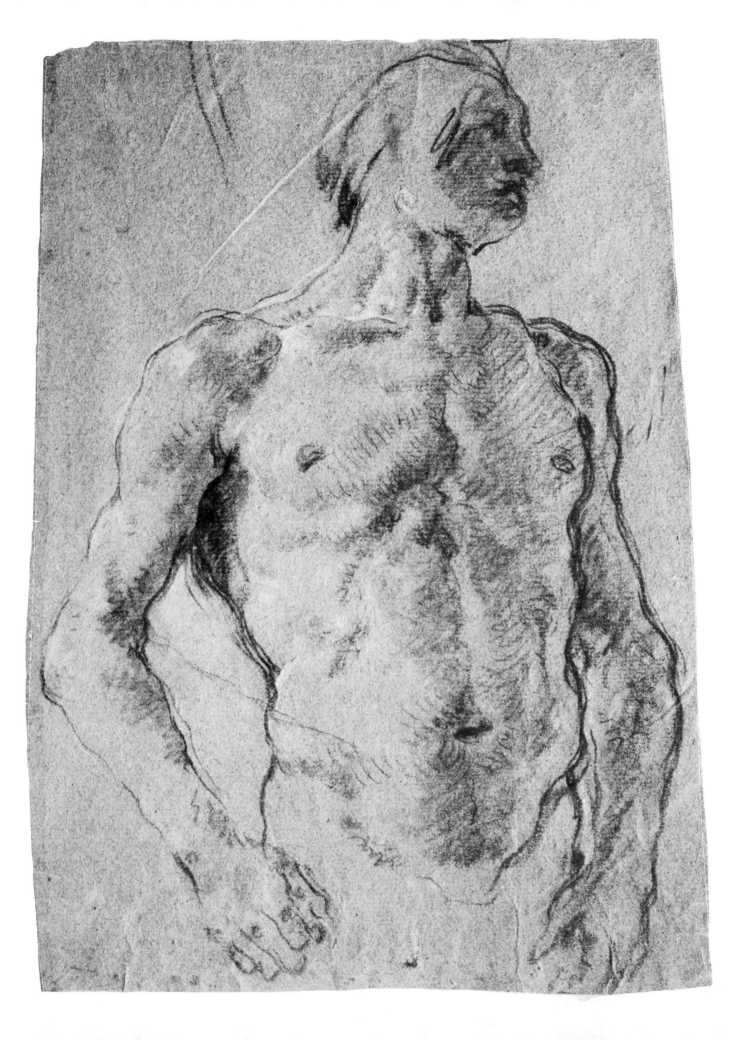

Raphael Sanzio (1483-1520)
FIVE NUDE MEN
pen and ink
10 5/8" x 7 3/4" (269 x 197 mm)
British Museum, London

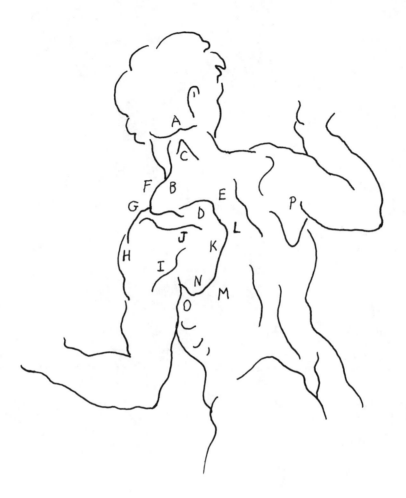

Landmarks, Posterior Aspect

Let us see how Raphael handles the posterior landmarks of the shoulder girdle and how the changing positions of the arm can affect these forms.

Follow the upper trapezius (B) downward from its origin in the superior curved line of the occipital protuberance (A). Protruding from beneath the trapezius, a little triangle indicates the levator anguli scapulae (C) at work in raising (as its name implies) the upper angle of the scapula (D). The middle part of the trapezius (E) covers this area of the scapula and the supraspinatus that originates there.

The outside curve of the trapezius (F) is interrupted by the prominence of the outer clavicle or collarbone (G), site of the acromioclavicular joint. The curve is picked up again by the outline of the middle portion of the deltoid (H).

Now follow the shaded lines of the posterior deltoid (I) to the hatchings along the spine of the scapula (J). The varied forms and relationships of Raphael's marks show his total awareness of the forms of the shoulder girdle: the vertebral border of the scapula (K), the rhomboids (L) over the spinal muscles, the latissimus dorsi (M) holding in the inferior angle of the scapula (N), and the hatchings at the side of the teres major (O) and the infraspinatus (P).

Observe and compare the changes in Raphael's drawings from the simple surface markings of the shoulder girdle in the drawing at the lower right, where the arms are moved forward, to the more complex forms in the drawing on the left, where the arms are back.

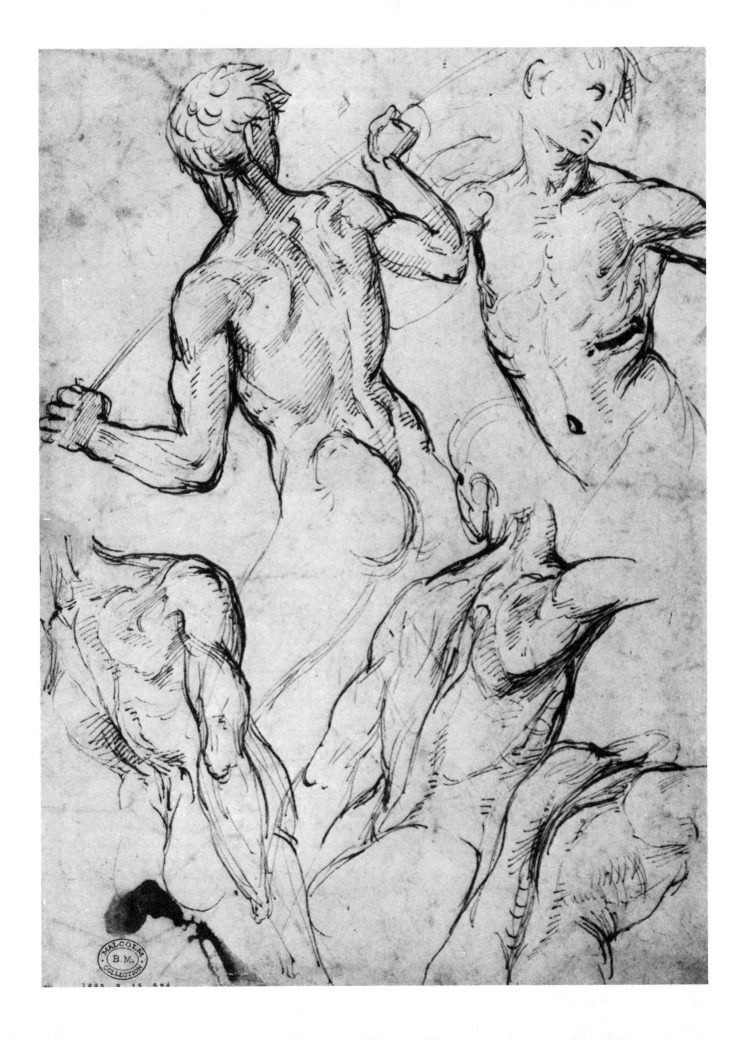

Michelangelo Buonarotti (1475-1564)
STUDY FOR A PIETÀ
black chalk
10" x 12 1/2" (254 x 318 mm)
Louvre, Paris

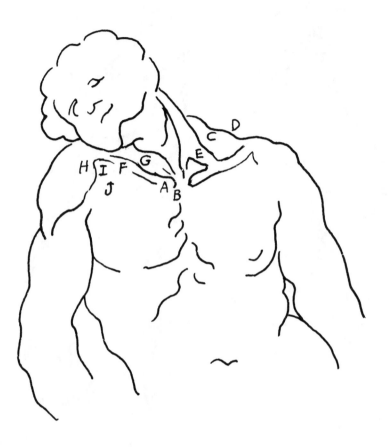

Sternoclavicular Articulation, Elevation and Lowering

The sternoclavicular joint is the center from which all movements of the shoulder girdle originate and is its only bony connection with the rib cage. This joint is made up of the inner end of the clavicle (A), on the one hand, and the upper lateral part of the manubrium (B), the upper bone on the sternum, on the other hand. Strong ligaments hold the inner end of this swinging spiral clavicle to its base in the sternum of the rib cage.

Normally, the sternoclavicular joint is active to some degree in all movements of the arm, as is the acromioclavicular joint. But the greatest movement of the sternoclavicular joint occurs in the first ninety degrees of upward movement of the arm.

In this drawing, the shoulders are hunched, as in shrugging, in order to meet and support the laterally inclined head. In this action, the clavicle in the front and the scapula behind are elevated upon the rib cage by the levator anguli scapulae(C) and the upper trapezius (D) in the back, and by the clavicular head of the sternocleidomastoid muscle (E) in the front. This upward shift of the shoulder girdle is followed from the sternoclavicular joint by upward movement of the clavicle.

Michelangelo has clearly indicated many anterior surface changes. On the left, as the upper clavicle (F) moves upward to the sternocleidomastoideus and the side of the neck, the posterior triangle of the neck (G) all but disappears. As the shoulder is raised, the anterior portion of the deltoid (H) presses upward and inward, the infraclavicular fosset (the space between the pectoralis and the deltoid) (I) deepens, and the shape of the pectoralis (J) elongates.

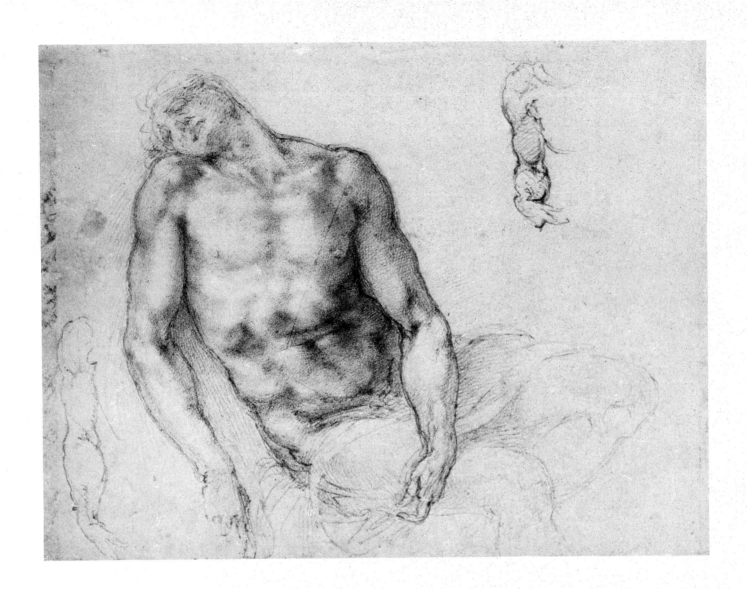

Michelangelo Buonarotti (1475-1564)
STUDY OF ST. LAWRENCE FOR *THE LAST JUDGMENT*
black chalk
9 1/2" x 7 1/4" (242 x 183 mm)
Teyler Museum, Haarlem

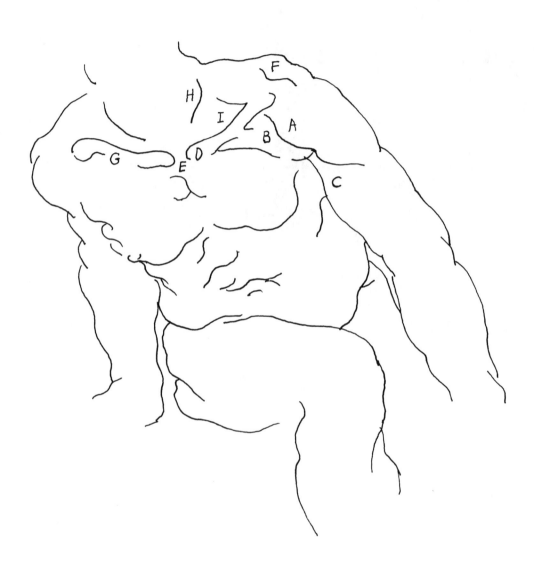

Sternoclavicular Articulation, Forward and Back

Forward elevation or flexion of the arm takes place by the synchronous action of the parts of the shoulder girdle. The action is initiated by the contractions of the anterior portion of the deltoid (A) and the clavicular portion of the pectoralis major (B), with some participation of the coracobrachialis and the biceps (C).

As the arm is moved from the side to the front of the body, the clavicle (D) rotates upward on its long axis from the sternoclavicular joint (E), and the acromion process (F) and the scapula follow. The convex curve of the inner clavicle (G) permits this bone some freedom in its limited movements over the contour of the rib cage beneath. As the clavicle moves away from the sternocleidomastoid (H) and the column of the neck, which occurs when the arm is thrust forward, the posterior triangle of the neck (I) deepens and the angle formed by the spine of the scapula and the clavicle is diminished.

Michelangelo knew that the inside end of the clavicle at the sternoclavicular joint (E) is less prominent when the shoulder is moved forward, so he emphasized the adjacent muscles instead.

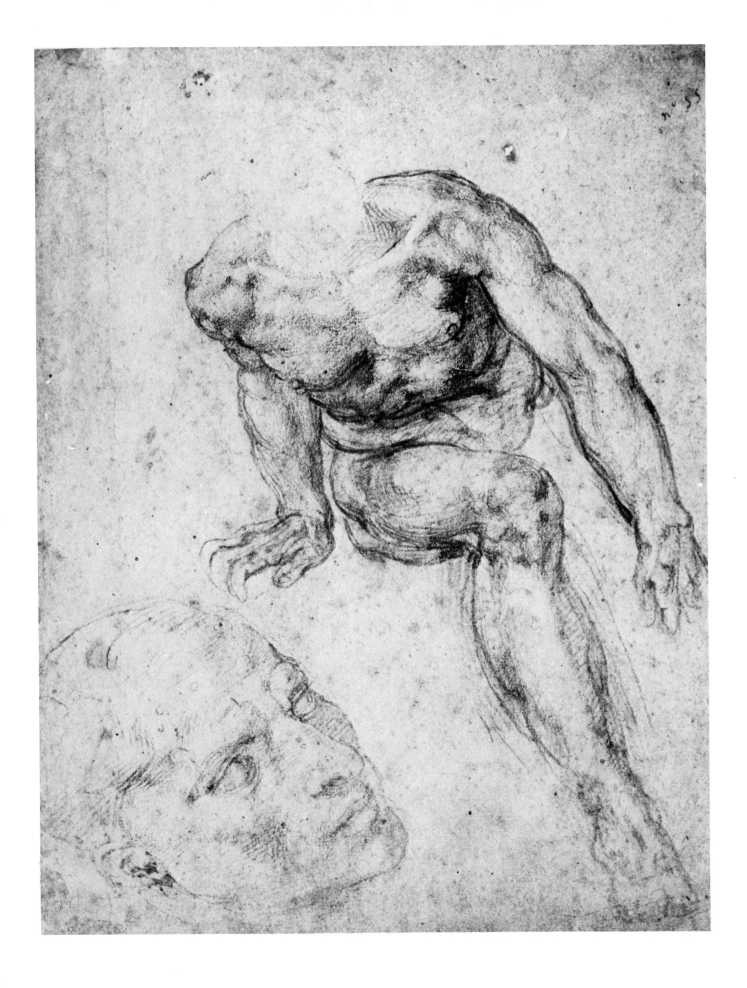

Michelangelo Buonarotti (1475-1564)
STUDY FOR THE NUDE AT RIGHT
ABOVE THE PERSIAN SIBYL
red chalk
11" x 8 1/8" (278 x 211 mm)
Teyler Museum, Haarlem

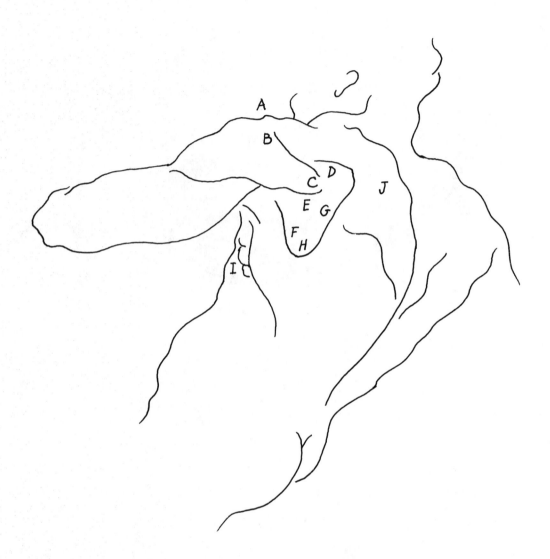

Acromioclavicular Articulation, Forward and Back

The acromioclavicular joint, where the clavicle meets the acromion process of the scapula, is active in nearly all movements of the shoulder girdle and contributes to its great mobility.

You can find this important joint of the shoulder girdle by the projection of the enlarged outer end of the clavicle (A) as it rises slightly above the acromion process of the spine (B) of the scapula.

You can find the line of the spine of the scapula by drawing a spiral line between the bulge (A) at its outer and upper end to the inner end of the origin of the posterior portion (C) of the deltoid. If you follow the edge of the bulging muscular masses of the supraspinatus (D), infraspinatus (E), and teres major (F), all of which originate in the scapula, you will find the inner or vertebral border of the scapula (G). The inferior or lower border of the scapula (H) is being pulled forward by the lower and stronger fibers of the serratus anterior (I), several fingerlike digitations of which are visible. From its insertion in the spine of the scapula, the middle portion of the trapezius (J) assists by inward and upward action to lift the shoulder. The scapula tilts on its vertical axis and follows the movement of the arm.

By way of the acromioclavicular joint (A) and its connection with the clavicle, the scapula acts as an adjustable base or platform for the humerus of the arm and, at the same time, takes part in the movement of the whole shoulder girdle.

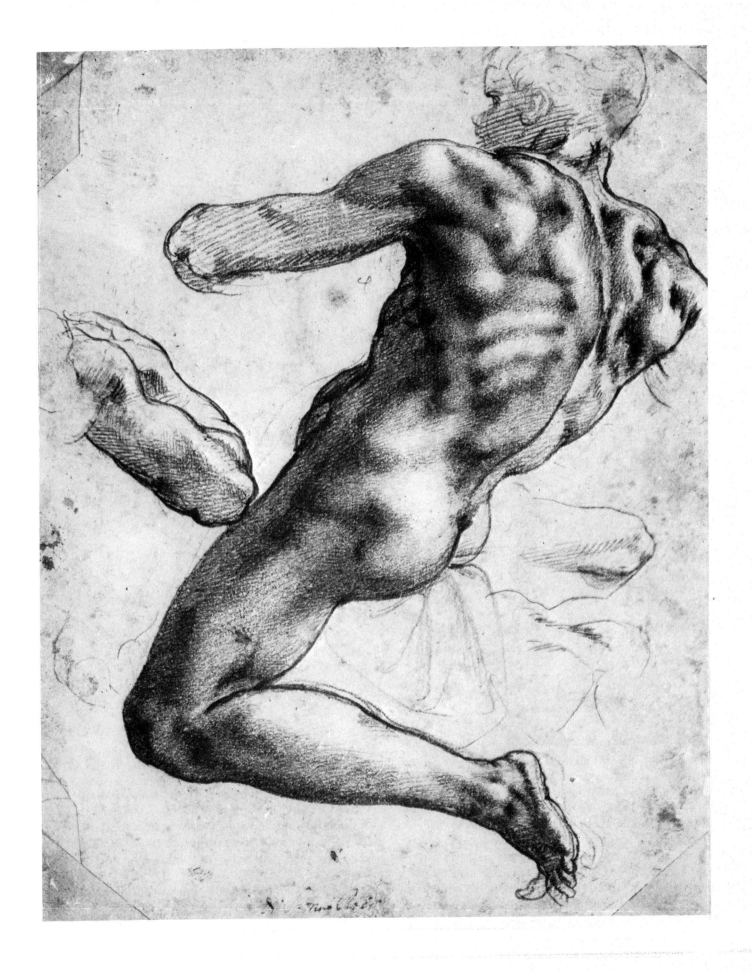

Raphael Sanzio (1483-1520)
NUDE MAN BETWEEN TWO FEMALES
pen and ink
11 1/2" x 8 1/2" (290 x 215 mm)
Musée Bonnat, Bayonne

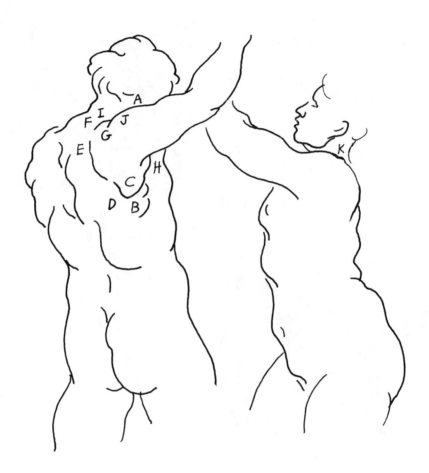

Acromioclavicular Articulation, Up and Down

Elevation of the arm above the horizontal level calls for increased activity at the acromioclavicular joint (G). The deltoid (A) has reached its limit of upward action in lifting the arm to the horizontal level. As the arm is raised, the lower fibers of the serratus anterior (B) draw the inferior angle of the scapula (C) to the front of the body, along the wall of the rib cage. This tilts the scapula upward, placing the shoulder joint in a better position to raise the arm higher.

The scapula is held against the ribs by the serratus (B), the latissimus dorsi (D), and by the trapezius (E). The middle (E) and upper (F) fibers of the trapezius aid the upward movement of the shoulder. The acromion process of the scapula (G) swings in an arc around the upward-moving clavicle to accommodate this strong elevation of the arm. This is accompanied by the external rotation of the humerus. The forward or flexion movement of the arm is carried out by the pectoralis major (H) and by the anterior portion of the deltoid (A).

The acromion process (G) is pointed to by a bony groove into which the trapezius (I) dips and inserts on one side, and the deltoid (J) originates on the other. The projection of the enlarged outer end of the clavicle above the acromion process is shown as just a bump (K).

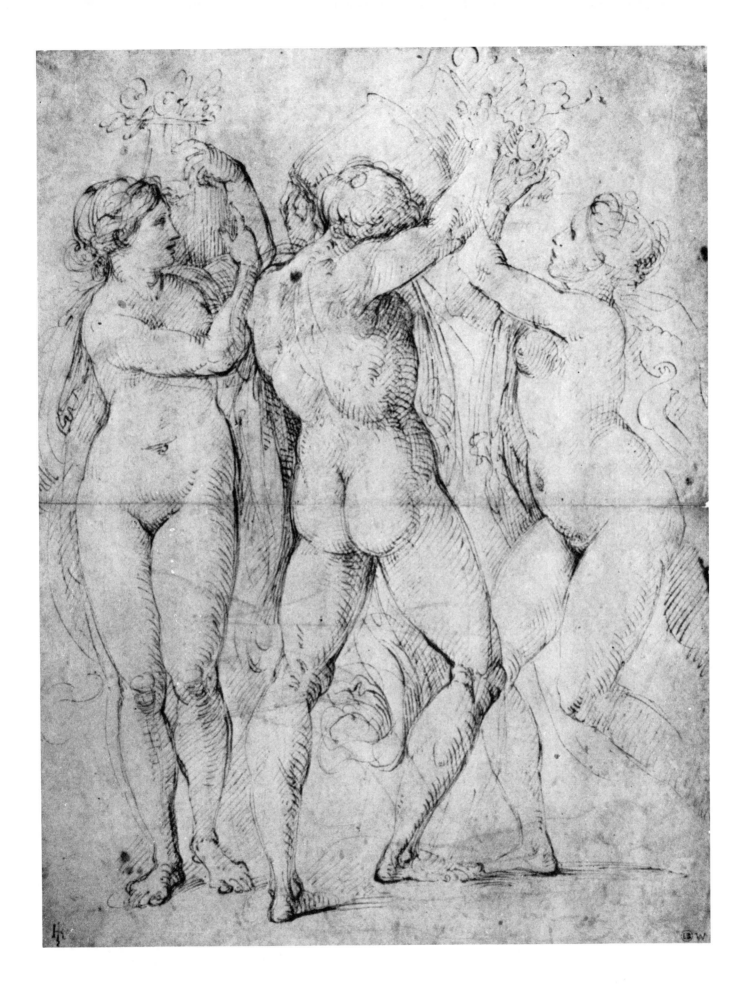

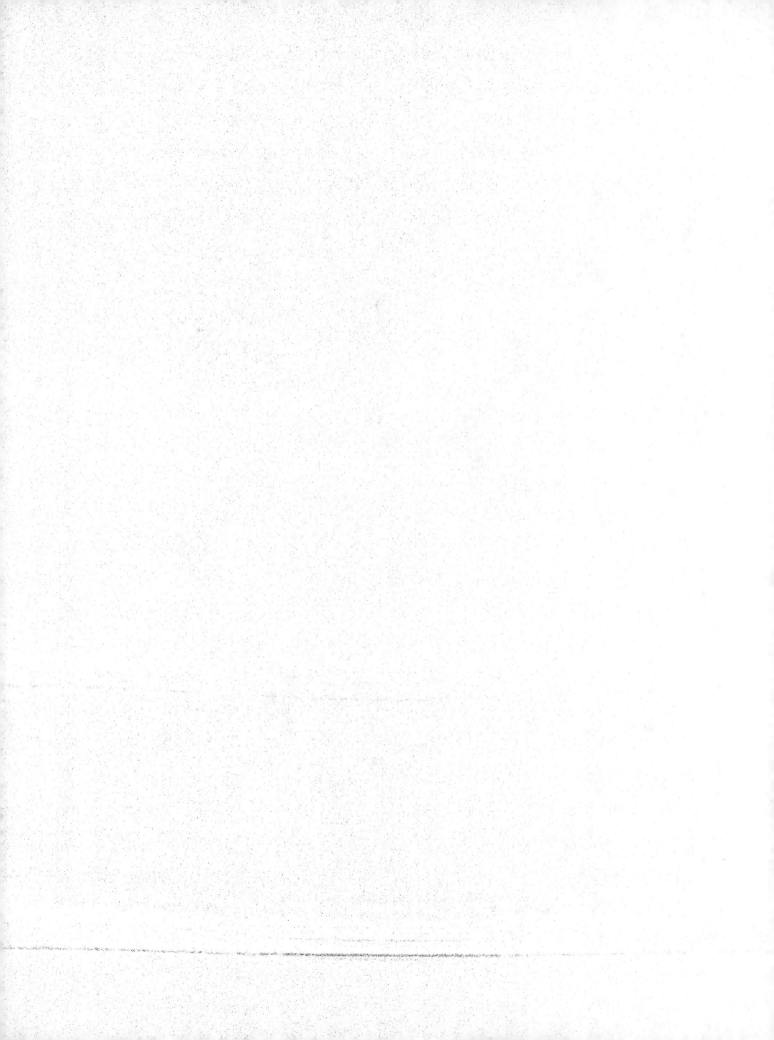

6

THE ARM

Andrea del Sarto (1486-1531)
STUDY OF ST. JOHN THE BAPTIST
FOR *BAPTISM OF THE MULTITUDE*
red chalk
Felton Bequest, 1936
National Gallery of Victoria, Melbourne

Axilla, Arm in Flexion

When the arm moves forward, away from the body, in a movement known as "flexion," a small portion of the hollow under the arm becomes visible. This is the axilla or armpit, where the arm emerges from the trunk.

This pyramidal area is partly formed by the muscles that pass from the trunk to the humerus bone of the arm. The posterior fold or wall of the armpit is formed by the latissimus dorsi (A) and the teres major (B). They go from their origins in the pelvic and shoulder girdles, respectively, to insert (C,D) in the humerus bone. In this view, the hollow of the armpit is concealed by the long head of the triceps (E). You can also see the serrations of the serratus anterior (F) that, with the rib cage, form the inner wall of the axilla. The edge of the pectoralis major (G), which forms its anterior or front wall, is just barely visible beneath the triceps.

Notice the contour lines of the latissimus dorsi (A), teres major (B), the infraspinatus (H), and the posterior (I) and middle (J) portions of the deltoid. Their lines converge as lines and wedgelike pointers from their inner bases to the outstretched arm. You can easily follow the rhythmical flow of these transitions of line and mass from the trunk to the arm.

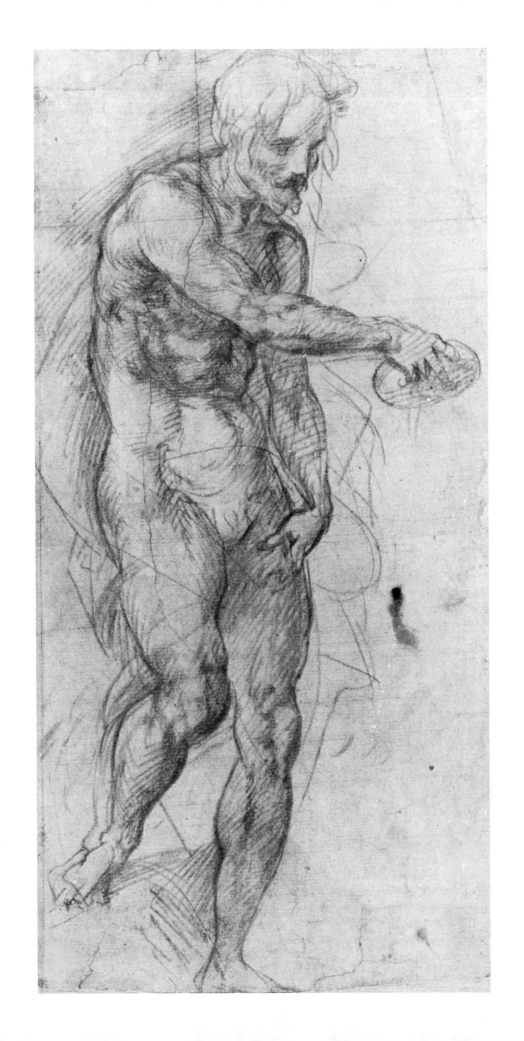

Rembrandt van Rijn (1606-1669)
STUDY OF A NUDE
pen and brush with bistre wash on brown paper
9 1/8" x 7 1/8" (233 x 178 mm)
Collection of Tiffany and Margaret Blake
Art Institute of Chicago

Axilla, Arm in Vertical Elevation

The shape and size of the axilla, or armpit, varies with each movement of the arm. In this figure by Rembrandt, with the arm raised above the head, we see more of the hollow of the armpit.

The masses of the teres major (A) and the latissimus dorsi (B) constitute the posterior wall of the axilla and conceal the medial wall (C). Two little oblique lines, called the anterior furrow, separate the masses of pectoralis major (D) from the latissimus dorsi (B). This furrow twists around the coracobrachialis (E) and follows the edge of the pectoralis major (F) which

forms the anterior wall of the armpit.

Students often make use of memory devices. Scottish medical students use one to learn the placement and order of muscles about the axilla from back to front. The sounds of the first syllables of the names of the muscles are made into a sentence: *tri*ceps, *tere*s major, *lat*issimus dorsi, *cor*ocobrachialis, *bi*ceps, *pec*toralis, which is read as, "Try to let corbie pet." "Corbie" is Scottish for "crow." This is an imaginative use of positional order that, when combined with a word order, creates an easily remembered mental image.

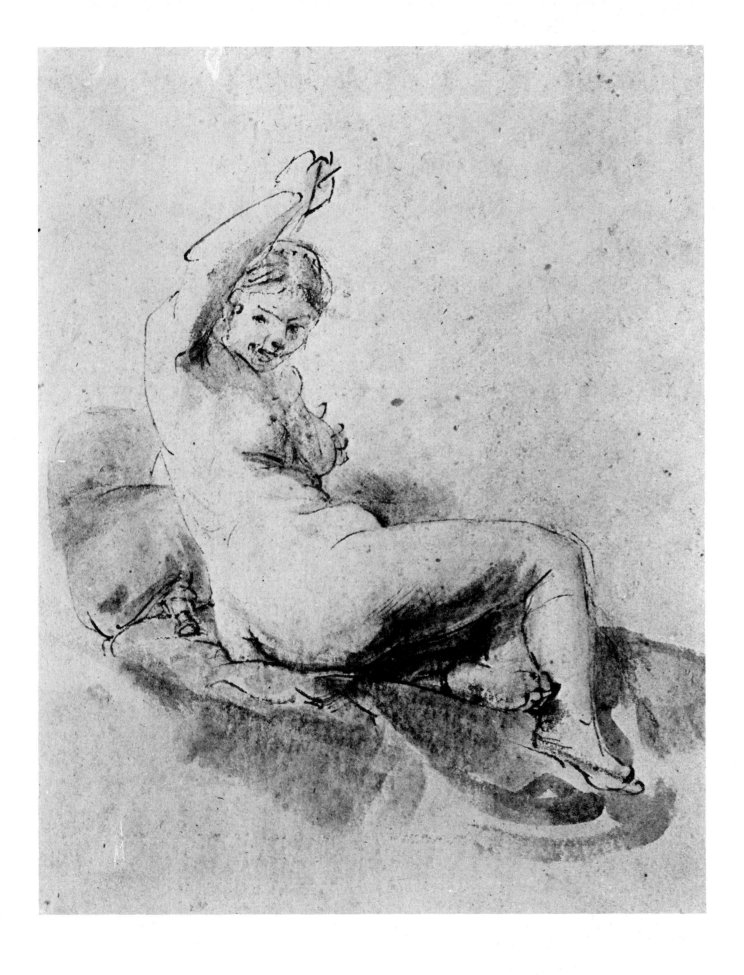

Jacopo Pontormo (1494-1556)
STUDY OF FIGURES
black and red pencil blended on white paper
8" x 6 1/4" (204 x 158 mm)
Uffizi, Florence

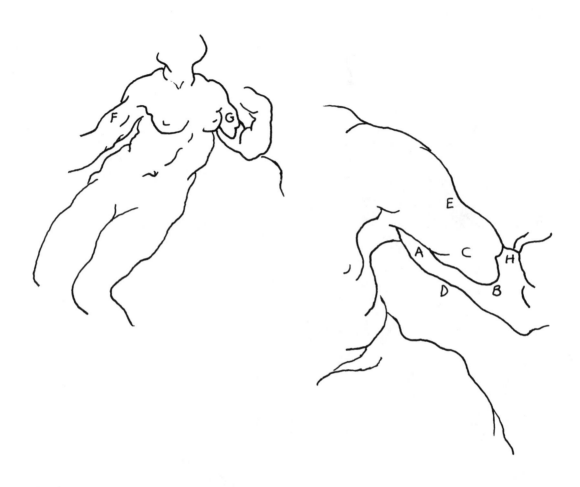

Biceps Brachii, Anterior Aspect

The fleshy masses of the upper arm lie along both sides of the humerus, the bone of the upper arm. From its ball and socket joint in the shoulder blade, the humerus extends downward about two shoulder blade or sternum lengths. Its upper cylindrical shaft curves slightly to accommodate the rib cage. Its lower end is flattened and widened into two condyles, which receive the radius and ulna at the elbow.

Two muscles help fill out the inside of the arm in the figure on the right: the coracobrachialis (A) and the brachialis (B), both of which lie in the groove between the short or inner head of the biceps (C), and the medial head of the triceps (D). The long outer (E) and short (C) heads of the biceps lie upon the brachialis (B) or "pillow muscle" below.

Together with the coracobrachialis (A) and brachialis (B), the biceps flex the forearm. These muscles bulge when they contract, becoming shorter and thicker as they pull upon the radius bone of the forearm when the elbow is bent. In the drawing, compare the surface changes of the biceps during its different phases: from its relaxed extension position (F), to its flexion at right angle (G).

Observation and knowledge of anatomical structure can help you to harmonize the breaks between forms when you draw the body. For example, the small curved plane created by the tendon of the biceps (H) as it inserts into the forearm, softens the right angle between upper arm and forearm. As another example, the distinct separation and varied lengths of the long (E) and short (C) heads of the biceps adds an interesting contrast of size and shape to these two masses, as they move between scapula and radius.

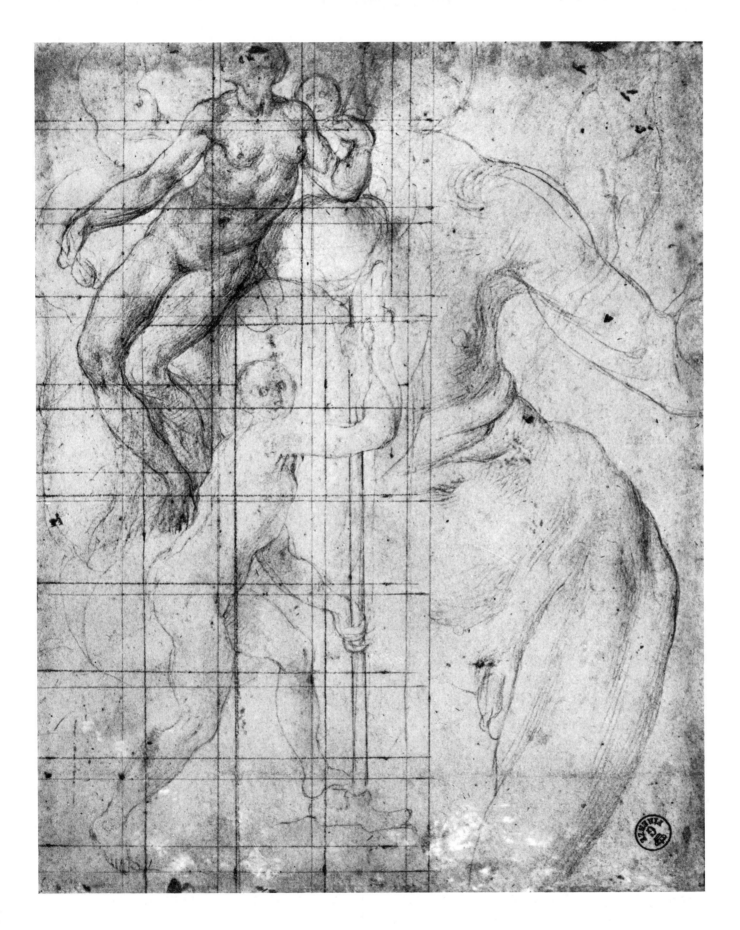

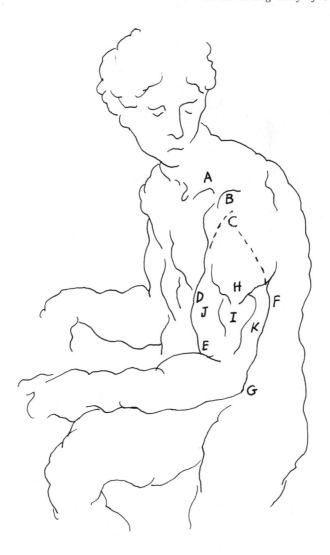

Biceps Brachii, Lateral Aspect

Function creates form. The form of the fish allows it to flow easily through water, maneuvering like an airfoil. The limbs of a running animal must move clear of the body, so the curve of the humerus bone performs a practical function. In man, the dominant muscular masses of the upper arm follow the slightly curving shape of the humerus beneath.

Draw the muscles of the upper arm from their origins in the bone of the shoulder to their insertion in the bones of the lower arm. First locate the bump of the outer edge of the clavicle (A). This leads you to the summit of the shoulder (B) and the acromioclavicular joint, where the clavicle rises above the acromion process of the scapula. The acromion process, in turn, hovers protectively over the glenoid cavity (C), which holds the head of the humerus. The rounded highlight on the deltoid reflects the head of the humerus below

that fits into this cavity. Put your pencil at the top of the glenoid cavity (C) and follow the edge of the long head of the biceps (D) to its inserting tendon (E) in the radius. Now place your pencil at the bottom of the glenoid cavity (C) and move it down to the outside contour line of the triceps (F). Follow the triceps to its insertion in the olecranon process of the ulna (G).

Observe in particular the mass of the deltoid (H) as it moves into the groove between the biceps and triceps enroute to its insertion. There it goes between the fibers of the brachialis (I), and bulges with the biceps as it helps flex the arm. Tintoretto has placed the highlight (J) and the strong dark (K) of the big cylinder of the arm well away from the groove of the brachialis (I), which forms a line between biceps and triceps. He thus makes certain that the mass conception (of the arm as a cylinder) dominates over the individual forms.

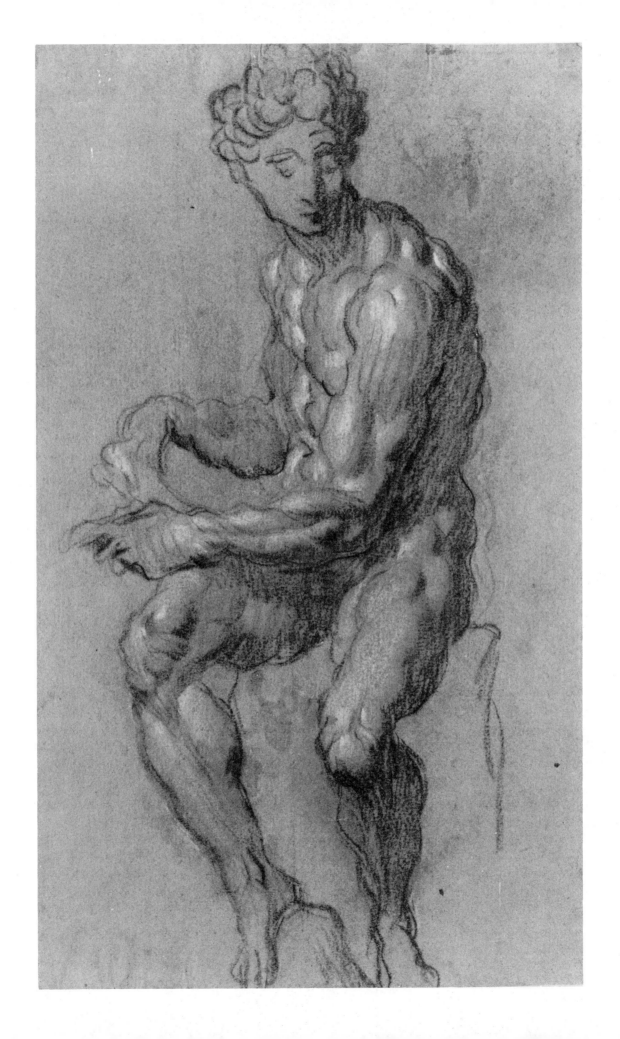

Jacopo Tintoretto (1518-1594)
STUDY OF A STATUE OF ATLANTIS
black chalk heightened with white, on blue paper
10 11/16" x 7 1/8" (268 x 181 mm)
Museum Boymans-van Beuningen, Rotterdam

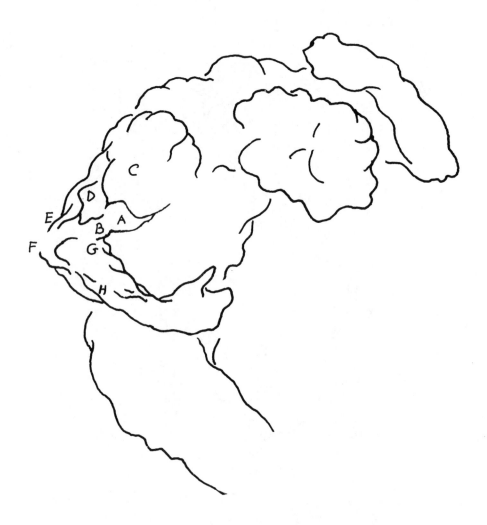

Flexion

Flexion or bending of the forearm upon the upper arm is carried out by the biceps brachii (A) and the brachialis anticus (B). At rest, when the arm hangs limply at the elbow, the biceps is a long, tapered, cylindrical shape. Here, Tintoretto shows it contracting to flex the forearm upon the upper arm. He renders it short and globular-shaped, with its maximum thickness front to back, at about the middle of the upper arm. The upper portion of the biceps is covered by the deltoid (C), which moves into the intermuscular groove between the triceps (D) and the biceps (A).

The triceps muscle is the antagonist to the biceps. The biceps flexes or bends the arm and the triceps bulges slightly in counterbalancing resistance.

The flexed elbow stretches the common tendon of the triceps (E) from mid-arm to its insertion into the posterior and superior part of the olecranon process (F). The flat surface of the tendon is distinct from the swelling fleshy heads of the surrounding muscles.

Tintoretto knows that the upper back of the olecranon process (F) of the ulna forms the tip of the elbow, and that it becomes very prominent when the arm is bent. Notice how he uses curved rather than flat lines around the point of the elbow, where ulna meets humerus.

The supinator mass (G) emerges from between triceps and brachialis, about one third of the way up the arm. When the radius crosses over the ulna, as it does here, it carries the supinator mass over these two underlying bones, widening the upper forearm. At the back of the lower arm, Tintoretto has emphasized the extensors (H), which contract synergetically, that is, working together as a counterbalance or mild opposition, when the wrist and fingers are flexed.

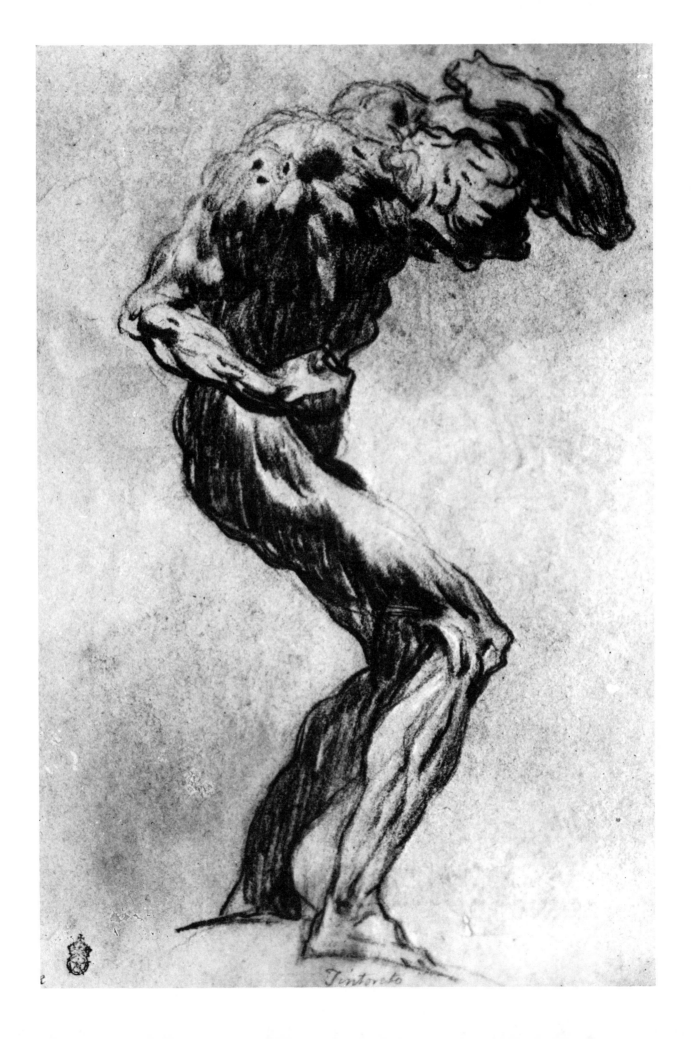

Tintoretto

Raphael Sanzio (1483-1520)
NUDE MAN SITTING ON STONE
black chalk
13 5/8" x 10 7/16" (345 x 265 mm)
Ashmolean Museum, Oxford

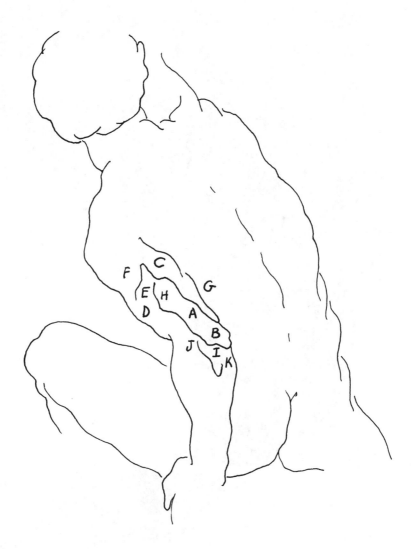

Triceps, Posterior Aspect

The triceps, virtually three muscles in one, covers the entire posterior surface of the upper arm. All three heads of this muscle are inserted through a large tendon (A) to the end of the olecranon process of the ulna (B).

The triceps is the chief extensor of the lower arm. Its long or middle head (C) crosses the shoulder joint from its origin in the humerus, and also aids the extension and adduction of the upper arm.

Just above the curve of the lateral head of the biceps (D), the mass of the outer head of the triceps (E) moves out from under the deltoid (F), where it originates in the upper lateral surface of the humerus. The inner head of the triceps (G) also arises from the humerus, but from the lower medial portion, so that it covers the entire posterior surface of the lower part of the bone.

A characteristic of the triceps, which becomes more prominent in extension, is its outward slanting line (H). There the rounded fibers of the muscle meet the long, low, flat plane of the common tendon.

If you see a side view of the insertion of the common tendon at the olecranon process of the ulna, you will see the small triangular relief of the anconeus (I). This little muscle fills the gap between the back of the lateral epicondyle of the humerus (J) where it originates, the outer border of the olecranon process, and the posterior surface of the ulna (K) into which it inserts. In extension of the forearm, the anconeus (I) initiates the action and stabilizes the elbow joint. When more strength is needed, the inner, outer, and then the long heads of the triceps must come into play.

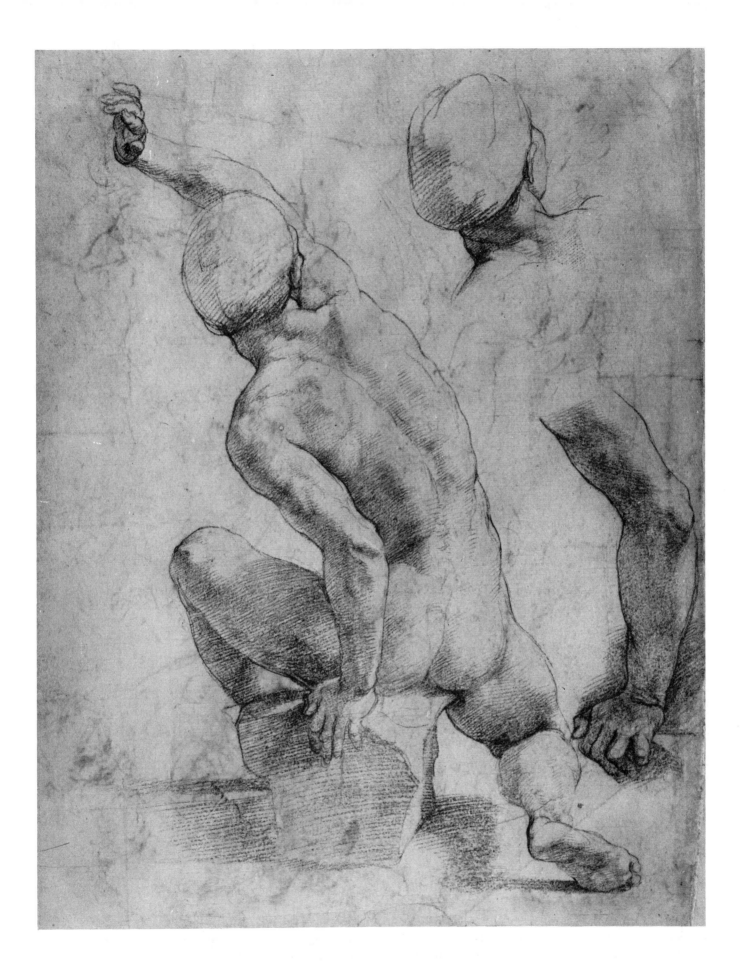

François Boucher (1703-1770)
RECLINING SATYR
charcoal heightened with white
19 11/16" x 15 3/8" (500 x 390 mm)
Woodner Family Collection II, New York

Triceps, Lateral and Medial Aspect

It helps to know that the big cylinder of the arm, seen from the side in this drawing by Boucher, might be broken up into the smaller cylinders of the outer head of the triceps (A) and the biceps (B). The downward end of the triangular bulb of the deltoid (C) plunges into the groove between these two cylinders to its insertion in the mid-humerus (D).

At about this midpoint in the upper arm, you can see a dip (E) in the outline of the triceps, where muscles meet tendon. It is through this long, flat, common tendon (F) of the triceps that its three heads are inserted into the olecranon process (G) of the ulna. In the upraised arm, you can see the furrow separat-

ing the long head (H) and the inner head (I) of the triceps.

The inner head (I) of the triceps might be compared to the brachialis (J), which is the workhorse of the flexors of the arm. The outer (A) and long (H) heads of the triceps are reserves in the action of extension, as the two heads of the biceps are reserves in the action of flexion. Different muscles of the body work together to complement each other's actions by steadying and supporting the dominant movement. The muscles also follow an order of action required by the demands imposed upon the body. This insures functional efficiency and conserves energy.

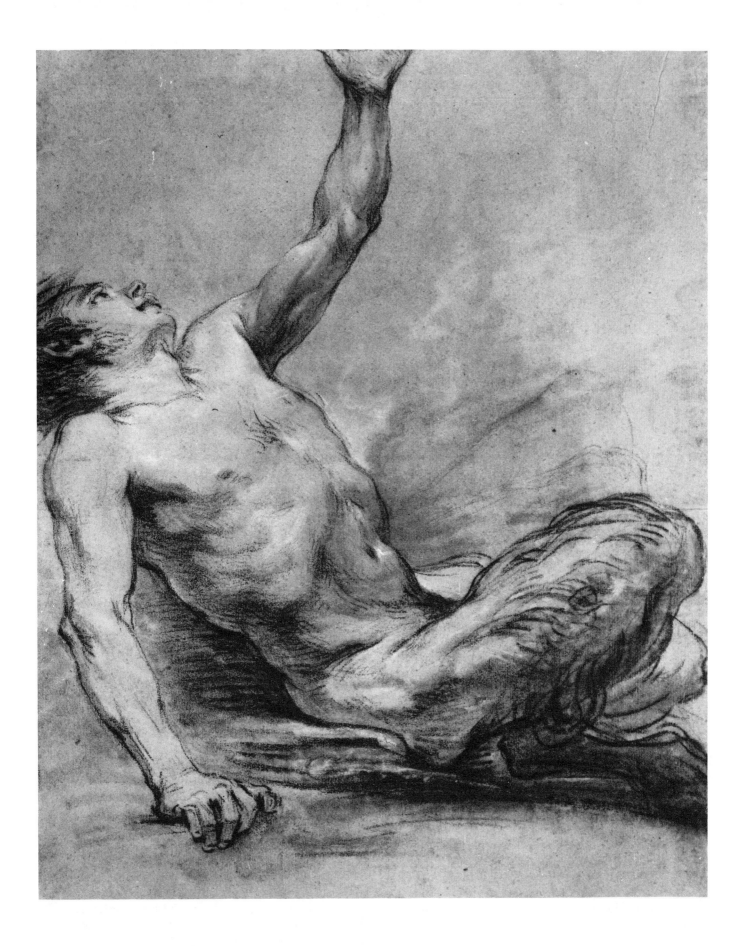

Luca Cambiaso (1527-1585)
CAIN AND ABEL
pen and wash drawing
11 1/4" x 6 1/4" (286 x 159 mm)
Woodner Family Collection I, New York

Extension

Extension is the opposite of, or antagonistic to, flexion. Its movements make the angles between joints larger rather than smaller. Extensions are straightening or stretching movements rather than bending movements. In this example, the fingers are extended upon the hand, the wrist is extended upon the forearm, and the lower arm is extended upon the upper arm. Extension of the forearm upon the upper arm is produced by the anconeus (A) and triceps brachii (B).

In this back view of the extended arm, you can see three knobs of bone at the elbow: the inner (C) and outer (D) condyles of the humerus, with the olecranon process (E) of the ulna between them (marked by the two little extension wrinkles). You can easily follow the direction of the ulna bone from the olecranon process (E) down to the ulnar furrow (F), which lies

between the flexors (G) and extensors (H), to its lower extremity in the styloid process (I) on the little finger side of the wrist.

Like many artists who reduce anatomical forms to simple geometrical shapes in order to clarify their direction in perspective, Cambiaso visualizes the arm and hand as a block or cube. He blocks in the hand simply, starting with the extension fold (J) of the annular ligament of the wrist. From there, the eye is led back into the picture, moving from volume to volume. From the radius (K) at the thumb side of the blocklike wrist, you move back along the mass of the extensor digitorum (L), to the suggestion of the extensor carpi radialis brevis (M), to the two overlapping muscles of the supinator mass (N) that invade the upper arm, and then to the biceps (O), which in turn overlaps the deltoid (P).

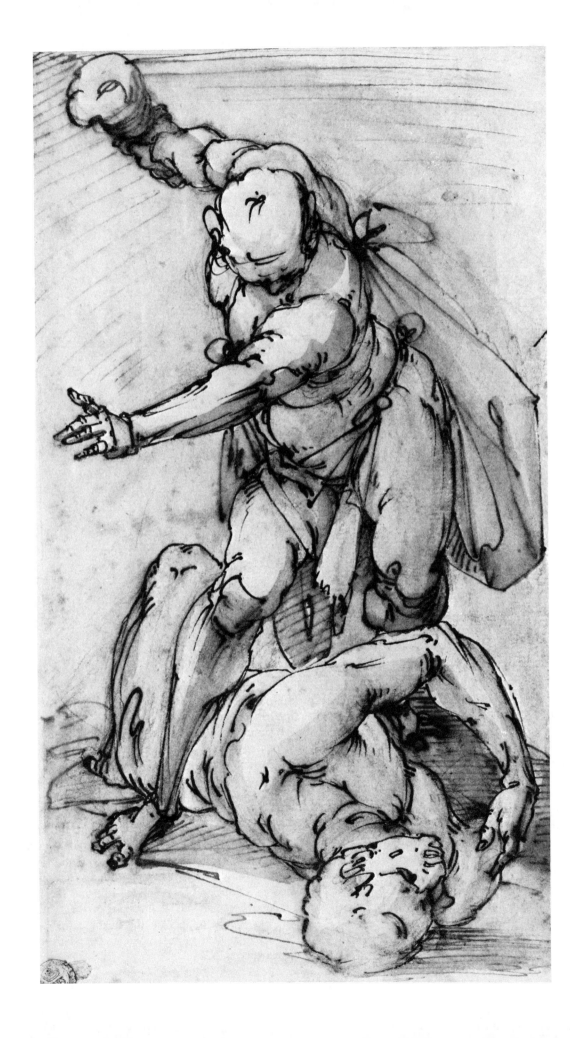

Albrecht Dürer (1471-1528)
THREE STUDIES FROM NATURE FOR ADAM'S HAND
engraving
8 1/2" x 10 13/16" (216 x 274 mm)
British Museum, London

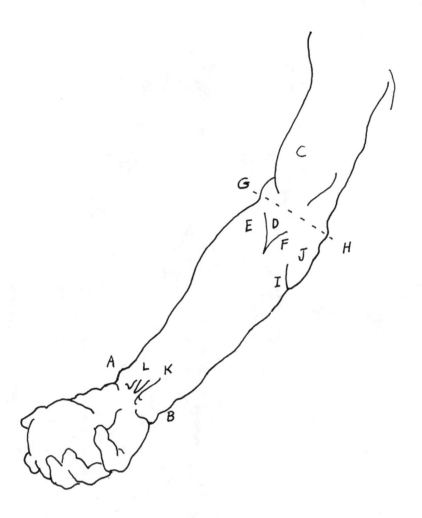

Lower Arm, Anterior Aspect

In Dürer's drawing, the arms of the two figures on the right are extended at the elbow, and in supination with the fingers flexed. In this anatomical position, the two bones of the forearm lie side by side. You can verify their position by locating and identifying the superficial landmarks made by them and the muscles that relate to them.

At the wrist, the styloid process of the radius (A) on the thumb side and the styloid process of the ulna (B) opposite give us the lower extremities of these two bones.

The biceps (C) overlook the front of the elbow joint, and the furrows on either side of this muscle converge to a triangular hollow (D) on the front of the elbow. This triangle points downward, its outer side bordered by the supinator mass (E), its inner side by the pronator teres (F), and its base determined by a line drawn between the exterior (G) and the interior (H) condyles of the humerus. This line is not at right angles to the axis of the upper arm, but is lower on the inside. The angle between the axis of the upper and lower arm is called the carrying angle.

By way of its aponeurotic tendon, the biceps produces a shallow oblique furrow (I) in the upper fleshy body of the flexor mass (J). The large forearm muscles—the supinator mass (E) on the outside and the flexor mass (J) on the inside—merge into narrow tendons midway between elbow and wrist. The flexor tendons of the palmaris longus (K) and the flexor carpi radialis (L) stand out at the base of the forearm. If you place your fingers on the flexor carpi radialis, you can feel the beat of the radial artery where the doctor takes your pulse.

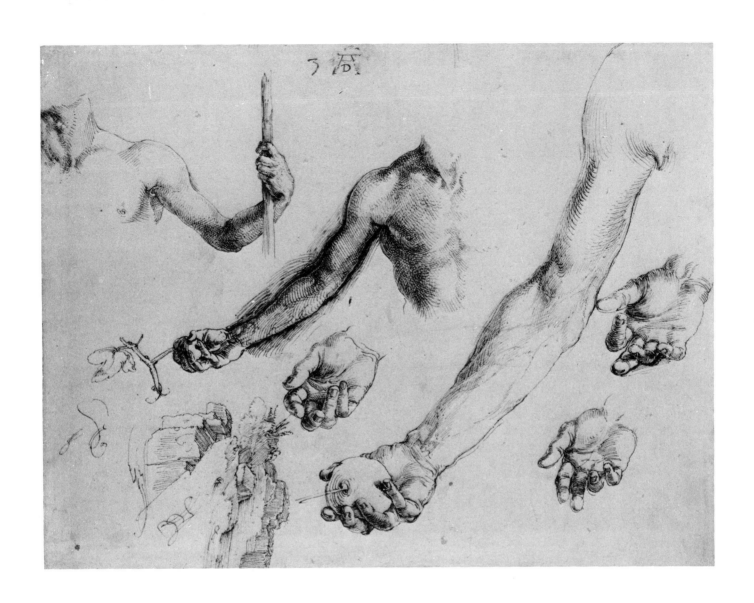

Peter Paul Rubens (1577-1640)
STUDIES FOR A PAINTING OF *THE DEATH OF DECIUS MUS*
black chalk, heightened with white
15 15/16" x 12 1/4" (405 x 310 mm)
Victoria and Albert Museum, London

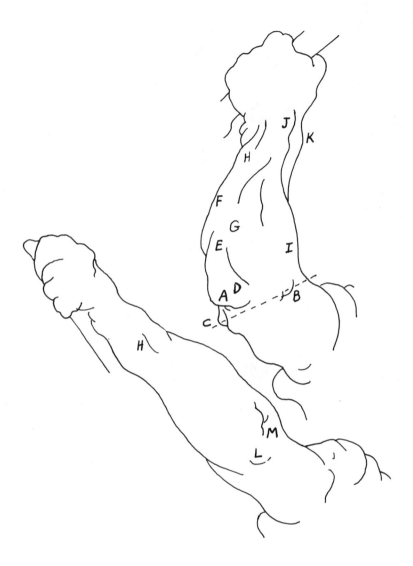

Lower Arm, Posterior Aspect

At the back of the arm, the olecranon process (A) of the ulna forms the tip of the elbow. In the flexed arm on the right, it forms the apex of a triangle of three bony protrusions. A construction line between the external (B) and internal (C) condyles of the humerus, forms the base of this triangle of bony landmarks. Rubens has stressed the more prominent internal condyle, and emphasized the protrusion of the olecranon process in this flexed position of the arm.

A greater awareness of shapes can help you more quickly locate bone and muscle forms. The triangular relief of the anconeus (D) originates in the external epicondyle (B) of the humerus and points downward to its insertion (E) into the posterior surface of the ulna. The flexor carpi ulnaris (F) and the extensor carpi ulnaris (G) border the sides of the anconeus (D) and the shaft of the ulna bone, and help create the ulnar furrow (H).

The mass of the supinators (I) swell the upper half of the forearm. The tendon of the extensor digitorum (J) helps you to block in the wrist. The slight swelling at the side indicates the extensors of the thumb (K).

When the arm is extended, the olecranon process (L) moves upward and inward, creating a deep furrow (M) toward the outside. If you extend your arm and place your fingers in this furrow, you will feel the bony mass of the external condyle (B) of the humerus. If you rotate your arm back and forth from supination to pronation, just below the external condyle you will feel the head of the radius articulating with the capitulum or radial head of the humerus at the elbow.

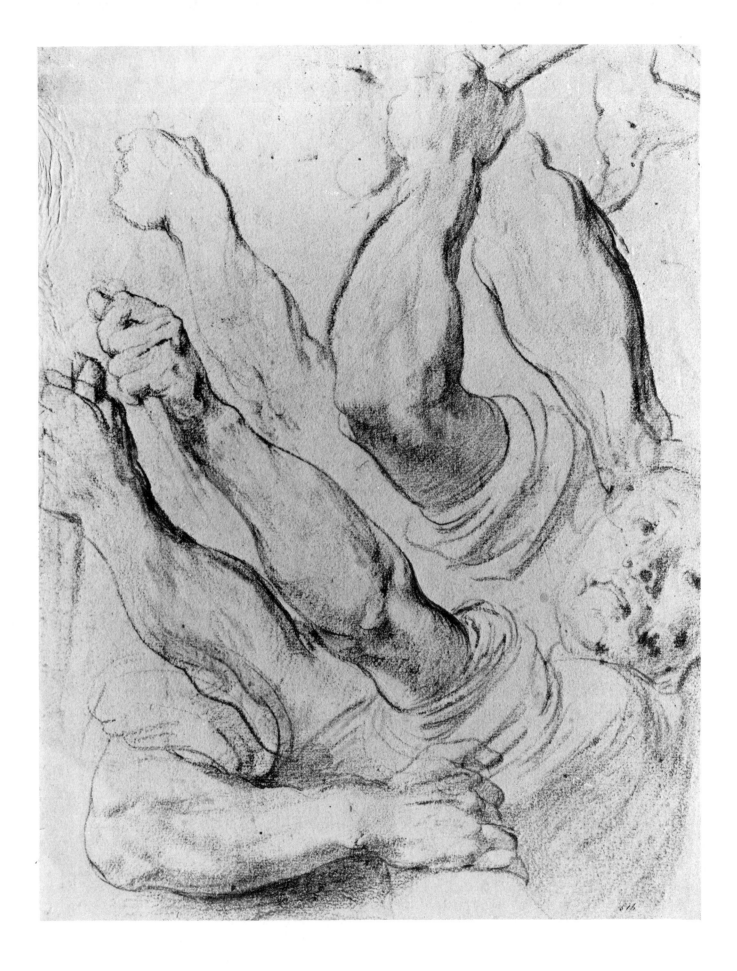

Federico Barocci (c.1535-1612)
STUDIES FOR *THE MARTYRDOM OF SAN VITALE*
chalk
Staatliche Museen, Berlin

Lower Arm, Lateral Aspect

The most prominent muscular mass of the lateral arm is that of the adjacent spiral muscles, called the supinator longus or brachioradialis (A) and the extensor carpi radialis longus (B). These two spiral muscles are massed together under the name of the supinator group.

The supinator group emerges from between the triceps (C) and brachialis anticus (D) muscles, about a third of the way up the upper arm. It swells to its greatest width just below the external condyle (E) of the humerus. The forearm narrows into tendons of the extensor group (F) at about the middle of the forearm.

Between the bulge of the interior border of the extensor carpi radialis longus (G) and the anconeus (H), you can see the deep furrow of the back of the extended arm at the position of the underlying external condyle and styloid process of the radius (see anatomical plate on page 254). This is a larger version of the dimples that are found throughout the body wherever a bone protrudes. You can find such dimples appearing at the sacrum (at the base of the spine) and by the bulge of the great trochanter of the femur (at the side of the hip). The dimple is caused by the bulging of muscles surrounding a bone. The bulging muscles create a prominence, the bone appears as an indent, and the result is a dimple.

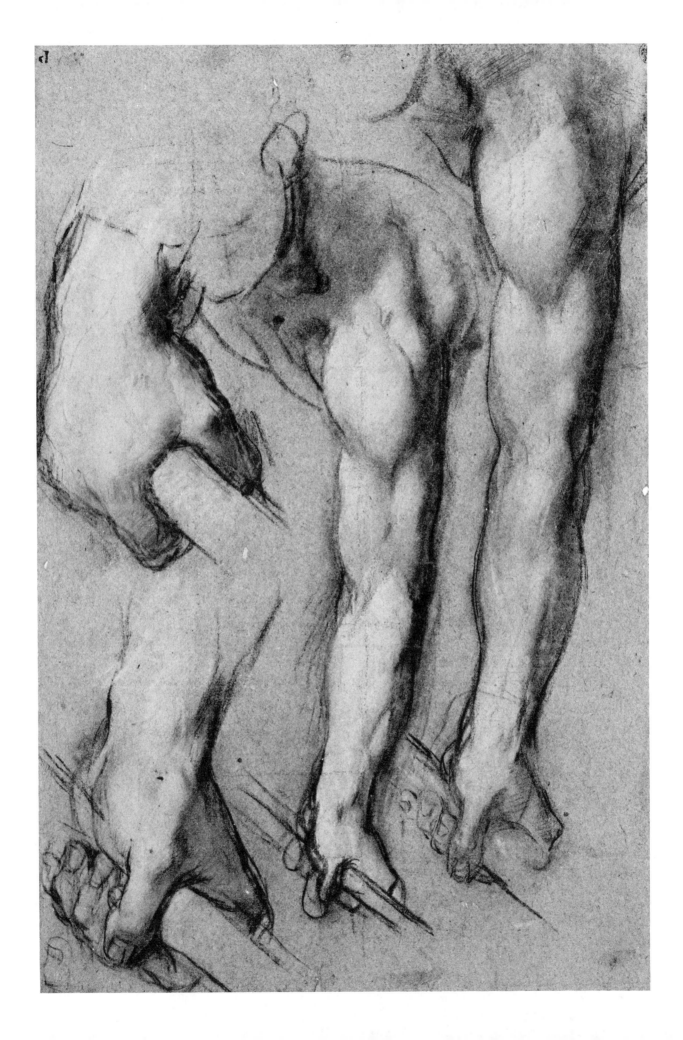

Albrecht Dürer (1471-1528)
THE ARM OF EVE
brush and brown ink
13 3/16" x 10 1/2" (335 x 267 mm)
Cleveland Museum of Art

Lower Arm, Medial Aspect

In Dürer's drawing of the medial aspect of the forearm, the ulnar furrow (A) lies well below the dark shadow of the plane break (B). This plane break follows the mass of the flexor carpi ulnaris (C). The ulnar furrow moves down from the styloid process (D), and separates the mass of the flexors (C) at the front and side of the forearm, from the extensor group (E) at the back.

What more convenient, yet often overlooked, model can you find than your own body? Look carefully in a mirror to see and feel your muscles in action, so they become more than mere words to memorize. Extend and turn your right forearm upward. Place the thick upper portion of your forearm in the palm of your left hand. Clench and relax your right fist, and flex your wrist upon your forearm, trying to touch the front of your arm with your fingers. You will see and feel the contraction and relaxation of the flexors (C), moving around from the ridge of the ulna bone at the back to the front half of the lower arm.

To feel the extensors at the back of your hand, move your wrist as far back as you can. This position is called hyperextension or dorsiflexion. Alternate this movement with a side-to-side movement of the wrist. You will feel the changing forms of the long muscular bundles of the extensors (E) as they contract and expand. The motion created by this muscular movement is transferred to the wrist and fingers by long, cord-like tendons in the lower, more narrow half of the forearm.

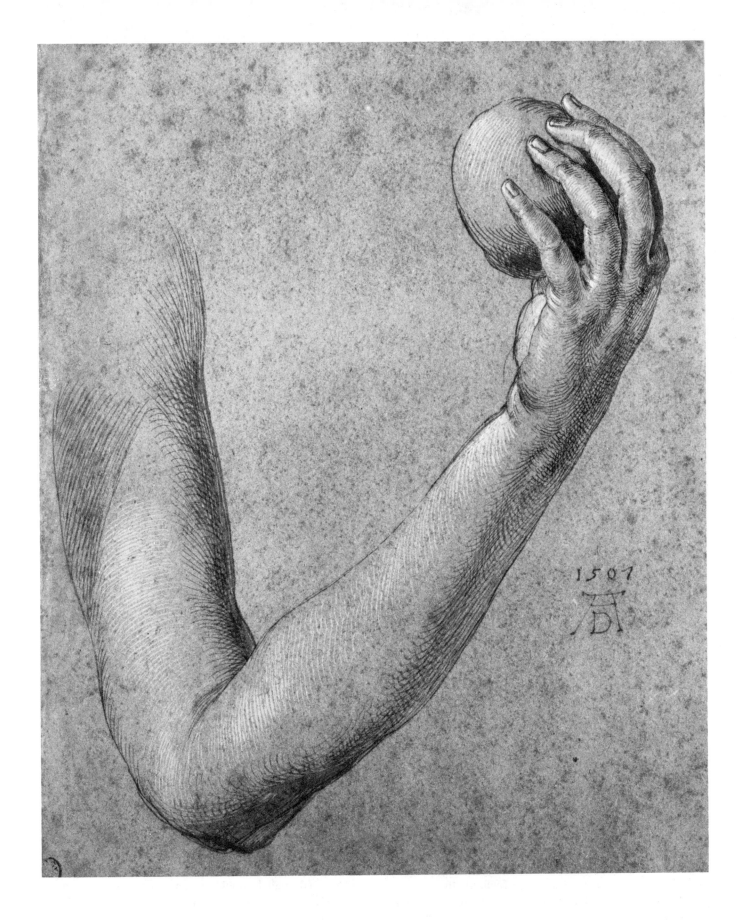

Giovanni Battista Piazzetta (1683-1754)
ACADEMIC STUDY OF A MALE FIGURE
black chalk on gray paper heightened with white
21 1/8" x 15 3/16" (537 x 386 mm)
National Gallery of Canada, Ottawa

Pronation

Here are examples of two opposite stages in the rotation of the forearm. The right arm of the figure is in pronation, or turned downward, and the left arm that is extended behind the trunk is in supination, or turned upward.

The downward movement of pronation is carried out by two muscles in the front of the forearm, the pronator teres (A) and the pronator quadratus (B). From their inner origins, they pull the radius, together with the hand, across the ulna. The forearm is moved back into supination by the supinator longus (C), the deep supinator brevis, and the biceps (D), pulling in an opposite direction from a different vantage point.

In all muscular actions, the same laws of leverage that apply to simple machines also apply to the human body as it overcomes gravity and inertia. In pronation, the contracting pronator teres (A) and pronator quadratus (B) pull by their tendons on the lever of the radius. The radius pivots on the axis or fulcrum of its joint at the base of the humerus. Against the resistance of gravity and its own weight, the hand is carried inward with the radius as it crosses the ulna.

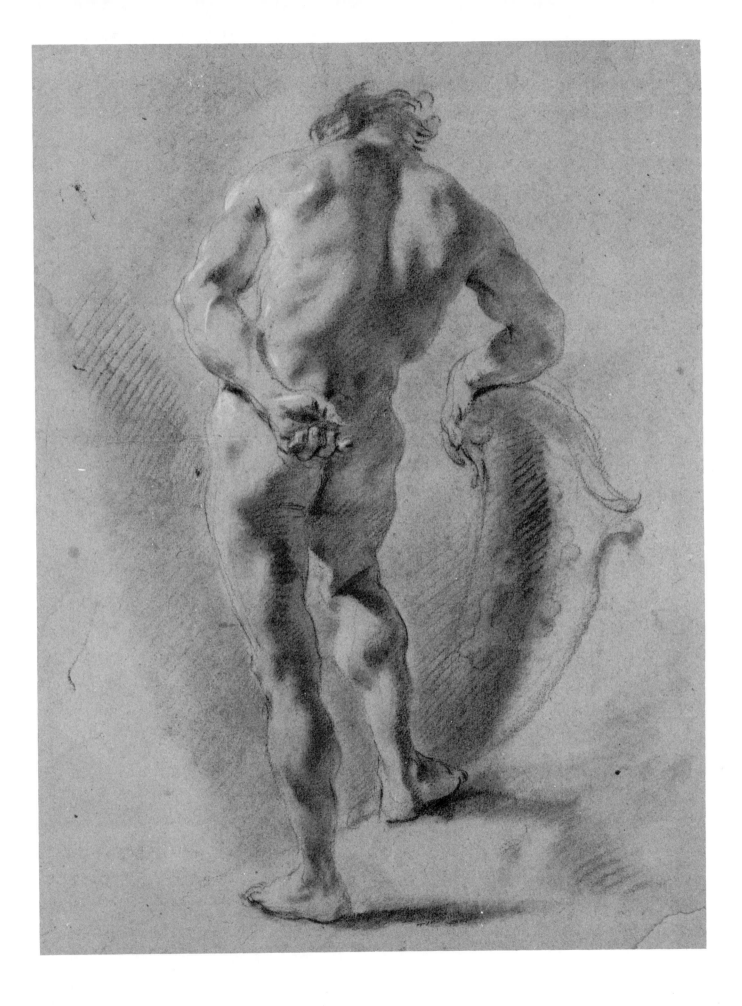

Peter Paul Rubens (1577-1640)
STUDY OF A NUDE MALE TORSO
charcoal and white chalk
12 7/16" x 14 7/16" (315 x 367 mm)
Ashmolean Museum, Oxford

Supination

Spiral contour lines are linear symbols of rotation. The lines that curve over the extensors of the thumb (A) in the lower forearm suggest that Rubens' model has just rotated the forearm from a palm-down or pronated position to this palm-upward, supinated position.

The contracting of the extensor digitorum (B), together with the activity at the extensors of the thumb (A), are followed by the spreading of the fingers and thumb. Try these movements on your own forearm and feel the changes in the different masses as you move your thumb and fingers.

Supination is carried out by the supinator longus (C) and its deeper muscle, the supinator brevis. In sudden movements or in supinating against resistance—such as when, in turning the key in your door lock it sticks a little—the biceps (D) comes to the rescue. By their turning action, the supinators and the biceps pull the pronated radius back across the ulna, so that both bones are again parallel with the palm upward. (This is the position your hand would be in if, for example, you were holding a bowl of soup.) The biceps shorten as they contract in supination. You can feel them move if you place one hand on your biceps as you rotate your other hand.

In such simple everyday activities as tightening a screw or turning the cap of a jar, you can experience a practical application of two anatomical factors—that the right hand is usually dominant and that supination is stronger than pronation.

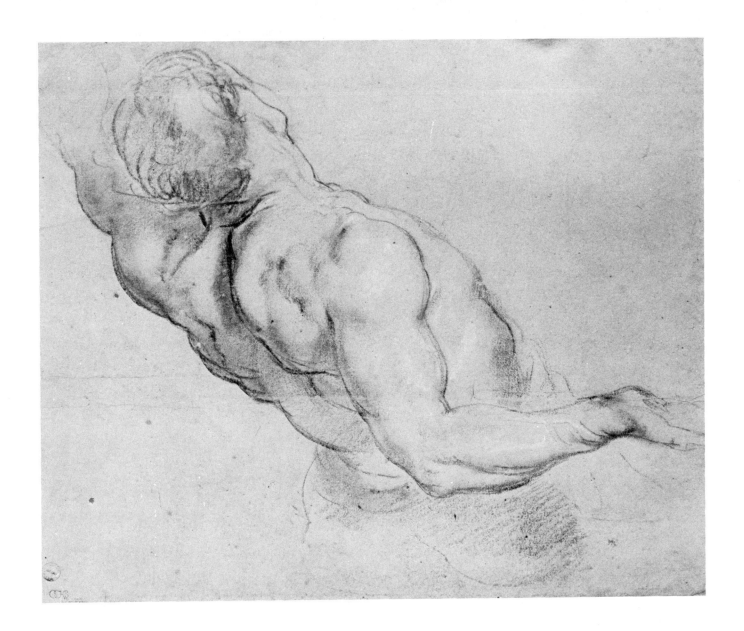

Jacopo Pontormo (1494-1556)
YOUNG MAN HOLDING A SMALL CHILD
black chalk
15 3/8" x 8 15/16" (389 x 227 mm)
National Gallery of Scotland, Edinburgh

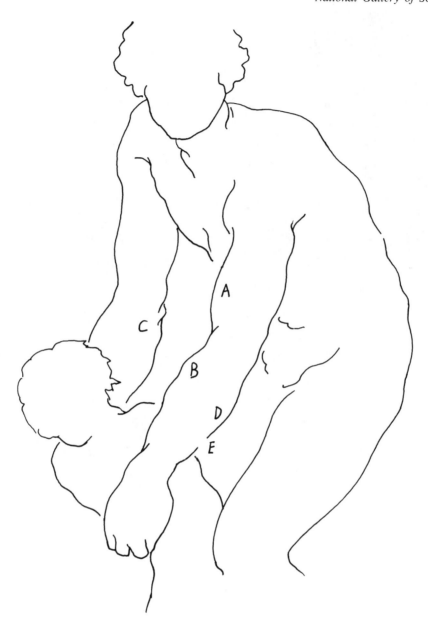

Demipronation

In the demiprone position of the forearm, the palm faces inward. This position has been described as the natural position of the forearm, or the position of rest. This is the position that the forearm and hand most naturally assume when you place your hand across your chest. If you drop your arms to your sides, your palm will neither face forward in supination nor backward in pronation, but will face inward in demipronation. This is also the position of greatest mechanical advantage for most functions of the upper limb.

The figure in Pontormo's drawing is holding a squirming child. The biceps (A) and supinators (B) are contracted and, together with the opposing pronator teres (C), they stabilize the arm in this demipronated position. The flexor mass (D) bulges in contraction as it flexes the wrist and fingers.

Pontormo's use of several lines of action at the supinator mass (B) suggests agitation of the upper forearm. Below, he breaks the long outline of the inner forearm and flexor mass (E) with an area of contrast to the hard unbroken line. At the same time he fuses values into a single tone in order to unify front and back masses.

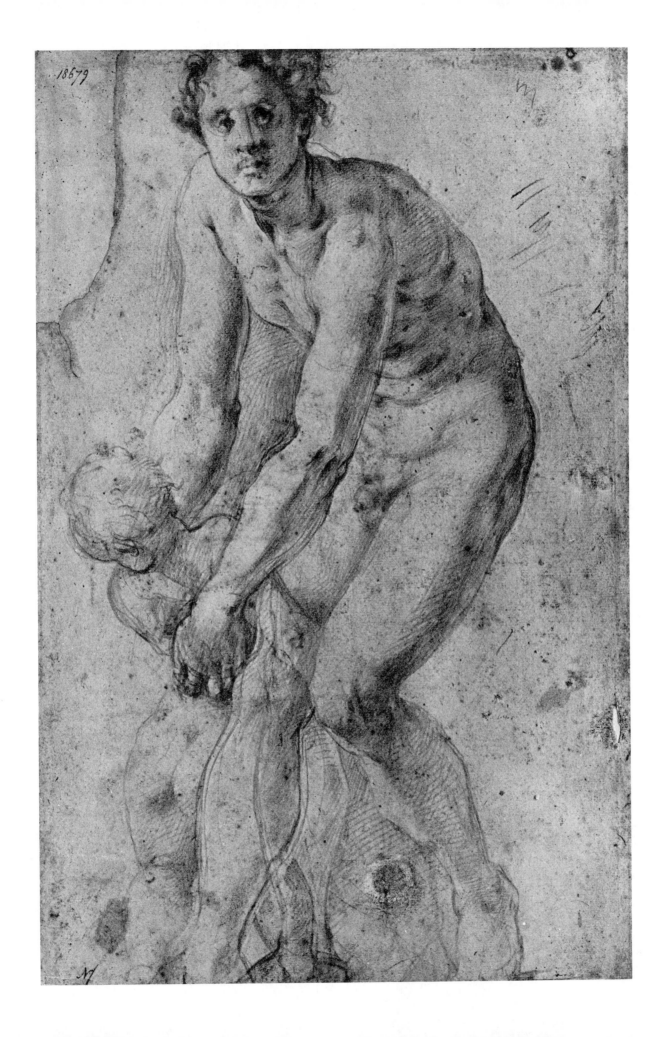

Raphael Sanzio (1483-1520)
PRELIMINARY STUDY FOR *THE DISPUTÀ*
pen and ink
11" x 16 3/8" (280 x 415 mm)
Stadelsches Kunstinstitut, Frankfurt-am-Main

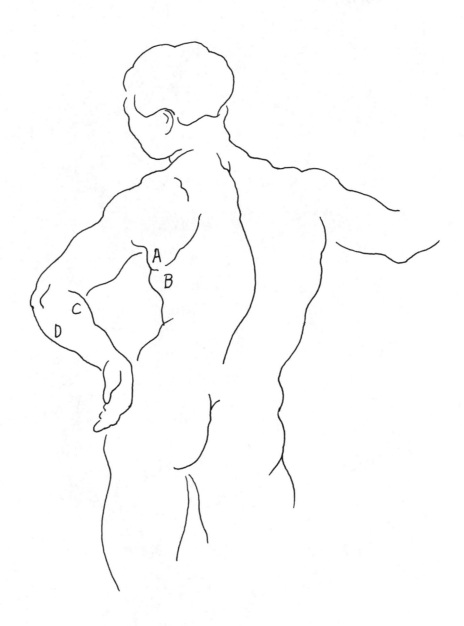

Forced Pronation

The movement of pronation, or rotating the hand so as to bring the palm downward, is accompanied by some rotation of the humerus, even in the initial stages. In the extreme position of forced pronation, rotation of the humerus is considerable. This inward and forward rotation of the humerus is brought about by the action of the teres major (A) and the latissimus dorsi (B) from the back, and by the pectoralis major from the front all pulling on the anterior or front surface of the humerus.

Notice the change in the form of the lower forearm as it moves from its generally flatter form in supination to a very cylindrical shape in this position of forced pronation. The mass of the supinators (C) follows the radius to the inside of the arm and adds to the thickness of the rounded form of the upper forearm. The bulging of the flexor mass (D) on the opposite side of the forearm is followed by flexion in the wrist and fingers.

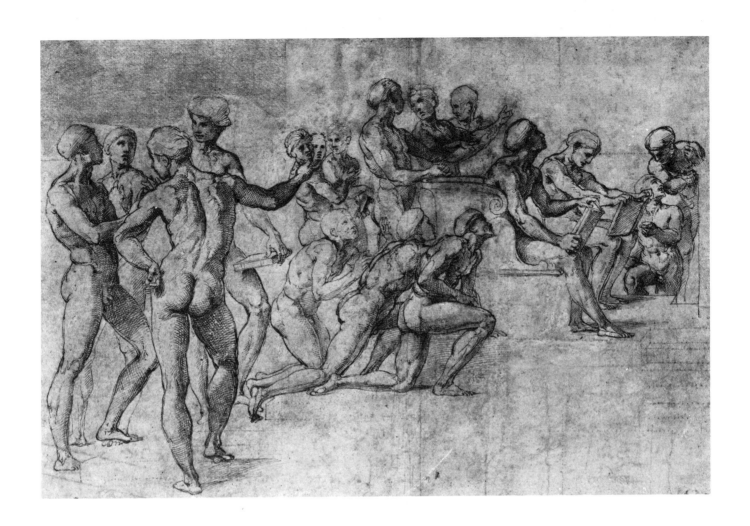

THE HAND

Raphael Sanzio (1483-1520)
DRAPERY OF HORACE AND OTHER STUDIES
pen and brown ink over black chalk
13 1/2" x 9 1/2" (343 x 242 mm)
British Museum, London

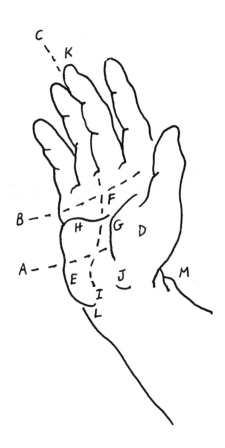

Muscles and Bony Landmarks, Anterior Aspect

The two lower hands in Raphael's drawing are in a position of hyperextension, also called "dorsiflexion," of the wrist with the fingers extended. The bony and muscular eminences that make up this anterior or volar hand, are readily distinguishable.

The bones of the hand are arranged in a series of arches: the carpal or proximal transverse arch (A) which follows the distal carpal row beneath, the very flexible metacarpal or distal transverse arch (B) along the line of the metacarpal heads, and the longitudinal arch (C-I) along the direction of the median crease of the palm.

The intrinsic or short muscles of the hand divide into the masses of the thenar eminence (D) at the base of the thumb, the hypothenar eminence (E) below the little finger, and the interossei and lumbricals which lie beneath the palmar fasciae (F) and between the meta-carpal bones in the body of the hand. The action of

the muscular masses upon the thumb and fingers, known collectively as "digits," causes the flexion wrinkles on the hand used in palmistry. These lines follow the contour of the palm. Raphael has repre-sented the two lines most dominant: the thenar or life line (G), and the more distal line of the fingers, or heart line (H). In the center, he shows the median crease (I-C) (called "the career line" in palmis-try) which begins just inward of the bump of the scaphoid appendage (J) and contours down over the palm, pointing to the middle finger (K) approximating the center line of the hand. The middle finger comes off at right angles to the carpal arch (A).

Opposite the scaphoid, on the ulnar side of the hand, the bump of the pisiform bone (L) marks the base or heel of the hand, and above the thenar eminence (D), the styloid of the radius (M) clues us to the lateral border of the wrist.

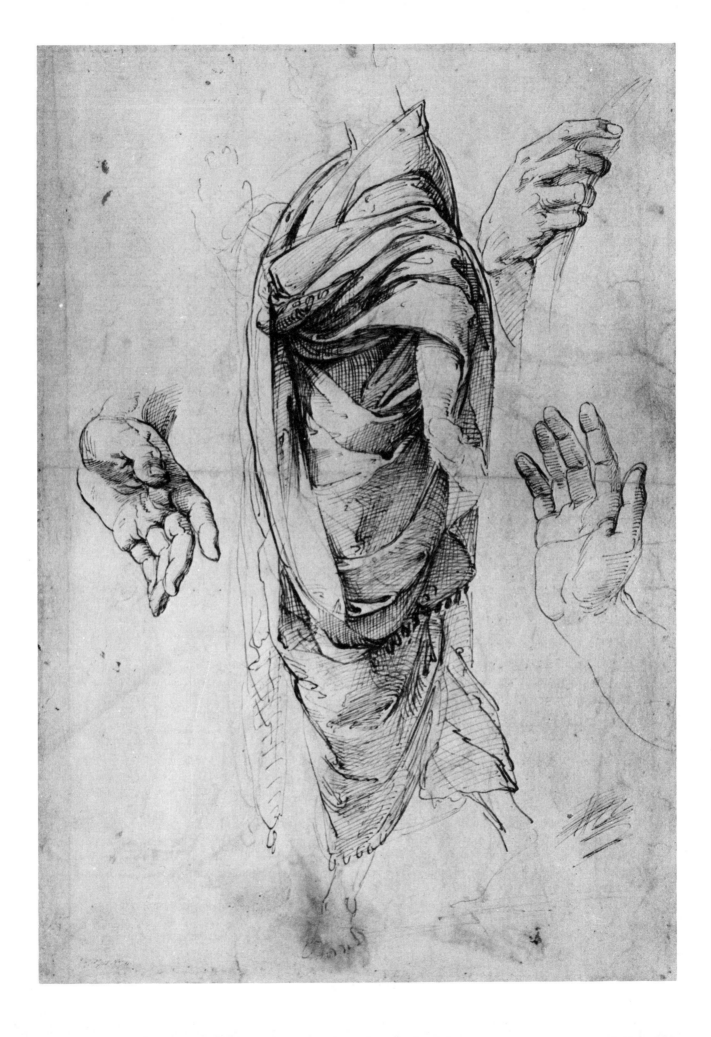

Bartolomeo Passarotti
STUDIES OF HANDS AND NUDE FIGURES
pen and brown ink
16 1/8" x 10 3/8" (410 x 263 mm)
Ashmolean Museum, Oxford

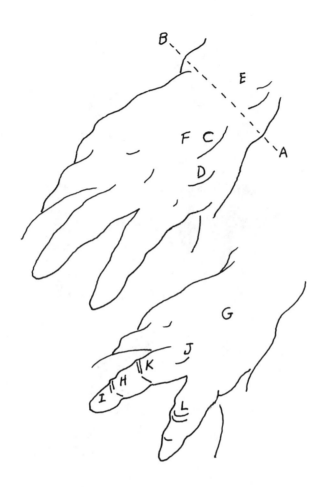

Muscles and Bony Landmarks, Posterior Aspect

The hand is like a puppet show run by strings. The strings are the long tendons of the extrinsic, or long, muscles of the hand that are situated in the forearm. They move to the hand by way of the wrist.

Most prominent at the wrist are the bony extremities, or styloid processes, of the radius (A) and ulna (B). If you draw a line between these two landmarks, you will see that it crosses the wrist obliquely, not horizontally. When you analyze this, you will notice that the more prominent and more anterior (frontal) radial styloid descends lower than that of the ulna.

The back of the grasping hand is convex. Passarotti has massed the hand along the prominent metacarpal of the index finger (C). Below this, he uses contoured hatchings to suggest the egg-like shape of the first dorsal interossei (D), also called the abductor of the index finger. This mass reaches from the bone of the thumb to the bone of the index finger and turns the skeleton into a hand.

Place your thumb upon the styloid of the radius. Move it slowly upward until at the back you feel the bump of Lister's tubercle (E). This landmark is on a line with the most prominent third metacarpal (F) that lies highest on the back of the hand. The long extensors of the fingers (G) are suggested in the center of the hand, reaching by their four tendons to their insertions in the second (H) and third (I) phalanx of each finger. The knuckles indicate the position of the heads of the second to fifth metacarpals, and the slight flexion of the fingers reveals the greater prominence of the knuckle of the third (J) metacarpal.

Passarotti has strongly contrasted the skin wrinkles over the mid-phalangeal joint (K), which he has blocked in with straight lines. He has relegated the index finger to the area of shade and subdued the contrast at its middle joint by the less obvious contour line (L), thus preserving the simplicity of the two dominant value areas of light and dark.

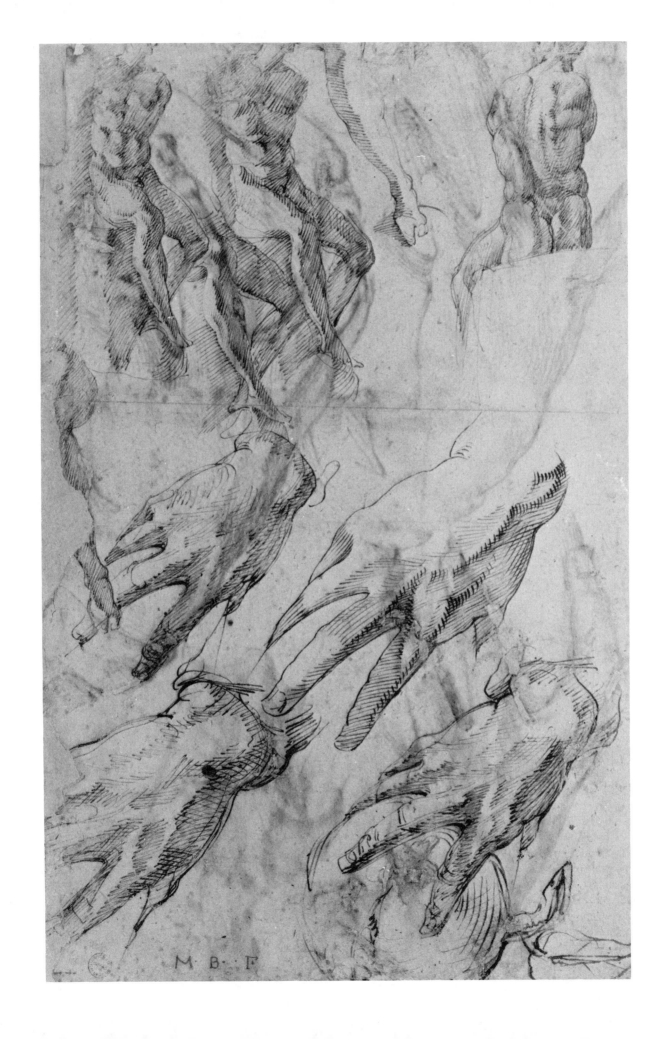

Albrecht Dürer (1471-1528)
STUDY OF THE HANDS OF GOD THE FATHER
FROM THE HELLER ALTARPIECE
8 1/4" x 11 5/8" (209 x 295 mm)
Kunsthalle, Bremen

Muscles and Bony Landmarks, Lateral Aspect

Like the great toe, the thumb has only two phalanges, a distal (A) and a proximal one (B), which are divided by creases at the joint (C). Dürer has accented the head of the first metacarpal (D), which protrudes with slight flexion of the thumb against the ball.

The highlight (E) on the proximal phalanx follows the single line of the extensor tendons to the head of the metacarpal. Above this point, they divide into the tendon of the extensor pollicis brevis (F) at the radial side, and the obliquely moving tendon of extensor pollicis longus (G) in the ulnar direction. Between them, they create the hollow of the anatomical "snuff

box" (H). Here, it is only slightly indicated—it is most visible when the thumb is extended to its utmost.

The flexion wrinkles (I) at the back of the hand are always seen when the wrist is extended. Below, the gentle contour of the abductor pollicis longus (J) leads into the dominant mass of the thenar eminence (K) which overlaps the hollow of the palm and the hypothenar eminence behind (L).

Dürer highlights the edge of the first dorsal interossei or abductor of the index finger (M). His contour lines run slightly oblique to the long and short axis of the muscular masses.

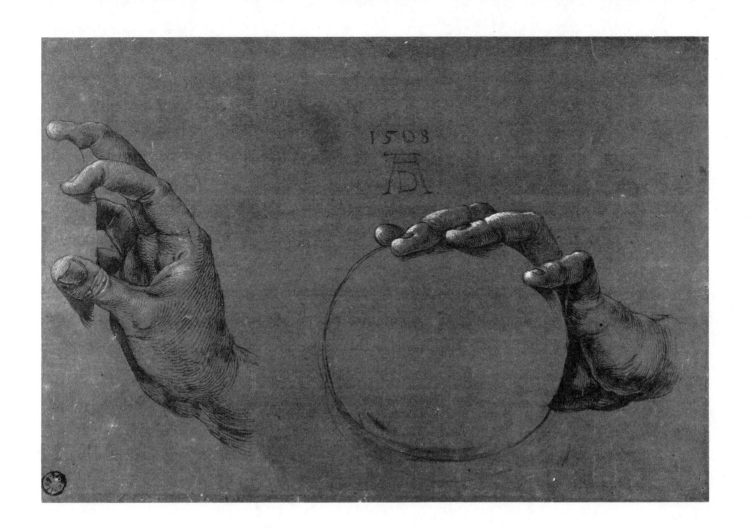

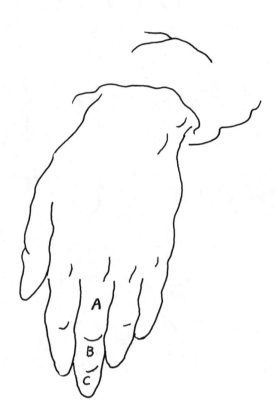

Muscles and Bony Landmarks, Medial

If the hand is allowed to assume its own position of rest, like the hand on the far right in del Sarto's drawing, it will always be in slight palmar flexion, bent inward toward the palm. In this position, the proximal phalanx (A) tends to extend, with a compensating flexion or bending of the middle (B) and distal (C) joints. This is a position of rest, with the muscles in balance, but with little practical function possible.

The hand on the far left is also in slight palmar flexion. With the fingers slightly flexed and hooked around the material, the wrist pulls inward. In this position, the strength of the grasp is weak because the long finger extensors are stretched. (If the fingers were bent into a fist, the wrist would have to be extended straight out.) The police are well aware of this and, accordingly, disarm an opponent by forcing his wrist into palmar flexion so that his grasp is weakened.

Del Sarto knew that the plane break at the back of the medial side of the hand was at the edge of the fifth metacarpal (D). The mass of the abductor of the little finger (E) gives softness to the side of the hand. It

originates in the pisiform bone (F) and from the tendon of the flexor carpi ulnaris (G) that has its insertion in the pisiform.

It is an error to think that simply because a muscle is named after a function (like adductor, flexor, or extensor), it is the only action that muscle is capable of. Quite the contrary. For example, although the abductor of the little finger (E) moves it away or abducts it from the ring finger (H), it also stabilizes the metacarpophalangeal joint (I) when the thumb opposes the little finger. The abductor of the little finger (E), also a weak extensor, helps straighten the little finger.

You should also be aware that a motion is seldom performed by a single muscle or tendon. The moving part also needs a stable base to work from which is controlled by muscular action. As an example, if you place your thumb on the anterior or frontal border of the opposite hand just below the pisiform bone (F) and abduct and adduct the little finger, moving it back and forth, you will feel the movement of the tendon of the flexor carpi ulnaris (G) as the muscle contracts to stabilize the ulnar border of the wrist.

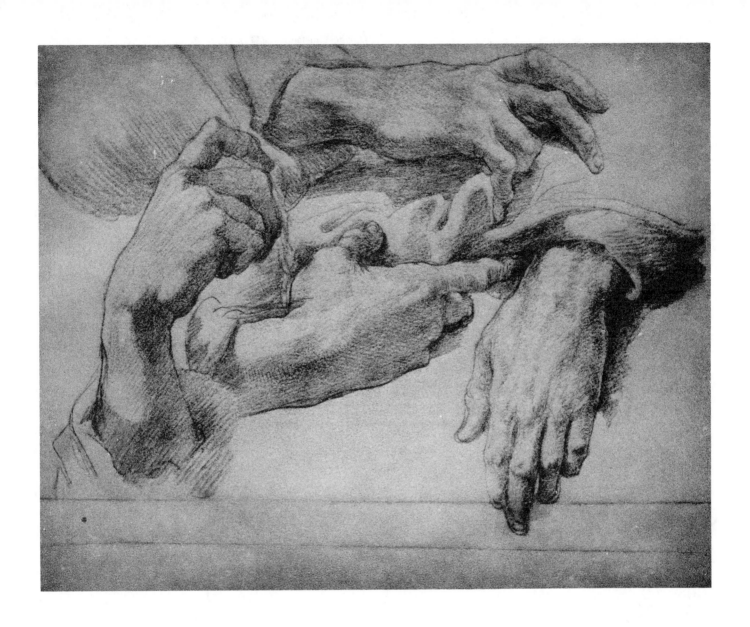

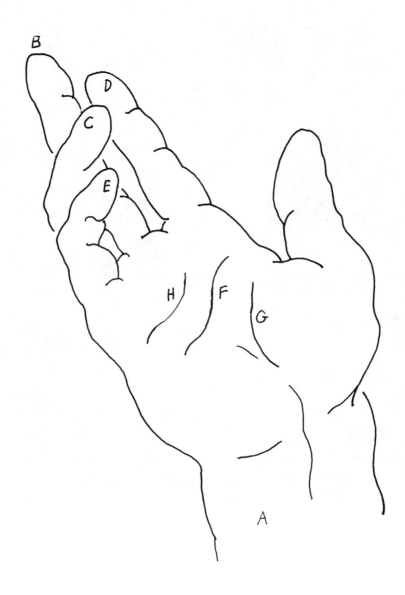

Extension

The wrist can turn and bend in any direction and at any angle. Here, it is in hyperextension or dorsiflexion, extended straight out and back. In the opposite position of palmar flexion, the wrist can almost make a right angle. Try to touch your wrist and see. Also, it can move much further in ulnar flexion (adduction) than it can in radial flexion (abduction), its opposite movement.

The extensor muscles at the back and the opposing flexor muscles at the front of the wrist, overlie, stabilize, and act upon the joints of the wrist, and have their ultimate attachment to the metacarpals and phalanges of the fingers. The strongest wrist motors are the two radial wrist extensors in the back of the hand, and the opposing flexor carpi ulnaris (A) at the front.

If the ring and little fingers in this drawing were extended with the other fingers, they would all be unequal in length: the middle finger (B) longest, the ring finger (C) next with the index or forefinger (D) a close third in length, and the little finger (E) the shortest. When the fingers are partially flexed together, their tips form a straight line. When they are fully flexed, they touch the palm at the midpalmar crease (F) (known in palmistry as the head line) that lies between the thenar (G) (or life line) and distal (H) (or heart line) creases.

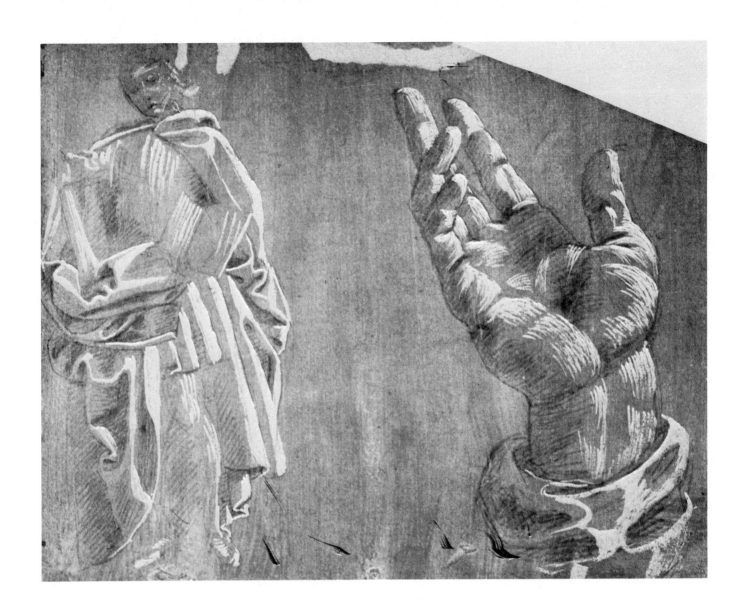

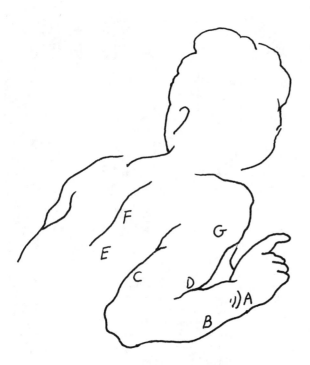

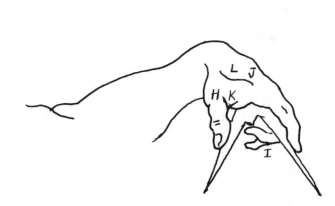

Flexion

The versatility of the hand is based not only upon the mobility of its skeleton, but upon a mechanical chain of joint and muscle action that extends all the way to the trunk. The hand must be positioned properly, opposing muscles must be stabilized, and joints must be rendered immobile to prevent unwanted motion.

The wrist of Delacroix's model (left) is bent backwards in order to facilitate flexion (or curling) of the fingers. Note the flexion folds (A) at the back of the wrist. If the model were to grasp a hammer, she would be using a power grip. If she were to hammer in a nail, let us say, the additional strength would be provided by the wrist, elbow, and finally the shoulder. At the wrist, the stronger flexor carpi ulnaris (B) and the extensors come into play. The triceps (C) and the brachialis (D) stabilize the elbow. At the shoulder, the lower two-thirds of the latissimus dorsi (E), the inferior portion of the trapezius (F), the pectoralis in front, and the deltoid (G) are important contributors to

powerful hand action.

As you can see in the drawing on the right, the mobile skeleton of the hand gives it a cuplike shape. The very flexible metacarpal of the thumb (H), and the mobile mass of the two metacarpals and phalanges of the ring and little finger (I) can move the mass of the hand inward from the more stable mass of the metacarpals of the index and middle finger (J). Thus your hand becomes birdlike in motion, the two wings at the side closing in upon the central mass when you grasp at objects.

The hand in Delacroix's drawing holds the compass loosely in combination of the hook grip of the ring and little fingers, and the precision grip of the thumb and index fingers. The abductor policis (K) and first dorsal interossei (L) (the abductor of the index finger) hold the thumb and index finger lightly against the compass.

Delacroix has accentuated the action of the latter muscle by placing his dominant plane break on its curved mass.

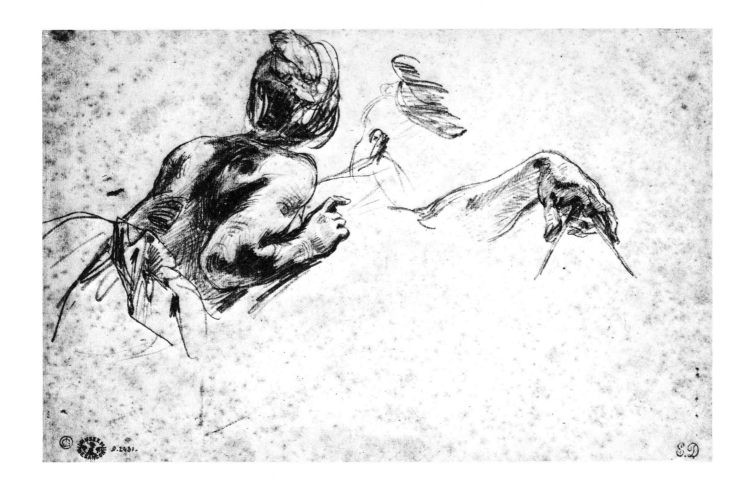

Albrecht Dürer (1471-1528)
PREPARATORY DRAWING FOR *CHRIST AMONG THE DOCTORS*
pen and wash
9 13/16" x 16 3/8" (249 x 415 mm)
German National Museum, Nuremberg

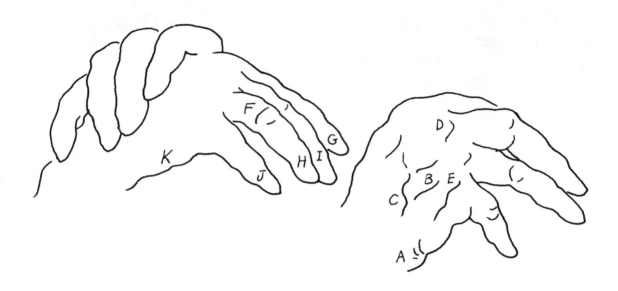

Adduction

Terms of wrist movement are based on the anatomical position of the hands being at the sides and the palms turned forward. *Adduction* means to draw inward or toward the center or median line of the body. *Abduction,* its opposite, to move away from this center line. Because the arm is flexible and can move in many directions, the terms *ulnar deviation* and *radial deviation* are also applied in order to explain the action of the wrist. Ulnar deviation refers to adduction or a movement toward the ulna, and radial deviation refers to abduction or a movement toward the radius.

The strong flexion folds (A) in Dürer's drawing of the hands opening a book suggest adduction of the wrist toward the ulnar side or ulnar deviation. Movement in the opposite direction toward the radius is called abduction or radial deviation.

At the back of the hand, the tendons of the long extensors (B) move underneath the veins (C) following the direction of the metacarpals, where they form the knuckles (D).

The direction of the lines of shading describe the contour of the forms beneath. Dürer kept his highlight at the fifth metacarpal (E) close to the dark area because he wished to portray the back of this hand as relatively flat. He similarly squared up the two strongly lit fingers of this hand. By contrast, in the hand on the left, the separation of the highlight and the dark by larger masses of middle tone contributes to the illusion of roundness. The change in the direction of the curves of the wrinkles (F) over the middle joint of this dominant ring finger, is a clue to the direction of the first phalange.

The index (G) and ring (H) fingers are pressed inward or adducted toward the middle finger (I), or midline of the hand. The little finger (J) is moved away or abducted from the midline by the action of the abductor digiti minimi, located in the hypothenar eminence (K).

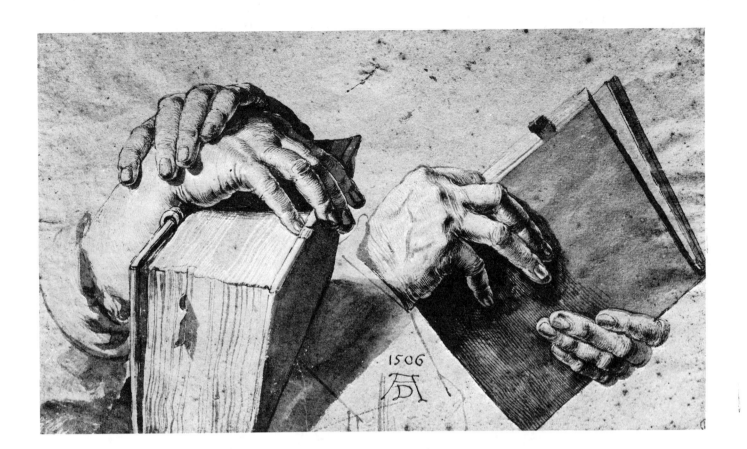

Jean-Baptiste Greuze (1725-1805)
A SEATED NUDE
red chalk on heavy cream paper
17 1/2" x 14 1/2" (445 x 370 mm)
Paul J. Sachs Collection
Fogg Museum of Art, Harvard University, Cambridge

Abduction

The term *abduction* means movement outward or away from a center or median line. In the anatomical position where the arms are at the side and the palms are facing forward, the abducted wrist moves outward, moving sideward away from the body in the direction of the thumb. This wrist movement is also termed *radial deviation*. Abduction of the fingers describes sideward motion away from the middle finger or midline of the hand. By contrast, the thumb is abducted when you move it out from the palm at right angles to it, and adducted when you move it into the palm and down on the index finger.

The wrist (A) at the right in this drawing is in abduction or radial deviation. This is carried out primarily by the flexor carpi radialis muscle of the anterior forearm (see plate #22 at the back of the book) and by the two radial extensors or supinator group of the wrist (B). The limited motion of abduction is always increased by the additional movement of the wrist toward the palm, or palmar flexion. The other wrist (C) is in slight adduction also with palmar flexion.

Learning about the hand will help you study the foot, for you will find many similarities. But there are structural differences relating to function. The butterfly-like hand has become a flexible extension of man's intellect, whereas the foot is structurally designed to withstand great weight and pressure. The more you can see the relationship between structure and function, the more the study of anatomy will reveal universal design principles.

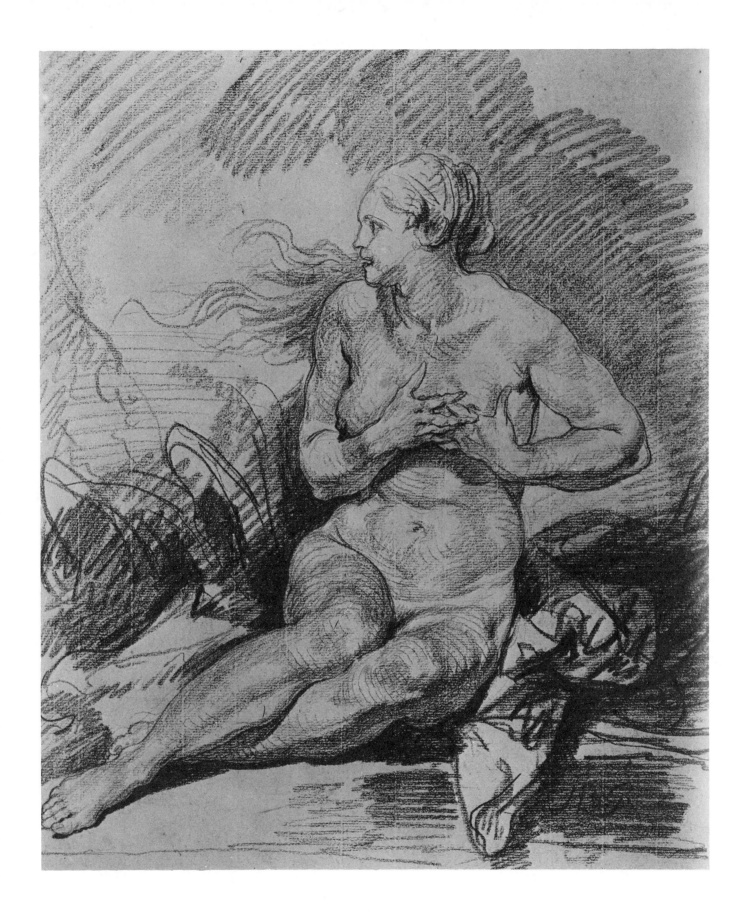

THE NECK
AND HEAD

Domenico Beccafumi (1485/6-1551)
STUDY FOR PART OF THE MOSAIC FRIEZE OF THE
SIENA CATHEDRAL PAVEMENT
pen and bistre wash
8" x 11 5/8" (203 x 295 mm)
Bequest of Meta and Paul J. Sachs
Fogg Art Museum, Harvard University, Cambridge

Neck, Anterior Aspect

The inner base of the column of the neck arises out of the circle of the first ribs and follows the curve of the spinal column at the back. At the front, the lower limit of the neck is formed on each side by the clavicle (A), from the jugular notch (B) (or pit of the neck) to the acromion process (C) at the side.

In this drawing, the head, and the neck which always moves with it, are rotated to the viewer's right. The sternocleidomastoideus (D), the most prominent muscle in the neck, spirals vertically downward, filling a large portion of this mass. This rotator, sometimes called the "bonnet string" muscle, extends from its cordlike origin in the manubrium (E) of the sternum and the inner third of the clavicle (F) to the mastoid process (G) behind the ear. The sternal head (H) swells just below the angle of the jaw (I) as it pulls the head back and rotates it toward the trapezius (J) at the side.

With the rotation of the head and neck, the prominent landmark of the thyroid cartilage or Adam's apple of the larynx (K) is also pulled to the side. The middle line of the neck (L) that runs from the mental protuberance (M) (the center of the chin bone) to the pit of the neck (B) overlaps the relaxed sternocleidomastoideus (N) on the other side. This lowered sternocleidomastoideus is pushed obliquely toward the posterior triangle of the neck (O) and overlaps the anterior edge of the trapezius (J) at the shoulder.

A shaded down plane marks the submaxillary or digastric triangle and the area of the mylohyoid muscle (P). The posterior belly of the digastric muscle (Q) moves along the lower border of this triangle to the hyoid bone (R) at the front.

The thyroid cartilage (K), which is very prominent in the male neck, is accented by the strong contoured hatchings (S) that mark its down plane.

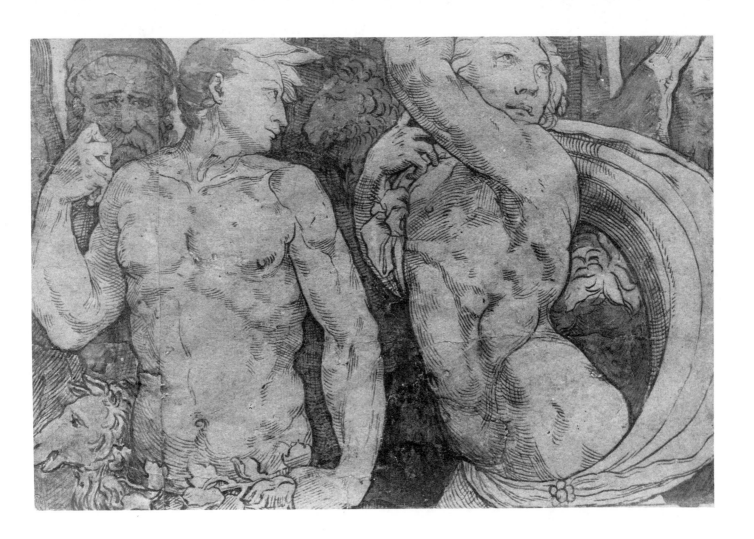

Michelangelo Buonarotti (1475-1564)
FIGURE STUDY FOR *THE BATTLE OF CASCINA*
black chalk over stylus
7 5/8" x 10 1/2" (194 x 267 mm)
Albertina, Vienna

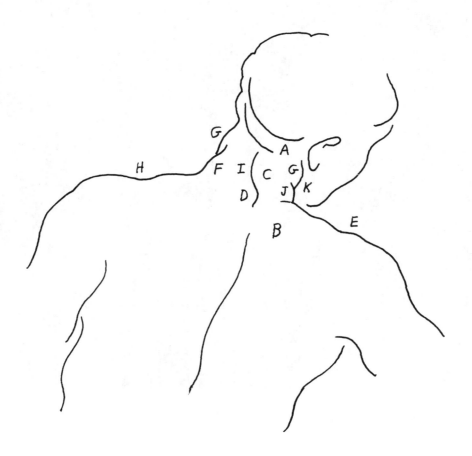

Neck, Posterior Aspect

The contour of Michelangelo's lines suggest the ball and egg shape of the head. The cylinder of the neck is formed on the spinal column, follows its curve, and takes on its supple character. At about the level of the middle of the ear, Michelangelo's strong curve at the back of the head suggests the occipital protuberance (A), which is the upper limit of the neck. Below this eminence lies the bony ring of the atlas—the first cervical vertebra—on which the head moves forward and backward in flexion and extension, and beneath it, the axis on which the head is rotated. Together with the five vertebrae below, they form the back of the column of the neck.

Powerful ligaments and muscles, called the strong chords of the neck, connect the base of the skull and the vertebral column. They help to keep the head erect and assist in its movements. The trapezius or table muscle (B) moves down from its origin in the occipital protuberance. Molding itself on the deeper layers of muscle, the trapezius creates a longitudinal elevation (C) on each side of the nuchal furrow, the central furrow of the neck. This furrow follows down along the spines of the vertebrae to the important landmark of the seventh cervical or vertebra prominens (D). An imaginary line drawn from the seventh cervical to the acromion process (E) of the scapula defines the lower border of the posterior of the neck.

The outline of the upper section of the trapezius (F) is widened by the mass of the scalenus and the levator anguli scapulae beneath. The upper mass of the sternocleidomastoideus (G) outlines the neck above. Below, the outline changes direction as the fibers of the trapezius project obliquely upward from the acromion process (H) to about the fifth vertebra (I).

Michelangelo places the plane break along the upper edge of the trapezius (J) where a transverse fold (K) marks the sternocleidomastoideus (G) as it twists into the trapezius. In the light area, he subdues the contrast at the nuchal furrow, and in the dark mass of the face, he minimizes the reflected light to unify his two big values.

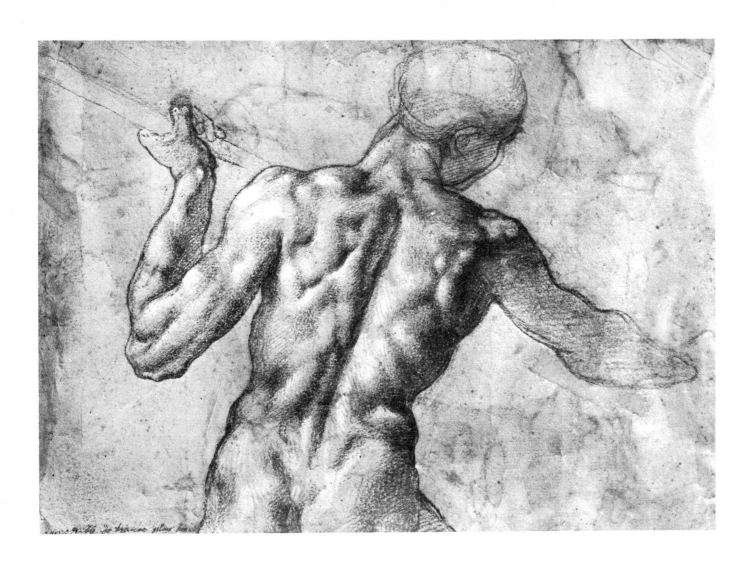

François Boucher (1703-1770)
SEATED NUDE FACING RIGHT AND RECLINING ON CUSHIONS
chalk on gray paper
11 13/16" x 15 7/16" (300 x 392 mm)
Rijksmuseum, Amsterdam

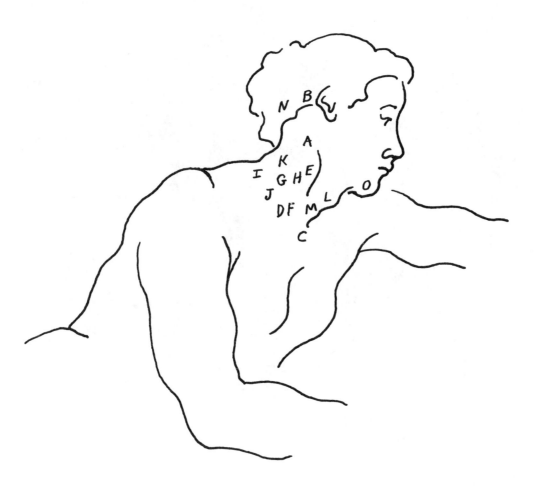

Neck, Lateral Aspect

The sternocleidomastoideus (A), coursing down from its mastoid and occipital insertions behind the ear (B) to its origins in the sternum (C) and the inner clavicle (D), covers a wide area of the lateral region of the neck. Boucher has emphasized its middle portion (E) with contoured hatchings. At the pit of the neck (C), where the two sides of this "bonnet string" muscle (the sternocleidomastoideus) meet the front line of the neck, he has placed a dark accent.

A small, shaded area indicates the sternoclavicular fosset (F), where the clavicular portion of the sternocleidomastoideus inserts into the inner third of the clavicle. Above and behind this, a deeper depression (G), called the "salt box," marks the area of the posterior triangle of the neck. This area is bounded in the front by the posterior border of the sternocleidomastoideus (H), in the back by the anterior edge of the trapezius (I) and below by the middle third of the clavicle (J). In the rotated and laterally inclined head, the posterior triangle is rounded out by the combined mass (K) of the three scaleni and the levator anguli scapulae that converge like the sternocleidomastoideus to the area behind the ear.

The column of the neck always curves slightly forward along with the curve of the vertebral column. This forward thrust is stronger in the female. Boucher has also softened the sharp prominence of the thyroid cartilage (L) in this female throat, but at the same time he has slightly filled out the area directly below (M) to allow for the larger thyroid gland in women.

Note how the base of the skull (N) at the back is well above the chin (O) and mental protuberance of the lower jaw. The long, graceful line of the trapezius (I) at the back of the neck, emphasizing the more flowing lines of the female, is broken up into three convex movements of varying lengths, rhythmically reflecting the influence of the underlying muscles.

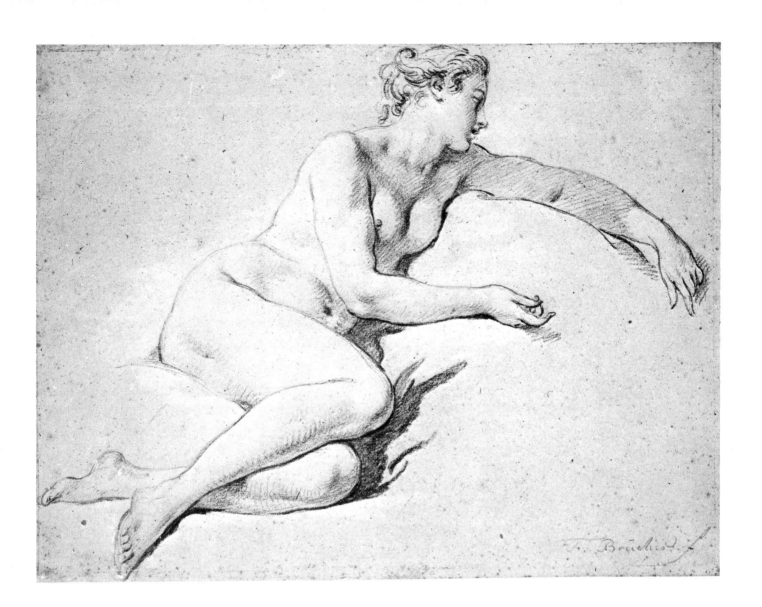

Michelangelo Buonarotti (1475-1564)
STUDIES FOR THE CRUCIFIED HAMAN
red chalk
7 1/2" x 10" (191 x 254 mm)
Teyler Museum, Haarlem

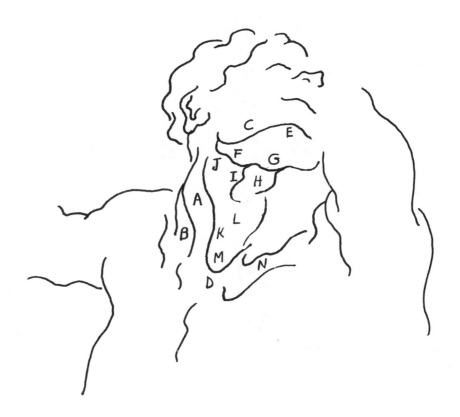

Neck, Extension

Movements of the head are usually combined. The head of Michelangelo's model is extended upward, rotated, and slightly inclined to the right. At the back, the strong chords of the neck are assisted by the two sides of the trapezius acting together to cause extension of the neck and head.

The sternocleidomastoideus (A) contracts in the rotating of the head. This muscle is the dividing line between the two principal triangles of the neck, the almost hidden posterior triangle (B), and the anterior triangle (EDJ) at the front. The anterior triangle is defined above by the lower line of the jaw (C), in front by the imaginary center line of the neck (ED), and by the inner border of the sternocleidomastoideus (A).

The upper portion of the anterior triangle that lies under the chin (EGJ) is separated from the rest by the posterior portion of the digastric muscle (F) and the hyoid or tongue bone (G). This area is called the submaxillary or digastric triangle. A slight hollow in its center (E), marks the interval between the two bellies of the anterior digastric muscle lying over the broad mylohyoid muscle that fills this triangle.

Below the hyoid bone along the midline of the neck, a larger hollow (H) outlines the thyroid notch at the center of the thyroid cartilage or Adam's apple.

At the side, the line of the omohyoid (I) moves down and outward from the hyoid bone, dividing the lower area of the anterior triangle into the superior (J) and inferior (K) carotid triangles. A transverse furrow separates the thyroid (H) and cricoid (L) cartilages. Below this, the masses of the thyroid gland and trachea or windpipe move down behind the pit of the neck (M). The clavicle (N) follows the upraised arm and approaches the column of the neck.

Michelangelo places his dominant plane break and strongest contrast along the edge of the most projecting part, the thyroid cartilage (H). Gradually softening this contrast, he moves his plane break downward along the throat, and upward along the anterior belly of the digastric muscle (E).

Edgar Degas (1834-1917)
AFTER THE BATH
charcoal on yellow tracing paper
13 7/8" x 10" (352 x 254 mm)
Clark Art Institute, Williamstown

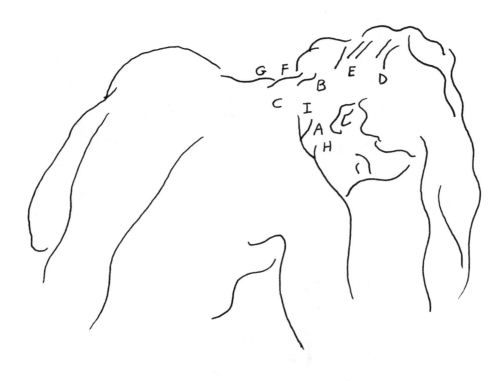

Neck, Flexion

Flexion of the neck and head is principally initiated by the three scaleni muscles in the lower neck and by the two sides of the sternocleidomastoideus (A), acting in unison. At the base of the skull (B), the condyles of the occipital roll upon the surface of the atlas or first cervical vertebra, and the head moves downward. When gravity begins to influence the downward movement of the weight of the skull, the antagonistic muscles, the strong chords of the back and the trapezius (C), take over to regulate the action of gravity upon the fall of the head.

The downward flowing hair counterbalances the upward thrust of the body lines, harmonizes with the flexion movement of the head, and by near parallelism, draws attention to the face.

In the highlight of the hair, Degas strikes two oblique lines (D), one curved to give the contour of the skull, and an adjacent straight line to turn the plane. Below this, the movement is continued with three straight lines (E) marking the important plane change of the occipital protuberance at the back of the skull.

At the back of the neck (F), short convex lines break up the larger movement, suggesting the strong chords beneath the mass of the trapezius and the prominence of the seventh cervical vertebra (G) and two or three dorsal vertebrae.

The flexion and rotation of the head causes the angle of the jaw (H) to push the sternocleidomastoideus (A) against the side of the trapezius (I), creating the deep flexion folds in the neck.

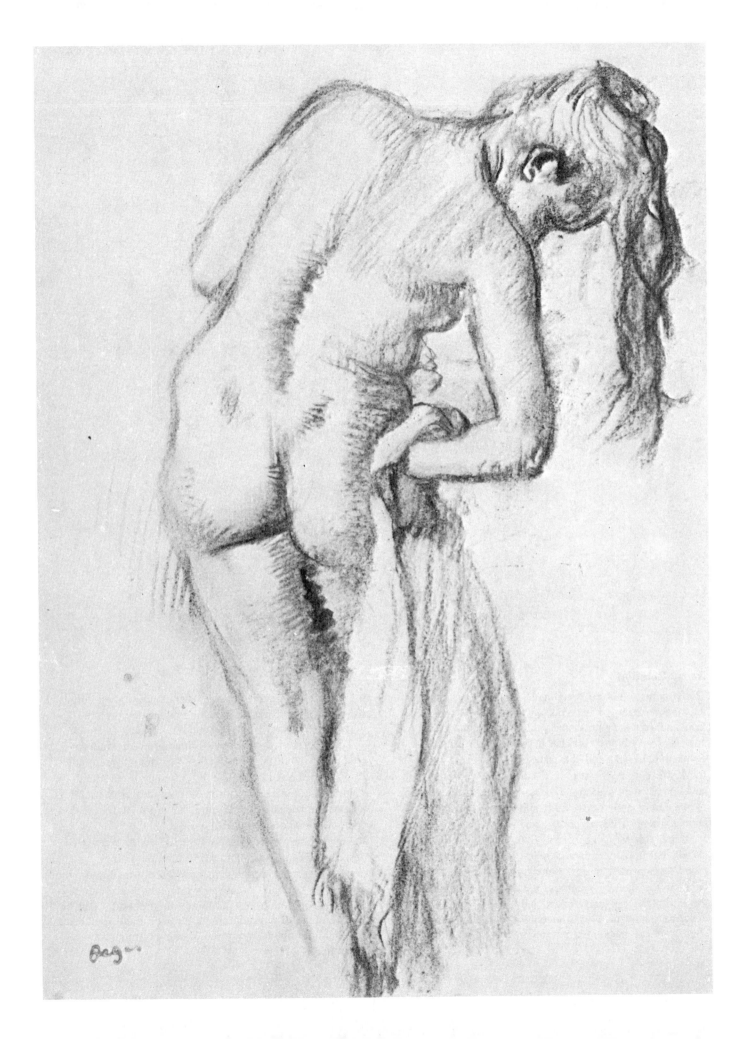

Raphael Sanzio (1483-1520)
DOUBLE STUDY OF KNEELING WOMAN
black chalk
15 9/16" x 9 7/8" (395 x 251 mm)
Ashmolean Museum, Oxford

Neck, Rotation

The rotating head pulls upon the muscle and skin of the neck, causing the forms on that side to stand out firm and round (A). At the other side, the neck is crossed by oblique wrinkles between the sternocleidomastoideus (B) and the trapezius (C).

As the column of the neck curves forward, the seventh cervical vertebra (D) stands out in the midline of the back, and the forward and rotary motion is echoed in the folds of the gown.

Drapery covers like a second flesh. Its contours should harmonize with and give "clues" to the body forms over which it lies. Note how the fold at the back of the neck (E) curves, not just up to the line of the neck, but out and around the cylinder, helping to describe its form. This fold contours down over the shapes of the back in a sweeping curve that breaks up into smaller segments that converge with other curves from above and below to a common source at the vertebral column (F) in the back.

The observant artist knows that different kinds of cloth each have their individual "cluster characteristics," just as do the different species of trees in the landscape. The particular construction of the cloth, its texture and density, determine the types of forms that it takes as it falls over the figure.

Finally, the artist concerns himself with the varied design arrangements of the lines, shapes, sizes, and directions of the material in his figure drawing. In the headpiece, Raphael creates an interesting arrangement of varied contour lines playing over the skull. But he is careful to give predominance to the band tied behind at the important plane break of the occipital protuberance (G).

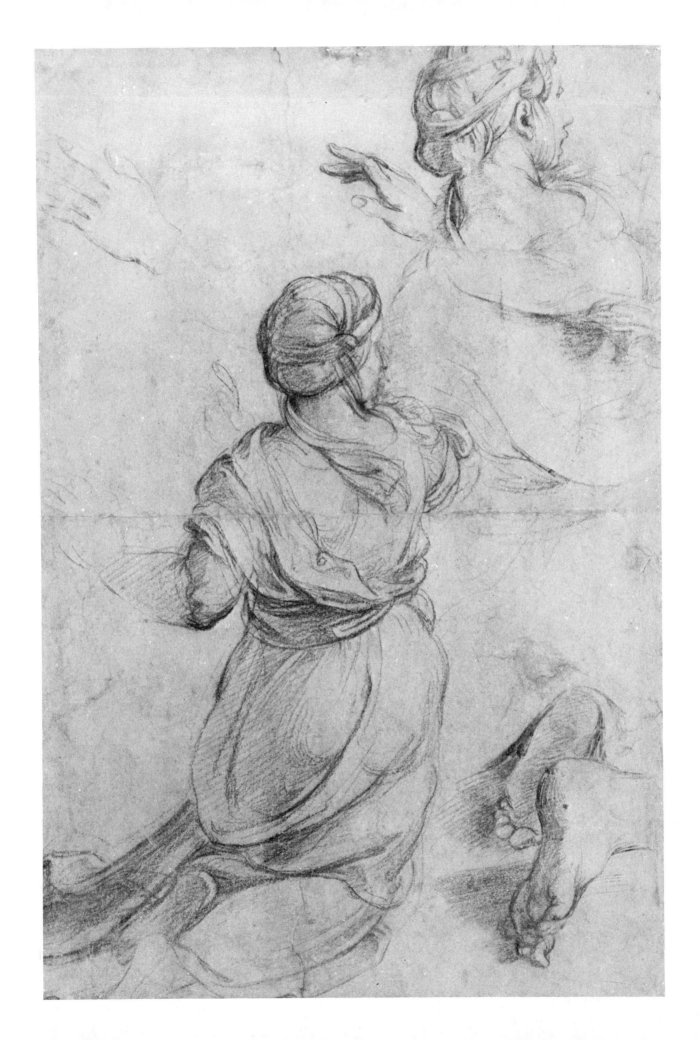

Peter Paul Rubens (1577-1640)
YOUNG WOMAN WITH CROSSED HANDS
black and red chalk, heightened with white
18 1/2" x 14 1/8" (470 x 358 mm)
Museum Boymans-van Beuningen, Rotterdam

Neck, Lateral Inclination

Rubens has subdued the details of the neck in order to emphasize the face of his model. Lateral inclination of the head or tilting of the head to the side is usually accompanied by rotation toward the shoulder. Here this action of lateral inclination is produced by the simultaneous contraction of the extensors and flexors on the right-hand side.

At the other side of the neck, the long graceful spiral of the trapezius (A) and the upper portion of the sternocleidomastoideus (B) reflect the curve of the backbone. On the inner side, a short curved line suggests the other sternocleidomastoideus (C) bending slightly toward the posterior triangle (D) of the neck, and overlapping the area of the cast shadow, which represents the direction of the upper trapezius (E).

The larger thyroid gland of the female helps soften the protrusions of the throat. In the fullness beneath the jaw and throughout the drawing, Rubens has emphasized the more delicate feminine qualities in his line and modeling.

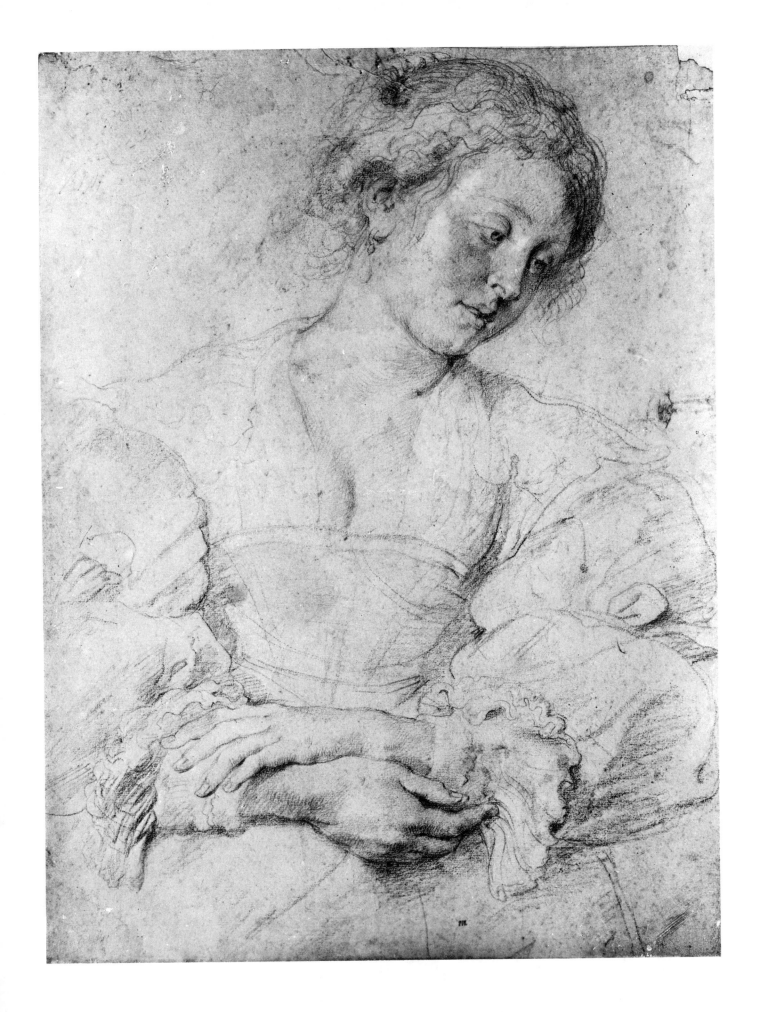

Albrecht Dürer (1471-1528)
CONSTRUCTED HEAD OF A MAN IN PROFILE
pen and brown and red inks
9 9/16" x 7 1/2" (243 x 189 mm)
Pierpont Morgan Library, New York

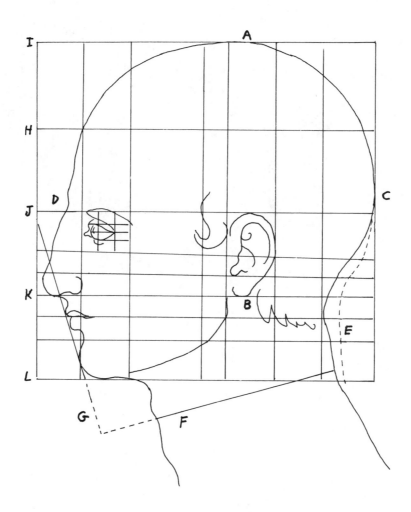

Constructed Head

Historically, in their analysis of growth and form and
in the search after harmonic mathematical relationships
in the shapes of the human head and features, artists
and scientists have created a variety of geometric
arrangements by which to compare these forms.

The artist knows that in order to create, he must
exaggerate reality. But to do this, he must have an
idea of what reality is to begin with. Once familiar
with the norms or standards, the variations can easily
be perceived and played upon. These diverse and only
generally accurate artistic canons should be no more
than guides and secondary to artistic needs.

Here Dürer experiments with a block or cube, which
he divides into a network of rectangular coordinates
of seven units horizontally, four equal divisions ver-
tically, with additional subdivisions for the eye and ear.

The ovoid shape of the cranium dominates Dürer's
contructed head. The facial portion of the skull lies
below the brows and in front of the ears. Dürer places
the high point of his skull (A) above the mastoid
process (B), and the wide point (C) at about the level

of the glabella of the frontal bone (D).

Note how Dürer ignores his original line (E) in order
to give the cylinder of the neck the forward thrust of
the spine. The depth line of the neck (F) is four-
sevenths the length of the total block, and forms a
right angle with the limiting line (G) of the lower face.

With the exception of his enlargement of the area
between the hairline (H) or widow's peak, and the
crown (I), Dürer's breakup follows the traditional three
equal divisions between hairline (H) and brow (J),
brow to base of nose (K), and base of nose to base of
chin (L).

Note how the top of the brow (J) and the base of
the nose (K) are horizontally coincident or level with
the top and bottom of the ear, and how the front of
the eye lines up with the back of the nose.

Had the drawing progressed further in detail, other
relationships would have become evident. But it is
clear that the artist knows that one secret of likeness
lies in comparisons made possible by the use of a
structural system such as this one.

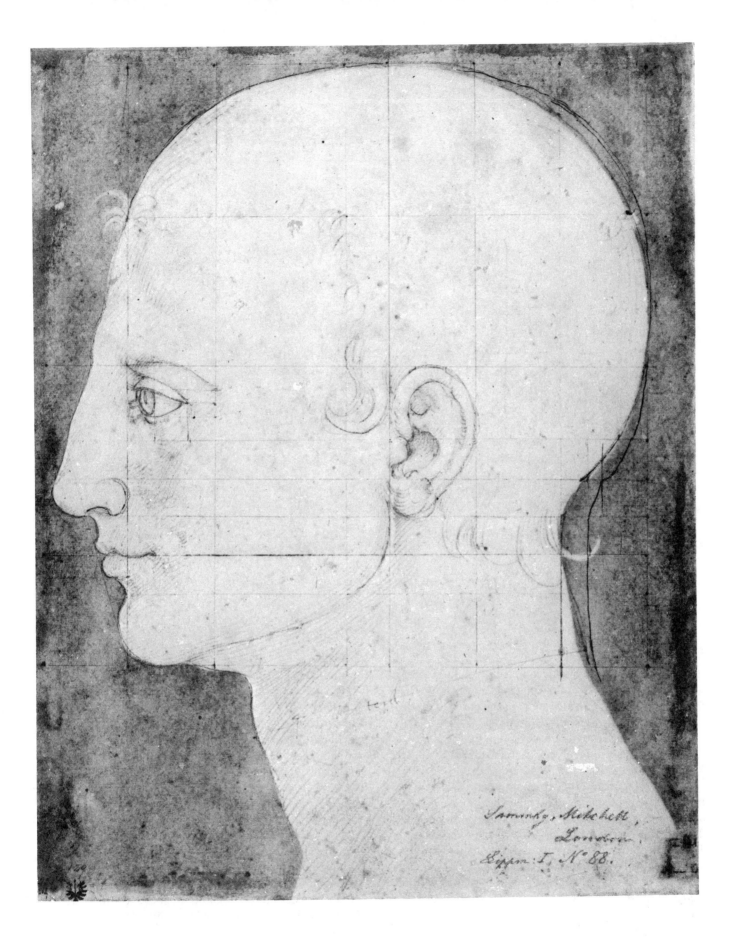

Hans Baldung (1484-1545)
HEAD OF SATURN
black chalk
Albertina, Vienna

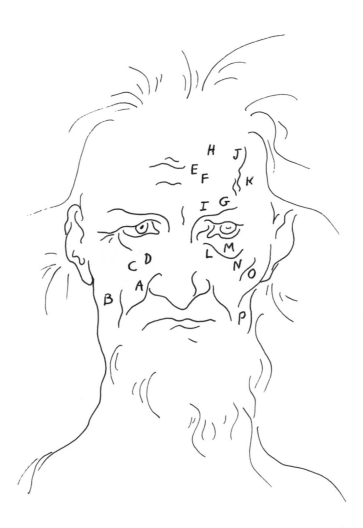

Head, Anterior Aspect

If you want to learn to draw good heads, you must learn to draw good skulls. This drawing by Baldung shows how the head in old age provides a good subject for study of the bony scaffolding upon which the head is based. The effects of time and gravity upon the skin tissues render the facial muscles more obvious and the planes of the face easier to place.

The facial muscles differ from most muscles in that instead of moving one bone upon another, they mostly move the skin. While they may have some attachment to the bones of the face, their insertions are into the skin. The fibers of the muscles of the face tend to converge toward the oral region, the area of the mouth.

Observation shows us that wrinkles form at about right angles to the direction of the muscles that cause them. The prominent nasolabial furrow (A), which separates the wing of the nose from the cheek, forms in a direction contrary to the buccinator (B), zygomatic minor (C), and levator labii superioris (D) muscles.

The horizontal furrows (E) of the frontal eminence are at tight angles to the vertical occipitofrontalis muscle (F). The furrows (E) and the form of the eyebrows (G) below reveal the shape and values of the frontal eminences (H) and the superciliary eminences (I) of the skull beneath. Above this, Baldung places the plane break of the forehead (J), which is broken at the side by the superficial temporal vein (K) commonly seen in the aged.

The infrapalpebraral furrow (L) spirals down along the edge of the "tear bag" (M), extending down to the infraorbital region (N), over the plane break on the malar (O), and down the front of the masseter (P) muscles.

Furrows move like rivers through valleys in the aged faces in master drawings and in the elderly around us. Tracing their course can provide profitable insights into the form and function of the muscles and bones of the face.

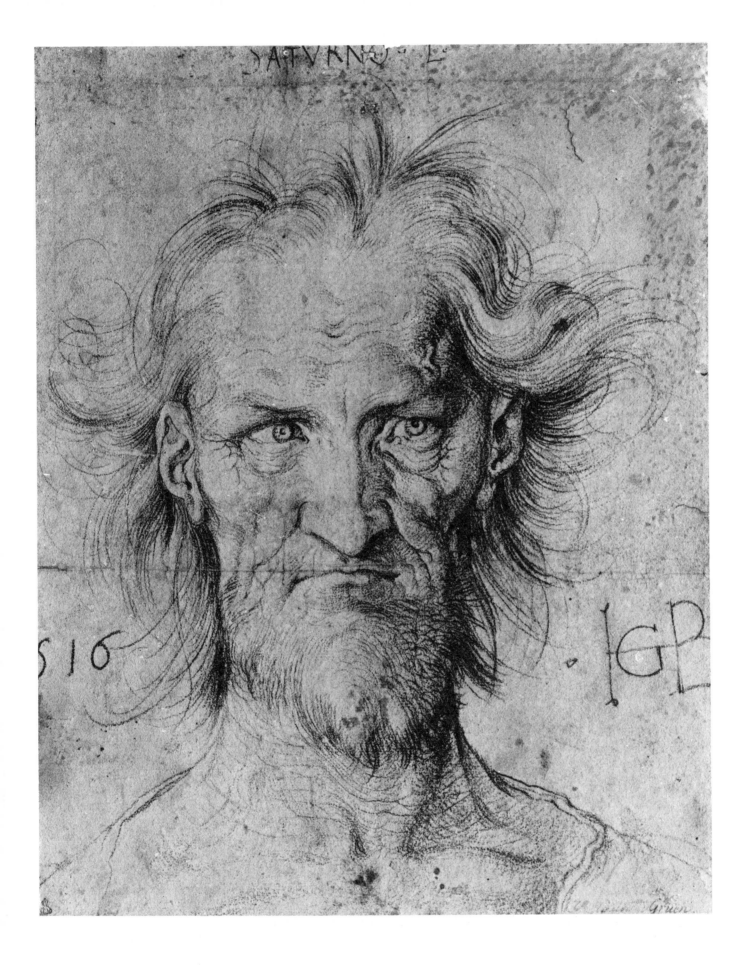

Jean Fouquet (1415-1481)
PORTRAIT OF AN ECCLESIASTIC
silverpoint on paper, black chalk.
7 11/16" x 5 5/16" (195 x 135 mm)
Metropolitan Museum of Art, New York

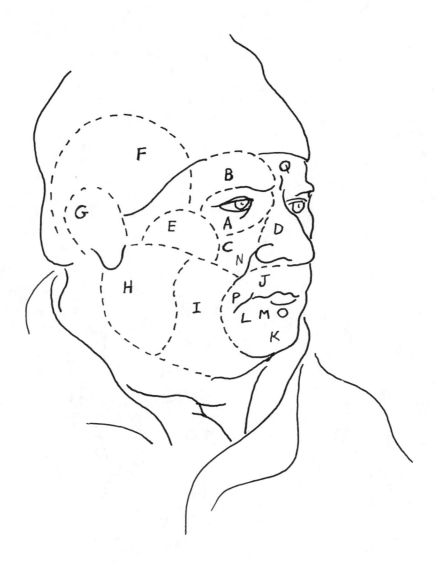

Head, Lateral Aspect

The superficial muscles of the face are called the muscles of facial expression. Besides influencing our expressions, they also perform major functions such as closing the eyelids, opening and closing the lips, and auxiliary functions during eating and speaking.

The facial muscles greatly vary in size, shape, and strength. They are not always easily distinguishable, as they sometimes exchange their fiber bundles, and they are not all located on a superficial level. They are sometimes grouped in relation to the openings which they modify, such as the orbit of the eye, the nasal aperture, and the mouth. Again, they can be placed by facial region: orbital (A), supraorbital (B), infraorbital (C), nasal (D), zygomatic (E), temporal (F), auricular (G), parotid-masseteric (H), buccal (I), oral (J), and mental (K).

Seeing muscles in terms of similarity in shape—such

as the circular orbicularis palpebrarum surrounding the eye, and the orbicularis oris surrounding the mouth— may help you to remember them. In the mental or chin region, it is valuable to contrast the shapes and functions of the depressor anguli oris or triangularis (L), which lowers the corner of the mouth, with the square muscle of the lower lip or the depressor labii inferioris (M), which causes the lip to protrude when you pout.

Fouquet's heavy-set model is middle-aged, so his wrinkles are not emphasized. Nevertheless, in order to create plane change, the nasolabial (N) and the mentilabial (O) furrows are almost always needed. The "commissural" furrow (P) at the angle of the mouth and the vertical frown line (Q) also help to break the horizontal direction of the adjacent furrows and add a note of seriousness to the face.

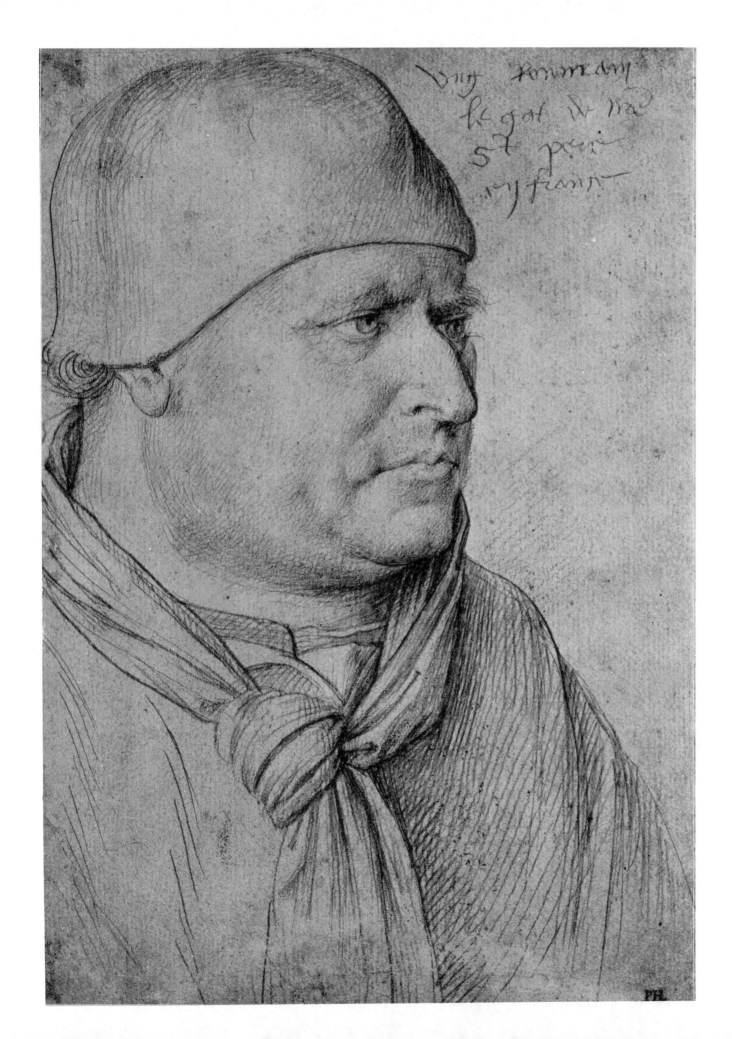

Albrecht Dürer (1471-1528)
PORTRAIT OF HIS MOTHER
charcoal
16 5/8" x 12" (421 x 303 mm)
Staatliche Museen, Berlin

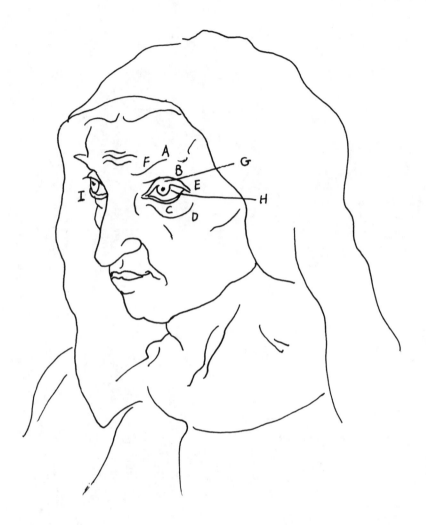

The Eye

At the halfway point of the head, the eye sits well within the orbital cavity of the skull. It is protected above by the supercilliary eminence (A) and by the external angular process (B) of the frontal bone. The tear bag of the lower lid (C) lies along the infraorbital margin (D) of the malar or zygomatic bone. Note that the outer corner of the eye (E) sits higher and further back than the inner corner. The eyebrow (F) rides the upper rim of the orbit and the line fades in the highlight as it rises over the external angular process.

The layman tends to see a person in terms of the details of their features. The artist, on the other hand, thinks in terms of the underlying structure of the skull so that the features are positioned correctly on the skull and in relation to each other. This will insure a good foundation for both likeness and perspective.

Dürer treated the lids as ribbons of flesh moving over the sphere of the eye and he made certain that the upper lid just cleared the pupil. The curve of this lid follows the shape of the eyeball to its highest point (G) just above the black spot of the iris that is raised by the transparent mound of the cornea. This upper lid is usually drenched in shadow by the mass above. But since it is an up plane, which normally catches the light, the artist either minimizes this cast shadow, as Dürer did, or eliminates it entirely.

Two little, wet highlights in the dark pupil of the near eye reflect multiple light sources. A dark accent in the iris where it meets the sclera or "white of the eye" (H) gives the gradation of value in the iris, as well as the illusion of the mound of the cornea lying over it.

The near eye is spherical in shape and the little highlights in the iris are side by side horizontally. In the distant eye, the lower lid (I) curves sharply behind the eyeball, and both the sphere of the iris and the highlight within it become ellipses as they move into perspective.

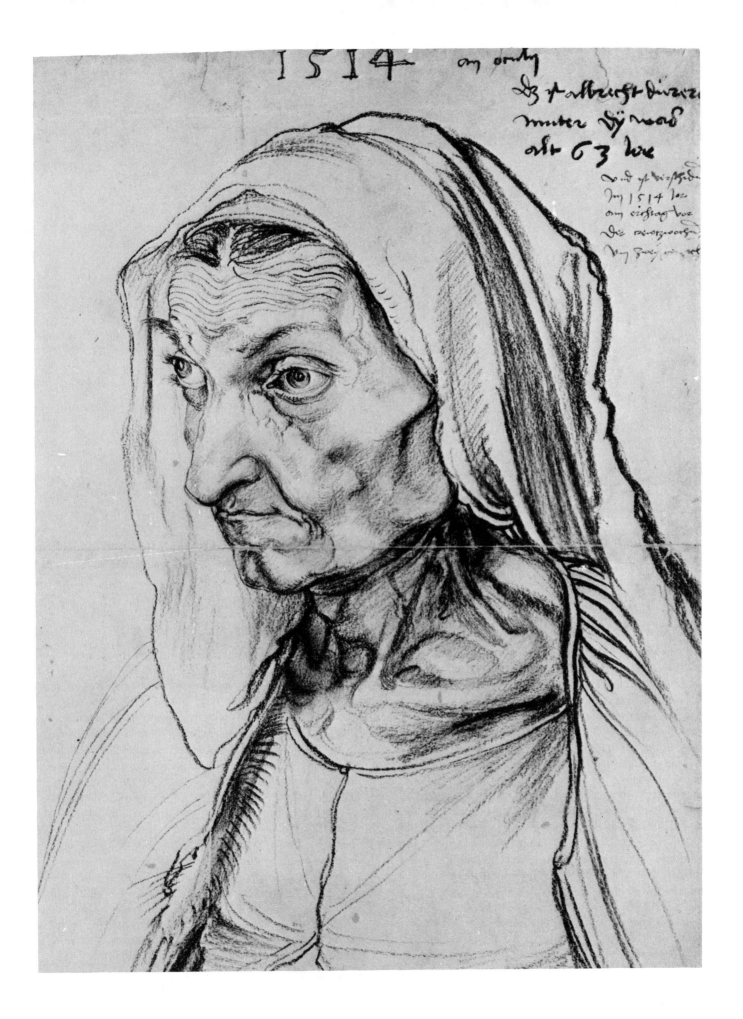

Albrecht Dürer (1471-1528)
STUDY FOR *SAINT JEROME* (PORTRAIT OF A MAN OF NINETY-THREE)
brush and black ink, heightened with white, on gray violet tinted paper
16 1/2" x 11 1/8" (420 x 282 mm)
Albertina, Vienna

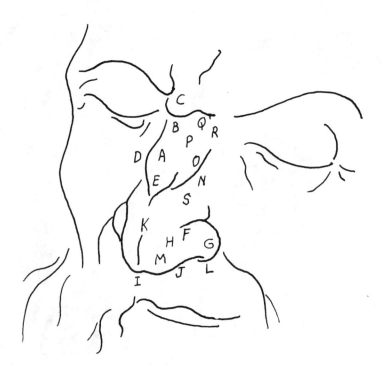

The Nose

The landmarks of the nose are easily defined in the time-worn face of Dürer's line and wash drawing. In studying the nose, the artist must first learn something of its basic structure and its parts. He must then examine and compare the sizes, shapes, directions, and positional relationships of these parts. Finally, he can give form and individuality to these parts in his drawing by the way in which he assembles and designs these elements.

The form of the nose depends on the size and shape of the nasal bones and the nasal cartilage. The bony pyramid of the nasal bone (A) runs from the root of the nose (B) just below the glabella (C) to about mid-nose. Dürer clues us to its end by angling it slightly (D) where the bone turns to cartilage. The line moves inward to form half of the septal angle (E) at the midline of the nose. The lower lateral, comma, or alar cartilage (F) curves from behind, creating the wings or alae (G) and the central bulb (H), and then curves over the tip or dome (I), folding back upon itself and helping to form the inner nostril (J). Dürer marks the cleft at the meeting of the two halves of this cartilage by a short line (K).

The septal cartilage that divides the nasal passage under the tip of the nose is not visible on this lowered head, and the curve of the reflected light (L) on the nasal wing is our only indication of the nostrils. Dürer breaks the plane at the tip of the nose (M), on the wing or ala (G), and at the side of the nasal bone (N), where a transitional halftone (O) eases us into the highlight (P).

The horizontal furrow (Q) at the root of the nose forms at right angles to the vertical pyramidalis nasi or procerus muscle (R) at the sides of the bridge of the nose. The compressor nasi (S) lies on either side of the upper lateral cartilage. Tiny dilator and depressor muscles on the wing of the nose also contribute to the form. They become prominent during times of great exertion and in expressions of strong emotions.

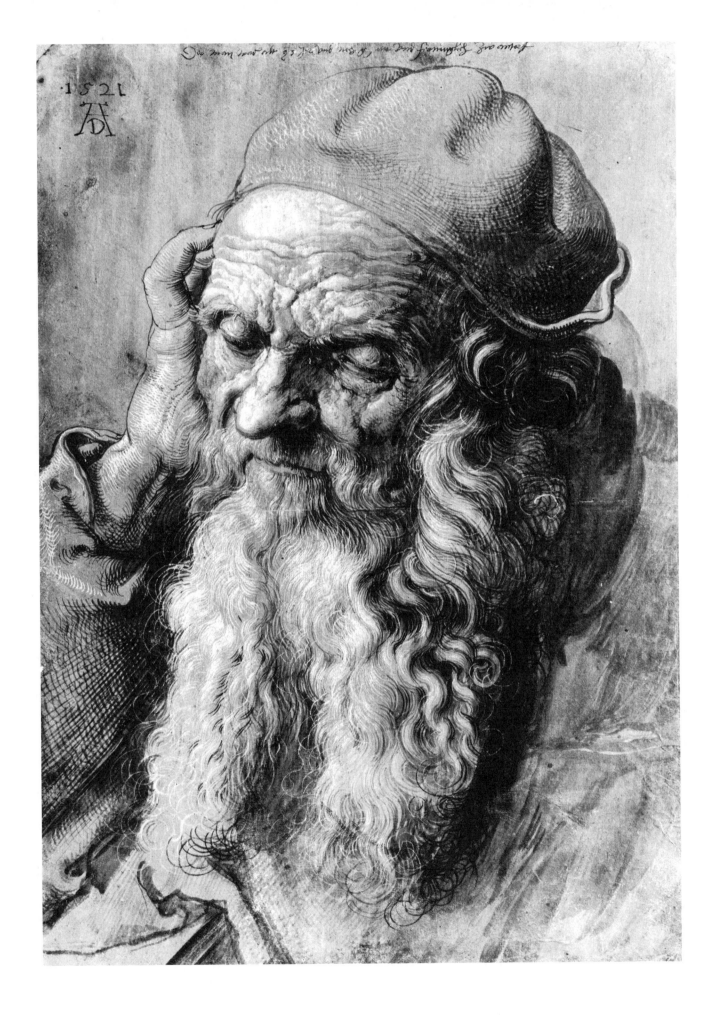

Lorenzo di Credi (c.1458-1537)
HEAD OF A YOUNG MAN
black chalk and ink on pink paper
7 1/8" x 5 3/8" (180 x 138 mm)
Museum Boymans-van Beuningen, Rotterdam

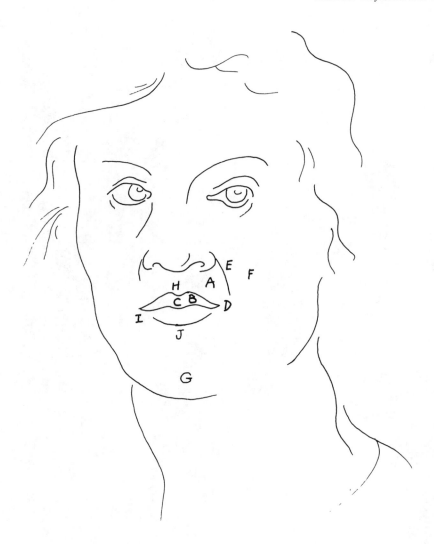

The Mouth

The oral region includes the mouth, the teeth, and the tongue. The obicularis oris muscle (A) circles the mouth, creating the thickness of the lips. The outer surface of the lips (B), called the red margin or vermillion zone, varies greatly in individuals. It is generally thicker at the middle tubercle of the upper lip (C), which forms the central section of the lip. Both lips taper to meet the corner or angle of the mouth (D).

The upper lip extends to the base of the nose, out to the nasolabial furrow (E) at the edge of the buccal region of the cheeks (F), and down to the opening of the mouth. The line of this opening and the mass of the upper lip form a cupid's bow, a shape that curves around the cylinder of the mouth following the curved form of the teeth. If you divide the distance between the base of the nose and the base of the mental eminence or chin (G) into three parts, you will note that di Credi has placed the slit of the mouth at the upper third division.

The highlight (H) runs along the rim of the upper lip on the long, thin, light area called the new skin. It curves down at the center to accentuate the shallow vertical groove of the philtrum (H), the groove above the cupid's bow. In the lower lip, the highlights in the top plane follow the contour of the skin creases. Small highlights (I) at either end mark its outer limit at the angle of the mouth (D), and a dark accent (J) below shows the down plane where the lower lip meets the mentilabial furrow, the groove between the chin and lip area.

The central fibers of the obicularis oris (A) close and compress the mouth, and its outer fibers project the lips forward, as in pouting. Superficial and deep muscles converge upon the obicularis oris from all sides to raise, lower, and expand the lips, and to contribute significantly to the range of facial expressions.

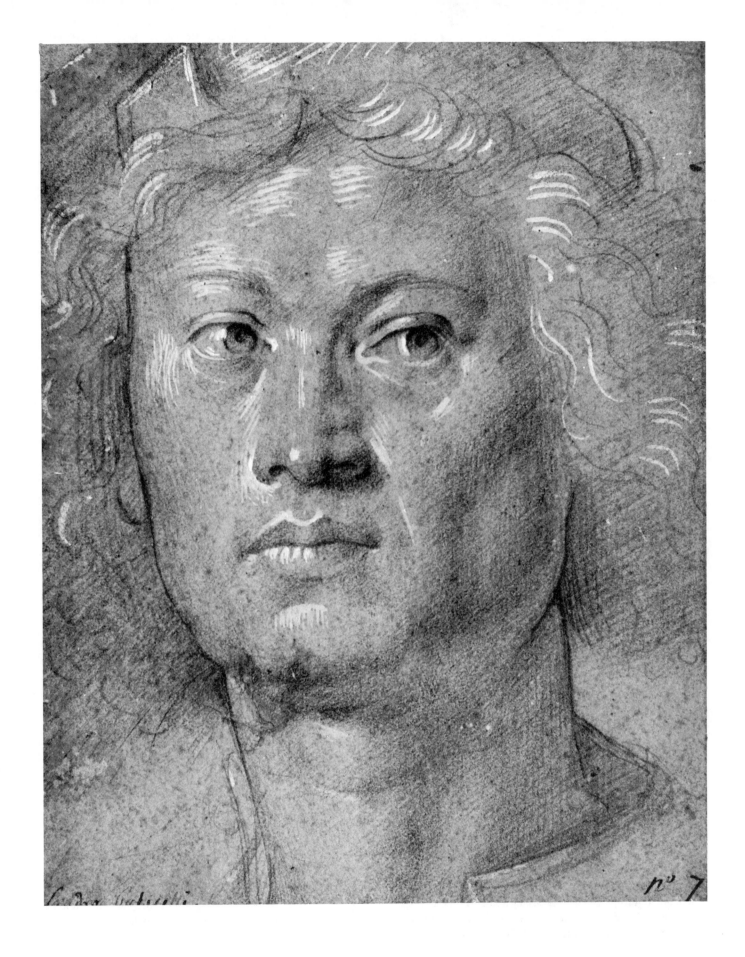

Michelangelo Buonarotti (1475-1564)
SKETCHES OF HEADS AND FEATURES
pen and ink
8 1/4" x 10" (206 x 255 mm)
Kunsthalle, Hamburg

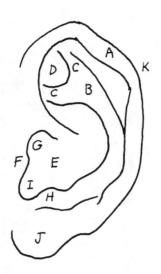

The Ear

This page of features delicately drawn by Michelangelo provides a good example of the auricle or external ear. The ear is connected to the skull by ligaments and muscles and consists of cartilage shaped for the collection of sound waves. Seen in profile, it lies behind the center-line of the head, behind and above the ramus or vertical portion of the jawbone, and above the mastoid process of the temporal bone of the skull.

The curved outer rim of the ear is called the helix (A). Inside this is the broader, curved ridge of the antihelix (B). In its upper and forward portion, the antihelix forms two separate ridges, called the crura (C), which create a small triangular fossa or depression (D).

Michelangelo places a large area of darks in the deep cavity of the lower ear, called the concha (E), that lies in from the lower portion of the antihelix (B). This area is bounded in the front by the small prominence of the tragus (F). The tragus, from which grow fine filtering hairs, overhangs the small black area that marks the opening of the auditory canal (G), leading to the inner ear. Another small tubercle, the antitragus (H), is the cartilage that sits opposite the tragus; the two are separated by the intertragic notch (I). Below this notch lies the soft oval form of the lobe (J).

The auricular muscles lie above, in front, and behind the ear, and help maintain it in its position on the skull, but otherwise are of little use to artists. Michelangelo has placed a slight angle in the long curve of the helix at the slight rise of the Darwinian tubercle (K). This evolutionary leftover represents the extreme point of the very movable ear that we can still observe in animals such as the horse.

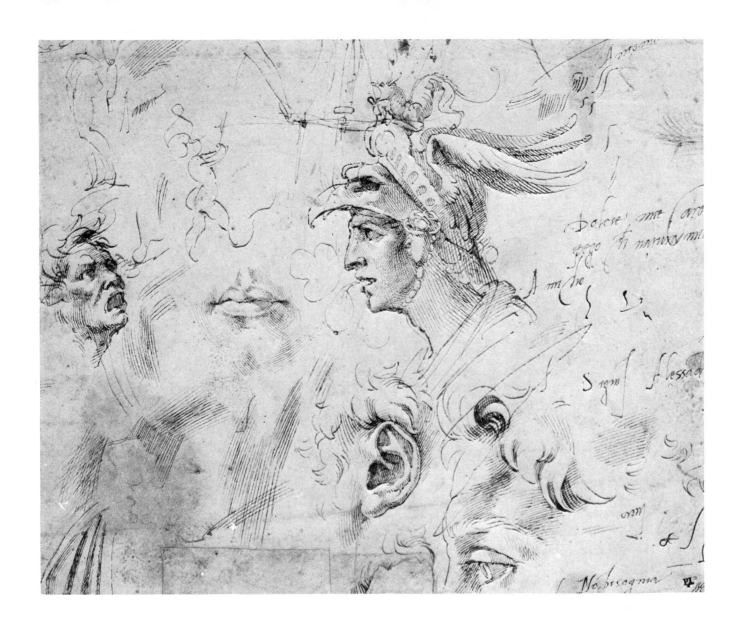

Leonardo da Vinci (1452-1519)
GROUP OF FIVE GROTESQUE HEADS
pen and ink
10 1/4" x 8 1/2" (260 x 215 mm)
Reproduced by gracious permission of
Her Majesty the Queen
Royal Library, Windsor

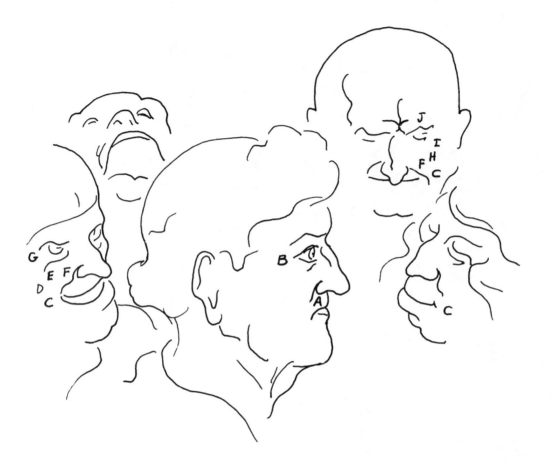

Emotions: High Spirits to Laughter

In order to master the finer gradations of human expressions, a careful study of the muscles of the face is of great importance. It is helpful to examine Leonardo's five heads, which suggest a graduated series of emotions ranging from a pleased countenance, through grinning and smiling, to violent laughter.

The man with the bald head, which is crowned with oak leaves, gives the appearance of self-satisfaction. The head is upright with no inclination and the central fibers of the orbicularis oris (A) compress the lips firmly. The strong contrast between the pupil and the iris give the eye the bright sparkle of a pleased or bemused state of mind and the "crow's feet" (B) at the corner of the eye suggest his tendency to smile frequently.

The head on the lower right exhibits a stubborn grin activated by the risorius muscle (C), with little expression about the eyes. It is a short step between this expression and that of the grinning woman at the extreme left. Here the risorius (C) together with the zygomatic major (D) and the zygomatic minor (E) muscles pull the lips back and upward. This deepens the nasolabial furrow (F) and, with the orbicularis palpebrarum (also called the orbicularis oculi) muscle surrounding the eye, causes wrinkles to form at the corners of the eye (G).

The figure in the background at the upper right suggests a false smile. The angles of his mouth are spread by the risorius (C) as in a very wide grin. In a true smile, the action of the two zygomatic muscles (H) and the lower portion of the orbicularis palpebrarum muscle (I) would have raised the nasolabial furrow (F) much higher, causing crow's feet to form at the corners of the eyes. Above all, the action of the corrugator muscle (J), causing a vertical frown crease, reveals the falseness of the smile. The corrugator never acts under the influence of joy.

At the end of the sequence, the figure on the upper left is in a state of violent laughter. His head is thrown back, his mouth is opened to its widest point, and his upper lip is raised in a grin that exposes his teeth.

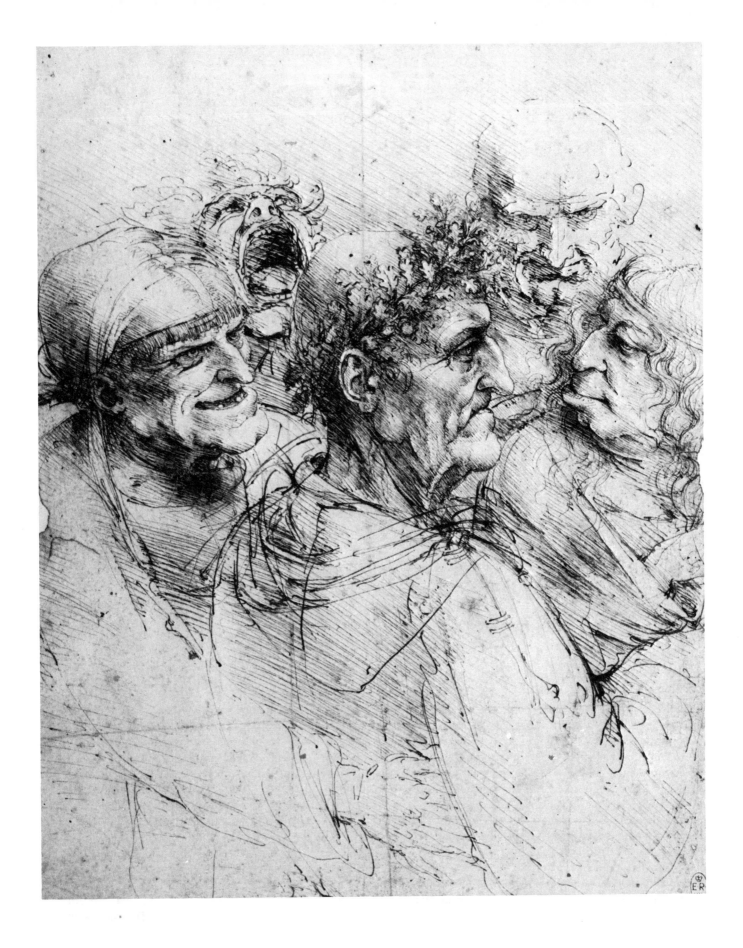

Nicholas Poussin (1594-1665)
SELF-PORTRAIT
chalk
British Museum, London

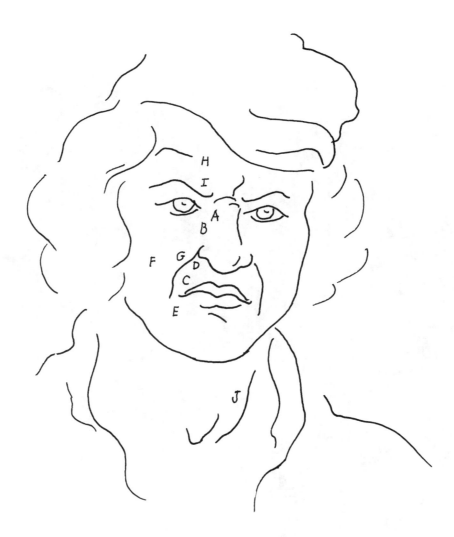

Emotions: Contempt to Disgust

The expressions of contempt, scorn, disdain, and disgust are expressed in many variations of facial movements, as well as by gestures of the head and limbs that represent rejection of something or someone.

Poussin depicts himself wearing a strong expression of disgust. Contempt, scorn, disdain, and disgust are merely variations in intensity of related emotions, since their combinations of muscular movements are similar. The most common means of expressing contempt is by movements about the nose and mouth.

In Poussin's drawing, there is a slight lifting of the nose by the pyramidalis nasi or procerus (A) and the levator labii superioris alaeque nasi (B), causing the wrinkle that forms at the root of the nose. This is usually accompanied by a slight, snarling, upward movement of the upper lip with the assistance of the caninus (C), as if to display the canine tooth. In the expression of disgust, the nose is slightly constricted by the depressor alae nasi (D) which partly closes the opening, as if to exclude an offensive odor.

The angle of the mouth is moved downward in displeasure by the action of the depressor anguli oris (E). The zygomaticus major (F) pulls the upper lip and cheek backward and up, deepening the nasolabial furrow (G).

The skin of the forehead is drawn downward and wrinkled by the frontalis (H) and the corrugators (I) of both sides, adding to the frowning appearance.

The eyes stare contemptuously ahead, and the emphasis on one sternocleidomastoideus (J) indicates that the head has just turned to direct the gaze at the object of dislike.

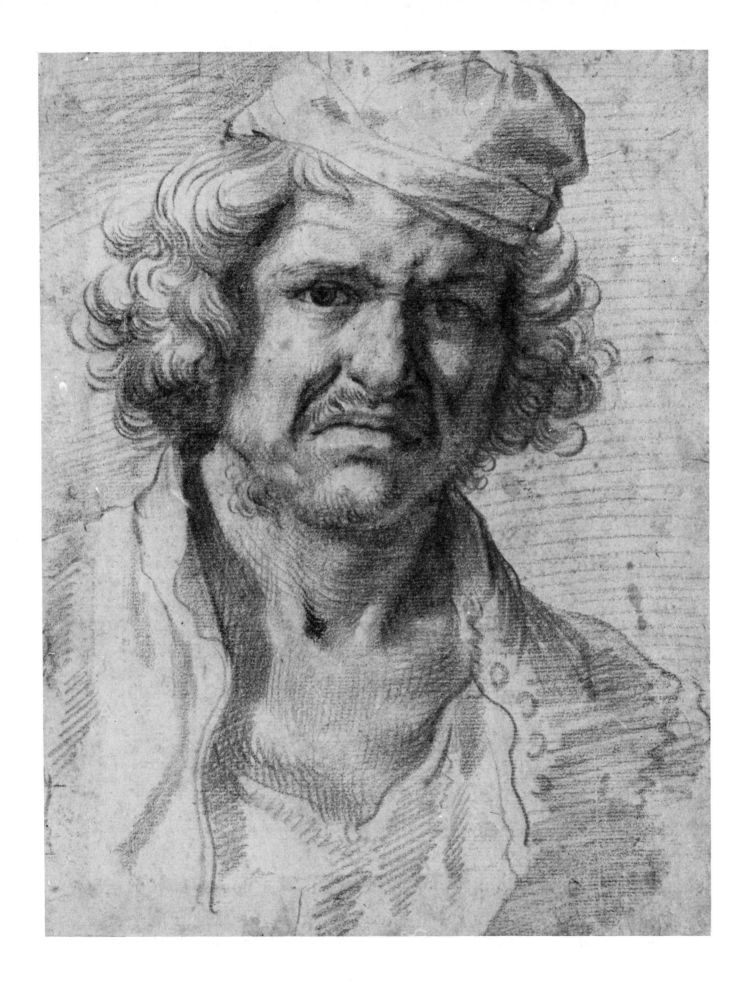

Jacopo Pontormo (1494-1556)
STUDY OF A PORTRAIT OF PIERO DE' MEDICI
red chalk
6 3/16" x 7 13/16" (157 x 198 mm)
Uffizi, Florence

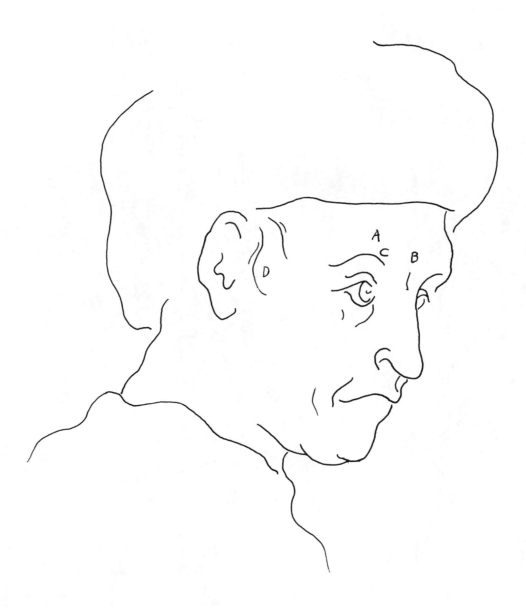

Emotions: Attention to Horror

Most artists have observed the transformations of the features of the face as the expressions graduate from sudden attention to surprise, admiration, astonishment, fear, and finally, to horror. In Pontormo's study, the subject is at the attention stage. The brows are strongly raised by the occipito-frontalis muscle (A) to allow the eyes to rapidly open wide in order to quickly perceive the cause of attention.

The mouth of Pontormo's subject has not opened as it would in astonishment, but is compressed as in thought. This facial gesture is reinforced by the vertical frown line (B) suggesting the action of the corrugator supercilii (C), the muscle of reflection.

The two wisps of hair (D) that echo the curves of the brow and eye and draw attention to the ear suggest that the model is listening intently to an unidentified sound. Our interest in this area is further reinforced by the nearly parallel lines of these two spirals of hair.

In fear, the chief play of muscles is seen in the areas of the eyes and the mouth. As attention turns to fear, the jaw drops, the mouth opens, the eyes widen, and the pupils dilate.

As fear turns to horror, the platysma myoides muscle, which spreads over the surface of the side of the neck from mouth to shoulder, is strongly contracted. This further draws down the angles of the mouth and produces deep oblique wrinkles in the neck.

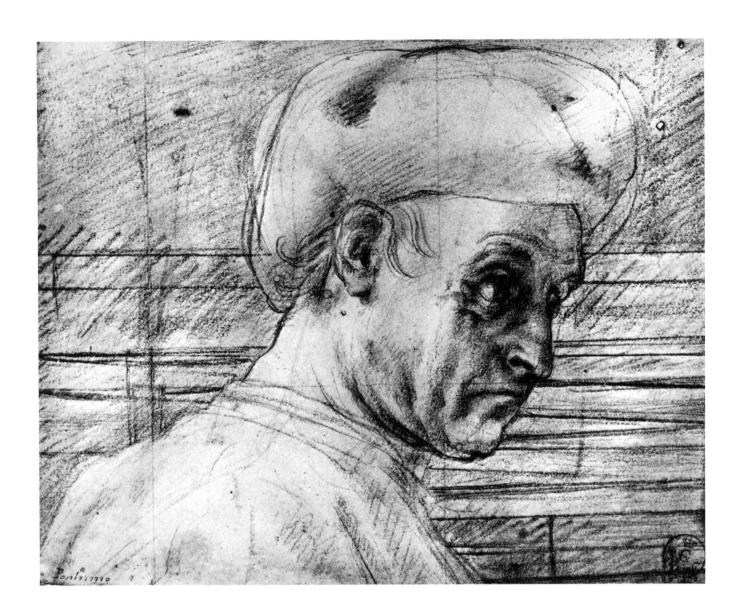

Giovanni Bellini (c.1430-1516)
HEAD OF AN OLD MAN
brush on blue paper, heightened with white
10 1/4" x 7 1/2" (260 x 190 mm)
Reproduced by gracious permission of
Her Majesty the Queen
Royal Library, Windsor

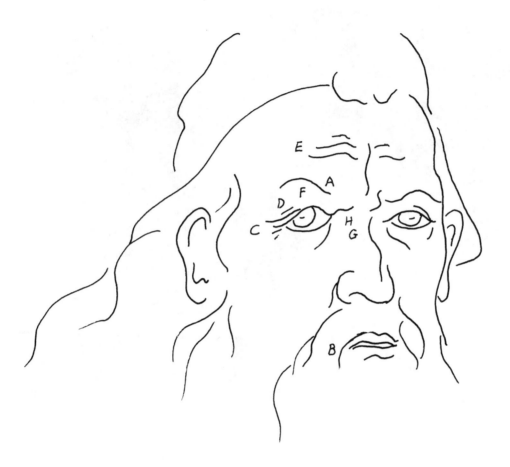

Emotions: Reflection to Grief

The corrugator supercilii (A) is the muscle of troubled reflection. In Bellini's old man, by its contraction, this muscle "knits" the eyebrows by drawing them inward. It helps convey the impression of deep thought, as well as some difficulty or disturbance to the tranquil state of mind.

The model's slightly opened mouth suggests an element of pain, exhaustion, and resignation. The despair of long suffering expresses itself in actions opposite to those that produce laughter. There is a relaxation, not only of the muscles of the face, but of the whole body. The jaw drops, the mouth opens, and the angle of the mouth (B) droops downward. There is a general sagging around the cheeks and eyes.

The familiar "crow's feet" wrinkles (C), the wrinkles in the upper eyelid (D), and the wrinkles in the area of the frontal eminence (E) suggest frequent activity of the obicularis palpebrarum (F) that surrounds the eye and the vertical frontalis muscle (E) above.

With the increase of grief, the whole frowning brow is drawn further down by the vertically placed pyramidalis nasi (G) on either side of the nose, causing the horizontal wrinkles (H) at the root of the nose.

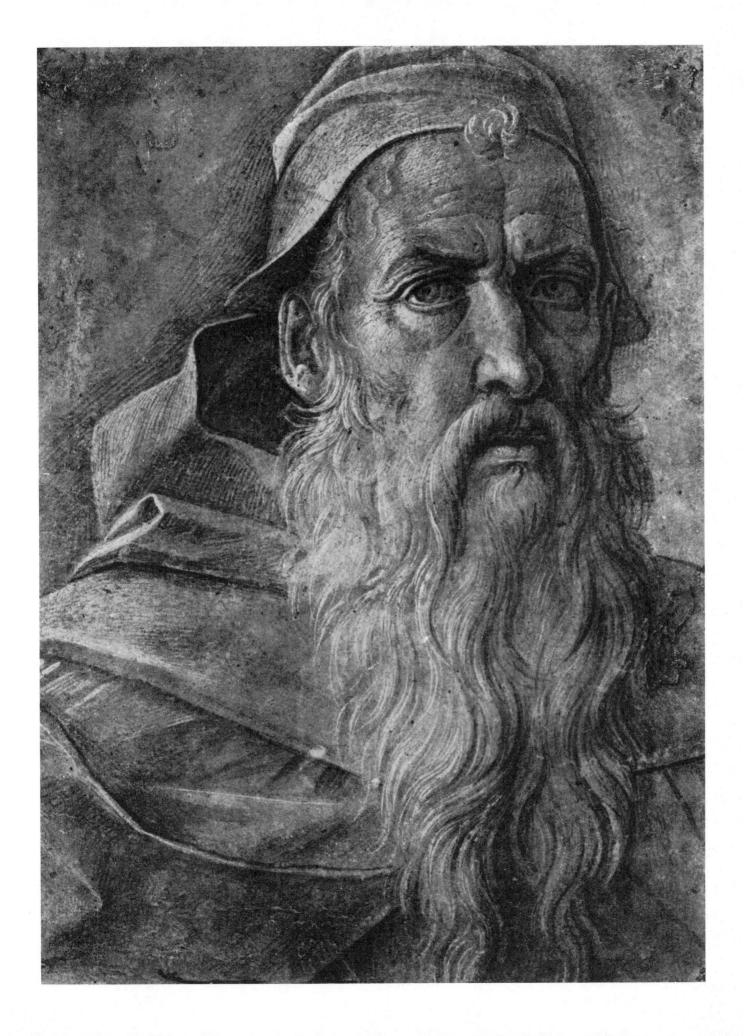

Michelangelo Buonarotti (1475-1564)
DAMNED SOUL, A FURY
black chalk
ll 5/8" x 8" (295 x 203 mm)
Uffizi, Florence

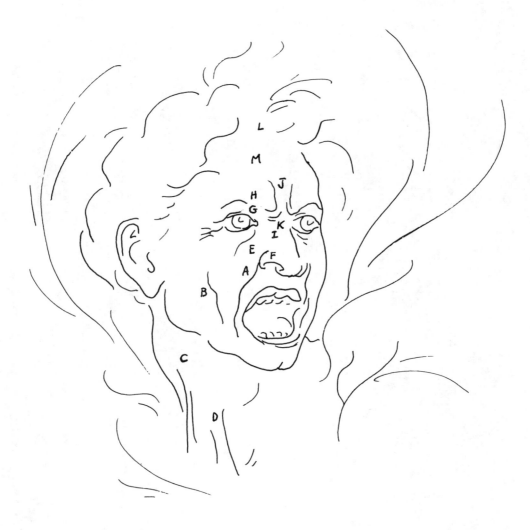

Emotions: Defiance to Rage

The rage of Michelangelo's "Fury" is an intensification of the simple, sneerlike defiance, when a threatening canine tooth is exposed by drawing up the upper lip. The mouth of the raging "Fury" is opened wide. The lips are drawn to the sides and upward causing the deepening of the nasolabial furrow (A) and the jugal furrow (B) of the cheek bone.

One dominant vertical strand of muscular fiber (C) clues us to the contractions of the platysma muscle which covers the front and side of the neck. This muscle shows in times of rage, great fright, nausea, or disgust. The anterior portion of the platysma draws down the inferior maxillary in order to open the mouth, and it aids in drawing down the lower lip and the sides of the mouth.

The sternocleidomastoideus (D) stands out as the head is turned to face the antagonist. The swirl of the surrounding drapery both accentuates this action and harmonizes with it.

The entire upper lip is retracted by the levators (E), exposing a row of teeth, as if to bite the opponent. The upper lip and the wing of the nose move upward. The nostril is dilated by the anterior and posterior dilator naris muscles (F), permitting greater intake of air in preparation for strenuous action.

The orbicularis palpebrarum (G), the corrugator (H), and the pyramidalis nasi or procerus (I) depress and contract the brows, causing deep central furrows (J) and wrinkles over the bridge of the nose (K).

The bristling of hairs (L) associated with violent anger is caused by contraction of the frontalis muscle (M), these movements intensifying the overall agitation of the curved lines in the drawing.

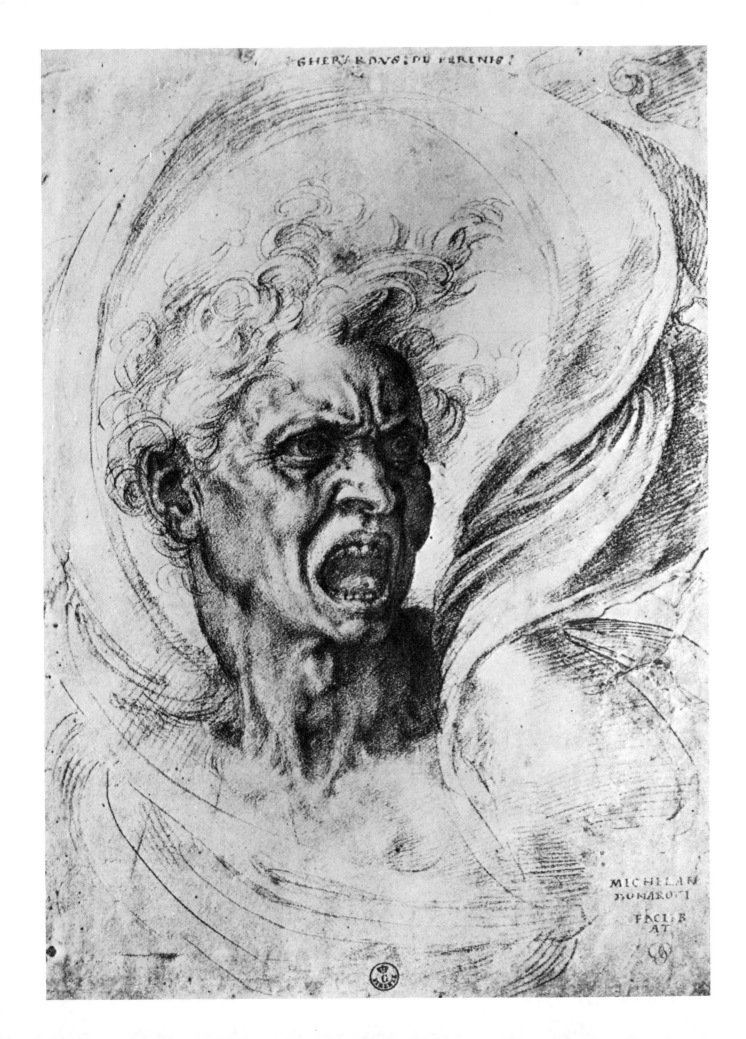

Leonardo da Vinci (1452-1519)
MALE NUDE FACING FRONT
red chalk on red paper
9 1/4" x 5 3/4" (236 x 146 mm)
Reproduced by gracious permission of
Her Majesty the Queen
Royal Library, Windsor

Proportions

Many methods have been devised for measuring the human figure. The units of measurement have ranged from the length of the middle finger used by the Egyptians, to the length of the palm of the hand of the Greeks, to the eight-headed figure of Vitruvius, to the five-eyed width of the head used by Cousins, to the seven-and-a-half heads of the Canon des Ateliers advocated by Richer that is very much in use today.

In the study of proportions, the artist seeks keys to harmonic relationships in nature. The ancient Greeks applied knowledge gained in the study of the human body to the construction of the Parthenon. Like the body, the Parthenon is a harmonious unit in which the component parts function in balance with the whole, and yet deviate from absolute mathematical regularity in order to correct optical illusions.

Since individuals vary so greatly, it is impossible to lay down absolute rules on proportions. And with every movement of the body there are changes in perspective and foreshortening that also frustrate attempts to measure the body visually. So a set of rules on proportions can never be more than a guide. But organizing the body in a logical way can help to clarify relationships between its parts.

Leonardo used the seven-and-one-half-head measurement in this drawing, though he often deviated from this measurement, as did Dürer and the other great masters. He knew that the traditional measuring points of the nipple, navel, and genital organs were not fixed points, but only guides from which he could create individual modifications.

All great master drawings will show deviations from basic structure. Once the standard measurements, landmarks, memory devices and other clues have taught you to observe and compare, you can safely put them aside and follow your own creative impulses.

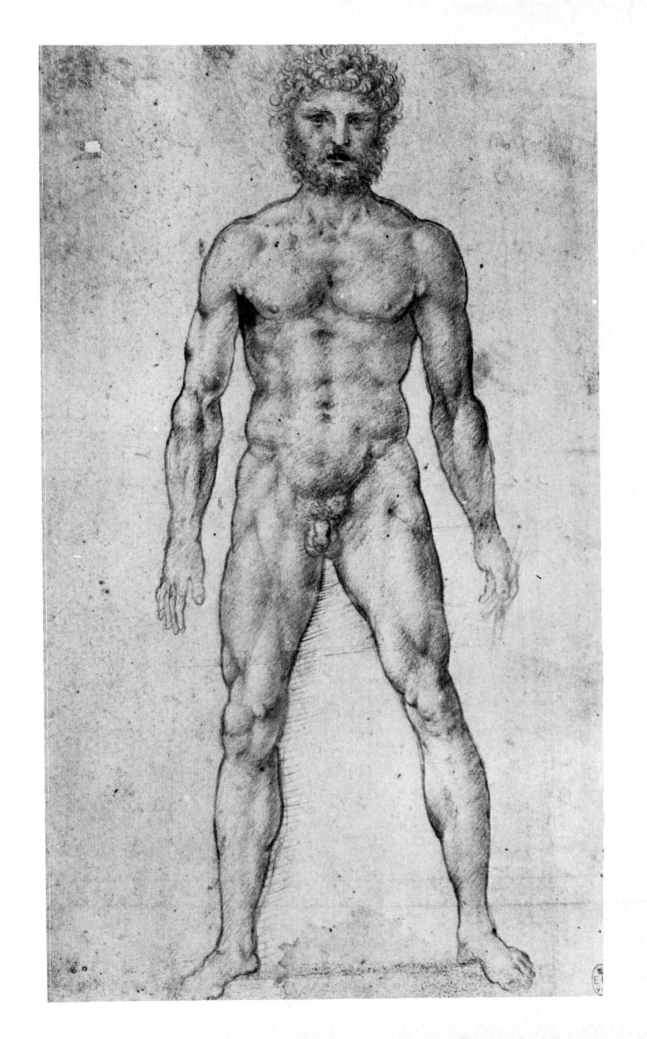

ANATOMICAL REFERENCE PLATES

Anatomical plates, to be of practical use to art students in the study of anatomy, should provide clear, precise, and quick reference to important anatomical information. These fine plates from Dr. Richer's *Artistic Anatomy* (translated and edited by Robert Beverly Hale) more than fill that need. As reference material for the student of anatomy, these plates are scientifically and simply presented so as to avoid the anatomical inaccuracies and perspective distortions so often seen in anatomical illustration. It seems appropriate that, in contrast to the 100 drawings of the great masters, the style of these reference plates is subdued so as to provide accurate information without influencing the student's personal style.

Plate 1: THE SKULL

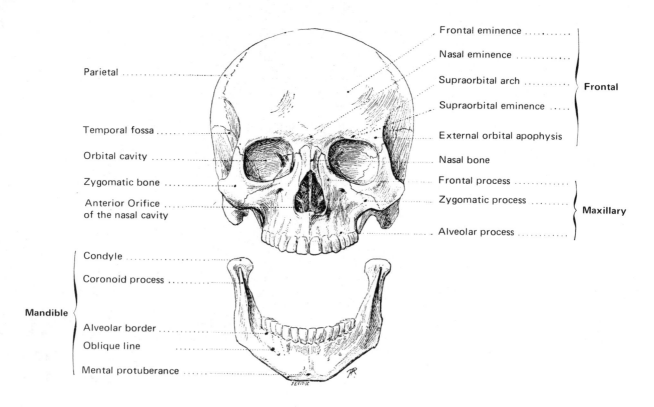

Frontal eminence
Nasal eminence
Supraorbital arch
Supraorbital eminence
External orbital apophysis
Nasal bone
Frontal process
Zygomatic process
Alveolar process

Frontal

Maxillary

Parietal

Temporal fossa
Orbital cavity
Zygomatic bone
Anterior Orifice
of the nasal cavity

Mandible
Condyle
Coronoid process
Alveolar border
Oblique line
Mental protuberance

ANTERIOR ASPECT

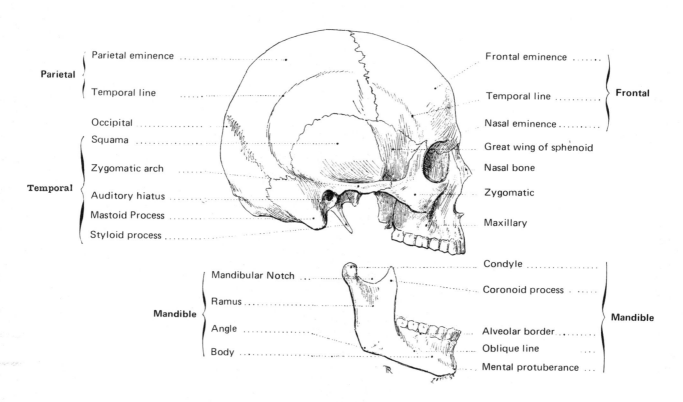

Parietal
Parietal eminence
Temporal line

Occipital

Temporal
Squama
Zygomatic arch
Auditory hiatus
Mastoid Process
Styloid process

Frontal eminence
Temporal line
Nasal eminence
Great wing of sphenoid
Nasal bone
Zygomatic
Maxillary

Frontal

Mandible
Mandibular Notch ...
Ramus
Angle
Body

Condyle
Coronoid process
Alveolar border
Oblique line ...
Mental protuberance ...

Mandible

LATERAL ASPECT

Plate 2: THE SKULL

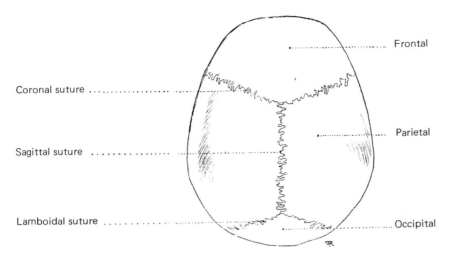

Frontal

Coronal suture

Sagittal suture

Lamboidal suture

Parietal

Occipital

SUPERIOR ASPECT

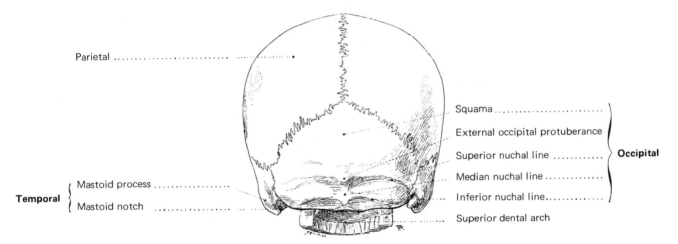

Parietal

Temporal {
Mastoid process
Mastoid notch
}

Squama

External occipital protuberance

Superior nuchal line

Median nuchal line

Inferior nuchal line

Superior dental arch

Occipital }

POSTERIOR ASPECT

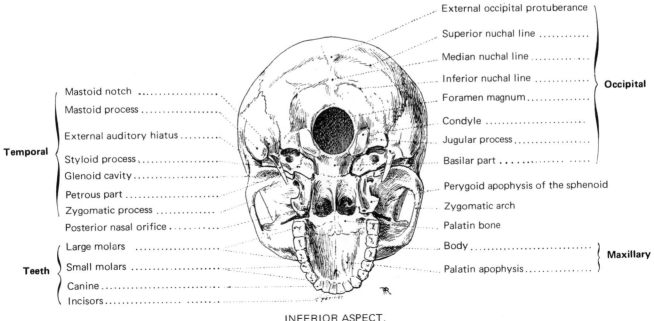

Temporal {
Mastoid notch
Mastoid process
External auditory hiatus
Styloid process
Glenoid cavity
Petrous part
Zygomatic process
Posterior nasal orifice
}

Teeth {
Large molars
Small molars
Canine
Incisors
}

External occipital protuberance

Superior nuchal line

Median nuchal line

Inferior nuchal line

Foramen magnum

Condyle

Jugular process

Basilar part

Occipital

Perygoid apophysis of the sphenoid

Zygomatic arch

Palatin bone

Body

Palatin apophysis

Maxillary }

INFERIOR ASPECT,
BASE OF CRANIUM

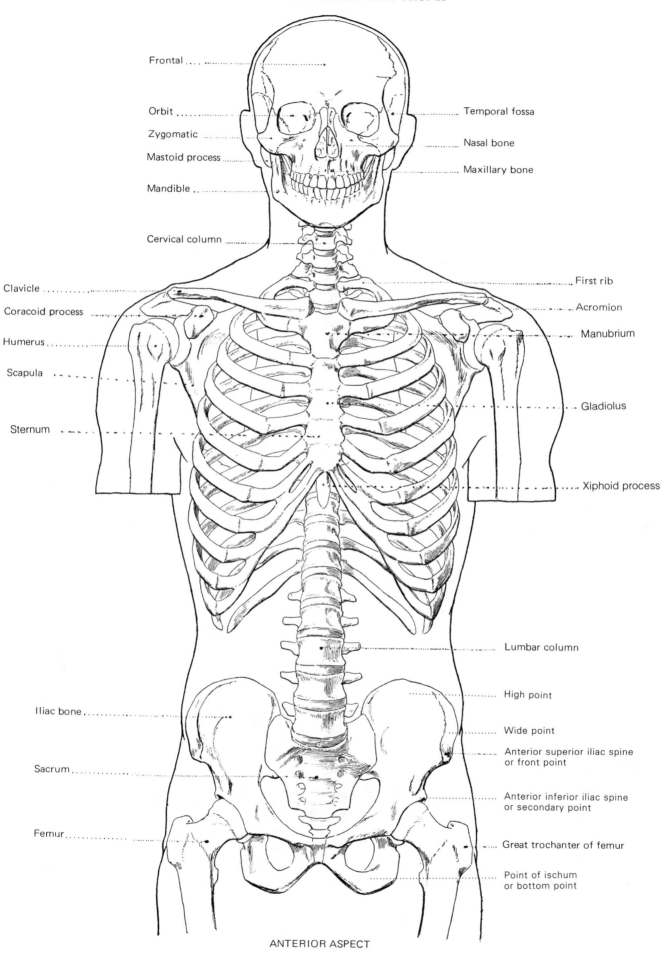

Frontal

Orbit

Zygomatic

Mastoid process

Mandible

Cervical column

Temporal fossa

Nasal bone

Maxillary bone

Clavicle

Coracoid process

Humerus

Scapula

Sternum

First rib

Acromion

Manubrium

Gladiolus

Xiphoid process

Lumbar column

High point

Iliac bone

Wide point

Anterior superior iliac spine
or front point

Sacrum

Anterior inferior iliac spine
or secondary point

Femur

Great trochanter of femur

Point of ischum
or bottom point

ANTERIOR ASPECT

Plate 4: SKELETON OF THE TRUNK

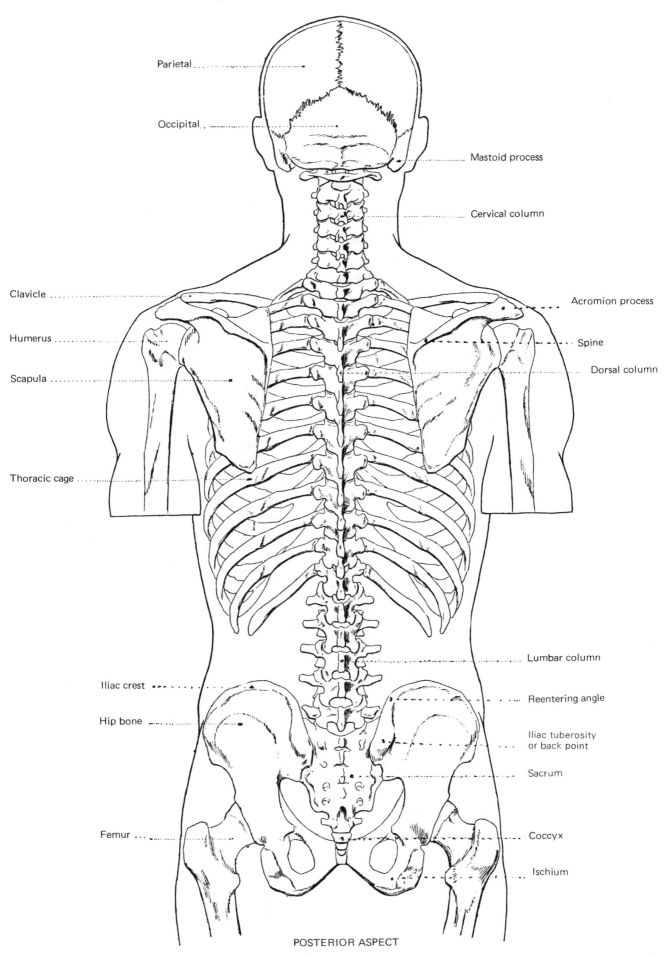

Parietal

Occipital

Mastoid process

Cervical column

Clavicle

Acromion process

Humerus

Spine

Scapula

Dorsal column

Thoracic cage

Lumbar column

Iliac crest

Reentering angle

Hip bone

Iliac tuberosity
or back point

Sacrum

Femur

Coccyx

Ischium

POSTERIOR ASPECT

235

Plate 5: SKELETON OF THE TRUNK

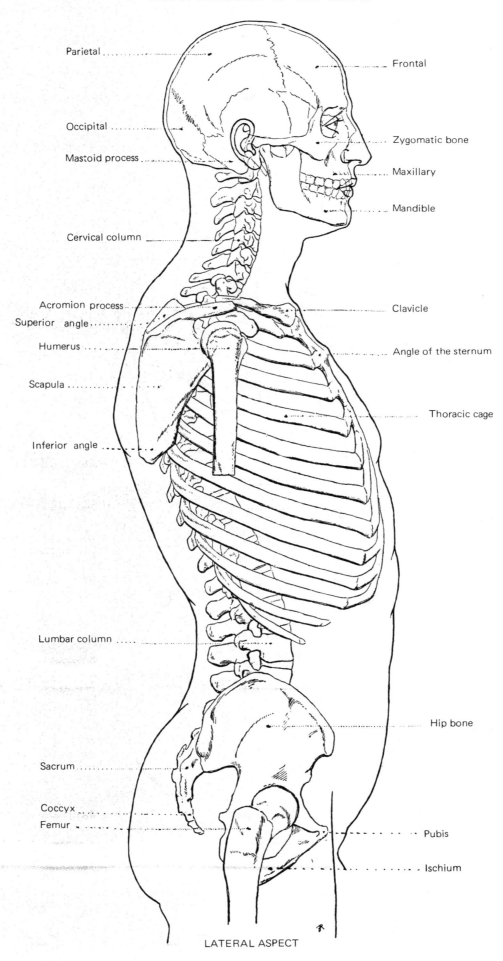

Parietal

Occipital

Mastoid process

Cervical column

Acromion process
Superior angle
Humerus

Scapula

Inferior angle

Lumbar column

Sacrum

Coccyx
Femur

Frontal

Zygomatic bone

Maxillary

Mandible

Clavicle

Angle of the sternum

Thoracic cage

Hip bone

Pubis

Ischium

LATERAL ASPECT

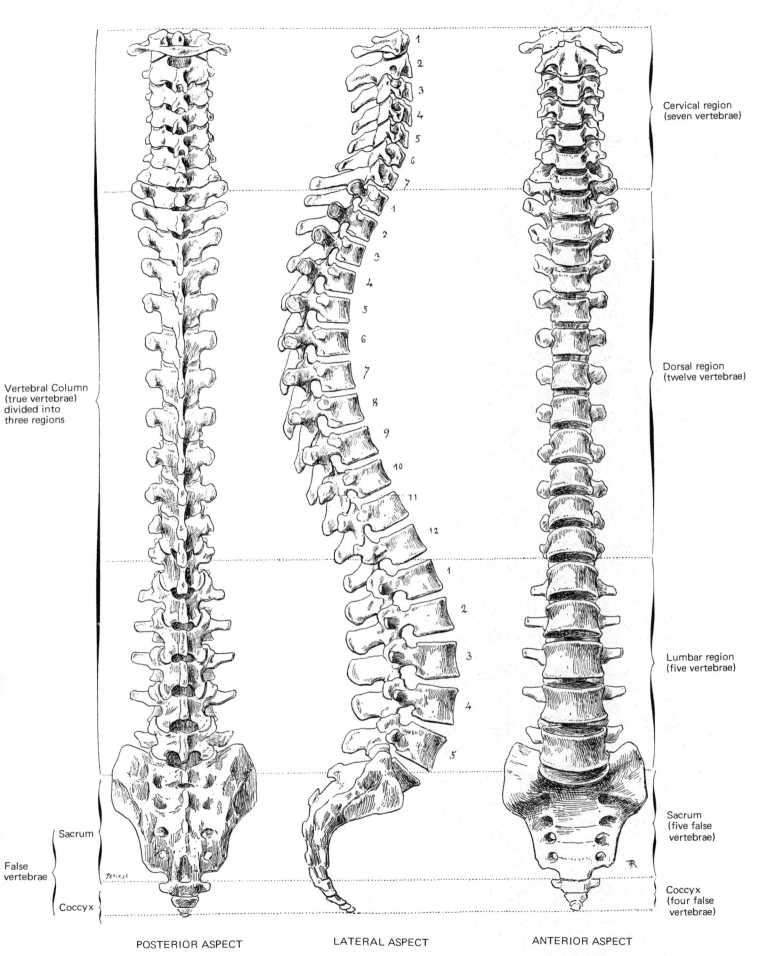

POSTERIOR ASPECT LATERAL ASPECT ANTERIOR ASPECT

237

Plate 7: THE PELVIS

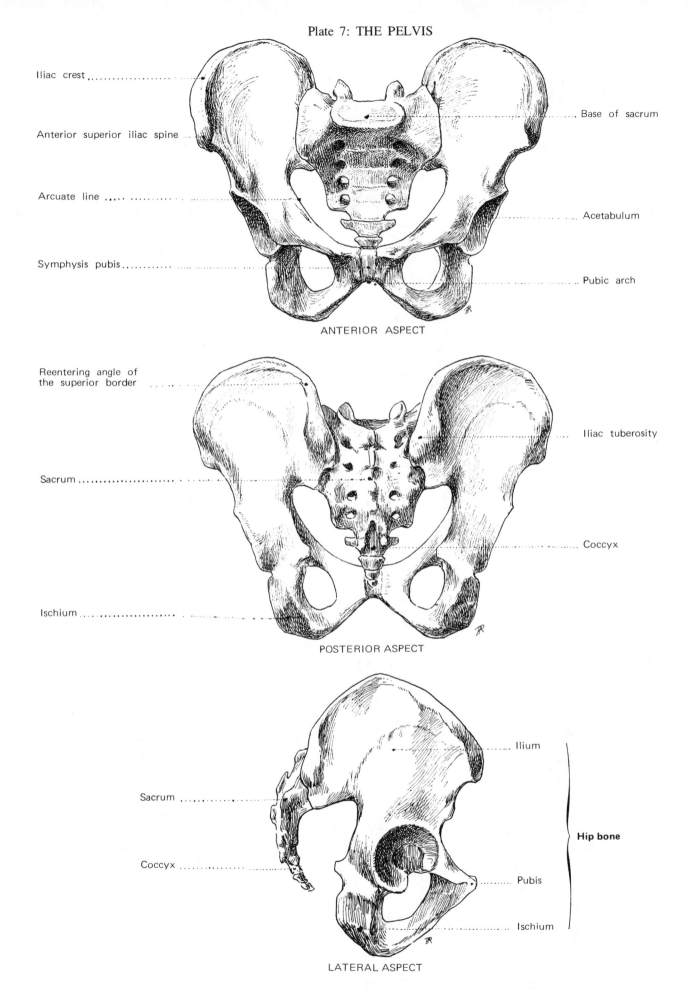

Iliac crest

Anterior superior iliac spine

Arcuate line

Symphysis pubis

Base of sacrum

Acetabulum

Pubic arch

ANTERIOR ASPECT

Reentering angle of the superior border

Sacrum

Ischium

Iliac tuberosity

Coccyx

POSTERIOR ASPECT

Sacrum

Coccyx

Ilium

Hip bone

Pubis

Ischium

LATERAL ASPECT

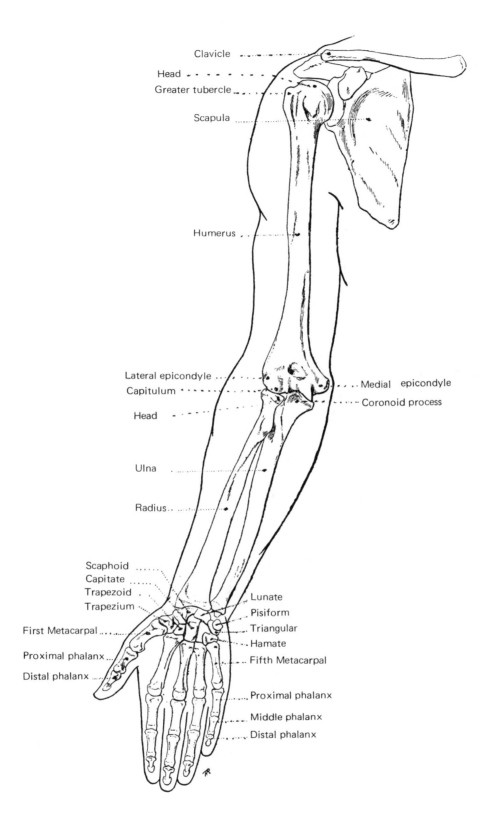

Clavicle

Head

Greater tubercle

Scapula

Humerus

Lateral epicondyle

Capitulum

Head

Ulna

Radius

Scaphoid

Capitate

Trapezoid

Trapezium

First Metacarpal

Proximal phalanx

Distal phalanx

Medial epicondyle

Coronoid process

Lunate

Pisiform

Triangular

Hamate

Fifth Metacarpal

Proximal phalanx

Middle phalanx

Distal phalanx

ANTERIOR ASPECT

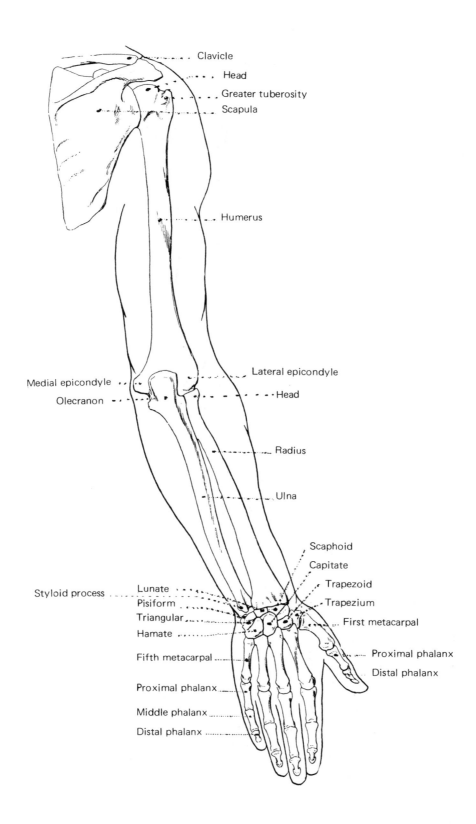

Clavicle
Head
Greater tuberosity
Scapula

Humerus

Lateral epicondyle
Medial epicondyle
Olecranon
Head

Radius

Ulna

Scaphoid
Capitate
Trapezoid
Trapezium
Styloid process
Lunate
Pisiform
Triangular
Hamate
First metacarpal

Proximal phalanx
Distal phalanx
Fifth metacarpal

Proximal phalanx

Middle phalanx

Distal phalanx

POSTERIOR ASPECT

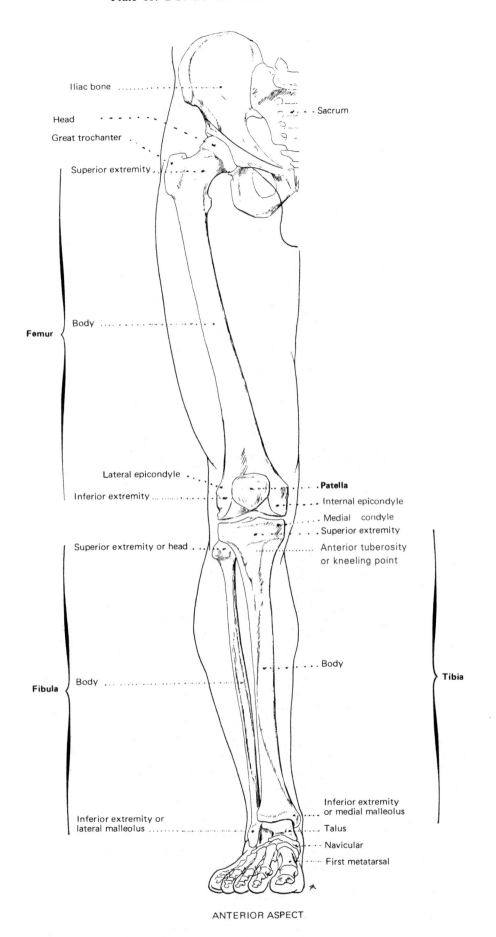

Iliac bone

Head

Great trochanter

Superior extremity

Sacrum

Femur

Body

Lateral epicondyle

Inferior extremity

Patella

Internal epicondyle

Medial condyle

Superior extremity

Superior extremity or head

Anterior tuberosity
or kneeling point

Fibula

Body

Body

Tibia

Inferior extremity
or medial malleolus

Inferior extremity or
lateral malleolus

Talus

Navicular

First metatarsal

ANTERIOR ASPECT

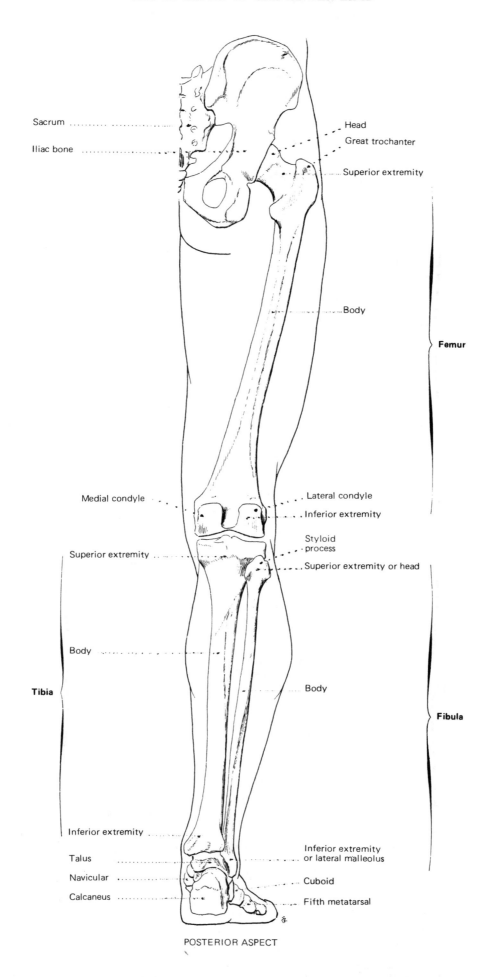

Sacrum

Iliac bone

Head

Great trochanter

Superior extremity

Body

Femur

Medial condyle

Lateral condyle

Inferior extremity

Styloid process

Superior extremity

Superior extremity or head

Body

Tibia

Body

Fibula

Inferior extremity

Inferior extremity or lateral malleolus

Talus

Navicular

Cuboid

Calcaneus

Fifth metatarsal

POSTERIOR ASPECT

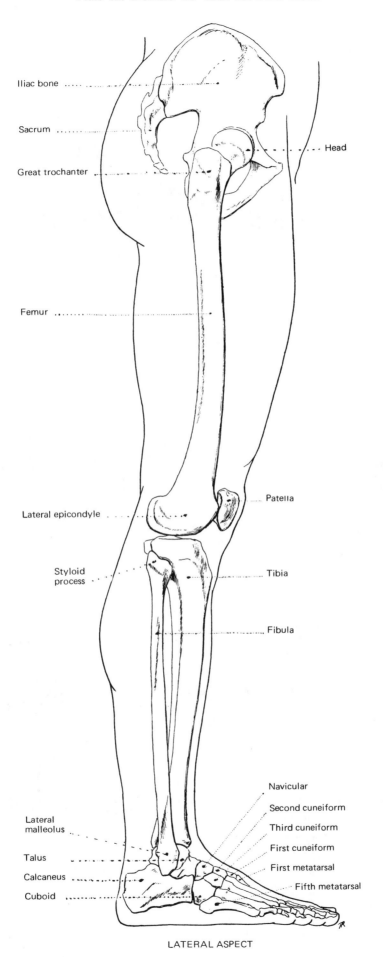

Iliac bone

Sacrum

Great trochanter

Head

Femur

Lateral epicondyle

Patella

Styloid
process

Tibia

Fibula

Navicular

Second cuneiform

Third cuneiform

First cuneiform

Lateral
malleolus

First metatarsal

Talus

Fifth metatarsal

Calcaneus

Cuboid

LATERAL ASPECT

Plate 13: BONES OF THE FOOT

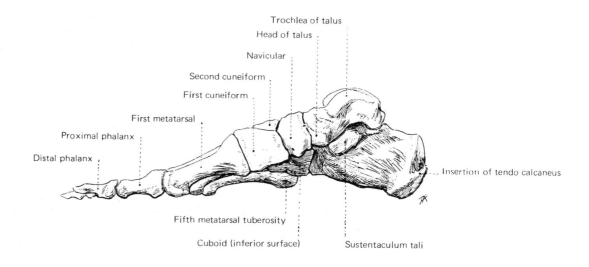

Trochlea of talus
Head of talus
Navicular
Second cuneiform
First cuneiform
First metatarsal
Proximal phalanx
Distal phalanx

Insertion of tendo calcaneus

Fifth metatarsal tuberosity
Cuboid (inferior surface)
Sustentaculum tali

MEDIAL ASPECT

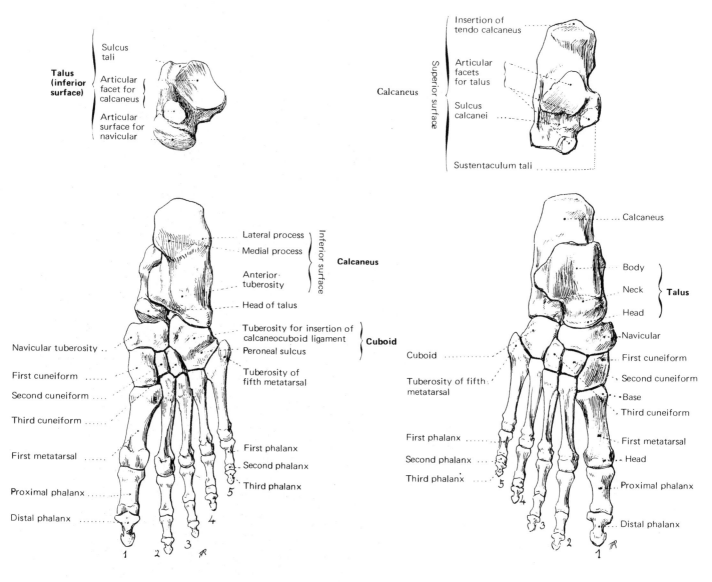

Talus (inferior surface)

Sulcus tali
Articular facet for calcaneus
Articular surface for navicular

Insertion of tendo calcaneus

Articular facets for talus

Sulcus calcanei

Sustentaculum tali

Calcaneus

Superior surface

Lateral process
Medial process
Anterior tuberosity

Calcaneus — Inferior surface

Head of talus

Tuberosity for insertion of calcaneocuboid ligament

Cuboid

Peroneal sulcus

Tuberosity of fifth metatarsal

Navicular tuberosity
First cuneiform
Second cuneiform
Third cuneiform
First metatarsal
Proximal phalanx
Distal phalanx

First phalanx
Second phalanx
Third phalanx

1 2 3 4 5

INFERIOR ASPECT

Calcaneus

Body
Neck
Head
Talus

Navicular
First cuneiform
Second cuneiform
Base
Third cuneiform
First metatarsal
Head
Proximal phalanx
Distal phalanx

Cuboid

Tuberosity of fifth metatarsal

First phalanx
Second phalanx
Third phalanx

1 2 3 4 5

SUPERIOR ASPECT

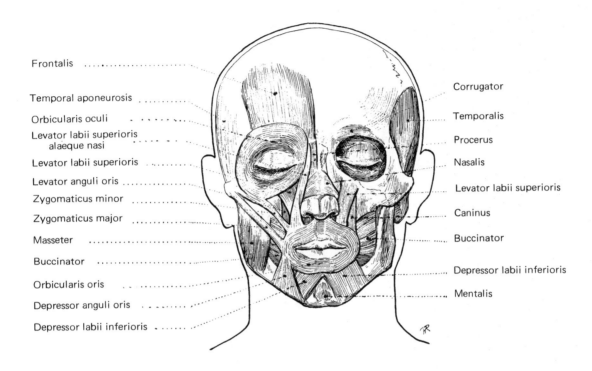

Frontalis

Temporal aponeurosis

Orbicularis oculi

Levator labii superioris
 alaeque nasi

Levator labii superioris

Levator anguli oris

Zygomaticus minor

Zygomaticus major

Masseter

Buccinator

Orbicularis oris

Depressor anguli oris

Depressor labii inferioris

Corrugator

Temporalis

Procerus

Nasalis

Levator labii superioris

Caninus

Buccinator

Depressor labii inferioris

Mentalis

Plate 15: MUSCLES OF THE HEAD

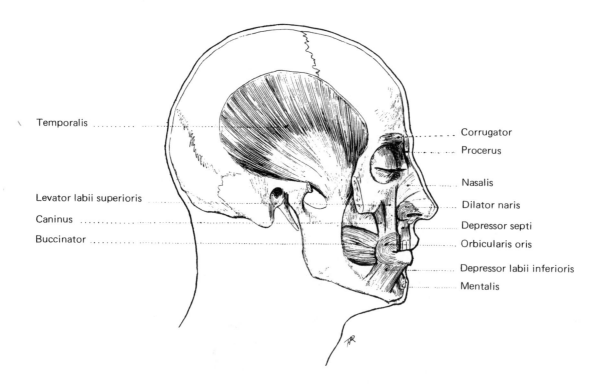

Temporalis

Levator labii superioris

Caninus

Buccinator

Corrugator

Procerus

Nasalis

Dilator naris

Depressor septi

Orbicularis oris

Depressor labii inferioris

Mentalis

DEEP LAYER

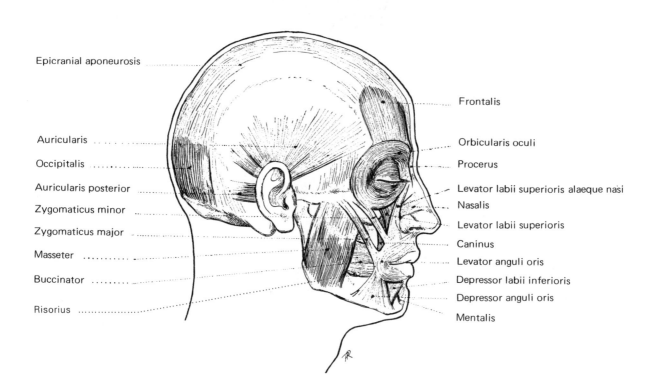

Epicranial aponeurosis

Auricularis

Occipitalis

Auricularis posterior

Zygomaticus minor

Zygomaticus major

Masseter

Buccinator

Risorius

Frontalis

Orbicularis oculi

Procerus

Levator labii superioris alaeque nasi

Nasalis

Levator labii superioris

Caninus

Levator anguli oris

Depressor labii inferioris

Depressor anguli oris

Mentalis

SUPERFICIAL LAYER

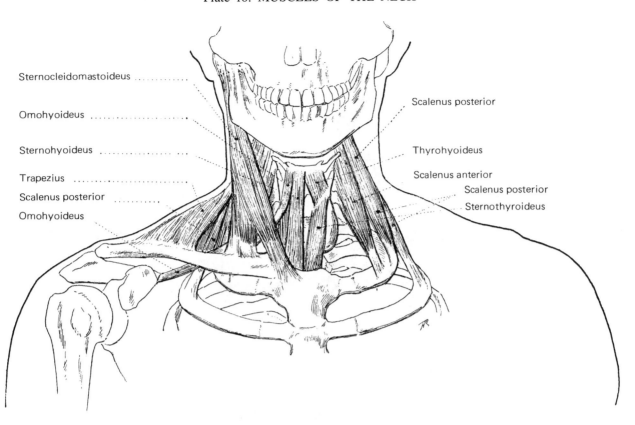

Sternocleidomastoideus

Omohyoideus

Sternohyoideus

Trapezius

Scalenus posterior

Omohyoideus

Scalenus posterior

Thyrohyoideus

Scalenus anterior

Scalenus posterior

Sternothyroideus

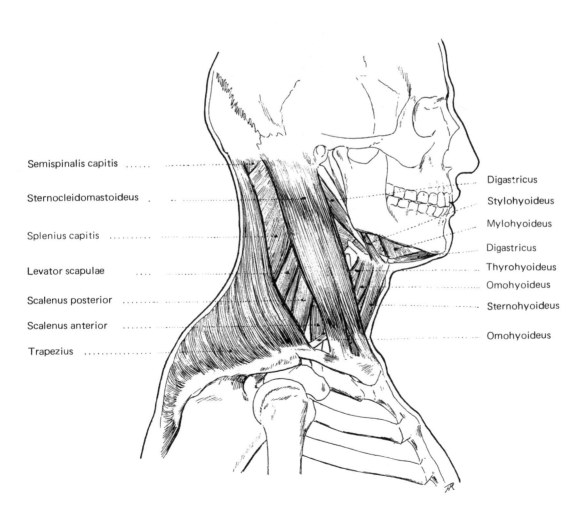

Semispinalis capitis

Sternocleidomastoideus .

Splenius capitis

Levator scapulae

Scalenus posterior

Scalenus anterior

Trapezius

Digastricus

Stylohyoideus

Mylohyoideus

Digastricus

Thyrohyoideus

Omohyoideus

Sternohyoideus

Omohyoideus

247

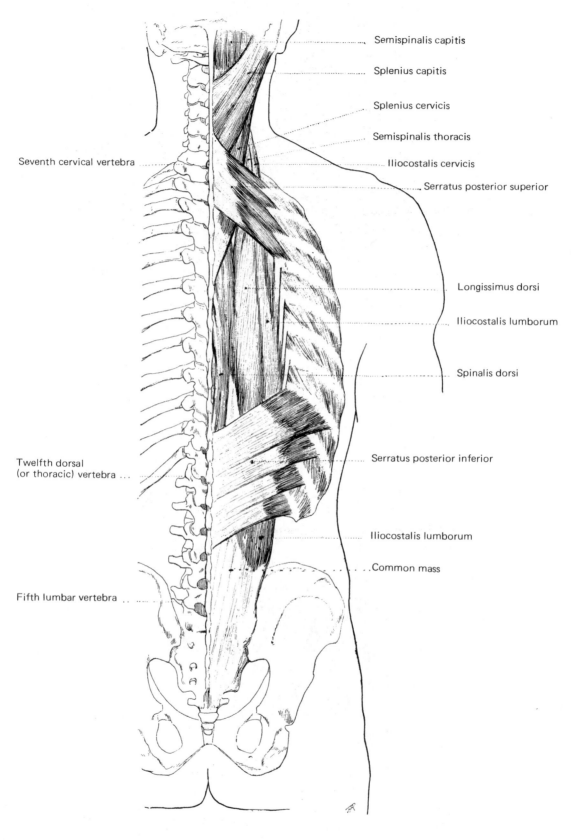

Semispinalis capitis

Splenius capitis

Splenius cervicis

Semispinalis thoracis

Iliocostalis cervicis

Serratus posterior superior

Seventh cervical vertebra

Longissimus dorsi

Iliocostalis lumborum

Spinalis dorsi

Serratus posterior inferior

Twelfth dorsal
(or thoracic) vertebra

Iliocostalis lumborum

Common mass

Fifth lumbar vertebra

SERRATUS POSTERIOR,
SUPERIOR AND INFERIOR

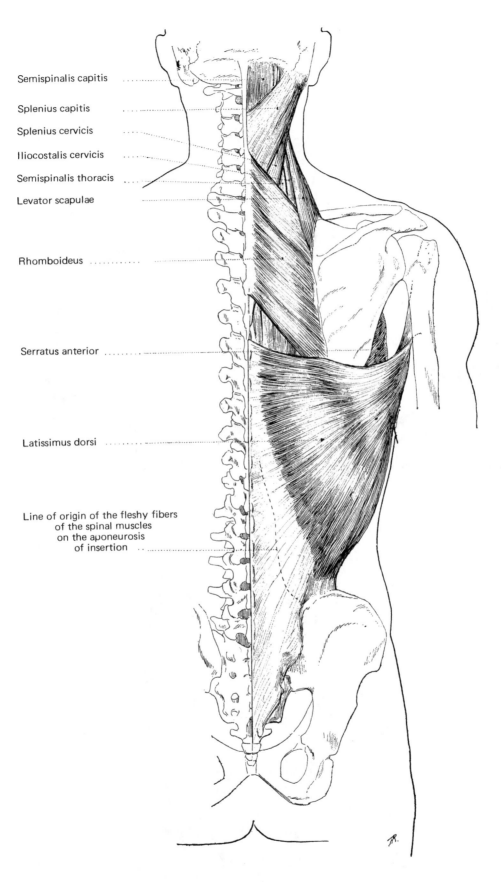

Semispinalis capitis

Splenius capitis

Splenius cervicis

Iliocostalis cervicis

Semispinalis thoracis

Levator scapulae

Rhomboideus

Serratus anterior

Latissimus dorsi

Line of origin of the fleshy fibers
of the spinal muscles
on the aponeurosis
of insertion

LATISSIMUS DORSI

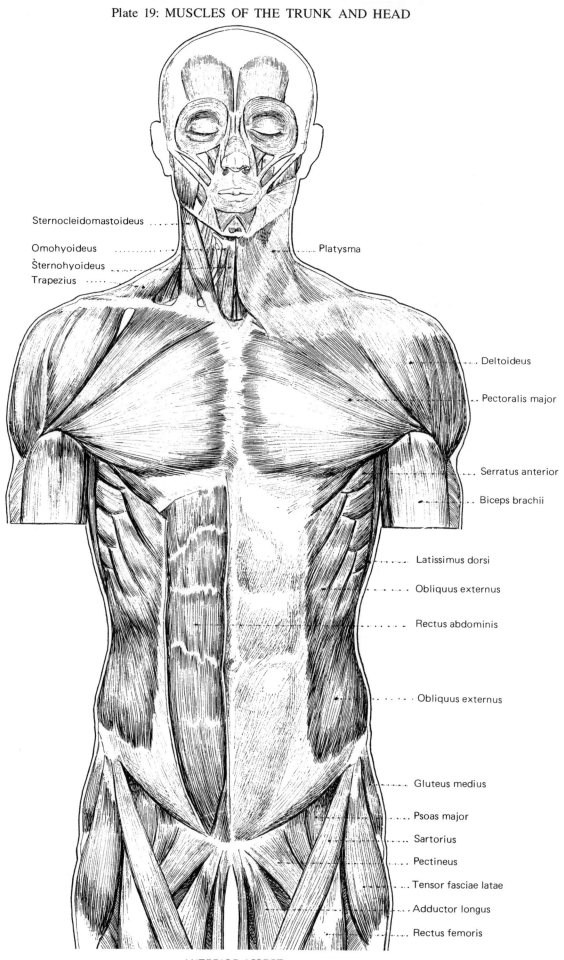

Sternocleidomastoideus

Omohyoideus
Sternohyoideus
Trapezius

Platysma

Deltoideus

Pectoralis major

Serratus anterior

Biceps brachii

Latissimus dorsi

Obliquus externus

Rectus abdominis

Obliquus externus

Gluteus medius

Psoas major

Sartorius

Pectineus

Tensor fasciae latae

Adductor longus

Rectus femoris

ANTERIOR ASPECT

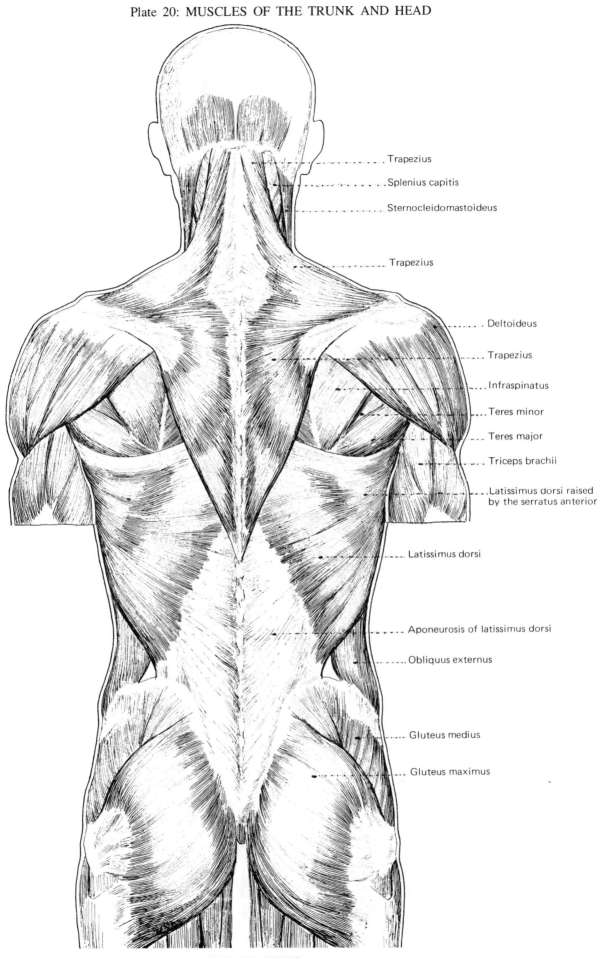

Trapezius

Splenius capitis

Sternocleidomastoideus

Trapezius

Deltoideus

Trapezius

Infraspinatus

Teres minor

Teres major

Triceps brachii

Latissimus dorsi raised by the serratus anterior

Latissimus dorsi

Aponeurosis of latissimus dorsi

Obliquus externus

Gluteus medius

Gluteus maximus

POSTERIOR ASPECT

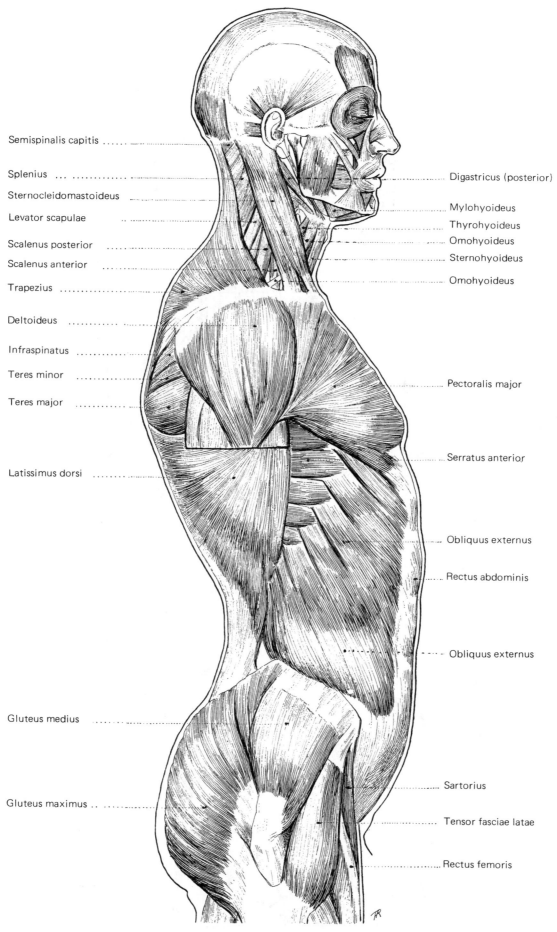

Semispinalis capitis

Splenius

Sternocleidomastoideus

Levator scapulae

Scalenus posterior

Scalenus anterior

Trapezius

Deltoideus

Infraspinatus

Teres minor

Teres major

Latissimus dorsi

Gluteus medius

Gluteus maximus

Digastricus (posterior)

Mylohyoideus

Thyrohyoideus

Omohyoideus

Sternohyoideus

Omohyoideus

Pectoralis major

Serratus anterior

Obliquus externus

Rectus abdominis

Obliquus externus

Sartorius

Tensor fasciae latae

Rectus femoris

LATERAL ASPECT

Deltoideus (anterior portion)

Deltoideus (middle portion)

Pectoralis major

Triceps brachii

Biceps brachii

Brachialis

Triceps brachii

Brachioradialis

Brachialis

Pronator teres

Extensor carpi radialis longus

Aponeurotic extension of the biceps

Flexor carpi radialis

Extensor carpi radialis brevis

Palmaris longus

Flexor digitorum superficialis

Flexor digitorum superficialis

Flexor carpi ulnaris

Abductor pollicis longus

Flexor pollicis longus

Muscles of the thenar eminence

Palmaris brevis

Muscles of the hypothenar eminence

Palmar aponeurosis

Inferior extremities of interossei muscles

Sheaths of flexor tendons

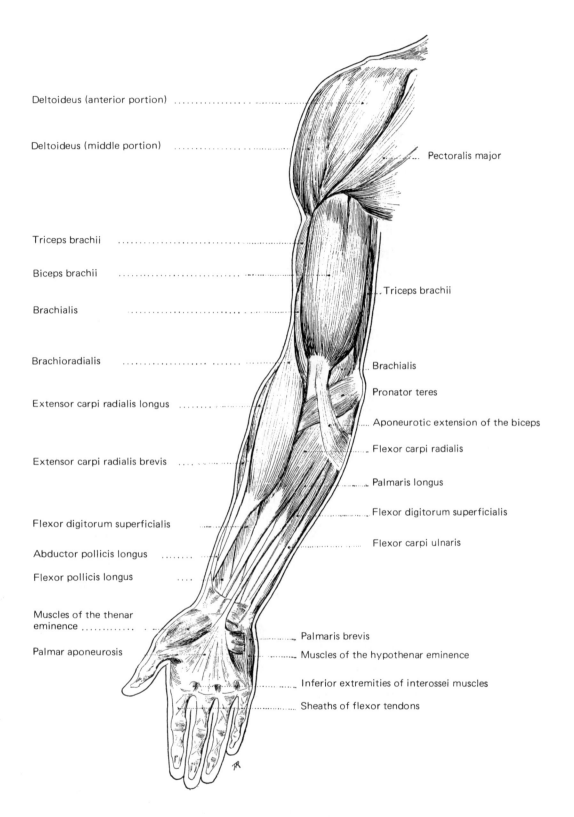

ANTERIOR ASPECT

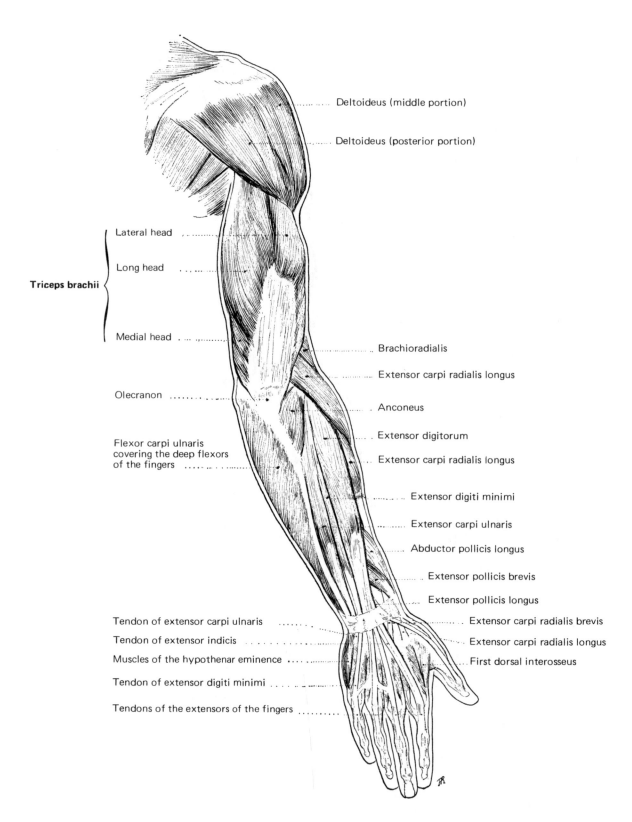

Deltoideus (middle portion)

Deltoideus (posterior portion)

Lateral head

Long head

Triceps brachii

Medial head

Brachioradialis

Extensor carpi radialis longus

Olecranon

Anconeus

Extensor digitorum

Extensor carpi radialis longus

Flexor carpi ulnaris
covering the deep flexors
of the fingers

Extensor digiti minimi

Extensor carpi ulnaris

Abductor pollicis longus

Extensor pollicis brevis

Extensor pollicis longus

Tendon of extensor carpi ulnaris

Extensor carpi radialis brevis

Tendon of extensor indicis

Extensor carpi radialis longus

Muscles of the hypothenar eminence

First dorsal interosseus

Tendon of extensor digiti minimi

Tendons of the extensors of the fingers

POSTERIOR ASPECT

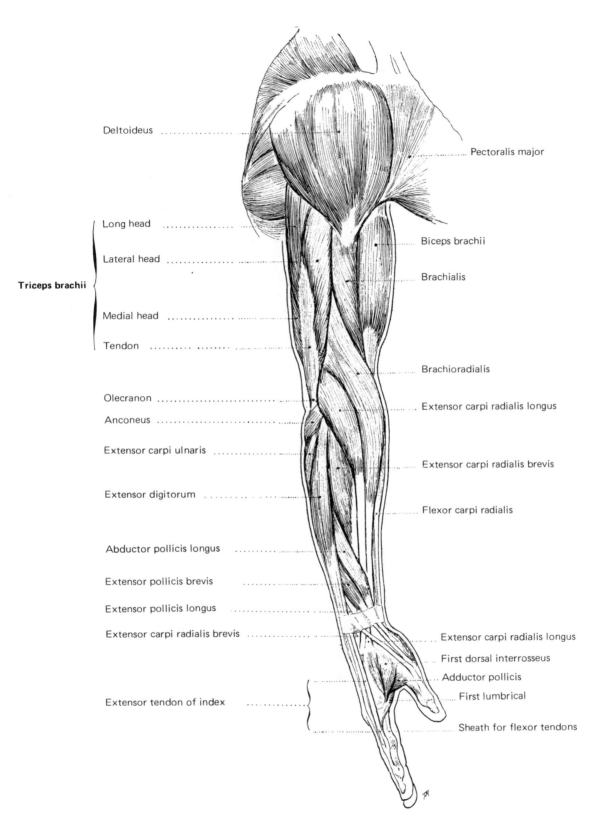

Deltoideus

Pectoralis major

Long head

Biceps brachii

Lateral head

Brachialis

Triceps brachii

Medial head

Tendon

Brachioradialis

Olecranon

Extensor carpi radialis longus

Anconeus

Extensor carpi ulnaris

Extensor carpi radialis brevis

Extensor digitorum

Flexor carpi radialis

Abductor pollicis longus

Extensor pollicis brevis

Extensor pollicis longus

Extensor carpi radialis brevis

Extensor carpi radialis longus

First dorsal interrosseus

Adductor pollicis

First lumbrical

Extensor tendon of index

Sheath for flexor tendons

LATERAL ASPECT

255

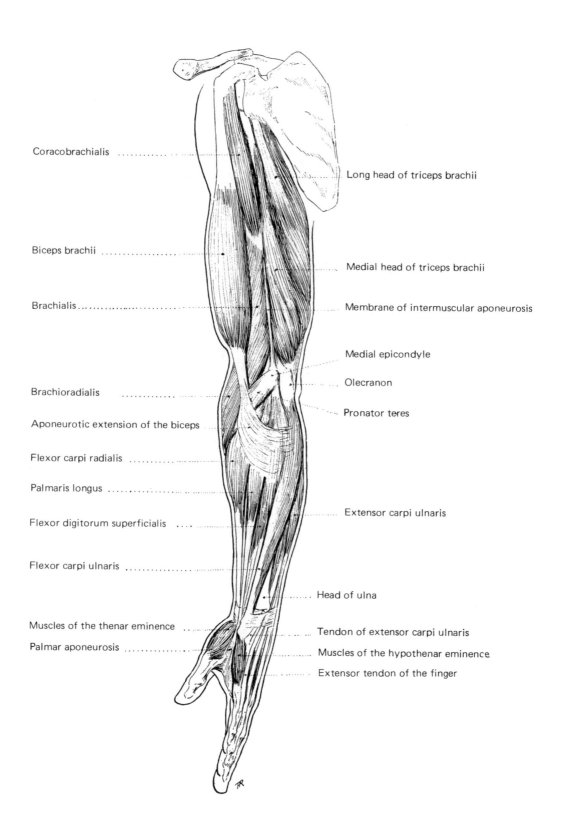

Coracobrachialis Long head of triceps brachii

Biceps brachii Medial head of triceps brachii

Brachialis........................... Membrane of intermuscular aponeurosis

Medial epicondyle

Brachioradialis Olecranon

Aponeurotic extension of the biceps Pronator teres

Flexor carpi radialis

Palmaris longus

Flexor digitorum superficialis Extensor carpi ulnaris

Flexor carpi ulnaris

Head of ulna

Muscles of the thenar eminence Tendon of extensor carpi ulnaris

Palmar aponeurosis Muscles of the hypothenar eminence

Extensor tendon of the finger

MEDIAL ASPECT

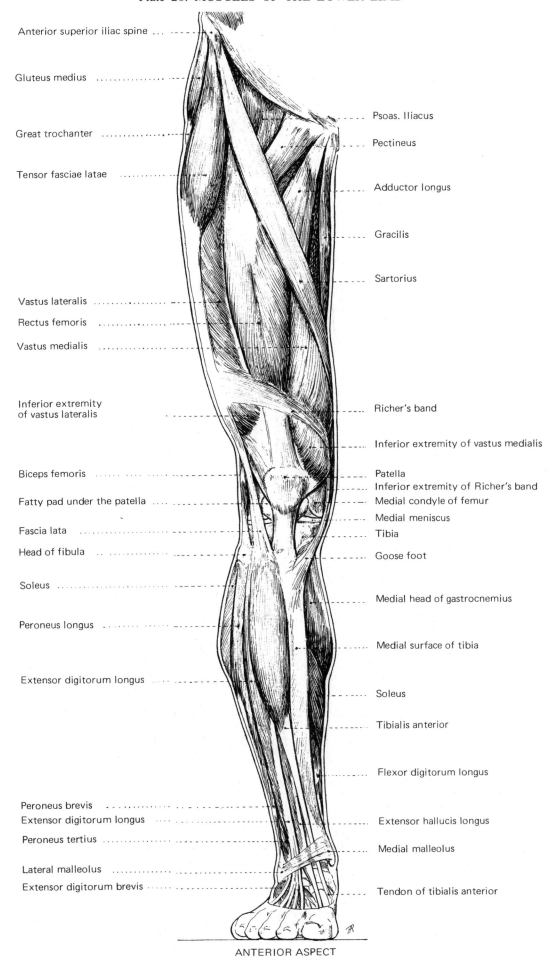

Anterior superior iliac spine

Gluteus medius

Great trochanter

Tensor fasciae latae

Vastus lateralis

Rectus femoris

Vastus medialis

Inferior extremity
of vastus lateralis

Biceps femoris

Fatty pad under the patella

Fascia lata

Head of fibula

Soleus

Peroneus longus

Extensor digitorum longus

Peroneus brevis

Extensor digitorum longus

Peroneus tertius

Lateral malleolus

Extensor digitorum brevis

Psoas. Iliacus

Pectineus

Adductor longus

Gracilis

Sartorius

Richer's band

Inferior extremity of vastus medialis

Patella

Inferior extremity of Richer's band

Medial condyle of femur

Medial meniscus

Tibia

Goose foot

Medial head of gastrocnemius

Medial surface of tibia

Soleus

Tibialis anterior

Flexor digitorum longus

Extensor hallucis longus

Medial malleolus

Tendon of tibialis anterior

ANTERIOR ASPECT

257

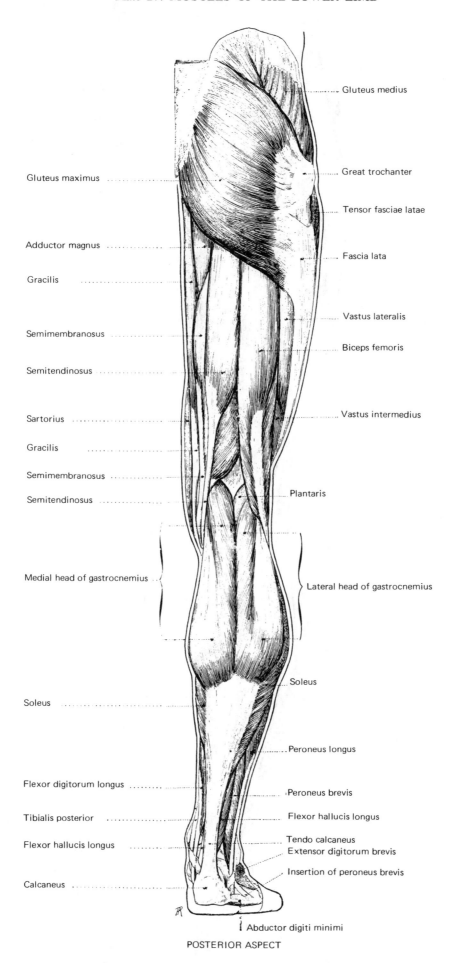

Gluteus medius

Gluteus maximus

Great trochanter

Tensor fasciae latae

Adductor magnus

Fascia lata

Gracilis

Vastus lateralis

Semimembranosus

Biceps femoris

Semitendinosus

Sartorius

Vastus intermedius

Gracilis

Semimembranosus

Semitendinosus

Plantaris

Medial head of gastrocnemius

Lateral head of gastrocnemius

Soleus

Soleus

Peroneus longus

Flexor digitorum longus

Peroneus brevis

Tibialis posterior

Flexor hallucis longus

Flexor hallucis longus

Tendo calcaneus
Extensor digitorum brevis

Calcaneus

Insertion of peroneus brevis

Abductor digiti minimi

POSTERIOR ASPECT

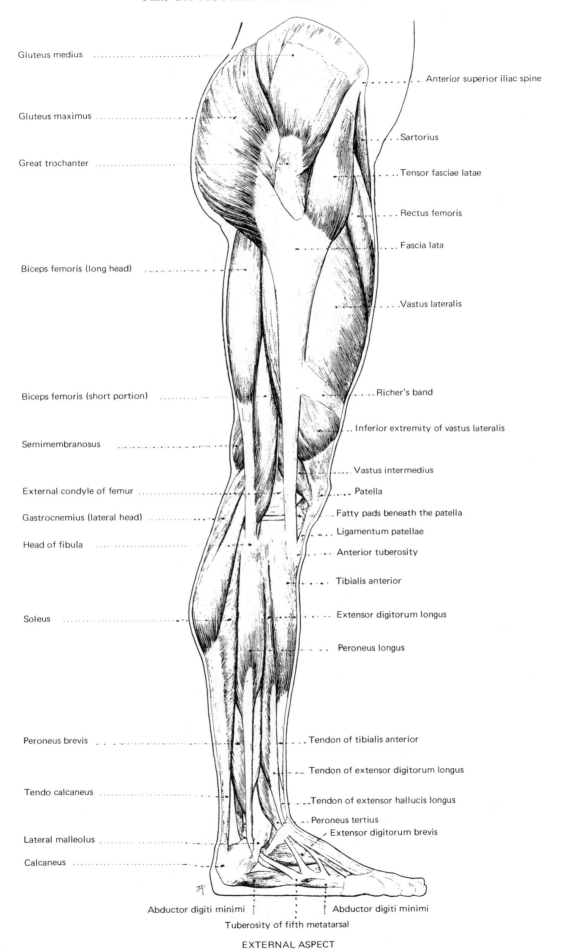

Gluteus medius

Gluteus maximus

Great trochanter

Biceps femoris (long head)

Biceps femoris (short portion)

Semimembranosus

External condyle of femur

Gastrocnemius (lateral head)

Head of fibula

Soleus

Peroneus brevis

Tendo calcaneus

Lateral malleolus

Calcaneus

Anterior superior iliac spine

Sartorius

Tensor fasciae latae

Rectus femoris

Fascia lata

Vastus lateralis

Richer's band

Inferior extremity of vastus lateralis

Vastus intermedius

Patella

Fatty pads beneath the patella

Ligamentum patellae

Anterior tuberosity

Tibialis anterior

Extensor digitorum longus

Peroneus longus

Tendon of tibialis anterior

Tendon of extensor digitorum longus

Tendon of extensor hallucis longus

Peroneus tertius

Extensor digitorum brevis

Abductor digiti minimi

Tuberosity of fifth metatarsal

Abductor digiti minimi

EXTERNAL ASPECT

259

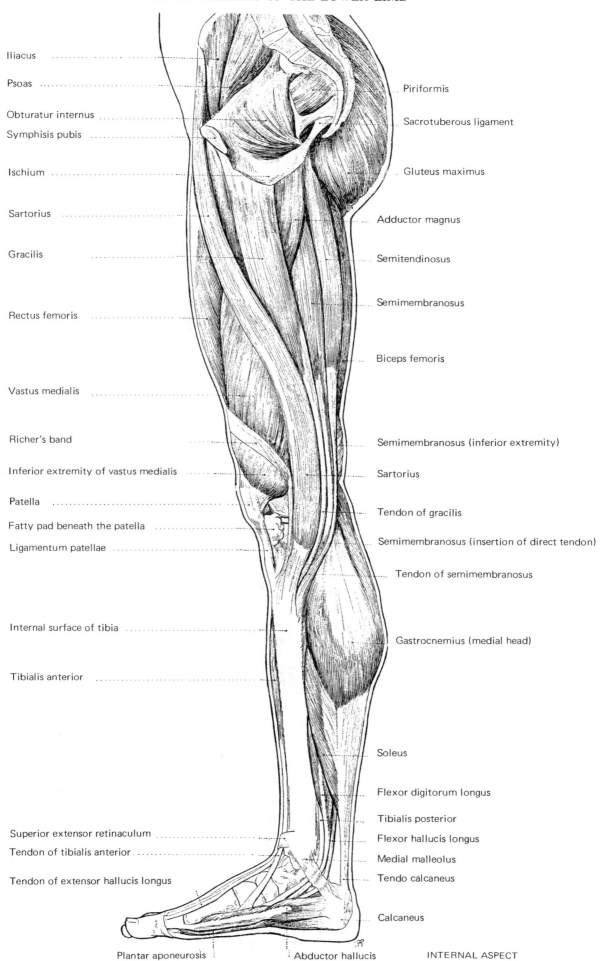

Iliacus

Psoas

Obturatur internus

Symphisis pubis

Ischium

Sartorius

Gracilis

Rectus femoris

Vastus medialis

Richer's band

Inferior extremity of vastus medialis

Patella

Fatty pad beneath the patella

Ligamentum patellae

Internal surface of tibia

Tibialis anterior

Superior extensor retinaculum

Tendon of tibialis anterior

Tendon of extensor hallucis longus

Piriformis

Sacrotuberous ligament

Gluteus maximus

Adductor magnus

Semitendinosus

Semimembranosus

Biceps femoris

Semimembranosus (inferior extremity)

Sartorius

Tendon of gracilis

Semimembranosus (insertion of direct tendon)

Tendon of semimembranosus

Gastrocnemius (medial head)

Soleus

Flexor digitorum longus

Tibialis posterior

Flexor hallucis longus

Medial malleolus

Tendo calcaneus

Calcaneus

Plantar aponeurosis

Abductor hallucis

INTERNAL ASPECT

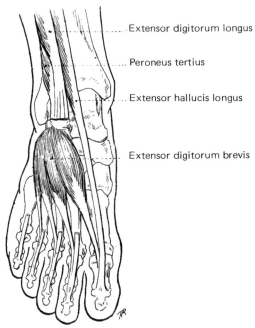

Extensor digitorum longus

Peroneus tertius

Extensor hallucis longus

Extensor digitorum brevis

DORSAL REGION

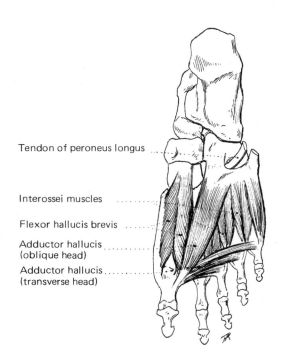

Tendon of peroneus longus

Interossei muscles

Flexor hallucis brevis

Adductor hallucis (oblique head)

Adductor hallucis (transverse head)

PLANTAR REGION, DEEP LAYER

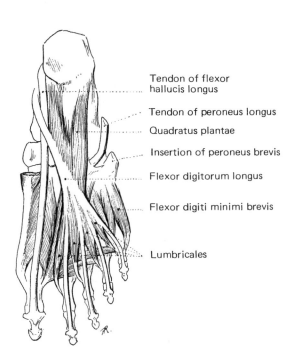

Tendon of flexor hallucis longus

Tendon of peroneus longus

Quadratus plantae

Insertion of peroneus brevis

Flexor digitorum longus

Flexor digiti minimi brevis

Lumbricales

PLANTAR REGION MIDDLE LAYER

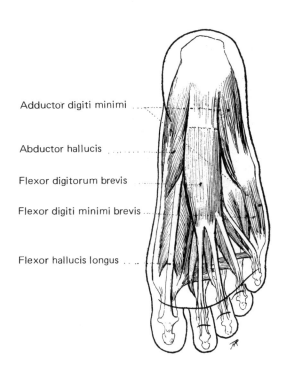

Adductor digiti minimi

Abductor hallucis

Flexor digitorum brevis

Flexor digiti minimi brevis

Flexor hallucis longus

PLANTAR REGION, SUPERFICIAL LAYER

SUGGESTED READING

Richer, Dr. Paul, *Artistic Anatomy*. Translated and edited by Robert Beverly Hale. New York: Watson-Guptill, 1971.

Hale, Robert Beverly/Coyle, Terence, *Master Class in Figure Drawing*. New York: Watson-Guptill, 1991.

——, *Albinus on Anatomy*. New York: Watson-Guptill, 1979.

Hatton, Richard G., *Figure Drawing*. New York: Dover, 1951. (paperback)

Thompson, Arthur, *A Handbook of Anatomy for Art Students*. 4th ed. New York: Dover, 1964. (paperback)

Bridgman, George B., *Constructive Anatomy*. New York: Dover, 1973. (paperback)

Peck, Stephen R., *Atlas of Human Anatomy for the Artist*. New York: Oxford University Press, 1951.

Schider, Fritz, *An Atlas of Anatomy for Artists*. 3rd ed. Translated by Bernard Wolf. New York: Dover, 1929.

Rimmer, William, *Art Anatomy*. New York: Dover, 1962. (paperback)

Barásay, Jeno, *Anatomy for the Artist*. Budapest: University Press, 1968.

Further Reading

Gray, Henry, F.R.S., *Gray's Anatomy: The Illustrated Running Press Edition of the American Classic 1901 Edition*. Philadelphia: Running Press, 1973. (paperback)

Basmajian, John V., M.D., *Grant's Method of Anatomy*. 9th ed. Baltimore: Williams & Wilkens, 1975.

——, *Primary Anatomy*. 7th ed. Baltimore: Williams & Wilkens, 1976.

——, *Muscles Alive: Their Functions Revealed by Electromyography*. 3rd ed. Baltimore: Williams & Wilkens, 1974.

Hollinshead, W. Henry, *Functional Anatomy of the Limbs and Back*. 4th ed. Philadelphia: Saunders, 1976.

Wells, Luttgens, Kinesiology: *A Scientific Study of Human Motion*. Philadelphia: Saunders, 1976.

Groves, Richard/Camaione, David N., *Concepts in Kinesiology*. Philadelphia: Saunders, 1974. (paperback)

Hale, Robert Beverly, *Drawing Lessons from the Great Masters*. New York: Watson-Guptill, 1964.

Blake, Vernon, *The Art and Craft of Drawing*. New York: Dover, 1951. [Reproduction of 1927 ed. New York: Hacker, 1971.

Lanteri, Edouard, *Modeling and Sculpture: A Guide for Artists and Students*. Vol. 1. New York, Dover, 1965. (paperback)

Thompson, D'Arcy W., *On Growth and Form*. New York: Cambridge University Press, 1966.

Darwin, Charles, *The Expression of the Emotions in Man and Animals*. Chicago: University of Chicago Press, 1965. (paperback)

Bell, Sir Charles, *The Anatomy and Philosophy of Expression*. 6th ed. London: H. Bohn, 1872.

Audiovisual Material by Robert Beverly Hale

Video Lectures on *Artistic Anatomy and Figure Drawing*. New York: Jo-An Pictures, P.O. Box 6020, New York, NY 10150.

INDEX

Abduction, 102-103, 180, 184, 186-187
Abductor, 178
Abductor digiti minimi, 94, 96, 102, 184
Abductor hallucinis, 88, 96, 100, 261
Abductor pollicis longus, 176, 182, 252, 254, 255
Academic Study of a Male Figure (Piazzetta), 162-163
Acetabulum, 238
Achilles tendon, 82, 96
Acromioclavicular joint, 126, 128
 articulation, 132-133, 134-135
Acromion process, 22, 28, 106, 108, 110, 116, 122, 130, 134, 144, 190, 192, 234, 235, 236
Adam and Eve (Rembrandt), 68-69
Adam's apple, 190, 196
Adduction, 100-101, 180, 184-185
Adductor digiti minimi, 261
Adductor hallucis, 261
Adductor longus, 257
Adductor magnus, 258, 260
Adductor pollicis, 255
Adductors, 42, 46, 52, 54, 58-59, 120, 250
After the Bath (Degas), 198-199
Alae, 212, 220
Alar cartilage, 212
Alveolar border, 232
Alveolar process, 232
Anconeus, 148, 152, 156, 158
Aneas and Anchises (Raphael), 78-79
Ankle, 72, 74, 82, 86, 98
Annular ligament, 152
Anterior annular ligament, 98
Anterior furrow, 140
Anterior superior iliac spine, 234,257
Antihelix, 216
Antitragus, 216
Aponeurosis, 110, 118, 154, 251, 253, 256
Arcuate line, 238
Arm of Eve, The (Dürer), 160-161
Armpit, 120

Arm, 116, 120, 137-169
 bones of, 239-240
 muscles of, 253-256
Astragalus, 86, 88
Atlas, 192, 198
Auditory canal, 216
Auditory hiatus, 232, 233
Auricularis, 246
Auricular muscles, 208
Auricle, 216
Axilla, 120, 124, 138-139, 140-141
Axillary fold, 124

Back muscles, 28-29
Back View of Female Figure (Delacroix), 182-183
Baldung, Hans, 206-207
Ball and socket joint, 42
Barocci, Federico, 158-159
Basilar part, 233
Beccafumi, Domenico, 190-191
Bellini, Giovanni, 224-225
Bertora, Jacopo, 48-49
Biceps, 60, 64, 66, 68, 74, 122, 130, 257, 258, 259, 260
Biceps brachii, 140, 142, 144-145, 146, 148, 162, 164, 166, 250, 253, 255, 256
Bony landmarks, 172-179
Boucher, François, 150-151, 194-195
Brachialis, 142, 144, 146, 148, 182, 254, 255
Brachioradialis, 158, 253, 254, 255, 256
Breast bone, 32
Breasts, 32
Bronzino, Agnolo, 44-45
Brow, 204
Buccal muscles, 208
Buccinator, 206, 245, 246
Buttocks, 38, 42, 44

Cain and Abel (Cambiaso), 152-153
Calcaneus, 74, 82, 86, 88, 96, 244

Calf, 64, 66, 74, 80, 82, 100, 102
Cambiaso, Luca, 152-153
Canine teeth, 233
Caninus, 220, 245, 246
Capitate, 239, 240
Capitulum, 239
Carotid triangles, 196
Carpal arch, 172
Carracci, Annibale, 116-117
Cellini, Benvenuto, 40
Cervical column, 234, 235, 236
Cervical region, 237
Cervical vertebra, 110, 192, 198, 200, 248
Chin, 204, 208
Circular orbicularis palpebrarum, 208
Clavicle, 30, 106-107, 120, 122, 126, 128, 130, 132, 134, 144, 190, 194, 196, 234, 239, 240
Coccyx, 38, 235, 236, 237, 238
Collar bone. *See* Clavicle
Compressor nasi, 212
Concha, 216
Condyles, 64, 66, 68, 70, 152, 154, 156, 158, 232, 233, 241, 242, 257, 259
Constructed Head of a Man in Profile (Dürer), 204-205
Copy after Bandinelli's "Cleopatra" (Bronzino), 44-45
Coracobrachialis, 130, 140, 256
Coracoid, 234
Coronal suture, 233
Coronoid process, 232, 239
Corrugators, 218, 220, 222, 224, 245
Cricoid cartilage, 196
Crow's feet, 218, 224
Crura, 216
Crureus, 42
Cuboid, 86, 244
Cuneiforms, 86, 98, 243, 244
Cupid's bow, 214

Damned Soul, A Fury (Michelangelo), 226-227
Da Vinci, Leonardo, 54-55, 60-61, 66-67, 218-219, 228-229
Degas, Edgar, 198-199
Delacroix, Eugène, 180-181
Del Piombo, Sebastiano, 36-37
Delpectoral line, 124
Del Sarto, Andrea, 138-139, 178-179
Deltoid, 26, 32, 106, 108, 114, 116, 118, 122-123, 126, 128, 130, 132, 134, 138, 144, 146, 148, 150, 152, 182, 250, 251, 253, 254, 255
Deltoid furrow, 124
Demipronation, 166-167
Dental arch, 233
Depressor angulis oris, 208, 220, 245, 246
Depressor labii inferioris, 208, 245, 246
Depressor septi, 246
Di Credi, Lorenzo, 214-215
Digastric muscle, 196, 247, 252

Digastric triangle, 190, 196
Digits, 172
Dilator naris, 226, 246
Distal crease, 180
Distal transverse arch, 172
Domenichino, 88-89, 94-95
Dorsal interosseus, 174, 176, 182, 254, 255
Dorsal region, 237
Dorsiflexion, 160, 172, 180
Dorsiflexors, 76
Double Study of Kneeling Woman (Raphael), 200
Draped Youth (Ghirlandaio), 180-181
Drapery of Horace (Sanzio), 172-173
Drawing of a Satyr for the Portal of Fontainebleau (Cellini), 40-41
Dürer, Albrecht, 32-33, 86-87, 154-155, 160-161, 176-177, 184-185, 204-205, 210-211, 212-213

Ear, 216-217
Emotions, expression of
 attention, 222-223
 contempt, 220-221
 defiance, 226-227
 disgust, 220
 grief, 224-225
 high spirits, 218-219
 horror, 222-223
 laughter, 218
 rage, 226-227
 reflection, 224-225
Ensiform cartilage, 30
Epicondyles, 239, 240, 241, 243, 256
Epicranial aponeurosis, 246
Epigastric depression, 124
Erector spinae, 28
Extension, 100-101, 152-153, 180-181
Extensor carpi radialis brevis, 152, 253, 255
Extensor carpi radialis longus, 158, 253, 254
Extensor carpi ulnaris, 156, 254, 255, 256
Extensor digiti minimi, 254
Extensor digitorum brevis, 94, 98, 102, 257, 258, 259, 261
Extensor digitorum longus, 68, 72, 78, 94, 98, 102, 152, 156, 158, 164, 257, 259, 261
Extensor hallucis longus, 100, 257, 260, 261
Extensor indicis, 254
Extensor muscles, 160, 180, 182, 184, 202. *See also* specific extensors; Quadriceps
Extensor pollicis brevis, 176, 254, 255
Extensor pollicis longus, 176, 254, 255
Extensor retinaculum, 260
Extensor tendons, 176, 254, 255, 256
External angular process, 210
External oblique, 24, 28, 36. *See also* Oblique Externus
External orbital apophysis, 232
Eye, 210-211

Eyeball, 210
Eyebrows, 206, 224
Eyelids, 210

Faccini, Pietro, 64-65
Facial muscles, 206,208
Fasciae latae, 42, 50, 257, 258, 259
Female Nude Sitting on a Stool (Rembrandt), 94-95
Femur 36, 38, 40, 42, 50, 56, 58, 64, 66, 68, 70, 80, 234, 235, 236, 241, 242, 243, 257, 259
Fibula, 42-50, 60, 64, 68,72, 86, 88, 257
Figure Study for the "Battle of Cascina" (Michelangelo), 192-193
Fingers, 180, 182, 184, 254-256
Flexion, 102-103, 146-147, 168, 172, 176,182-183
Flexor carpi radialis, 186,
Flexi carpi ulnaris, 156, 160, 178, 182, 253, 254, 255, 256
Flexor digiti minimi brevis, 261
Flexor digitorum brevis, 261
Flexor digitorum longus, 72, 257, 258, 260, 261
Flexor digitorum superficialis, 253, 256
Flexor hallucis brevis, 261
Flexor hallucis longus, 258, 260, 261
Flexor mass, 154, 166
Flexor pollicis longus, 253
Flexor tendons, 96, 253, 255
Flexors, 152, 160, 180, 202
Foot, 85-103
 muscles of, 261
Foramen magnum, 233
Forehead, 206
Fouquet, Jean, 208-209
Frontal eminences, 206, 208, 224, 232
Frontalis, 220, 226, 244, 246
Frontal process, 232, 234
Frown line, 222
Fuseli, Henry, 118

Gastrocnemius, 64, 66, 68, 72, 74, 76, 82, 257, 258, 259, 260
Géricault, Théodore, 52-53
Ghirlandaio, Davide, 180-181
Glabella, 204, 212
Glenoid cavity, 108, 144, 233
Gluteus maximus, 38, 40, 44, 48-49, 50, 252, 258, 259, 260
Gluteus minimus, 50
Goose foot, 58, 257
Gracilis, 44, 46, 58, 64, 66, 74, 82, 257, 258, 260
Greuze, Jean-Baptitste, 186-187
Group of Five Grotesque Heads (DaVinci), 218-219

Hair, 222, 226-227
Hairline, 204
Hallucis longus, 98
Hamate, 239, 240
Hamstring, 40, 44, 50, 58, 60, 64, 66, 80, 82

Hand, 171-187
Head, 204-217. See also Skull
 mucles of, 245-246, 250-252
Head of an Old Man (Bellini), 224-225
Head of Saturn (Baldung), 206-207
Head of a Young Man (Di Credi), 214-215
Heel, 74, 82, 86, 88, 92, 96, 100
Helix, 216
Hercules and Antaeus (Signorelli), 72-73
Hip bone, 235, 236, 238
Humerus, 28, 32, 109, 114, 116, 118, 120,122, 124, 132, 134, 136, 144, 148,150, 152, 154, 156, 158, 162, 168,234, 235, 236, 239, 240
Hyoid bone, 190, 197
Hyperextension, 160, 172, 180
Hypothenar eminence, 176, 184, 253, 254, 256

Iliac bone, 234, 235, 236, 238, 241, 242, 243
Iliac crest, 20, 22, 24, 36, 38, 40, 44,48, 50, 52
Iliac spine, 48
Iliacus, 257, 260
Iliocostalis, 28, 248, 249
Iliopsoas, 58
Iliotibial band, 52, 54, 56, 60, 68, 80
Ilium, 238
Incisors, 233
Inferior maxillary, 226
Infraclavicular fosset, 124, 128
Inframammary furrow, 124
Infraorbital muscles, 208, 210
Infrapalpebraral furrow, 206
Infraspinatus, 108, 110, 114-115, 126, 132, 138, 252
Infrasternal notch, 26, 124
Intercondyloid notch, 80
Intercostal furrows, 22
Intermuscular aponeurosis, 256
Internal malleolus, 72
Internal oblique, 26
Interossei, 172, 253, 261
Intertragic notch, 216
Intrinsic muscles, 172
Ischium, 48, 60, 235, 236, 238, 260

Jaw, 194, 222, 224
Jawbone, 216
Jugal furrow, 226
Jugular notch, 124, 190
Jugular process, 233

Knee and lower leg, 63-83, 96
Kneecap, 42, 64
Keeling point, 64, 68, 70, 72, 102
Knuckles, 184

Lamboidal suture, 233
Larynx, 190

Latissimus dorsi, 20, 28, 108, 115, 116, 118-119, 120-121, 126, 134-135, 138, 140, 168, 182, 249, 250, 251, 252
Lebrun, Charles, 98-99
Left Foot (Domenichino), 94-95
Leg. *See also* Thigh *and* Knee and lower leg
 bones of, 241-243
 muscles of, 257-260
Levator anguli oris, 244, 246
Levator anguli scapulae, 112, 126, 128, 192, 194.
 See also Levator scapulae
Levator labii superioris, 206, 245, 246
Levator labii superioris alaeque nasi, 220, 244
Levator scapulae, 247, 249, 252
Ligamentum patellae, 259
Linea alba, 52
Lips, 214
Lister's tubercle, 174
Long cords, 20
Longissimus dorsi, 20, 22, 28, 118
Longitudinal eminence, 98
Lucretia (Dürer), 32-33
Lumbar column vertebrae, 38, 234, 235, 236
Lumbar region, 237
Lumbricals, 172, 255, 261
Lunate, 239, 240

Malar, 206, 211
Male Nude Facing Front (da Vinci), 228-229
Male Nude with Proportions Indicated (Michelangelo), 30-31
Malleolus, 74, 88, 90, 94, 96, 240, 241, 242, 243, 257, 259, 260
Mandible, 232, 234, 236
Mandible notch, 232
Manubrium, 106, 128, 190, 234
Masseter, 206, 244, 246
Mastoid notch, 233
Mastoid process, 204, 232, 233, 234, 235, 236
Maxillary, 232, 234, 236
Medial condyle, 42
Medial epcondyle, 58
Medial malleolus, 100
Medial meniscus, 257
Mental muscles, 209
Mental protuberance, 232
Mentalis, 245, 246
Mentilabial furrow, 208, 214
Metacarpals, 172, 174, 178, 180, 182, 184, 239, 240, 244
Metacarpophalangeal joint, 178
Metatarsals, 86, 88, 90, 92, 98, 100, 102
Michelangelo Buonarotti, 26-27, 28-29, 42-43, 58-59, 80-81, 82-83, 106-107, 110-111, 112-113, 120-121, 128-129, 130-131, 132-133, 192-193, 196-197, 216-217, 226-227
Molars, 233
Mouth, 214-215
Muscles, 96-97, 98-99, 172-179, 245-261
Muscles, 96-97, 98-99 172-179, 245-261

Mylohyoid, 190, 247, 252
Naked Man Sitting on the Ground (Rembrandt), 100-101
Nasalis, 245, 246
Nasal bone, 212, 232, 234
Nasal cavity, 232
Nasal eminence, 232
Nasal muscles, 208
Nasolabial furrow, 206, 208, 214, 218, 220, 226
Navel, 26, 36, 52
Navicular, 76, 86, 96, 241, 243, 244
Neck, 189-203
 muscles, 247-249
Nipples, 32
Nose, 204, 206, 212-213
Nuchal furrow, 192
Nuchal lines, 233
Nude Back (Tiepolo), 28-29
Nude Male Figure (Zuccaro), 76-77
Nude Man Between Two Females (Raphael), 134-135
Nude Man Raising His Body (Rubens), 92-93
Nude Man Sitting on a Stone (Raphael), 148-149
Nude Man Standing (Da Vinci), 66-67
Nude Seen from Behind (Signorelli), 74-75
Nude Studies (Pontormo), 122-123
Nude Study (Tiepolo), 124-125

Obicularis oris muscle, 214, 218
Oblique externus, 250, 251, 252.
 See also External Oblique
Oblique line, 232
Oblique muscle, 23
Obliquus externus, 19
Obliquus internus, 260
Occipital protuberance, 126, 192, 198, 200, 232, 233, 236
Olecranon process, 144, 146, 148, 150, 152, 240, 254, 255, 256,
Omohyoid, 196, 247, 250, 252
Oral muscles, 208
Orbicularis oculi, 244, 246
Orbicularis oris, 208, 218, 245
Orbularis palpebrarum, 218. 224, 226
Orital cavity, 232
Orbit, 234
Orbital muscles, 208
Os calcis, 86, 88

Platin apophysics, 233
Palatin bone, 233
Palm, of hand, 172, 176, 180
Palmar aponeurosis, 253-256
Palmar fasciae, 172
Palmar flexion, 186
Palmaris brevis, 253
Parietal, 232, 233, 235, 236
Parotid-masseteric muscles, 208
Passarotti, Barolomeo, 174-175
Patella, 42, 46, 56, 56, 64, 68, 70, 76, 78, 80, 82, 102, 241, 243, 257, 259, 260

Pectineus, 58, 250, 257
Pectoralis major, 106, 116, 118, 120-121, 128, 130, 138, 140, 182, 252, 253, 255
Pectoralis minor, 120
Pectoralis muscles, 18, 250
 female, 32-33
 male, 30-31
Pelvis, 24, 35-56, 138, 238
Peroneus brevis, 98, 100, 102, 258, 259, 261
Peroneus longus, 68, 72, 78, 80, 94, 100, 102, 257, 258, 259, 261
Peroneus tertius, 257, 261
Perygoid apophysis, 233
Petrous part, 233
Phalanges, 86, 90, 92, 174, 178, 180, 182, 239, 240, 244
Philtrum, 214
Piazzetta, Giovanni Battista, 162-163
Piriformis, 260
Pisiform bone, 172, 178, 239, 240
Plantar flexion, 100-101
Plantaris, 258
Platysma, 226, 250
Platysma myoides, 222
Polyphemus Hurling the Rock at Odysseus (Fuseli), 118-119
Pontormo, Jacopo, 24-25, 90-91, 122-123, 142-143, 166-167, 222
Popliteal fossa, 60, 66, 74
Portrait of an Ecclesiastic (Fouquet), 208-209
Portrait of His Mother (Dürer), 210-211
Poupart's ligament, 36, 38
Poussin, Nicholas, 220-221
Preliminary Study for the "Disputà" (Sanzio), 168-169
Preparatory Drawing for "Christ Among the Doctors" (Dürer), 184-185
Procerus, 212, 220, 245, 246
Prometheus (Le Brun), 98-99
Pronation, 162-163, 168
Pronator quadratus, 162
Pronator teres, 154, 162, 166, 253, 256
Proportions, 228-229
Proximal transverse arch, 172
Prud'hon, Pierre-Paul, 70-71
Psoas iliacus, 257
Psoas major, 250, 257
Pubis, 26, 36, 236, 238
Pupil, 218, 222
Pyramidalis nasi, 212, 220, 224

Quadratus plantae, 261
Quadriceps, 40, 42, 50, 54, 56-57, 58, 64, 66, 78

Radial deviation, 184, 186
Radius, 142, 146, 152, 154, 156, 162, 164, 172, 174, 239, 240
Ramus, 232
Raphael Sanzio, 20-21, 22-23, 48-49, 78, 126-127, 134-135, 148-149, 168-169, 172-173, 200-201

Reclining Satyr (Boucher), 150-151
Rectus abdominis, 26-27, 250, 252
Rectus femoris, 42, 46, 52, 54, 56, 64, 82, 250, 252, 257, 259, 260
Red margin, 214
Rembrandt van Rijn, 68-69, 96-97, 100-101, 102-103, 140-141
Return of the Prodigal Son (Rembrandt), 102-103
Rhomboids, 22, 28, 110, 112-113, 126, 248
Rib cage, 15-33, 40, 48, 114, 116, 120, 128, 130, 142
Richer's band, 257, 259, 260
Right Foot and Bone Structure (Dürer), 86-87
Risen Christ, The (Michelangelo), 42-43
Risorius muscle, 218
Rubens, Peter Paul, 18-19, 38-39, 92-93, 108-109, 156-157, 164-165, 202-203

Sacral foramina, 38
Sacral triangle, 16, 38, 48
Sacral dimples, 44
Sacroiliac, 38
Sacrotuberous ligament, 260
Sacrum, 22, 28, 42, 158, 234, 235, 236, 237, 239, 241, 242, 243
Sagittal suture, 233
Salt box, 124, 194
Saphenous veins, 94
Sartorius, 42, 46, 54-55, 56, 58, 64, 66, 78, 82, 250, 252, 257, 258, 260
Scaleni, 192, 194, 198, 247, 252
Scaphoid, 96, 172, 239, 240
Scapula, 22, 28, 106, 108, 110, 112, 114, 116, 118, 122, 126, 128, 130, 132, 134, 142, 192, 234, 236, 239, 240
Seated Female Nude (Prud'hon), 70-71
Seated Nude, A (Greuze), 186-187
Seated Nude Facing Right and Reclining on Cushions (Boucher), 194-195
Selera, 210
Self-Portrait (Poussin), 220-221
Semimembranosus, 60, 66, 78, 259, 260
Semispinalis capitis, 247, 248, 249, 252
Semispinalis thoracis, 248, 249
Semitendinosus, 58, 60, 64, 66, 78, 258, 260
Septal cartilage, 212
Serratus anterior, 20, 22, 24, 28, 112, 120, 134-135, 138, 249, 250, 252
Serratus posterior inferior, 28, 118, 248
Shin bone. *See* Tibia
Shoulder blade. *See* Scapula
Shoulder girdle, 28-29, 105-135, 138
Signorelli, Luca, 72-73, 74-75
Sketch for the Saint Sebastian (Titian), 46-47
Sketches of Heads and Figures (Michelangelo), 216-217
Skull, 110, 204, 206, 210, 232-233
Sole, of foot, 93
Soleus, 68, 72, 74, 76, 78, 82, 257, 258, 259, 260
Sphenoid, 232
Spinae, 20
Spinalis dorsi, 248

Spine, 16, 22, 38, 118, 126, 248, 249
Splenius capitis, 247, 248, 249, 252
Splenius cervicus, 248, 249
Squama, 232
Standing Female Nude (Del Piombo), 36-37
Standing Nude (Faccini), 64-65
Standing Nude, Seen from Back (Michelangelo), 110-111
Sternoclavicular articulation, 128-129, 130-131
Sternoclavicular fosset, 125, 194
Sternocleidomastoideus, 106, 112, 128, 130, 190, 192, 194, 196, 198, 200, 202, 220, 226, 247, 250, 251, 252
Sternohyoideus, 249, 250
Sternum, 30, 32, 106, 120, 124, 194, 234
Strong chords, 20, 38
Studies (Pontormo), 24-25
Studies for the Crucified Haman (Michelangelo), 196-197
Studies for the Martyrdom of San Vitale (Barocci), 158-159
Studies of Hands (Del Sarto), 178-179
Studies of Hands and Nude Figures (Passarotti), 174-175
Studies of Human Legs (Da Vinci), 60-61
Studies of Legs (Titian), 56-57
Studies of Two Female Nudes (Bertola), 48-49
Studies of a Woman Sleeping (Van Dyck), 114
Study for a Bather (Michelangelo), 106-107
Study for the Figure of Christ on the Cross (Rubens), 18-19
Study for Figure on "The Raft of the Medusa" (Géricault), 52-53
Study for Left Leg of "Day" (Michelangelo), 82-83
Study for the Nude at Right above the Persian Sibyl (Michelangelo), 132-133
Study for One Resurrected of "The Last Judgment" (Michelangelo), 112-113
Study for Part of the Mosaic Frieze of the Siena Cathedral Pavement (Beccafumi), 190-191
Study for a Painting of "The Death of Decius Mus" (Rubens), 156-157
Study for a Pietà (Michelangelo), 128-129
Study for Saint Jerome (Dürer), 212-213
Study of Figures (Pontormo), 142-143
Study of the Hands of God the Father from The Heller Altarpiece (Dürer), 176
Study of John the Baptist for "Baptism of the Multitude" (Del Sarto), 138-139
Study of the Legs of a Nude Man (Michelangelo), 58-59
Study of the Lower Half of the Nude Man (Da Vinci), 54-55
Study of Lower Part of Female Nude (Pontormo), 90-91
Study of Male Figure (Rubens), 38-39
Study of Male Nude Torso (Rubens), 164-165
Study of a Model of the Giuliano de' Medici (Michelangelo), 144-145
Study of a Nude (Carracci), 116-117
Study of a Nude (Rembrandt), 140-141
Study of Nude Youth for Sistine Ceiling (Michelangelo), 120-121

Study of a Portrait of Piero de' Medici (Michelangelo), 222-223
Study of a River God for "The Four Rivers" (Rubens), 108-109
Study of Saint Lawrence for "The Last Judgment" (Michelangelo), 130-131
Study of a Statue of Atlantis (Tintoretto), 146-147
Stylohyoid, 247
Styloid process, 152, 154, 158, 160, 172, 174, 232, 233, 240, 242, 243
Submaxillary triangle, 190
Sulcus tali, 244
Superficial external oblique, 26
Supination, 164-165, 166
Supinator brevis, 162, 164
Supinator longus, 112, 158, 162, 164
Supinators, 146, 152, 154, 156, 166, 186
Supraclavicular fosset, 124
Supraorbital arch, 232
Supraorbital eminence, 232
Supraorbital muscles, 208
Supraspinatus, 108, 114, 116, 118, 126, 132-133
Suprasternal notch, 124
Sustentaculum tali eminence, 88, 244
Symphysis pubis, 52-53, 238, 260

Table muscle. *See* Trapezius
Tailor's muscle, 54
Talus, 86, 241, 242, 243, 244
Tarsus, 88, 90
Tear bag, 210
Teeth, 233
Temporal aponeurosis, 245
Temporal bone, 216, 232, 233, 234
Temporalis, 245, 246
Temporal muscles, 208
Tendo calcaneus, 259, 260
Tensor fasciae latae, 52-53, 250, 252, 257, 258, 259
Teres major, 20, 22, 108, 110, 116-117, 126, 132, 138, 168, 252
Teres minor, 114, 252
Tertius muscles, 98
Thenar eminence, 172, 176, 180, 253, 256
Thigh, 42-61, 74, 80
Thoracic arch, 18, 26
Thoracic vertebrae, 20, 28, 110, 112, 234, 236
Thorax, 44
Three Graces (Raphael), 50-51
Three Studies from Nature for Adam's Hand (Dürer), 154-155
Thyroid cartilage, 190, 194, 196
Thyroid muscle, 196, 202, 247, 252
Tibia, 42, 54, 56, 58, 60, 64, 66, 68, 70, 72, 76, 78, 80, 82, 86, 90, 96, 98, 100, 102, 241, 242, 243, 257, 260
Tibialis anterior, 68, 72, 76, 78, 82, 94, 96, 98, 100, 102, 257, 259, 260

Tibialis posterior, 76, 258, 260

Tiepolo, Giovanni Battista, 16-17, 28-29, 124-125

Tintoretto, Jacopo, 146-147

Titian, 46-47, 56-57

Toes, 78, 88, 92, 96, 98, 100, 102

Tongue bone. *See* Hyoid

Torso of Seated Man (Michelangelo), 80-81

Trachea, 196

Tragus, 216

Transverse line, 26

Trapezium, 239, 240

Trapezius, 20, 22, 28, 106, 108, 110, 112, 114, 116, 118, 126, 128, 130, 182, 190, 192, 194, 196, 198, 200, 202, 247, 250, 251, 252

Trapezoid, 239, 240

Triangularis, 208

Triceps, 80, 112, 122, 138, 140, 144, 146, 148-149, 150-151, 152, 182, 253, 254, 255, 256

Tripod, 64

Trochanter, great, 36, 38, 40, 44, 50, 52, 158, 234, 241, 242, 243, 257, 258, 259

Trunk
 bones of, 234-236
 muscles of, 248-252

Tubercle, 239

Tuberosity, 240, 259

Two Bacchantes (Tiepolo), 16-17

Two Male Figure Studies (Raphael), 20-21

Two Naked Figues Crouching Under a Shield (Raphael), 22-23

Two Studies of a Left Leg (Domenichino), 88-89

Ulna, 142, 144, 146, 148, 150, 152, 154, 156, 162, 164, 174, 239, 240, 256

Ulnar deviation, 184

Ulnar furrow, 160

Umbilicus, 26

Van Dyck, Anthony, 114-115

Vastus externus, 42, 44, 56, 60, 64, 78

Vastus intermedius, 42, 56, 80, 258

Vastus internus, 42, 46, 64, 70, 78, 82

Vastus lateralis, 68, 257, 258, 259

Vastus medialis, 257, 260

Vermillion zone, 214

Vertebral column, 16-17, 22-23, 44, 192, 194, 237, 260

Vertical frontalis, 224

Volar hand, 172

Windpipe, 196

Wrist, 172, 174

Young Man Holding a Small Child (Pontormo), 166-167

Young Woman with Crossed Hands (Rubens), 202-203

Youth Beckoning; A Right Leg (Michelangelo), 26-27

Zuccaro, Taddeo, 76

Zygomatic arch, 232, 233

Zygomatic bone, 210, 232, 236

Zygomatic minor, 206, 218, 245, 246

Zygomatic major, 220, 245, 246

Zygomatic muscles, 208

Zygomatic process, 232, 233, 234

Edited by Bonnie Silverstein
Designed by Bob Fillie
Set in 10-point Times Roman by Intergraphic Technology, Inc.